PRAISE FOR JEREMIAH MOSS AND
VANISHING NEW YORK

"Essential reading for fans of J⋯ ⋯ ⋯ Smith, Luc Sante, and cheap pierogi."　　　　—David Kamp, *Vanity Fair*

"A full-throated lament for the city's bygone charms." —*Wall Street Journal*

"Moss won me over almost immediately and has written a cri de coeur that is essential reading for anyone who loves this city."
　　　　　　　　　　　　　　—Michael J. Agovino, *Village Voice*

"The pleasure . . . of reading Moss is his purity."
　　　　　　　　　　　　　　　—*New York Times Book Review*

"Moss, a cantankerous defender of the city he loves, chronicles its disconcerting metamorphosis from cosmopolitan melting pot to bland corporate lounge with passion and vigor; New York is lucky to have him on its side."
　　　　　　　　　　　　　　　　　　　　—NewYorker.com

"A remarkable atlas charting where New York has gone, and why."
　　　　　　　　　　　　　　　　　　　　—*New Republic*

"A compelling and often necessary read."　　　　—*Daily Beast*

"An impassioned work of advocacy on behalf of a city that's slipping away."
　　　　　　　　　　　　　　　　　　　　—*Guernica*

"There is much embitterment, snark, and rhapsodizing about egg-creams to satisfy the downright romantic here. . . . But the book is much more than a nostalgia trip."　　　　　　　　　　　　—*CityLab*

"Moss's book is very much in the tradition of Jane Jacobs's *The Death and Life of Great American Cities*, with a more acerbic outrage suited to our nasty, barbaric times. . . . His glimpses of New York can be engagingly personal and eloquent."　　　　—*Los Angeles Review of Books*

"Passionate, sprawling." —Slate

"A vigorous, righteously indignant book that would do Jane Jacobs proud."
—*Kirkus Reviews*

"A very good, angrily passionate, and ultimately saddening book. . . . Brilliantly written and well-informed." —*Booklist* (starred review)

"A passionate case against 'the luxury vision of New York that characterized the Bloomberg years.' . . . Likely to stir a lot of emotions."
—*Publishers Weekly*

"I haven't read a more impassioned book in over a decade. Jeremiah Moss writes like a man who has lost the love of his life to a junk bond trader. *Vanishing New York* is angry, incredulous, but also full of insight into a city of legend, where every legend happened to be true." —Gary Shteyngart

"Jeremiah Moss came to the party that is New York City just in time to see it turn into a wake. The New York of poets and weirdos and cranks and outsiders and keepers of various flames—and of ordinary hardworking sorts with no aspirations to stardom or wealth—has pretty much receded into memory now, and Jeremiah has become that memory. His book is lucid, eloquent, phenomenally detailed, and terribly sad. Future generations, assuming there are any, will read it in wonder and disbelief." —Luc Sante

"Meticulously researched, thoroughly reported, at once a call to arms and a soul cry, *Vanishing New York* is a love letter to originality and the human spirit. Grab a knish and settle in."
—Charles Bock, *New York Times* bestselling author of *Alice & Oliver*

"I can't stand going on vanishingnewyork.com and seeing what's next to go." —Andy Cohen, TV personality
and executive vice president at Bravo

VANISHING

NEW YORK

VANISHING NEW YORK

HOW A GREAT CITY LOST ITS SOUL

JEREMIAH MOSS

DEY ST.

An Imprint of WILLIAM MORROW

A hardcover edition of this book was published in 2017 by Dey Street Books, an imprint of William Morrow.

FIRST DEY STREET BOOKS PAPERBACK EDITION PUBLISHED 2018.

Designed by Suet Chong

Library of Congress Cataloging-in-Publication Data has been applied for.

ISBN 978-0-06-243968-0

HB 01.18.2024

FOR ALL THE NEW YORKERS WHO FIGHT FOR THE
CITY'S SOUL EVERY DAY, IN WAYS LARGE AND SMALL,
AND WHO NEVER FORGET WHAT A CITY IS.

CONTENTS

PART THREE

AUTHOR'S NOTE

IN THE SUMMER OF 2007, I FINISHED THE FIRST DRAFT OF A (STILL unpublished) novel about a New Yorker named Jeremiah Moss who laments the vanishing of his city. Writing in that voice was cathartic and I wanted to keep going. One night, without much thought, I launched the blog Jeremiah's Vanishing New York using Jeremiah Moss as my pseudonym. I didn't expect anyone to read it. Though public, it was personal, a place to chronicle the losses that were important to me. But the readers came. And I kept the name.

I soon discovered that a pen name bestows the great gift of being heard but not seen. This brings psychological freedom. Jeremiah didn't need to be polite. He didn't need to see things from all sides. He could be outraged and opinionated and forthright without getting hamstrung by my neurotic hesitation and doubt.

From the beginning, I've been openly pseudonymous. Many readers enjoy the mystery and don't want to see the mask removed. But it's time. I don't know what will become of Jeremiah. The blog may or may not continue, but I doubt that I'll be able to write with the same fervor. And so, like the New York I love, Jeremiah might vanish, too.

INTRODUCTION

O NE OF THE GREAT TRAGEDIES OF MY LIFE WAS THAT I HAD the misfortune to arrive in New York City at the beginning of its end. It was 1993, I was twenty-two years old, and already I was too late. I had missed the city's every heyday—the rambunctious punk years of the 1970s and '80s, the beatnik days of the 1950s and '60s, the glorious wartime forties, the radical lefty thirties, the bohemian 1920s and '10s, all the way back to the ur-countercultural era of Walt Whitman carousing and espousing at Pfaff's beer cellar in the 1850s. I missed it all, over a century of the best of New York, thanks to two uncontrollable facts of my birth: its year and geographic location. But we cannot choose our time or place, and I hurried to the city as soon as I could, unaware that the early 1990s was quite possibly the worst moment to get attached to New York. It was like falling crazily in love with a ninety-three-year-old, too blind to see that she was fading. I was Harold and New York my Maude. The city looked so alive—filled with creative vitality, still untamed and rough around the edges. How could I not believe it would last forever? I allowed myself to fall, as if we would have all the time in the world together.

That experience of having missed out, along with its attendant emotional cocktail of anger, grief, and bitter disappointment, surely helps drive everything I write on New York and its vanishing. On this topic, I am not dispassionate. I am biased and prone to nostalgia. You should know that up front. While the *New York Times* called me a "curmudgeon" with a "penchant for apocalyptic bombast," and the *Daily News* dubbed me a "fetishist for filth," I come to New York a romantic, Woody Allen's Isaac Davis in the opening of *Manhattan,* idolizing and romanticizing the city "all out of proportion." Like him, I've also struggled to find the right tone for my book, something profound, not too preachy or angry. But how can I write about the death of New York, the greatest city on earth, without shaking a fist? New York deserves preaching and anger, romance and nostalgia. It deserves a passionate, furious defense.

Dear reader, if you're the sort who's always telling the outraged romantics among us to "get over it" and "move on," because "everything changes," then you might not want to read further. You will be terribly bothered by most of what I have to say. If, on the other hand, you are troubled by New York's twenty-first-century transformation, if you lament the loss of the city's unique character and wonder what the hell happened, then read on. You will find the lost city in these pages, through a (sometimes painfully) detailed account of its disappearance. When all is said and done, you might end up with a broken heart. Either way, you've been warned.

To borrow the first line of Jane Jacobs's classic, *The Death and Life of Great American Cities*: "This book is an attack on current city planning and rebuilding." It is an attack on the luxury vision of New York that characterized the Bloomberg years. It is an attack on suburbanization, hyper-gentrification, and all that led up to it. A plea for the soul of the city, this book is not a nostalgia trip, but it is about history. Mostly, it's about the city in the 2000s, life in the New Gilded Age, now that the rambunctious New York we knew has breathed out its death rattle.

Reports of New York's death are not greatly exaggerated, though some would argue otherwise, insisting that the city's undomesticated heart still beats in far-off corners of Brooklyn and the Bronx, that you'll find a faint pulse in whitewashed Manhattan if you look hard enough. These insistent optimists, deep in denial, point to any trace of the old town and say, "There is New York." Yes, there it is. But it's only a remnant, a lone survivor from an endangered species rapidly vanishing. Maybe it's that dive bar with the Ramones on the juke-box, or that bookshop with a cat lounging atop the stacks, or the rare sighting of a transgender outlaw walking some West Village street in platform heels. It's like finding a polar bear, sweating on her melting chunk of ice, and then denying that the world is cooked because, hey, there's a polar bear. Others quote from the long history of doomsay-ers, the many writers who declared the city dead. "The complaint that the real soul of Manhattan has already expired is a long-standing one—perhaps as old as a nineteenth-century Knickerbocker's pin-ing for a mythological Dutch past," writes Bryan Waterman in *The Cambridge Companion to the Literature of New York*. That's true. But has the complaint ever been made by so many, so relentlessly, and with such passionate certainty as it is today—and with so much evidence to back it up?

Novelist Caleb Carr called the massive change to the twenty-first-century city a "regrettable, soul-sucking transformation." Patti Smith told us to "find a new city" because "New York has closed itself off to the young and the struggling." David Byrne wrote an essay on the cul-tural death of New York, saying, "most of Manhattan and many parts of Brooklyn are virtual walled communities, pleasure domes for the rich." Essayist David Rakoff observed how "the town's vibrancy and authenticity" have been "replaced by a culture-free, high-end-retail cluster-fuck of luxury condo buildings." Responding to all this, the counterargument goes: But it's safer! The streets are clean! And we have great restaurants! In *The New Yorker*, Adam Gopnik summed it up: "New York is safer and richer but less like itself, an old lover who

has gone for a face-lift and come out looking like no one in particular. The wrinkles are gone, but so is the face. . . . For the first time in Manhattan's history, it has no bohemian frontier."

I could go on with pages of similar quotes, all from the past decade or so, a chorus of voices from literature, art, new media, journalism, all making the same argument: at the beginning of the twenty-first century, the city changed in what felt like an instant, and the change wasn't good. In short, New York has lost its soul. The place is dead. Okay, "dead" might be hyperbolic. Is "dying" a better word? How about "comatose," awaiting a miraculous revival? Maybe this shift is just another phase in the city's long and ever-changing evolution. But who ever thought New York would have a soulless period?

This book, like my blog of the same name, is both a historic record and a personal document. I can't disentangle the two. As a historic record, it is filled with facts, many gleaned from newspapers, books, magazines, and blogs, as well as firsthand interviews and my own experiences. I've done my best to be accurate, but singular truth is a slippery thing when recounting the city's daily dramas. As a personal document, this book is filled with metaphor and conjecture. It is an emotionally inflected account from someone who lived the story and was affected by the plot. Let's not delude ourselves with fantasies of objectivity. How can anyone be objective about New York? It's not a souvenir snow globe or a designer coffee table. It's a living thing, an unwieldy ecosystem filled with many smaller ecosystems, all interdependent, making up the complex, multicellular organism of the city.

There are many New Yorks, as many as there are New Yorkers, each one of the eight million and change carrying a personal metropolis in the heart. Not to mention the many fantasized cities that throb in the hearts of aspiring New Yorkers yet to arrive. The city that I am lamenting is my New York, but it's also a version of the city shared by millions. Since 2007, in my blogospheric life, I have been talking with and listening to countless New Yorkers and lovers of the city from all

over the world. Continually, they pour out their grief and rage over the loss of New York's soul. That tragic Greek chorus backs me up, humming along in these pages.

When I say "the city," I'm talking about an idea that includes physical places, as well as people, but also a certain character and mood. I'm talking about the city I dreamed of back in my small-town New England life, when I plotted my own escape from a dull little world of snoozing Sunday afternoons domed in the drone of cicadas, lawnmowers, and—let me just quote the poet Frank O'Hara here: "I can't even enjoy a blade of grass unless I know there's a subway handy, or a record store or some other sign that people do not totally *regret* life."

My city is the city of artists, writers, and assorted outcasts. It's the city of E. B. White's passionate settlers, the "boy arriving from the Corn Belt with a manuscript in his suitcase and a pain in his heart." When I say "the city," I'm not talking about the whole city. I mean mostly Manhattan, but also large parts of Brooklyn. I mean only some of Queens and the Bronx, because my city is a romantic notion and, let's face it, it's not easy (for me, anyway) to conjure romance for Flushing or Throgs Neck. I don't mean Staten Island, because precious few feel romantic about Staten Island (no offense), though the ferry is delightful, especially on a hot and humid summer day. The city that I'm talking about is the one that, throughout history, has been a beacon to dissatisfied and desperate people, whether they were escaping from Peoria or Flatbush or old San Juan.

My city is the city of dark moods, scrapyards, and jazz. Of poets, painters, and anarchists. Of dirty bookstores, dirty movies, and dirty streets. Of Gershwin's "Rhapsody in Blue" trumpeting over black-and-white *Manhattan,* and Travis Bickle's taxi roving through the steamy rain, that grimy yellow splash. It's the city of Edward Hopper's melancholy rooms and Frank O'Hara's "I do this, I do that." It's also a working-class city peopled by men and women who love with a tough love, in thick accents and no time for bullshit. It's a tuna sand-

wich at Eisenberg's, an egg cream at Ray's Candy, and sometimes lunch at "21." It's shoeshines, dive bars, and riding the subway all the way to Coney Island for a corn dog and the freak show. Your city may differ, but if it's anything like mine, you're grieving, too, because the stuff of it, the gut-level feeling of it, is vanishing fast. Too much has already gone.

We all have our own lost city. If we stick around long enough, we lose the city of our youth, our dreams and foiled ambitions. Joseph Mitchell, great chronicler of Gotham, wrote, "I used to feel very much at home in New York City. I wasn't born here, I wasn't a native, but I might as well have been: I belonged here. Several years ago, however, I began to be oppressed by a feeling that New York City had gone past me and that I didn't belong here anymore." I could say the same today, but this book isn't about how we all lose our personal city. It's about how the city has been taken from us. It's not just the story of a death; it's the story of a murder.

From its beginnings, but especially since the late 1800s, New York was the unbridled engine of the nation's progressive culture and creativity, sustaining a diversity of people, feeding the world with art, ideas, and ways of life that pushed the boundaries of convention. But now it seems this period has come to an end. The spirit of the city as we knew it has vanished in the shadow of luxury condo towers, rampant greed, and suburbanization.

This is not unique to New York. Hyper-gentrification, the term I use for the force that drives the city's undoing—gentrification on speed, shot up with free-market capitalism—is a global pandemic, a seemingly unstoppable virus attacking much of the world. San Francisco is dying, maybe even faster than New York. You see it in Portland and Seattle. Austin and Boston. Paris, London, Barcelona, and Berlin have all been infected. The virus has spread as far as Tel Aviv, Beirut, Seoul, and Shanghai. And in every afflicted city, the story is the same: luxury condos, mass evictions, hipster invasions, a plague of tourists, the death of small local businesses, and the rise of corpo-

rate monoculture. While I speak to the global issue in this book, New York is my case study. It may be chauvinistic to say New York is the world's capital city, but New Yorkers are chauvinistic.

If you take away just one thing from this book, let it be this: Hyper-gentrification and its free-market engine is neither natural nor inevitable. It is man-made, intentional, and therefore stoppable. And yet. Just as deniers of global warming insist that nothing out of the ordinary is happening to our world's climate, so deniers of hyper-gentrification say that nothing out of the ordinary is happening to New York, and that its extreme transformation in the 2000s is just natural urban change. Let me be clear: I'm not talking about the weather, I'm talking about the climate, and New York's climate has been catastrophically changed.

How did such a catastrophe befall the greatest city on earth? It didn't happen all at once. After decades of scheming on the part of urban elites—the real estate magnates, financiers, planners, and politicians—who worked tirelessly to take the city from those they considered "undesirables," Mayor Ed Koch really got the ball rolling in the 1980s. Rudy Giuliani brought the muscle in the 1990s. The terrorist attacks of 9/11 played a pivotal role. And then, after the turn of the millennium, Mike Bloomberg dealt the death blow, a stunning coup de grâce. Gentrification morphed into hyper-gentrification. Mainstream young people flooded in from the suburbs where their white-flighty grandparents had fled years ago. They came in droves, many of them (not all) armed with a sense of Manifest Destiny, helping to turn New York into a sanitized vertical suburbia. They carry a share of blame, the new arrivals who say they love New York, yet celebrate the city's makeover into an image of their Maple Valleys and Prairievilles, their Springfields and Massapequas, complete with hundreds upon hundreds of chains: Starbucks and 7-Elevens, Applebee's and Olive Gardens, Home Depots, Targets, IHOPs, Dunkin' Donuts and—God help us—Denny's.

While it's true that you can still find a pulse, here and there, along

the thickly settled stretch of Manhattan, and that the city's soul still haunts pockets of the outer boroughs, this book is not a Baedeker to those pockets. It is a journey through the ruins, a dyspeptic trip through the parts of town hardest hit during the Bloomberg years. Starting out on the Lower East Side, where the East Village has been my home for more than twenty years and where twentieth-century New York was born, we'll move around the map, down through the Bowery and Little Italy, up through Greenwich Village, into Chelsea, Harlem, and then out to Brooklyn and beyond. Along the way, I'll offer theories and analyses of the changed city, the altered psyche of New York, once neurotic, now evermore narcissistic and sociopathic. Like my blog, *Vanishing New York* is a polemic, an obituary, a book of lamentations and a bitterly nostalgic look at a city in the process of going extinct. It is also, of course, a love letter to the town I can't seem to leave. Because there are still polar bears. If you look for them. And I am always looking for them.

Right now, as I write, it is spring. My window is open, the rusty screen quivering where steam heat from the wheezing radiator meets cool March air. It is Sunday. Quiet enough to hear the tap of an old man's cane as he walks to church in fedora and overcoat. A boy goes by carrying a bright green balloon. Taxis blaze in sunlight. On a draft comes drifting into my apartment the floral notes of a passing girl's perfume. A mourning dove casts his lament from the edge of my fire escape.

There are still things worth staying for, I remind myself, even while New York's glass is half-empty. It's that emptiness I'm interested in. The absent is easy to forget, and I'm against forgetting. So this book is filled with absence—the shops that have gone missing, the neighborhoods that vanished whole, the exiled poets and painters and dancers, the lost men and women who fixed cars and made sawdust and poured the best cappuccino. This book is for them—and for all of us who came to New York, to the mythical New York, whether

from suburban Boston or the deep Bronx, with an ache in our guts, a desperate hunger to become something more, to Be a Part of It, as the song goes, to grab the last gasp of the great city's big, sprawling, pounding heart.

To you, my fellow desperate and despairing, I say: We was robbed.

PART ONE

Every city changes, and walking through a slowly changing city is like walking through an organic landscape during various seasons; leaves and even trees fall, birds migrate, but the forest stands: familiarity anchors the changes. But if the pace of change accelerates, a disjuncture between memory and actuality arises and one moves through a city of phantoms, of the disappeared, a city that is lonely and disorienting; one becomes . . . an exile at home.

—REBECCA SOLNIT, FROM *HOLLOW CITY,* 2002

THE EAST VILLAGE

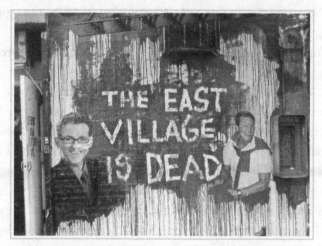

Mural on the side of Mars Bar. *Alex Smith/Flaming Pablum, 2009*

I CAME TO NEW YORK TO TRANSITION. TO BECOME A NEW YORKER after a lifetime in one small town. Riding the train into Penn Station upon my arrival, I caught a glimpse of the red neon sign atop the New Yorker hotel and thought, That's where the great magazine is published—and where my poems will appear. It wasn't and they didn't.

But what did I know at twenty-two years old? In my black Doc Martens, black jeans, black turtleneck, black leather biker jacket, I wanted to be taken for a real New Yorker. I wanted to pass—not as something I wasn't, but as the person I'd always known myself to be. A city person.

The city has the power to rejigger you completely, body and mind, rearranging your neural pathways and setting your heart to a different beat. It speeds up your nervous system, making you sharper and more savvy—if you let it. I welcomed my own urbanization, loving the smells of my neighbors' cooking and the crush of a subway crowd, savoring insider knowledge about important things, like how to order a bagel, how to hail a cab, and in which booth at Chumley's did F. Scott Fitzgerald *schtup* Zelda on their wedding night. (If you take New York into your cells, you pick up Yiddish, too, sparking your sentences with *schmuck* and *kvetch* and *plotz*.)

During my first years in the city, I would learn much more about passing, for I also came to New York to undergo another kind of transition. It was here that I made the passage from female to male, living a queer and transgender life in the days long before Caitlyn Jenner made the cover of *Vanity Fair* and trans athletes starred in Nike commercials. This book is not that story, but it bears mentioning because it is inevitably intertwined. Every person views the city through a prism of personal experience and, as different as all those prisms may be, for a long time, New York was able to accommodate every type. The city made space for all varieties and combinations. Queer and trans culture is one facet of my prism. So is poetry and literature—another pursuit that brought me to New York—and, later, a career in psychoanalysis. All of it informs my approach to the city. So does the working-class ethnic culture from which I come, mostly Italian, but also Irish dosed with Jewishness by close association (my Irish Catholic father, raised in a Jewish neighborhood, worked the rag trade, a *schmatta* salesman with a Hebrew Chai dangling from a gold chain around his 1970s neck).

I came to New York because I needed the city, and New York is for people who need cities, for those who cannot function outside of one. Open and permissive, insulating you with the sort of anonymity you can't find in a small town or suburb, the city allows us to expand, experiment, and become our truest selves. In the New York of the

early 1990s, there was no better place to perform that labor than the East Village.

For over a century, the East Village provided an uncommon space. It was, among other things, a long-sought-after refuge for those who never quite felt at home anywhere else. Reclusive misanthropes and creative exhibitionists, builders of junk towers and makers of psychedelic gardens, poets, punks, and queers, activists and anarchists, dominatrices and drug addicts, graffitists, nudists, and underground cartoonists all found a home in the East Village. A barricade of deviance and grit kept much of the straight world out, protecting the neighborhood's unconventional character. But at the end of the twentieth century, the East Village was invaded, its territory seized, and those of us who'd found our first true home between Astor Place and the East River were displaced. For many, that displacement was physical, one kind of eviction or another. For many more, the displacement has been emotional, a jarring dislocation of the psyche.

The East Village was not always the East Village. The neighborhood east of Bowery and bookended by Houston Street and 14th was simply the northernmost section of the Lower East Side until the early 1960s, when it was carved out and renamed to sound more like its fancier neighbor to the west. The *New York Times* dates the origin of "East Village" to 1964. In that year, the guidebook *Earl Wilson's New York* reported: "artists, poets and promoters of coffeehouses from Greenwich Village are trying to remelt the neighborhood under the high-sounding name of 'East Village.'" Beatniks, following the likes of Allen Ginsberg, had moved east years earlier, pushed out of Greenwich Village by rising rents after World War II. Willem de Kooning and other Abstract Expressionist painters came in the early 1950s, followed by galleries. The real estate industry, smelling a trail of money flowing eastward from the Village proper, took the name "East Village" and ran with it in those first days of proto-gentrification.

The headline of a 1964 *Times* article proclaimed, "The Affluent Set Invades the East Village; First Wave Is Lured by 'Atmosphere.'" It sounds like the beginning of the end. Still, the "uptown rich" weren't all that rich. Bohemian bar owner Stanley Tolkin described it at the time: "First there were the artists. Then there were the teachers and writers, and little by little, we had everyone—advertising men, doctors who live in walk-up tenements, lawyers just starting out, construction workers. They all seem to work at something during the day. But at night, they change their clothes and become Beatniks." In today's East Village, it's hedge fund managers, millionaire celebrities, and marauding dude-bros, but they don't become beatniks at night. That would be a blessing. Instead, stubbornly, they remain themselves.

The neighborhood's radicalism, however, was not invented in the 1960s. The streets had long been home to Jewish lefties and Italian agitators, theater people, avant-gardists, anarchists, artists, mobsters, as well as the very poor. In the late 1800s, Tompkins Square Park served as a space for riots and demonstrations against economic inequality. Justus Schwab's Saloon on East First Street was "the most famous radical center in New York," in the words of early feminist anarchist Emma Goldman, who frequented the place. In her memoirs, she called Schwab's "a Mecca for French Communards, Spanish and Italian refugees, Russian politicals, and German socialists and anarchists." In that tradition, a century later, the neighborhood was full of hippies, bohemians, queers, and punks, along with poor and working-class Ukrainians, Poles, and Puerto Ricans, drug dealers, junkies, and murderers. The most dangerous part was Alphabet City, the blocks between Avenues A and D, where landlords left buildings abandoned and set them ablaze for insurance money. With orange flames lighting the night sky, the easternmost section of the East Village became a postapocalyptic landscape of empty lots and forsaken tenements, hollowed husks turned into bordellos, Halleluiah churches, heroin shooting galleries, and squats. Creativity flour-

ished in this war zone of crime and grime. David Byrne credits life on Avenue A with the creation of Talking Heads' 1979 album, *Fear of Music,* especially "Life During Wartime," a song, he told biographer David Bowman, "about living in Alphabet City" while thinking of Baader-Meinhof, Patty Hearst, and Tompkins Square. Among locals, Avenues A, B, C, and D stood for Adventurous, Brave, Crazy, and Dead. (In 2016, writer George Pendle told the *Times* they now stand for "Affluent, Bourgeois, Comfortable, Decent.")

In the 1980s, the art establishment moved in, bringing commercial galleries that attracted a new wave of change, a process critiqued by Rosalyn Deutsche and Cara Gendel Ryan in their 1984 paper, "The Fine Art of Gentrification." An *Art in America* article of the same year described the East Village as a "unique blend of poverty, punk rock, drugs, arson, Hell's Angels, winos, prostitutes and dilapidated housing that adds up to an adventurous avant-garde setting of considerable cachet." That cachet, Deutsche and Ryan wrote, "conceals a brutal reality." Namely, the city's strategy to exploit the art scene for gentrification, for the housing of "a professional white middle class groomed to serve the center of America's 'postindustrial' society." Artists and gallerists, the authors argued, were complicit in this process. At the same time, many East Village artists led the fight against gentrification in what became an era of fierce resistance. Today, when people talk about gentrification, they often blame artists, labeling them as frontline gentrifiers. As I'll explore more in a later chapter, the relationship between art and gentrification is a complicated one, with artists often used as scapegoats to distract from the real culprits.

The Gap moved to St. Mark's Place in 1988. Taking the former space of the beloved, grungy St. Mark's Cinema, it was met with "there goes the neighborhood" outrage. One local painter tossed a cinder block at the Gap's plate-glass window, but failed to break through. Angry young men urinated on the store and agitators slapped stickers to it that read: "Why are you here?" and "Go away." In an ominous, Orwellian tone, the Gap's assistant manager told *Women's Wear Daily,*

"They think we are destroying the East Village image, but *like every-where else, they will accept it*" (emphasis mine). That same year, just five months after the Gap's arrival, Tompkins Square Park erupted in riots two blocks east. Protesting a new curfew and the removal of a homeless Hooverville, activists carried bedsheet banners spray-painted with the slogans: "Gentrification Is Class War" and "Gentrification Is Genocide." Police on horseback beat people with nightsticks. Protesters smashed their way into the Christodora, a former settlement house that had just been redeveloped into luxury condos. Occupying the lobby, the protesters chanted a new call to arms: "Die Yuppie Scum." The battle for the East Village was on.

In 1994, Mayor Giuliani came into office armed with a paramilitary police force and a zero-tolerance campaign. He waged war on the squats and the "communist" community gardens. Avant-garde art spaces were destroyed, including the anarchist sculpture garden Gas Station/Space 2B (at Second Street and Avenue B), evicted by a 900 percent rent increase. The Gap on St. Mark's Place survived (until 2001) and more chains followed. A Barnes & Noble opened at Astor Place in 1994, complete with a Starbucks. Another Starbucks moved in across the street in 1995 (followed soon by yet another), and across from that came Kmart in 1996. Politicians and developers licked their chops while residents blanched. Said one local to the *Times,* "I hate the thought of stepping over Kmart shoppers on my way to buy bagels on Sunday morning."

We saw the warning signs, but had no idea how bad it was going to get. Throughout the mid to late 1990s, the East Village spirit fought back against Giuliani's bulldozers and the tanks of the New York City Police Department (NYPD), but eventually the spine snapped. By the 2000s, the crime rate had dropped, following a nationwide trend, the charred skeletons of tenements had been retrofitted into new buildings, and too many of the more charismatic residents had died from AIDS. Cleaner and safer, after a century of agitation and creation, the East Village was now prepped for the next phase to begin.

When a notice appeared in the window of the shuttered Second Avenue Deli (forced to close by a rent increase after fifty-two years) announcing that Hooters was "Coming soon to your neighborhood," old-school East Villagers flew into collective apoplexy. It was 2006 and we were reeling from the neighborhood's seismic shift, a change that had come so quick, many of us walked in a daze of disorientation. For a while, I kept stopping, looking around, and asking myself: *Where am I?* I went to bed one night in a bohemian enclave and woke the next day in a mean-spirited, suburban high school hangout. Now Hooters was moving in? And into the beloved deli opened by Holocaust survivor Abe Lebewohl, of all places. Pastrami and chopped liver would be replaced by Buffalo hot wings and cheese sticks. In the Molly Picon room, dedicated to the star of Yiddish theater and films such as *Yidl Mitn Fidl,* young women hired for their breast size would soon be serving in short-shorts. A protest blog appeared, titled "Hooters Out of Second Avenue Deli." An angry mob began to brew, but then the notice turned out to be a hoax, a kind of protest itself, sending up the ugly new character of the twenty-first-century East Village, with its blocks of chain stores and gangs of frat boys, where the arrival of Hooters felt unbelievably believable.

The Florida-based chain restaurant never came to that spot, but a branch of Chase Bank did, installed just two blocks away from the next-nearest Chase branch and a block or two from several more banks. Today the Second Avenue Deli's Yiddish Walk of Fame remains, out of context and rapidly fading. Carved in stone on the sidewalk are names from the days when this strip was the Jewish Broadway—Fyvush Finkel, Ida Kaminska, Lillian Lux, Ludwig Satz. The names are worn down, ignored and flattened by the crowds walking past, grabbing cash from the ATM before making a beeline for the next pitcher of beer and bucket of Buffalo hot wings, easily had without Hooters at one of the many laddish sports bars that have sprouted along the avenue.

The East Village has long attracted a youth population from out-

side the mainstream. They were lefties, Beats, hippies, and punks, queer artists and scruffy castoffs. But in the 2000s, the young people who took over the neighborhood came straight from the mainest part of the Middle American stream. They are "basic bros" roaring out of sports bars in beery packs, dressed in alpha-male hot pink polo shirts, looking like the preppy villains from a John Hughes movie. In plastic Viking helmets, they howl in the streets. Woooo-hoooo! We, the holdovers, huddle in our apartments as the night reverberates with *woo*. The girls we call "Woo Girls" because all they do is woo, stumbling out of hot pink Hummer limousines, waving giant balloon penises overhead while they vomit Jägermeister onto our doorsteps. How could this happen here? I moved to New York hoping to avoid these people for the rest of my life. As legendary downtown performance artist Penny Arcade put it, "The ten most popular kids from every high school in the world are now living in New York City. Those are the people who most of us who came to New York came here to get away from."

It used to be the bridge-and-tunnel crowd coming in from Jersey and the outer boroughs to party on the weekends. At least they were part of the orbit around Manhattan, the ethnic and working-class Tony Maneros and Tess McGills of the city's gravitational field. The new people are much farther flung. And they don't go home at night. They live among us, in bigger apartments with better appliances. Youth-oriented condos extend the dormitory experience into adulthood, each building outfitted with postcollege amenities. On East 13th Street, the A Building became notorious as frat-house party central for young bankers. The *Daily News* captured a typical scene: "The roof's perfectly manicured lawn becomes a happy hour ballfield where losing Flip Cup teams have to play Dizzy Bat—they chug beer from a plastic baseball bat and run circles around it while their friends cry, 'Watch out for the wall!'"

While the former East Village had hardly been a tranquil country hamlet, it did have a quietude. The sidewalks weren't overcrowded.

Tourists didn't dare to visit. There were bars, but it wasn't Bourbon Street. New York University had dorms, but the student population wasn't a swarm. As East Village poet Eileen Myles wrote in her essay for the book *While We Were Sleeping: NYU and the Destruction of New York,* "there were more of us than them so the problem was fortunately contained. They were actually still part of what there was." NYU's presence remained in relative balance through the 1990s, until it spread like a virus, its students multiplying by the thousands in new dorms, overflowing into old tenements. "Then by the 21st c. they were living in our buildings," writes Myles. "They were wandering (or running) through the halls of the building at night with their beers or also in their bathrobes between apartments with their cups of tea. They were incredibly loud. The way they talked. Like no one was living here."

By 2007, the East Village was the second-most complained-about neighborhood in the city, with 4,957 noise complaints called in to Mayor Bloomberg's 311 phone line. By 2011, the East Village was number one on the *Post*'s list of neighborhoods with the most bars, topping out with 474 liquor licenses. One resident told the paper, "It's like a red-light district. It's honking cabs all night. It's like a bad, disturbing dream." People started to crack up. Frustrated, sleep-deprived residents dumped buckets of water from their apartment windows onto loud bar and restaurant patrons below. They tossed eggs. They unzipped their pants and urinated. Sometimes, driven to murderous rage, they dumped broken glass and scalding-hot oil. But the party never ended.

During one skirmish in the summer of 2015, newcomers besieged Italian restaurant Ballarò. The manager reported on Facebook: "I was offended, degraded and treated like shit by a group of 15 drunk people without any valid reason. They were screaming 'BOO, YOU SUCK!' at me and my wait staff because Taylor Swift wasn't playing on our sound system. I then played two Taylor Swift songs for them to placate them." Swift, by the way, had just been named New York's

official Global Welcome Ambassador. The gang "started screaming that the songs I played weren't the right one and I was told that, 'this place is shit, the music and the people here suck.' I was then told to, 'go back to your country with that fucking immigrant face.'" The gang finally left—without paying the five-hundred-dollar check. Ballarò has since shuttered.

A new breed of young people has come to the neighborhood and conquered. As East Village author Sarah Schulman put it, "This new crew . . . came not to join or to blend in or to learn and evolve, but to homogenize." Even celebrities complained about the homogenization. Chloë Sevigny told *The Daily Beast* in 2014: "walking around the East Village, I just want to cry at the state of it. There are so many fuckin' jocks everywhere! It's like a frat house everywhere . . . where are the real weirdos? The real outcasts? They're a vanishing breed here."

When I first moved to the city, making the great financial mistake of a master's degree in creative writing when the last thing a poet needs is a master's degree, I was living up on East 26th Street in a miserable NYU graduate housing unit dominated by dental students, in a nondescript part of town called Bellevue South for its proximity to the infamous madhouse. I felt painfully out of place, a young poet among aspiring dentists, all jammed in the elevator clutching their grisly, grinning tooth molds. I got romantically depressed, drinking cheap red wine while listening to John Coltrane and working on my Frank O'Hara knockoff poems when I wasn't cleaning toilets in uptown apartments for a few dollars an hour. On good days, I'd hike downtown with a notebook in my bag, a knife in one pocket and mugger money in the other, not quite breathing until I got below 14th Street, when I crossed that blessed threshold between Nothing and Everything.

One afternoon, I came upon Astor Place, gateway to the East Village, and felt a sense of wide openness. The thieves' market bustled

around an empty parking lot with junk for sale on dirty blankets. St. Mark's Place looked like a bazaar in Marrakech, a cluttered and inviting souk spiced with incense. A jazz trio played. Punks went in and out, hair stretched high into impressive, neon-colored Mohawks. Dealers whispered the rhythmic incantation, "Smoke, dope, smoke, dope, shrooooooms." It was love at first sight. I had found my home, the place I'd been searching for, and moved in soon after. Much more recently, however, Astor Place has become unrecognizable.

"Undulating." That was the word that starchitect Charles Gwathmey used for his newest creation, "Sculpture for Living." A twenty-one-story glass condo tower with a "limited collection of 39 museum-quality loft residences" priced from $1,995,000 to over $6,500,000, it began rising on Astor Place at the dawn of the new millennium. The East Village had never seen anything like it. This "green monster," as critic Paul Goldberger called it in *The New Yorker*, looks like a vertical fish tank, humming aquamarine. "It doesn't belong in the neighborhood," Goldberger concluded. "By designing a tower with such a self-conscious shimmer, the architect has destroyed the illusion that this neighborhood, which underwent gentrification long ago, is now anything other than a place for the rich."

Gwathmey's Sculpture for Living not only undulated, it dwarfed everything around it. Astor Place was no longer the open space I had encountered years before. Completely out of scale with the lower-rising nineteenth-century stone and terra-cotta architecture that surrounded it, the tower seemed to have migrated straight out of the dark caverns of Midtown, hailing the horrifying start of Astor Place's transformation into a corporate office park that realtors would rename Midtown South. The *New York Observer* marked the moment in 2004 when they wrote that "the gateway to the once-bohemian and still hardly wealthy East Village" was now "poised to become downtown Manhattan's next important driver of the luxury real-estate market." And it was Cooper Union that put the tower there.

The Cooper Union for the Advancement of Science and Art had

been offering a tuition-free college education since its founding in 1859. To do so, the school relied in large part on their real estate holdings, especially the millions in rent and tax monies from the Chrysler Building, built on land owned by the school. But in 2001, running at a deficit, they launched a plan that would put the Gwathmey tower on their parking lot, and then build two more like it, a "wow factor" academic building and a corporate office complex. The plan came with boutique zoning changes. The goal of the rezoning, explained the *Times*, "was to maximize the amount of usable office space in the new tower" and "to allow commercial development on land restricted by law to educational and philanthropic uses." In 2002, Bloomberg's City Planning Commission approved the scheme and added a plan of their own—to demap Astor Place itself, wiping away the historic street and visually joining the condo tower with the corporate tower to come. To no avail, East Villagers fought the plan, arguing that "the large-scale development would turn their eclectic, artistic neighborhood into a sterile business campus." A decade later, the office tower went up. At 400,000 square feet and skinned in black glass, 51 Astor Place became known to locals as "The Death Star" for its dark and hulking resemblance to Darth Vader's planet-killing space station. An anonymous satirist started a Twitter feed for the building called @51deathstar, describing itself as "Destroyer of neighborhoods. Unloved. Empty inside. Midtown South." The imagined voice of the building tweeted snarky messages like, "Hey East Village! Sorry I had to destroy you. My dad made me do it and he's kind of a dick."

When I moved to the East Village in 1994—though it had already changed, as any old-schooler from the 1970s and '80s will attest—the place was still full of poets, queers, and crazies. Young people came mostly to live as outsiders, to read their poems at St. Mark's Poetry Project and the Nuyorican, shoot pool in the dive bars, and go mad in Tompkins Square Park. I used to run into Allen Ginsberg squeezing the organic fruits at Prana Foods or slurping a bowl of soup at Kiev, the Ukrainian coffee shop where I'd order a buttered bagel and cup of

hot water, dipping my own tea bag to save money. (Ginsberg wrote of the place in a 1986 poem: "I'm a fairy with purple wings and white halo / translucent as an onion ring in / the transsexual fluorescent light of Kiev / Restaurant after a hard day's work.") In the window of the Cooper Square Diner, I'd see Quentin Crisp, hair tinted purple, silk scarf around his neck. They were already aged, these legends, and would not last much longer. Ginsberg went in 1997 and Crisp followed in 1999, both dead before the decimating changes of the twenty-first century could sweep them away.

I wonder what became of Warhol Van Gogh, the psychotic artist who'd draw your portrait for a dollar. She drew mine while eating falafel on St. Mark's Place. On bad days, I'd see her raving in the middle of traffic, head freshly shaved from Bellevue, dressed in a pale blue hospital gown. What happened to the other muttering madwoman who walked up and down First Avenue in Chinese laundry slippers, to the man who sat screaming on a milk crate outside my building but always made way for me, or to Marlene Bailey, better known as "Hot Dog," who drunkenly entertained the sidewalk bums outside Odessa restaurant (the "old" Odessa, site of a thousand late-night omelets and "Disco Fries," now shuttered)? What happened to Baby Dee, the transgender street artist who wore angel wings while she pedaled a giant tricycle and played the accordion? What happened to performance artist Gene Pool, aka the Can Man, who rode around on a unicycle dressed in a suit made of aluminum cans? He got a write-up in the *Times,* where the journalist pitied him for trying to get noticed in a town chock-full of eye-catching characters. "There's just so many people who look so odd and they're not trying to be noticed," Pool told the paper. "It's just their normal getup." You can't say that today; the New York character is vanishing fast. (This morning, however, I did see a bewigged drag queen rolling down Second Avenue on a Citi Bike. Hello, polar bear.)

Wherever these people went (Baby Dee left for the Netherlands, Pool's gone to Chicago), they took with them the distinctive feeling

of the place, a feeling of existing on the edge, in a space apart. For several years, when I'd come home from the dull uptown office job I had then, when I crossed 14th Street and veered east, I felt the everyday world lift away like a heavy winter coat shucked off. The crowds fell back. I relaxed, loosened my tie, and slipped into my true skin. I was not the only one. Stepping into the East Village, we saw others like ourselves—poets, oddballs, punks, queers—still a revelation after a lifetime of lonesome singularity. We read their signs and flags, messages broadcast from haircuts and jackets, from slogans on buttons and T-shirts, and we felt not alone. This is a big deal. For some of us, this is everything. Especially at twenty-two years old. But even at forty-five.

A neighborhood is an emotional ecosystem, and when it is destroyed by gentrification, it's trauma. Mindy Thompson Fullilove, professor of clinical psychiatry and public health at Columbia University, has a name for it. She calls it "root shock," a traumatic stress reaction that can increase anxiety and depression. She writes, "Root shock leaves people chronically cranky, barking a distinctive croaky complaint that their world was abruptly taken away." I must be suffering from some version of it, because I've been cranky since 2001.

With significant buying power, the East Village's newest residents have helped remake the neighborhood to suit their tastes, wiping away pieces of the long-standing cultural fabric like crumbs from a table. So much was lost during the first several years of the 2000s, it would require a whole book to hold it. Along with the people, we lost too many of our Polish and Ukrainian coffee shops, our cobbler shops and Laundromats, our theaters and performance spaces, record stores and bookstores, bodegas and dive bars. Before they pulverized the Blarney Cove to make room for a 240,000-square-foot luxury development, I had a last drink and listened while the barflies complained, "All the old bars we used to hang out at are gone. The Ukrainian Club. That's gone. Verkhovyna. That's gone. Vazac's was great, but now it's been yuppified. I mean the hipsters. When

they changed the Christodora to condos, that's when it all changed. Giuliani kicked 'em all out, back when he was, whattayacallit, the mayor." Everywhere you go, you hear these litanies—if any old-timers are left to deliver them. We keep almost losing Ray's Candy, a wonderfully grimy little hole for egg creams and hot dogs. We lost St. Mark's Bookshop after fighting to save it a thousand times. We lost Love Saves the Day, where Madonna got her glitter boots in *Desperately Seeking Susan,* and Lucky Cheng's with its sharp-tongued drag queens, and the original Holiday Cocktail Lounge, where W. H. Auden pickled his liver while scribbling poems. We lost the gorgeous little Variety Photoplays, a theater that opened as a nickel-odeon in 1914, went XXX in the 1960s, starred in *Taxi Driver,* became a jack-off house for gay men seeking liberation, went off-Broadway legit, got bought by NYU, lost the fight for landmarking, and was demolished in 2005 for a heartless glass tower by the Toll Brothers, infamous pioneers of mass-produced McMansions, the worst of sub-urban luxury *schlock.* I can't list them all. But if you ask me to name the most painful loss, at the moment of this writing, I would say it is De Robertis Pasticceria & Caffe. A perfectly preserved Italian-American pastry shop, unchanged on First Avenue since 1904.

One day in 2007, I sat down to chat with Annie De Robertis, who first went to work for her grandfather at eleven years old, fold-ing cake boxes and filling cannoli. I met her in the café on a quiet Friday afternoon. She was reading about corrupt city politics in the *Post* and wondering out loud if she should go back to Bari, her grand-father's hometown. She wore her iron-gray hair short, with lavender eye shadow that matched her top. We talked about the neighborhood of her childhood, when every street was filled with Jewish and Ital-ian businesses. And we talked about the newest people of the East Village.

Annie shook her head as she described impatient young custom-

ers who whined about waiting in line, ignored her help as they talked on cell phones, and then wanted service "right away, right away, right away." But worst of all, she said, were the Starbucks people.

"People come in and tell me I don't know how to make cappuccino," she said, incredulous. She'd been making cappuccino for fifty years. "They tell me, 'Starbucks makes it this way.' I tell them, 'I'm here *before* Starbucks.' They want flavors. I tell them, 'I got flavors. You want a flavor? I'll put it in.'" *Put it in?* They look at me with a look of disbelief. "Do these people really think the coffee bean *grows* in flavors? Like it *comes* in hazelnut and mint? These are people with college educations. But they want Starbucks. So I tell them, very nicely I say, 'So go to Starbucks.'"

At the end of 2012, Starbucks planted itself just two blocks away from De Robertis on First Avenue, taking the space of what had been Mee Noodle, a Chinese restaurant frequented by Allen Ginsberg, who always ordered the steamed flounder in ginger sauce. Just nine months later, the De Robertis family put their building up for sale. After 110 years of serving crisp cannoli and perfect cappuccinos, providing a warm and welcoming atmosphere, they announced they would be shuttering. Customers flocked to say goodbye. When I talked to third-generation co-owner, and Annie's brother, John De Robertis, he shook his head mournfully and said, "Where was everybody for the last ten years? Maybe we didn't have to do this."

Let me hold this moment, my final visit, in present tense. I am sitting inside De Robertis on the day before the last day in December 2014. It is morning and the café is quietly busy. There's a feeling of anticipation in the air. John and his son, also John, are prepping for the day, wrapping black-and-white cookies, folding cake boxes, answering the phone that keeps ringing. "Tomorrow we're closing. Tomorrow afternoon!" Over the speakers, 106.7 Light FM is playing Christmas carols. Sinatra sings "Walking in a Winter Wonderland." A couple of old guys, the last of the die-hard regulars, are talking about hunting. "I still got the two rifles," says one. "They haven't been fired

in forty years, but I still got 'em. And the thing is, I never shot nuttin'. I tried shootin' deer, but I couldn't. They looked too nice."

A hale and hearty fellow bursts into the shop, announcing himself as Murray the Syrup Man. For years he's kept De Robertis stocked with Torani flavors—almond, vanilla, hazelnut. He bellows, "I gotta give the whole family a hug goodbye! God almighty!" They hug him, one by one, and then out he goes, saying, "Good luck to your family. You've been a great tribute to New York City. I'm not kiddin' 'bout that."

One of the old guys says to his pals, "Everybody's talking about what's happening to New York. They all got the same feeling that the city has changed. And not for the better."

The baker comes up from the basement with trays in his hands. Up comes the last batch of black-and-white cookies. *"No mas!"* says the baker. Up comes the last batch of sfogliatelle. *"Finito!"* says the baker. Up comes the last batch of pignoli cookies. "Last one!" he says, waving his hands like an umpire calling safe. A lone European tourist asks how many pignoli cookies in a batch. John the junior tells her, "One thousand three hundred and fifty-six," with a grin that says he's pulling her leg. She marvels at the large number, repeating it softly to herself as she exits, "One thousand three hundred and fifty-six. One thousand three hundred and fifty-six," committing it to heart.

Above the cash register, along the Wall of Fame, the faces of Robert De Niro and Martin Scorsese look on. Mike Tyson makes a fist. In the flesh, actor Michael Badalucco, who played David Berkowitz in *Summer of Sam* and about a million gangster types for TV and movies, walks in and calls out, "I want the last pignoli cookie!" He and the senior John talk about where you can still get real Sicilian food in the city. "Joe of Avenue U," Badalucco says. "The best. That's my place. The best, the best! Listen to me. You take the F train, and stay on the back of the train, all the way to Avenue U. They cook with spleen! Everything fresh. Forget it."

I ask John how the new Starbucks on 13th Street affected his busi-

ness. He tells me, "One night, there was just one person in here. I left work and I was walking past that Starbucks. I looked inside. The place was packed. And I thought, Well, this is what people want now." He shakes his head. "What can you do? Starbucks took a bite out of us."

A bite here, a bite there, and soon the entire city is devoured. Death by a thousand bites.

Few can escape the reach of the new gentrification. I can get all the master's degrees I want, dress in khakis (yes, from the Gap), and earn the middle-class living that my working-class family wanted for me, but I am not safe. In 2008, the East Village was rezoned, in part to put a cap on new building heights, protecting the area from more high-rise development. In 2012, the city's Landmarks Preservation Commission designated a segment of the neighborhood a historic district. I inspected the map to see if my home would be blessed with protection. It wasn't. By a hair's breadth, my building was left outside the boundaries of the historic district. I suspect it just wasn't pretty enough to make the cut. Vulnerable to real estate sharks, it can be forcibly emptied and demolished.

And then my worst fear was realized: my building was sold.

Men in designer suits and slick hair knocked on my door one day, pretending to be architects hired to make minor improvements. It was a ridiculous ruse. My old landlord's greatest "improvement," in two decades, had been to fix my leaking toilet with a drinking straw he pulled out of a Coke can. As he ushered the men inside, I stood stunned in the doorway. Before I could stop them, they took pictures with their iPhones, opened my closet door, and poked around my bedroom. When I waved at them to get out, they told me, "Relax, dude, everything's fine," like I was a psychiatric patient in need of de-escalation. Everything was not fine. The new owners have been doing what they can to get rid of me and all the other "stabies," that

impolite term for rent-stabilized tenants. They gut-renovated one apartment, installing it with a pair of fashionable young women who pay $4,000 a month for 400 square feet. They alone are blessed with a washing machine and dryer, which they use daily, causing my apartment to vibrate like a bed in a trashy motel.

I can't say that I love my building. It lacks personality. It's crooked and sags in the middle. Every time a truck rumbles past, the whole thing shakes. The hallways haven't been painted since the Carter administration. In my apartment, the radiators clang and weep all winter long. Mold blossoms through the bathroom tiles. The ceiling leaks. When the seasons change and the temperature shifts, the place stretches and yawns, opening gaps and cracks through which come creeping brazen, dust-colored mice. Still, it's my home. I've lived over half my life in this place. It's part of me. "An apartment in New York City tells many truths," wrote Sarah Schulman in *Rat Bohemia*. "It shows where you really stand, relationally. It shows when you came, how much you had and what kind of people you knew." Most of the people I knew when I came have left. They got priced out, kicked out, or just got tired of tenement life. But I remain.

The East Village still has a few things worth staying for. There's the Village East Cinema, with its antique marquee spelled out in three-dimensional letters, so the winter snow gathers along their tops like white hats. There's the ravioli at John's of 12th Street, since 1908. There's Moishe's Kosher Bakery with its windows full of hamantaschen and rugelach. And the lunch counter swivel stools at B&H Dairy, Veselka, and the Stage, fresh challah bread and chicken noodle soup. (As I write this, I'm afraid of jinxing these places. In fact, the Stage has since been evicted, but I won't delete it. Change happens so fast, the revisions are too much to keep up with.) We still have a couple of bookstores, a few places to get a real egg cream, and a last record shop or two (at this writing, another is about to close). The Astor Place barbershop remains, and I still get haircuts there, though

there's less hair now to cut. And there is the East Village light, that buttery glow that spreads itself across the fire escapes in the evening, making the tenement bricks blush like rose petals.

So I stay, but more and more, I wonder why. Is it only stubbornness that keeps me here? My former psychoanalyst used to tell me that I had a "constipated personality," likening me to Bartleby the Scrivener in Melville's novella. "I would prefer not to," she'd quote. "That should be your motto." Maybe so. I will not budge. I would prefer not to.

Recently, one of my upstairs neighbors dusted off his old piano. In the evenings, when I return from work, I hear him playing overhead as I climb the stairs. I pause outside my door, listening, keys in hand, as he struggles through a Bach concerto. These days, it's Number 5 in F Minor, a sad and lovely piece that, for a few minutes, reminds me of why I stay—in this neighborhood and in this town. E. B. White wrote, "On any person who desires such queer prizes, New York will bestow the gift of loneliness and the gift of privacy," blending it "with the excitement of participation." In this nightly scene, my neighbor is alone at his piano and I am alone at my door. Yet, in our private worlds, we are connected, participating in this moment together. It's these two seemingly opposite states—alone and connected—that hold me. Even in the howling crowds, as the city crumbles and dies all around us, now and then, here and there, if we're paying close attention, we can still find pleasure in the gifts of New York. It's just a hell of a lot harder than it used to be.

HYPER-GENTRIFICATION
IN THE REVANCHIST CITY

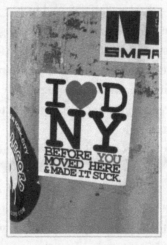

Sticker art. *Wally Gobetz (wallyg@flickr), 2008*

FIRST CLAIMED BY THE DUTCH IN THE EARLY SEVENTEENTH century, before those more uptight English Pilgrims landed at Plymouth Rock, New York City was forged in the Netherlander's twinned ethos of free trade and a permissiveness famously known as "Dutch tolerance," or *gedoogcultuur,* a culture that tolerates the breaking of rules. The city's salesmanship would make it powerful, but its openness to difference, its relative acceptance of rule breakers, would make it exceptional, an anomaly set apart from the rest of Puritan America. In his history *The Island at the Center*

of the World, Russell Shorto explains how "the Dutch Republic in the 1600s was the most progressive and culturally diverse society in Europe," providing safe harbor for exiled intellectuals and authors, Jews and other religious groups, oddballs, and peasants; and that progressivism was imported directly to Manhattan. While the Dutch were Calvinists, they were not Puritans, and they turned the town that would become New York into a multicultural, socially flexible zone—not a free-for-all, not a modern liberal utopia, but a different place from the more rigid society created in New England. Through British rule and centuries of near-constant change, that open character endured. Permissiveness is in the city's DNA. So is capitalism and its hunger for real estate. The two have been in tension ever since. But in the twenty-first century, a new breed of capitalism has tipped the scales to win the city, thanks in large part to its most powerful urban weapon: gentrification.

These days, when most people think about gentrification, they're thinking about an outdated concept. While it's arguable that the practice originated when the Dutch colonized Manhattan and displaced the natives, the word was coined by British sociologist Ruth Glass in the early 1960s. "One by one," Glass wrote, "many of the working class quarters of London have been invaded by the middle class—upper and lower." The invaders took over modest houses and turned them into "elegant, expensive residences," while refurbishing larger Victorians that had fallen into disrepair. "Once this process of 'gentrification' starts in a district," said Glass, "it goes on rapidly until all or most of the original working class occupiers are displaced and the whole social character of the district is changed." In this first definition of gentrification we find its basic elements: members of an upper class invade a lower-class neighborhood, purchase and upscale the houses, displace the people, and change the character.

Gentrification is not the simple shifting of one urban population to another. It does not describe, for example, the expansion of Chinese immigrants from Chinatown into Little Italy. One lower-income

group cannot gentrify another. Gentrification is about class—and the places where class intersects with race and other factors, like education and sexual orientation—but it is always about an imbalance of power. And in every scenario, the gentrifiers have more power.

Gentrification officially came to New York in the early 1970s. At the time, "Brownstone Fever" was sweeping South Brooklyn. The trend had its own conference, called "Back to the City." Organized by the Brownstone Revival Committee and held at the Waldorf-Astoria, the conference presenters provided techniques for "unslumming" a neighborhood. In media reports, however, gentrification continued to be an offshore peculiarity that first struck London and then spread to cities like Amsterdam and Paris, where architecture critic Ada Louise Huxtable described the upscaling of the slums, including Le Marais, "reclaimed as fashionable historic districts, with that curious side effect, 'gentrification,' or the driving out of the poor and working class for an influx of chic residents, restaurants and boutiques."

When the *New York Times Magazine* published their 1979 story "The New Elite and an Urban Renaissance," they celebrated gentrification's arrival in Manhattan with splashy photographs of boutiques and bistros, tins of paté at Zabar's, and expensive sports cars on (gasp!) the gritty Upper West Side's Columbus Avenue. Who were the new urban settlers enjoying all these luxuries? With an average age of thirty-five and annual incomes over $20,000, "[t]he young gentry," said the *Times,* had fled the suburbs to "gladly endure the urban indignities their parents ran away from. This new breed of professionals is willing to put up with smaller apartments, dirty streets, and crime in order to live in chic neighborhoods." The only noted downside to this process was that the poor and working class were being pushed out, making the city less colorful for the gentrifiers. "Ironically," said the *Times,* "the ethnic diversity that is drawing the gentry back to the city, the cultural heterogeneity that has always been the source of so much of New York's character and energy, may become lost in a forest of homogenized high-rises and rows of renovated brownstones."

While gentrification was causing a stir in the 1970s, it was nothing compared to what was coming down the pike. The influx of yuppies was still offset by white flight to the suburbs, and they were hardly stampeding to the city as they are today. A quarterly bulletin by the Federal Reserve Bank of New York titled "Are the Gentry Returning?" found little evidence to support the idea that the back-to-the-city movement had begun in earnest. They concluded, "The overall attractiveness of New York City to the 'gentry' . . . did not grow between 1970 and 1980." In fact, the city's share of high-income households, college graduates, and other high-status groups dropped. This vision of gentrification is still the one many of us think about when we think about gentrification—episodic and gradual, organic and minimally harmful, with some positive effects like fresh produce at the corner grocer and safer streets. But this is not the powerful force that's killing cities in the twenty-first century. Gentrification didn't just get bigger. It mutated into something monstrous.

Neil Smith, professor of anthropology and geography at the Graduate Center of the City University of New York (CUNY) until his death in 2012, outlined what is probably the most detailed and useful theory of gentrification and its changing shape. His work is essential to understanding how the city-killing process of today is not the gentrification of the past.

Smith called Ruth Glass's first version of gentrification the First Wave, or Sporadic Gentrification. Dating it from the 1950s to the mid-1970s, he referred to this wave as "small-scale" and "quaint," without the backing and support of local government and financial institutions.

In gentrification's Second Wave, from the late 1970s to 1989, the process anchored itself, becoming an essential part of the city government's master plan to take back the city from the poor, the working class, people of color, homosexuals, artists, socialists, and other undesirables. A process that had begun organically, more or less, driven

by individuals, was now exploited by City Hall for the benefit of corporations and developers. This momentous shift was largely due to a major political reorientation.

The fiscal crisis of the 1970s brought a new philosophy of governance to the city—the free-market capitalist ideology of neoliberalism, with its focus on privatization, deregulation, fiscal austerity, small government, and the elevation of Wall Street. This neoliberalization of the city marked a major departure from the progressive, redistributive, New Deal philosophy of old New York. It would change the course of gentrification and eventually lead to Michael Bloomberg's luxury vision in the 2000s—the main focus of this book.

In the late 1970s and '80s, under Mayor Ed Koch, City Hall's goal became to re-create New York, making it friendly to big business, tourists, real estate developers, and upscale professionals. In the process, City Hall turned away from its citizens. CUNY professor and urbanist David Harvey has called this the shift from managerialism to entrepreneurialism, meaning that the city government changed its main priority from providing services and benefits for its own people to competing with other cities for outside human resources and capital. In the new competitive city, attracting tourists, newcomers, and corporations was (and still is) more important than taking care of New Yorkers.

Gentrification was the big gun in the new competitive city's arsenal. Where early gentrification had been driven by middle-class people looking to move into affordable and diverse areas, now the city brought in big real estate developers and corporations with generous tax abatements and other government subsidies. Public money for the poor was rerouted to the rich. In 1979, the National Association of Black Social Workers vowed to oppose gentrification in cities across the country, along with austerity measures, "since these plans," wrote the *Times*, "aimed at removing poor blacks from inner-city areas." This may have been the first time that gentrification was publicly called a "plan" and its racist, classist aim clearly spelled out.

Evictions skyrocketed, along with the numbers of homeless New York. Visible on the streets, the homeless interfered with property values and the tourist-friendly image City Hall was hawking. So the NYPD pushed them out—and the people pushed back, most explosively in the Tompkins Square Park riots of 1988.

After this contentious Second Wave of gentrification, New York slipped into an economic recession from about 1989 to 1993. Property values and rents fell. Vacancies went up. Real estate investors panicked as journalists wrote of "degentrification." In 1991, the *Times* announced that gentrification was in retreat and "may be remembered, along with junk bonds, stretch limousines and television evangelism, as just another grand excess of the 1980's." A few years later, the paper declared gentrification dead and buried. But it did not die. It came back bigger, stronger, and meaner than ever.

Smith called the Third Wave of gentrification "Gentrification Generalized," marking its beginning in 1994 with no end date. In this phase, gentrification moved out from the city's center, into parts previously untouched. Generalized gentrification meant "new restaurants and shopping malls in the central city . . . brand-name office towers alongside brand-name museums, tourist destinations of all sorts, cultural complexes—in short, a range of megadevelopments." Gentrification was no longer sporadic or quaint. It was certainly not a natural trend. And its supporters knew it was coming. In 1995, Peter Salins, a senior fellow at the neoliberal think tank Manhattan Institute, told the *Times*, "Eventually, practically all of Manhattan, south of the northern edge of Central Park, will be gentrified, all the way down to the Battery, and that includes the Lower East Side." He thought it would take until 2025. It happened much faster.

Neil Smith stopped writing about gentrification after 2006. He did not put forth a Fourth Wave to account for the dramatic changes the city endured under Bloomberg. A year before Smith's death in 2012, I wrote to him and asked if he could provide a distillation of his complex theory. In conclusion, he told me:

The class remake of the city was minor, small scale, and symbolic in the beginning, but today we are seeing a total class retake of the central city. Almost without exception, the new housing, new restaurants, new artistic venues, new entertainment locales—not to mention the new jobs on Wall Street—are all aimed at a social class quite different from those who populated the Lower East Side or the West Side, Harlem, or neighborhood Brooklyn in the 1960s. Bloomberg's rezoning of, at latest count, 104 neighborhoods has been the central weapon in this assault.

That *total* class retake of the city might qualify as a Fourth Wave of gentrification, a process that jumped to a new level in the 2000s—under Bloomberg in New York, but also in similarly restructured cities around the globe. Loretta Lees, a professor of urbanism in London, has proposed a fourth wave, describing it as "the consolidation of a powerful national political shift favoring the interests of the wealthiest households, combined with a bold effort to dismantle the last of the social welfare programs associated with the 1960s." Call it Total Oligarchic Gentrification. Call it a Billionaire's Bonanza. I call it hyper-gentrification—because it's fast, frenetic, and aggressive, but also because hyper-gentrification just sounds sexier than "Fourth Wave" or "gentrification generalized."

Hyper-gentrification, as I think of it, encapsulates not only the real estate deals, the movement of money, and the displacement of lower-income people and small, local businesses. It's the whole *megillah*. It's the return of the white-flight suburbanites' grandchildren and their appetite for a "geography of nowhere," to take a term from social critic James Howard Kunstler, in which monotonous chain stores nullify the streets. It's cupcakes, cronuts, and hundred-dollar doughnuts dipped in 24-karat gold (yes, this exists—in Williamsburg, Brooklyn). It's the ugly extravaganza of what New York, and

too many other cities, have become—playgrounds for the ultra nou-
veau riche, orchestrated by oligarchs in sky-high towers, the streets
stripped of character, whitewashed and varnished until they look like
Anywhere, USA. It's the displacement of the working class and the
poor, people of color, artists and oddballs. And it's the changed psy-
chic climate. A city once famously neurotic is becoming malignantly
narcissistic. Hyper-gentrification has a character—and it's a socio-
pathic one. Intelligent, malevolent, and directed, it is shot up with
rage and vengeance. Which brings me to another of Neil Smith's crit-
ical points about late-stage gentrification, one that might help explain
the psychology of many gentrifiers today.

I n 1996, Smith called Giuliani's New York "the revanchist city."
Revanche is French for revenge. The original revanchists were a
group of late-nineteenth-century French bourgeois right-wingers
who didn't like the working class, the liberals, or the radical socialists
of the Paris Commune who had come to power. So they took revenge
on those they believed had stolen France from them. For Smith, the
revanchist city in the 1990s expressed "a race/class/gender terror felt
by middle and ruling-class whites." The yuppies had come to retake
and remake the bad old city in the 1980s, investing in brownstones
and condos, developing real estate, taking Wall Street jobs, and mov-
ing in their corporations, only to be stranded in a recession with
declining property values and a record-high murder rate. So when
the economy tanked in 1989, they were furious. They wanted re-
venge and voted for Giuliani, a Republican with an iron fist, a man
who would become known as Mayor Mussolini.

"The rallying cry of the revanchist city," wrote Smith, "might
well be: 'Who lost the city? And on whom is revenge to be exacted?'"
The scapegoats in the Giuliani era were people of color, the poor and
working class, immigrants, feminists, homosexuals, socialists, bohe-
mians. These people had made New York the city it became in the

twentieth century—open, progressive, diverse, and creative. They had also long been identified as enemies of the more conservative elites.

So what are we really talking about when we talk about gentrification in the twenty-first century? In many ways, the term itself is a diversion. It's the bright green face of Oz that distracts from the man behind the curtain, the invisible hands pulling all the levers. Those hands belong to the globalized world order of the so-called free market, the neoliberal agenda launched in the late 1970s to destroy socioeconomic progressivism, the stuff that made New York so New York. In cities across America and the world, those hands pull the levers on hyper-gentrification. There is nothing natural about it. It is a man-made virus that grows rhizomatically, creeping into every crack and crevice of Manhattan, reaching ever deeper into the outer boroughs, pushing out whatever stands in its way. It can be defeated. But first we must pull back the curtain and see it clearly for what it is: an act of revenge.

By the time Giuliani came along, a battle had been raging between the elites and undesirables for many decades. When I look at revanchism, I see the dark roots of its rage reaching back through the crisis of the 1970s and the race riots of the 1960s, all the way to the ethnic class struggles of the 1920s, and, ultimately, to the anti-immigrant nativism of the 1800s on the Lower East Side. That is where the wild, diverse, progressive New York was conceived—and where the battle for its soul began.

LUDLOW STREET AND THE LOWER EAST SIDE

Ludlow and Rivington Streets at night. *Efrain John Gonzalez, 1986*

KATZ'S DELICATESSEN HAS BEEN ON THE CORNER OF HOUSTON and Ludlow Streets since 1888. Now surrounded by towering luxury condos and hotels, the deli is still going strong. They make their own pickles, and people who know from pickles will stand outside just to inhale the briny, garlicky, half-sour aroma. In 2009, the East Village blogger E. V. Grieve quoted from a blog written by a young professional who, after living on the Lower East Side for a year, was getting ready to move out. The woman listed the things she would miss and not miss. I will just note the following two

items of Lower East Side life that she found loathsome: "The smell of pickles from Katz Deli that I am forced to inhale when walking home every day" and "The fact that there is not a close enough Starbucks."

While she's just one person jotting down her thoughts, I recount this story because it perhaps exemplifies the everyday voice of hyper-gentrification, the virus carried into New York in the psyches of many newcomers. To that mind, the stuff of old New York is smelly and bothersome, and probably should vanish. The new stuff, the extruded-plastic simulation that has nothing to do with New York, is so desirable you can never have too much. We will hear this voice again and again, so let's call it what it is. It's a meme, a self-replicating thought virus. "Old New York is bad," it repeats. "New corporate chains are good. Tenements are bad. Luxury condos are good. Preservation is bad. Gentrification is good." When we're fighting hyper-gentrification, we're often fighting a discursive battle, a war of words and ideas. We cannot ignore the meme. So keep listening for it.

In the young woman's list of what she *would* miss, she lovingly noted the amenities of her apartment, including her stainless steel stove, her in-house gym, and her window view, specifically, "The statue of Vladimir Lenin on top of the Red Square building."

Red Square was built on Houston Street, the dividing line between the East Village and the Lower East Side, in 1989. It was one of the first modern luxury buildings in the neighborhood, and probably the first to thoroughly exploit the poverty and socialist history of the area in its marketing materials. *The New Yorker* called it "a Communist-theme apartment building . . . that hastened gentrification on the Lower East Side while seeming to subvert it."

Parisian professor Frédérique Krupa wrote a 1992 essay on the engineering of the building's identity by "bad boy" graphic designer Tibor Kalman and his agency M&Co. In "Red Square, New York," she explains how Kalman and the building's developer created an image that would appeal to the rich by selling them on the grit, poverty, and risk of the old Lower East Side. According to Kalman's corporate

brochure, Red Square "was designed to appeal to a narrow audience of people with resources who wanted to live in a hip, extreme and even dangerous neighborhood." But those people also needed to be reassured that outside threats would not invade their space. Wrote Krupa, "The tenant can go out in this dangerous neighborhood and return to their safe, clean, private haven" of steel doors and doormen, video intercoms and double-glazed windows, all meant to keep the outside out. "The population in the area is then there to serve as a source of entertainment," a kind of Disneyfied entertainment, vividly illustrated in portions of the advertising copy from Red Square's original sales brochure:

> A seamstress and a presser, shy as villagers falling in love over the accompaniment of whirring sewing machines and sweet tea . . . The lint of sweat shops swept out by raucous Spanish accents . . . Long haired poets silk-screening posters for the revolution . . . Today it's an after hours club. Or is it the apartment where the incredible Dutch model with one name lives with Mr. Wallstreet? . . . A semi-famous guitarist comes out of a club and buys a pickle from a barrel as two young account executives head out to conquer the world.

Sweatshop workers, Latinos, musicians, and poets become animatronic characters in a theme park designed for world-conquering Mr. Wallstreet and his Dutch model girlfriend. Red Square was revolutionary in the way it marketed the authentic culture of the Lower East Side—socialism, bohemianism, the working class—in order to sell it to an invading culture that would then destroy it. In later years, the developer, along with Kalman and his team, voiced regrets. Designer Marlene McCarty said that of all the jobs she worked on for M&Co, "I was always most embarrassed about this one. I live in the neighborhood. Every day when I look out my window, I see Red

Square. It's my punishment." Kalman called the project "[t]he most masterful deceit of all."

At the end of the 1980s the Lower East Side south of Houston Street was still strongly connected to its history as a neighborhood for poor immigrants. For more than a century, from boats and later planes, they came flooding in—German, Irish, Chinese, Jewish, Italian, Puerto Rican. As they adapted to American culture, many left, but many stayed, maintaining their restaurants, shops, and other small businesses, struggling through poverty and standing up to crime. Throughout the 1960s and '70s they were joined by artists, writers, and musicians, also in search of cheap housing. The young creative people lived in squalor, not with double-glazed windows and steel-reinforced doors, but with broken windows and busted doors. The artists persisted and Ludlow Street, slowly at first, became a hub of creativity.

The founding members of the Velvet Underground were making music on Ludlow as early as 1965. Writing in the *Wall Street Journal*, John Cale recalled composing with Lou Reed in a fifth-floor apartment, combining the sounds of "Erik Satie, John Cage, Phil Spector, Hank Williams and Bob Dylan" to create "a new form of rock—more about art than commerce." The poet and downtown legend Taylor Mead, star of Andy Warhol's hour-long silent film *Taylor Mead's Ass*, lived on the street for thirty-four years, until he was displaced from his rent-stabilized apartment at age eighty-eight by real estate tycoon Ben "the Sledgehammer" Shaoul. Mead held out, enduring construction noise and poor conditions, for as long as he could, telling the *Post* in 2013 that Shaoul "doesn't give a shit about who I am. It's going to be hell." Mead eventually surrendered his apartment, accepting a buyout and leaving New York with the hope of returning one day. He never did. Within just a few weeks of moving out, he was dead from a massive stroke.

Throughout the 1980s, more artists, writers, and performers found their way to the Lower East Side. Ludlow Street—still filled

with junkies, dealers, killers, and gangs—was soon viewed as an untamed alternative to the gentrifying East Village. In a piece for *The New Yorker's* "Talk of the Town" in 1988, an anonymous "young married woman" described her move to the street: "No one we know would think of living here. No one we know has ever heard of Ludlow Street. Maybe someday this neighborhood will be the way the Village was before we knew anything about New York, the way the upper West Side was eight years ago, the way the East Village is now." She continues, evoking the spirit of Manifest Destiny pressing bravely into the urban wilderness, "We explain that moving down here is a kind of urban pioneering" and "liken our crossing Houston Street to pioneers' crossing the Rockies." The writer paints herself as an intrepid adventurer as she romanticizes the unspoiled frontier. "So we discover the ungentrified life," she writes, a world of no supermarkets, on a street that "becomes more chic by the day." She imagines that neighbors north of Houston envy her and her husband, and "only wish the East Village were still so authentic, so raw, so unhip it's hip."

In 1989, the same year that Red Square went up, artist Ulli Rimkus opened a bar on the northernmost end of Ludlow. It was an artists' bar, its colorfully painted walls a constantly changing democratic gallery of local work, and it became the heart, some say the engine, of the new Lower East Side scene, a scene that would help bring ever more hyper-gentrification. Rimkus called her bar Max Fish, dropping the ethnic *c* of the previous occupant's name. Max Fisch had sold Judaica on the block for more than thirty years. The bar settled in between Joseph Yavarkovsky's paper supply (in business since 1898) and a blanket salesman known as "the pillow man." Those two didn't last. The 1990s had begun and the Lower East Side would never be the same.

Artists, hipsters, musicians, and celebrities like Johnny Depp and Ethan Hawke flocked to Max Fish. Junkies and crack addicts copped on the corner and got high in the bar's dirty, graffiti-covered

bathrooms. Across the way, the Ludlow Street Café opened and be-
came known as a "beatnik haunt" (so said *New York* magazine) for
live bands and Sunday brunch. The café's atmosphere, explained
the *Times* in 1989, "is part relaxed Austin, Tex., part Lower East Side
arriviste, with patrons trying to live, second-hand, stories about
Manhattan Bohemia. Outside on Ludlow Street, cultures clash as
Nissans blaring salsa—the real music of the community—drive by
and the middle-class patrons of the cafe stand around awkwardly."
At the other end of the block, more salsa poured from the jukebox
at Mexican restaurant El Sombrero, also known as the Hat—since
1984, serving Latino and artist crowds alike with tacos, burritos, and
brain-slamming margaritas you could take out in paper cups, getting
rapidly intoxicated as you walked.

By 1991 word was getting out. The *Times* sent a reporter down for
a "Sunday Outing," during which she enjoyed a brunch of frittata and
cappuccino, and then shopped for that "one-of-a-kind party dress," a
strappy silk organza number for $250. Ludlow was coming up in the
world, but not all of the Lower East Side was Ludlow. Just a block
away, Orchard Street was still absolutely Orchard Street. On Sundays,
it shut down to vehicular traffic and the old shops rolled out tables
loaded with cut-rate hosiery, brassieres, hats, shoes, luggage, bottles
of perfume, leather jackets, and wind-up toy bullfrogs that swam in
plastic buckets of water. Bargain shoppers crowded the street looking
for deals from the mostly Jewish and Latino merchants who stood
waving and calling, "Check it out, check it out, good prices here,"
just as their predecessors had done for decades. The smell of the air
on Orchard was heady with new leather, that soft rawhide bite. Over
on Essex Street, the Judaica stores thrived, as they always had, with
shopkeepers advertising services and wares on text-cluttered signage:
"Scribe, Importer, Dealer & Repairing of: Sefer Torahs, Tefillin, Me-
zuzos & All Religious Articles. Yarmulkas, Tallises & Bags. Checking
Mezuzos & Tefillin While U Wait." And while Essex was no longer

the city's "Pickle District," you could still find the green delicacies at Izzy Guss's century-old store, loaded into streetside barrels: full-sour, half-sour, quarter-sour pickles, along with pickled tomatoes, kraut, and other specialties. (I liked to buy three for a dollar, slip the plastic baggie in my coat pocket, and eat pickles while I wandered the neighborhood, sometimes with an El Sombrero margarita in hand.) Latino merchants mixed among the Jewishness, their *botanica* and *carniceria* windows full of Catholic saints and the hanging carcasses of fleshy pigs.

Back on Ludlow, in came avant-garde theaters, along with music clubs like Mercury Lounge, Luna Lounge, and Arlene's Grocery, whose owner told the *Times* in 1997, "I liked this neighborhood because there was such a diversity of people, and the likes of Starbucks hadn't moved in. . . . One thing that may help preserve the Lower East Side is that it's a little less accessible. . . . I guess it'll be about five years before the Gap shows up." Five years would be about right, though it would be American Apparel, not the Gap. The Lower East Side gold rush was on, with money-hungry developers snatching up whole blocks of property, and landlords plotting to murder their rent-controlled tenants. By the end of the 1990s, Ludlow had been dubbed "Downtown's Disneyland" by *New York* magazine, and "The New Bohemia" by the *Times,* which credited Giuliani's NYPD crackdown on drug sales for kicking the street into "high gear." With the neighborhood turning white and middle-class, cops started swarming, making arrests for minor infractions like painting graffiti and drinking beer out of paper bags. For the major drug busts, they brought in helicopters. The neighborhood had to be made safe for the upper class to come. Blocks south, the building that had housed the socialist *Jewish Daily Forward* was converted into high-end condo lofts. With its bas-reliefs of Karl Marx and Friedrich Engels over the entrance, the Forward Building filled with supermodels and celebrities. Apartments went for $15,000 a month.

In 2013, Max Fish was forced out, its rent hiked to an impossible $20,000 a month. After the bar closed, Ulli Rimkus told *Paper* magazine, "The area started changing in the '90s, but really the most change has happened in the last 10 years. Before, it was like 'it's happening, it's happening, it's going to happen,' and then it happened in a flash. Just like that. It's like that Hemingway quote about going broke: 'How do you go broke? Gradually, then suddenly.'"

All at once, colossal luxury towers ripped into the air. In 2005 came The Hotel on Rivington, aka THOR, which architect and urbanist John Massengale called "a big, glass, yuppie box in the hip, old, low-rise Lower East Side." The bigger, glassier Blue building opened on Norfolk in 2006, complete with outdoor showers on the terraces, and a penthouse for $14,000 a month. Thompson LES, an eighteen-story luxury hotel, opened on Allen Street in 2008, featuring an outdoor swimming pool with Andy Warhol's face printed on the bottom. The Ludlow, twenty-three stories of luxury rentals, rose across from Katz's deli in 2008. More keep coming, their digging machines tearing up the streets for towering silhouettes that radically change the skyline from low-rise to sky-high, turning the once diverse and colorful streets into cold, sterile corridors of glass. The National Trust for Historic Preservation put the Lower East Side on their list of Most Endangered Places, stating that the rampant development "threatens to erode the fabric of the community and wipe away the collective memory of generations of immigrant families."

With the luxury towers and hotels came bars, bars, and more bars. Their presence was planned and engineered, in large part thanks to real estate *macher* Sion Misrahi, often credited and blamed for the Ludlow area's transformation into a booze-saturated party zone. Misrahi doesn't deny it. He told the *Times* in 2007, "We decided to rent to bars and restaurants who would bring in the hipsters and change the neighborhood." The plan worked. Lockhart

Steele at the Curbed blog network dubbed the vicinity "Hell Square" for its screaming, drunken mobs of the most excruciating people on earth. Hell Square caught on as a nickname with the locals, and a new micro-neighborhood was born. Those unfortunate enough to live in Hell Square, wrote James Barron at the *Times* in 2013, "say it is a realm where they are condemned to eternal torture and punishment in this life, not the next one." The chairman of the New York State Liquor Authority called it "one of the most saturated areas in the city—probably one of the most saturated in the world—in terms of liquor licenses." LES Dwellers, a group of concerned residents, formed in response to what they called "the decimation of quality of life and the deterioration of culture on the L.E.S. stemming from the over-saturation of liquor licenses and irresponsible nightlife-driven establishments and landlords."

Most of the Ludlow Street businesses beloved by the early artist gentrifiers have shuttered, moved, or turned over—Max Fish, Pink Pony, Ludlow Street Café, the original El Sombrero, theaters, clubs—many of them dropping all together in a cluster in 2013. Blogs and newspapers like the *Village Voice* were all wondering: "Why Ludlow Street's Last Bastions of Bohemia are Closing." El Sombrero turned over and got a more upscale renovation. In an interview during its last days, waitress and artist Regina Bartkoff told me they were having trouble paying the rent since the clientele on the block had changed so dramatically. She said, "The character of these new people coming in was weird. They didn't come in curious or wanting to find a place to call their own. They didn't try to fit into the neighborhood. They were rude and obnoxious."

Pretty much everything else that isn't related to the "revitalization" in and around Hell Square has died, or is in the process of dying, like houseplants left too close to a radiator. The men and women who made and maintained the neighborhood for over a century might have survived persecution and genocide in their home countries, followed by immigration stressors, poverty, and crime in New York, but

they were no match for hyper-gentrification. The Judaica stores on Essex Street folded, almost all at once, when their leases ended and rents spiked. Their spaces were snatched up by trendy cafés, bars, and bespoke boutiques. After eighty-nine years on the Lower East Side, Guss' Pickles was exiled to Brooklyn. The *botanicas* and *carnicerias,* with their Catholic saints and ham shanks, vanished.

Orchard Street, from end to end, was laid to waste in just a few short years, the majority of its longtime businesses wiped out and replaced by art galleries, cafés, and boutiques. Down came tenements and up went hotels and condos. Out went almost all the bargain underwear shops, and in came inexplicably high-end stores like Project No. 8, where the cost of one pair of underwear could pay an old Lower East Sider's rent for a month. Among the "out-of-control fashiony" items, *Times* Critical Shopper Mike Albo spotted one "pair of tightie whitie briefs" for a whopping $325. Vanishing and gone are the luggage stores and leather dealers, the hat merchants and *schmatta* salesmen, the sprawling spaces loaded with bolts of fabric. Only a few remain, stranded in their dwindling numbers between jam-packed oyster bars and farm-to-table bistros with cute, innocent-sounding names like Tiny Fork and Fat Radish (which the *Times'* Sam Sifton called "a restaurant for good-looking youngsters on their third jobs and second apartments, single and raging, with summertime Montauk shares and memories of Belize and Gstaad"). In between came slick, hybridized concept stores like Lost Weekend NYC, a café/ gallery/surf shop that sold surfboards and surfing-related art and apparel, along with $220 sunglasses and designer hair products, while serving a coveted brand of micro-roasted coffee and ten-dollar bars of Mast Brothers chocolate imported straight from Williamsburg, Brooklyn.

A few holdouts of old Orchard endure, most of them treasures of Jewish New York. The Orchard Corset Center remains a blessed place where buxom women find the best fits and, as I was told by one customer, the saleslady knows "more about breasts and bras, and how

they fit together, than anyone at Victoria's Secret." Guss' Pickles may be gone, but the Pickle Guys have come, keeping the open-barrel tradition alive. Russ & Daughters, the famous appetizing store, has expanded. Kossar's Bialys remains—albeit under new ownership, with a renovation and the promise to "toast and scoop" bagels for newcomers' tastes. Sol Moscot's is still there, in a new space at Orchard and Delancey, where its giant Eckleburgian spectacles have kept watch for seventy-seven years. They were forced out of their old spot when the building was sold for the wrecking ball and a twelve-story luxury condo. Thankfully, the fifth generation of Moscots will continue examining eyes and fitting frames at the Lower East Side crossroads. For now, anyway. Delancey is undergoing a total evisceration.

In the fall of 2013, a few months before his tenure ended, Mayor Bloomberg and a group of developers announced the grand plan for "Essex Crossing," a reconstruction of the Seward Park Urban Renewal Area (SPURA), a site that had long endured a controversial history. In 1967, the city demolished fourteen blocks of tenements here, evicting more than two thousand working-class and poor residents, Latino, white, black, and Chinese, to make room for market-rate housing and a section of Robert Moses's Lower Manhattan Expressway. Neither came to pass. Over the years, tied up in lawsuits, protests, and politics, SPURA sat mostly undeveloped. Until now. On the flattened ruins will rise a glittering mega-project.

Essex Crossing will cost $1.1 billion and cover 1.65 million square feet over nine parcels, mostly parking lots, forming a Tetris-like shape on and around Delancey and Essex. Architectural renderings show a phalanx of hulking glass towers so big, so sparkling, they dwarf and outshine the high-rises of the 2000s. They'll contain luxury condos, office space, floors of interior shopping-mall-style retail, glamorized suburban food courts, and some "affordable" housing (though not enough to make up for all the homes destroyed in 1967). But, wait—there will be an Andy Warhol museum! No, there won't. The museum plans fell through. But there will be a rooftop urban farm!

And a crafting center! It will be a place where poor aspiring artisans will be taught "craft skills" and lessons in how to "produce and sell hand-made merchandise," which, I imagine, they can hawk from an official Essex Crossing merchant's stall, watching the tourists go by and praying they can unload enough woven leather bracelets and re-purposed subway-token earrings to pay for groceries. As for grocer-ies, they will still be found at the city-owned Essex Street Market, but it won't be quite the same. Begun in 1940 by Mayor Fiorello La Guardia, the market's original buildings will be demolished and its vendors moved to the new complex. The city promises not to raise rents. Today's Essex Street Market is a blend of old and new, low and high prices, with Latino merchants selling plantains and Goya beans alongside hipster artisanal bacon- and basil-flavored ice cream, "Old World style" breads, and "American farmstead" cheese. In the glitzy future mall, expanded to accommodate more new upscale busi-nesses, will the old-school merchants survive?

The architectural renderings of Essex Crossing make it look like a manufactured utopia of the future. The gauzy air is filled with shiny, happy people, human clip art holding hands, shopping, riding bicycles, tending gardens, all grinning at the late-capitalist triumph. The urban wilderness has been tamed, the pioneers have settled, and the Lower East Side's socialism has been ripped out. In a gesture that felt like a final blow, in 2016 the statue of Vladimir Lenin atop the Red Square building was toppled, dragged down by ropes and relo-cated after developers bought the place for $100 million. But what did the statue, in that context, really symbolize? With a nod to the neighborhood's radical past, the commodified communist had stood on his luxury perch for almost thirty years, waving to Wall Street as if to say: The coast is clear. Send in the colonists. The major battle has been won.

THE BATTLE FOR
NEW YORK'S SOUL

Archival photograph of Ellis Island immigrants pasted by artist JR onto
an Orchard Street shop turned art gallery. *Jeremiah Moss, 2015*

WHEN MOST OF US THINK OF NEW YORK CITY, WE DON'T think of the Pleistocene, when ice sheets gouged the ground of what would become Central Park. Unless we're waiting for the 6 train at Astor Place and glance at the ceramic beavers in the station's tile work, we generally don't recall John Jacob Astor and his beaver pelts. "The Bronx" does not make us associate to the old Mennonite Jonas Bronck, and "Brooklyn" does not conjure farmland. Most of us don't live in deep history. When we think of New York, it's the city we know firsthand or described by parents

and grandparents, writers, filmmakers, and artists. When we think of New York, we most likely think of the twentieth-century city, the metropolis born from a confluence of restless, desperate people who arrived as underdogs and became the city's life force.

That is the vanishing New York. It is the city that should have survived, evolving on its exceptional, progressive trajectory, but fell instead to forces that fought against it every step of the way. As many people like to tell me, "New York is always changing." They're right—but they're also wrong about the change that suffocates the city in the twenty-first century. Hyper-gentrification can be seen as the culmination of a long battle for the soul of New York. The story of how it came to grip the city is long and complex, so I've put together a CliffsNotes version, a cheat sheet to the century of struggle that brought us to where we are today.

To tell the story of this battle, I'm taking what might be the ill-advised route of dividing sides into good guys and bad guys, knowing well that such binary categories are never simple or neat. On the bad guy side are the Elites, the power brokers who've schemed and destroyed to hold on to their power. The good guys I call the Undesirables; basically, everyone that the Elites have identified as a threat. The list includes immigrants, people of color, the poor and working class, queers, socialists, bohemians, and general dissenters. The two sides sometimes overlap. Within their own ranks, especially among the Undesirables, they often conflict among themselves—this is no portrait of race and class harmony. Still, the two sides can be viewed as opposing forces in the timeless New York tension between trade and tolerance, between the Haves and Everyone Else.

The way I figure it, today's vanishing New York began in the latter part of the 1800s, after the Civil War, when African Americans were emancipated from slavery and a great influx of European immigrants flooded lower Manhattan. Impoverished Irish Catholics,

already pouring in through the city's port, were met by hostile Nativists, Anglo-Americans rooted in Puritan origins, for whom Catholicism was a threat. The anti-immigrant, anti-Catholic Know-Nothing political party, along with other nativist groups, tried to stop the tide, but more waves of immigrants followed, millions of Italian Catholics and Russian Jews, along with Greeks, Hungarians, Poles, and others who, like the Irish before them, were not considered quite white. For generations, even as they held more status than black, brown, Asian, and Native Americans, lower-class European immigrants were subjected to racism, cast in the role of what sociologist John Dollard called "temporary Negroes." One New York newspaper summed up the sentiment in the 1890s: "The floodgates are open. The bars are down. The sally-ports are unguarded. The dam is washed away. The sewer is choked. Europe is vomiting! In other words, the scum of immigration is viscerating upon our shores. The horde of $9.60 steerage slime is being siphoned upon us from Continental mud tanks."

Anglo New Yorkers' fears were not unfounded. Immigrants brought major cultural change. In that continental flood came radical new ideas and ways of life, flowing first through the Lower East Side, the point of embarkation where multitudes began their American experience. Escaping oppression and poverty, they brought socialism and anarchism, organized and unionized, lifting the working class to power. With native Anglo reformers, they agitated for women's rights, including the early feminist ideal of free love—defined by Victoria Woodhull in New York City in 1871 as the "inalienable, constitutional, and natural right to love whom I may, to love as long or as short a period as I can; to change that love every day if I please." They also formed gangs, organized crime syndicates, and competed violently for resources and power.

In the same decades, American bohemianism developed, imported in the 1850s from the cafes and garrets of Paris to Pfaff's beer cellar below Broadway, where Walt Whitman rhapsodized on democracy, the mingling of multitudes, and homosexual love. With the

bohemians, a queer city evolved alongside the growing immigrant and working class. In *Gay New York,* George Chauncey describes how the rise of working-class life in the theaters, dance halls, and saloons of the *fin de siècle* Bowery and Harlem helped the queer city to flower. In the 1890s and early twentieth century, he notes, "the most visible gay world . . . was a working-class world, centered in African-American and Irish and Italian immigrant neighborhoods." Working-class "fairies," as they were known, openly wore women's clothing and hung out with blue-collar toughs in Bowery dives. In *The Female Imperson-ators,* one self-identified fairy, Jennie-Ralph, recalled queer life among working-class immigrants in late-nineteenth-century New York. S/he wrote, "as the 'classy,' hypocritical, and bigoted Overworld considers a bisexual as monster and outcast, I was *driven* to a career in the dem-ocratic, frank, and liberal-minded Underworld." That underworld wasn't easy, but it provided a space in which to exist.

Word of New York's relative tolerance for sexual nonconformity became a siren song to proto gay, lesbian, bisexual, and transgender Americans across the country, and like the immigrants, along with cultural refugees from straight-laced America, they flocked to the city to be liberated. As the 1900s began, New York started moving into its capital position as a progressive, socially liberal city, later solidified by the New Deal. The "democratic, frank, and liberal-minded" mem-bers of its citizenry would create a new city that, for the next century, would be viewed by much of America, with suspicion and envy, as a foreign country. As Ford Madox Ford would write in 1927:

> Well, one hears eternally that New York is not America.
> It is obviously not Europe—the Atlantic lies between.
> Is it, then, the outer fringe of America—or the end of
> Europe? Perhaps, the one overlapping the other, here
> we have the beginning of the world. I like, at any rate,
> to think of it like that and it is possible that it is true
> enough. For New York is Babel without confusion of

tongues. A place of refuge for all races of the world from the flood of ancient sorrows; the forlorn hope of humanity that, having lived too long, seeks rebirth. And indeed, the note of New York—its gayety, its tolerance, its carelessness is just that of a storming-party hurrying towards an unknown goal.

Imagine now that we are standing on the cusp of twentieth-century New York. We are in the last days of the old Gilded Age. Uptown, the tycoons rest in their Fifth Avenue mansions, all those Astors and Vanderbilts, Carnegies and Fricks, far from the rabble that agitates below. From our high vista, atop the recently risen Statue of Liberty, we see a town taken over by a new population—Catholics, Jews, queers, freed blacks, bohemians, socialists, feminists—all poised to redefine the city for a bold new era. Brick tenements have filled the streets to hold these crowds inside miserable steam-heated rooms where people bump and mix, conspire, and discover new forms of sex. Since no one luxuriates in a cramped tenement, they escape for relief into the streets, to the dive bars, cafés, and bookshops where they develop and spread provocative ways of life. From all that tenemental ferment will come jazz, poetry, punk, hip-hop, and the incomparable egg cream. Look out at the bold new city to come. It's noisy and dirty, a cacophony of cultures and classes, juiced by the energies of liberated people. They're giddy with freedom, but they're also grouchy, because they know that suffering is never far away. They compete with each other. Too often, they beat on each other. The New York character coalesces. It's rough around the edges. Brusque and opinionated, it's also neurotic. Emphatic. It doesn't mince words. It says what it means and means what it says. Sometimes it says, "Fuck you, you fuckin' fuck."

But don't think for one minute that the old Calvinist Elites will step aside and let their gilded city "go European," literally and figuratively. They have a plan. Its essence could be summed up in the

words of American educator Ellwood Cubberley, who wrote in 1909 on the problem of immigrants from southern and eastern Europe. Lazy, dirty, and not in line with "Anglo-Teutonic conceptions" of law and order, he wrote, "their coming has served to dilute tremendously our national stock, and to corrupt our civic life." These not-quite-white immigrants were taking over northern cities, making a mess of housing, morality, and government, clinging to their native cultures. "Our task," Cubberley concluded, "is to break up these groups or settlements, to assimilate or amalgamate these people as a part of our American race, and to implant in their children, so far as can be done, the Anglo-Saxon conception of righteousness."

One way to take back a city is to undermine the black and brown populations and turn working-class "temporary Negroes" into middle-class whites. To accomplish that dual task, it would require the playing of a long game with many steps.

DEINDUSTRIALIZATION AND DIVISION

In the first decade of the 1900s, nearly half of New York's workforce worked in manufacturing, and through progressive politics, the city had become, in the words of labor leader Samuel Gompers, "the cradle of the American labor movement." As the working class rose, so did the counterculture, and the two continued to coexist, despite their differences. At the Greenwich Village bohemian salons of radical socialite Mabel Dodge Luhan, you could find, in her own words, "Socialists, Trade Unionists, Anarchists, Suffragists, Poets, Relations, Lawyers, Murderers, 'Old Friends,' Psychoanalysts, IWWs, Single Taxers, Birth Controlists, Newspapermen, Artists," all speaking "in an unaccustomed freedom a kind of speech called Free."

The black population of New York was also growing rapidly due to the Great Migration from the segregated and dangerous Jim Crow South. Fleeing southern brutality, encouraged by northern recruiters

looking to fill factory jobs with low-paid laborers, millions of African Americans made the journey north, adding more color to cities like New York, where they settled in parts of town like Harlem and Bedford-Stuyvesant. Neighborhoods became more mixed, and while New York was hardly a non-racist utopia, it offered more opportunities for diversity than the American Heartland. This would not do.

Interracial, lower-class mixing has always been a threat to the power elites. For centuries, they've used the same strategy to stop it. In colonial America, African slaves and white indentured servants received similar, though not equal, treatment. They worked together, slept together, and in Bacon's Rebellion of 1676 they fought together, hoping to gain their freedom. This cross-class, interracial uprising terrified the elites. "The answer to the problem," as Edmund S. Morgan asserts in *American Slavery, American Freedom,* "was racism, to separate dangerous free whites from dangerous slave blacks by a screen of racial contempt." In what has become known as the "racial bribe," poor whites were given special privileges over enslaved blacks. For example, as Michelle Alexander points out in *The New Jim Crow,* white servants could police slaves and their labor was protected from black competition. So began institutional racism in America. With that, the colonial elites not only succeeded in splitting black and white workers; they also intertwined race and class in a perpetually confounding fusion that continues to thwart progress today.

In the early twentieth century, the Elites of New York reinforced their ancestors' system. They squeezed the working class, reducing the number of industrial jobs, and pitted immigrants and blacks against each other for dwindling resources. At the same time, not-quite-white ethnics moved to embrace whiteness for its privileges, what David Roediger, building on the work of W. E. B. Du Bois, has called "the wages of whiteness." It was a bonus, essentially, the racial bribe in modern times.

Too often, when people talk about the deindustrialization of New York, they talk about it like it happened naturally, a trend of

the times, nothing more than market forces. Journalist Robert Fitch offered an alternative explanation in his 1996 book, *The Assassination of New York*. Poring over the 1929 Regional Plan of New York and Its Environs, Fitch discovered something startling. The death of industrial New York was planned by a privately organized group of bankers and real estate developers. They didn't like having all those blue-collar, multiethnic people taking up space on valuable Manhattan land, so they appointed themselves the Regional Plan Association (RPA) and, starting in 1922, schemed to destroy working-class New York by zoning away industrial areas and claiming those territories for finance, insurance, and real estate (FIRE), upper-class fields ruled at the time by Anglo-Saxon Americans.

To Fitch, these urban Elites unabashedly "expressed a strong, single-minded desire to get rid of the city's blue collar industry and replace it with offices, apartment houses for the rich, and department stores." Robert Haig, the RPA's chief economist, made the group's viewpoint clear when he wrote:

> Some of the poorest people live in conveniently located
> slums on high-priced land. On patrician Fifth Avenue,
> Tiffany and Woolworth, cheek by jowl, offer jewels and
> gimcracks from substantially identical sites. . . . In the
> very heart of the "commercial" city on Manhattan Is-
> land south of 59th Street, the inspectors in 1922 found
> nearly 420,000 workers, employed in factories. Such
> a situation outrages one's sense of order. Everything
> seems misplaced. One yearns to re-arrange the hodge-
> podge and to put things where they belong.

Critic Lewis Mumford savaged the plan, writing in *New Republic* that it represented a "sociological failure" and existed for "the interests and prejudices of the existing financial rulers." You don't have to be a conspiracy theorist to see that the financial rulers wanted a

sociological failure, to disrupt the progressive working class of New York, dividing whites from blacks, to protect and expand their own power.

As the 1920s saw a resurgence of intense nativism, the federal government passed the Emergency Immigration Act, enforcing a quota to stop the influx of southern and eastern European immigrants. America was for Americans—and that meant native-born Anglo-Saxons. Not Italians, not Jews, not Catholics, not blacks. Du Bois declared the homogenizing trend of Americanization "a renewal of the Anglo-Saxon cult; the worship of the Nordic totem, the disenfranchisement of Negro, Jew, Irishman, Italian, Hungarian, Asiatic and South Sea Islander—the world rule of Nordic white through brute force." The only way to fight that force, he wrote, was through an alliance between "darker people," immigrants, and the working classes. That's exactly what the ruling class of New York didn't want. And they had friends in Washington.

REDLINING, SUBURBANIZATION, AND WHITE FLIGHT

The federal government of the United States has been anti-urban from the start, fearing the city with its messiness and diversity, its openness to social liberalism, sexual freedom, racial mixing, and alien ideas. In the 1930s, President Franklin Roosevelt's New Deal, even in its progressive agenda, built upon the RPA plan to decentralize America's dense, diverse, activist cities. With the National Housing Act of 1934, over time, it would help achieve the goal set forth by Cubberley—and others like him—by breaking up urban immigrant enclaves and converting ethnics into full-fledged whites assimilated into Anglo-Saxon righteousness.

The National Housing Act led to the Federal Housing Administration (FHA) and the Home Owners' Loan Corporation (HOLC).

They created residential security maps of cities across the country, color-coding each neighborhood according to investment risk. First-grade neighborhoods were homogeneous, filled with "American business and professional men," that is, white Anglo-Saxon Protestants. As Kenneth Jackson points out in *Crabgrass Frontier,* his analysis of suburbanization in America, Jewish neighborhoods and those with an "infiltration of Jews," in the words of HOLC assessors, did not qualify as American. The same went for Italian neighborhoods. But the least desirable streets were those occupied by blacks. As more African-American families migrated from the South to the city, assessors rated their neighborhoods as fourth grade, for "hazardous," and colored them red on the maps. This practice became infamously known as *redlining.*

On the HOLC maps from 1938, redlined areas include large chunks of the South Bronx and almost all of north Brooklyn, along with the Lower East Side, Chelsea, Hell's Kitchen, and Harlem, all neighborhoods occupied by blacks, along with poor and working-class Jews, Italians, Irish Catholics, and other "temporary Negroes" from Europe. Without the possibility of loan guarantees, the people in these areas could not invest in housing or small businesses, and their neighborhoods suffered. (Today it is striking, and surely no coincidence, to see those same redlined neighborhoods highlighted once again, this time on maps illustrating the most rapidly gentrifying parts of town.)

While the FHA was strangling neighborhoods with redlining, it encouraged working- and middle-class whites and ethnics to abandon the city, dangling the lure of low-interest loans impossible to refuse on single-home construction in new suburbs. The loans were not offered to blacks, who had little choice but to stay behind in neighborhoods fracturing under the pressure of anti-urban federal policy. "For perhaps the first time," writes Kenneth Jackson, "the federal government embraced the discriminatory attitudes of the marketplace. Previously, prejudices were personalized and individualized; FHA

exhorted segregation and enshrined it as public policy." The FHA's *Underwriting Manual* stated its racism openly: "Desirable neighborhood character" must be protected from "adverse influences," such as "the ingress of undesirable racial or nationality groups." Both race and class mixing would result in a "lower grade" neighborhood. "If a neighborhood is to retain stability," reads the manual, "it is necessary the properties shall continue to be occupied by the same social and racial classes." Diversity was not an FHA value. (It wasn't a suburban one, either, as many new developments, like Long Island's famous Levittown, included whites-only covenants.) But homeownership was an FHA value, and it proved to be a powerful tool for getting urban ethnics to literally buy into suburban American whiteness and its privileges. Tragically, the "price of the white ticket," as James Baldwin put it, would be alienation, the forsaking of cultural and communal ties.

Redlining would officially continue for at least three decades, until the U.S. Commission on Civil Rights called the suburbs a "white noose" around America's cities, and Presidents Kennedy and Johnson took action to legislate fair housing. During those decades, parts of the city were left to wither. Where there had been increasing ethnic and economic diversity, there would be slums. Where there had been a thriving working class of color, there would be poverty. Where there had been strong social bonds, there would be disconnection and dysfunction. And still the planners refused to admit it was all a plan.

In 1939, making his "Case for Fringe Locations," senior FHA official Seward Mott announced, "Decentralization is taking place. It is not a policy, it is a reality—and it is as impossible for us to change this trend as it is to change the desire of birds to migrate to a more suitable location." Again and again, we will hear the same insistence that this kind of urban change is natural and inevitable. But these are lies. As author Ta-Nehisi Coates has remarked, "white flight was a triumph of social engineering."

URBAN RENEWAL, SLUM CLEARANCE, AND BLOCKBUSTING

In his 1932 critique of the Regional Plan, Lewis Mumford presciently noted that what the RPA had prepared was an elaborate scheme "to lead the population farther and farther out into the suburbs, without bothering to ask what will become of the wasted districts that remain." But maybe they did ask. Maybe they knew. Even the new highways and bridges that led whites and ethnics out of the city to the suburbs were conceived by the RPA. As Robert Fitch explained, in the years to come, Robert Moses "simply poured the concrete on the dotted lines."

The powerful urban planner who shaped the city through the middle of the twentieth century, Moses possessed a deep disdain for the "common people," especially the poor and people of color. To Moses, they were dirty and lazy, in need of restriction and control. In *The Power Broker,* the definitive biography of Moses, by Robert Caro, we find many examples of his contempt for the poor of New York. In low-rent neighborhoods, he refused to develop even the smallest green spaces, and tried to segregate public pools by keeping the water unheated, believing that black people were repelled by cold water. Years later, in 2016, Caro told the blog Gothamist that Moses was "the most racist human being I had ever really encountered," recalling when he complained, "They expect me to build playgrounds for that scum floating up from Puerto Rico." But denying parks, pools, and playgrounds would not be punishment enough for the people Moses considered scum. He would destroy their homes, businesses, and social safety nets, all with help from the federal government under the flag of "urban renewal," a euphemism for racial cleansing, what James Baldwin called "Negro removal."

As it's written in the U.S. Constitution, the right of eminent domain gives governments the power to take private property for "public use" with "just compensation." This changed with the Housing

Act of 1949, which was meant, in the words of President Truman, to "equip the Federal Government, for the first time, with effective means for aiding cities in the vital task of clearing slums and rebuilding blighted areas." Again we see the federal government's distaste for the messiness of city life. Eminent domain was quietly expanded so private property could be designated as blight, seized (with some compensation), and handed to private individuals for profit-making developments. Urban renewal was a nationwide catastrophe for cities. In New York, Moses had a field day. For nearly two decades he flattened neighborhoods where the vast majority of people were working-class and nonwhite.

Some New Yorkers were evicted multiple times, forcibly moved from one building to another, the wrecking ball following close behind. Many were placed into grim public housing projects, but even that number was "pathetically small," as Caro noted. Many case files on the displaced were marked "Disappeared—whereabouts unknown." Where had the missing families gone? Not into the shiny new buildings that rose on their old neighborhoods. Those were for the white middle class. Uprooted and traumatized, the displaced moved into overcrowded ghettos like Harlem and the South Bronx, where they crammed into smaller spaces, separated from extended family, friends, churches, and other ties that keep a community connected and functioning.

On the working-class, multiethnic Upper West Side alone, Moses bulldozed two stable communities of color. One, along West 98th and 99th Streets, he destroyed as a gift to the builders of a market-rate development called Manhattantown (now Park West Village). At a reunion in 2011, a former resident told the *Times*, "It was a great neighborhood to live in. I remember playing jacks, eating Icees, playing stickball and dodge ball, jumping double Dutch and when it got really hot out they would open up the fire hydrants." Said another, "It wasn't a slum; why tear it down?" The other neighborhood was San Juan Hill, destroyed to make way for Lincoln Center. An African-

American and Latino working-class community, San Juan Hill was full of theaters, dance halls, and jazz clubs. In the early 1900s, it was the center of black cultural life in Manhattan, where James P. Johnson wrote the song "The Charleston," inspired by southern black dock-workers on the Hudson River. Still, it was branded as "blight." While they fought the city in court, 7,000 families and 800 small businesses were removed and scattered.

As Moses demolished their homes, displaced blacks and Latinos moved outward, pressing the color line farther into the outer bor-oughs, where the white ethnic working class had settled. Already steeped in racial anxieties, class tensions, and territorialities, if those mostly Italian, Irish, and Jewish New Yorkers needed more incentive to run for the suburbs, they got it with blockbusting.

Starting in the 1950s, largely in parts of Brooklyn like Crown Heights, Bushwick, and East New York, real estate speculators known as "blockbusters" exploited racist public policy and working-class worries by fanning the flames of fear. Into mailboxes they stuffed flyers urging white residents to sell their homes fast—at low prices and for all cash—because "the Negroes are coming!" They paid black "welfare mothers" to walk around with children in tow, and hired black men to stage fights in the streets. Terrified white New Yorkers, after decades in their communities, sold their beloved homes at a loss and fled to the new suburbs or the outermost fringes of the boroughs. The blockbusters then sold their houses to people of color at an ob-scene profit. Because the banks would still not lend to blacks, the predatory blockbusters offered secondary financing at huge mark-ups. Struggling to pay impossibly high premiums, black homeown-ers took in multiple boarders, overcrowding the houses. Unable to keep up with the costs of maintenance, their properties deteriorated. Mothers were forced to work. Fathers took on second jobs. Families became stressed. Social dysfunction increased. White neighbors saw only what showed on the surface—overcrowded, neglected houses

full of troubled black families that would, thanks to racist policy, bring down property values. More whites fled, abandoning Crown Heights, Bushwick, East New York, helping to create the slums that would later be "reclaimed" by more affluent whites during the gentrification of the future.

By the middle of the twentieth century, the picture of the city looked bleak. And yet the tenacious soul of New York thrived. Jazz clubs sprang up across the Village, where Billie Holiday sang "Strange Fruit" at the lefty Café Society in Sheridan Square and beatniks snapped their fingers to poetry, Allen Ginsberg howling his incendiary lines. On the Lower East Side, Christian anarchist Dorothy Day published the *Catholic Worker,* gave shelter to the homeless, and fought for social justice. Hundreds of thousands of Puerto Ricans migrated to the city, adding more culture to the mix and launching the Nuyorican Movement of poetry, music, and art. In Harlem, African Americans invented new ways of moving to new rhythms, jitterbugging at the Savoy and shifting swing into bebop at Minton's, all while fighting to work and live with equality. On 42nd Street, you could score drugs and sex, see a freak show, and buy a dirty book. A million songs came out of Tin Pan Alley. A million books were printed by the great publishers. Battleships boomed out of Brooklyn's berths. Despite the Elites' efforts to deindustrialize the city, the working class remained central to urban life. The fight for New York's soul was not over yet.

By 1960, nearly 2 million white New Yorkers had left town, many of them working-class, a Democratic group long credited as progressive, the salt of New York's agitated earth. That was about to change as the powder keg packed by redlining and urban renewal finally detonated. "What happens to a dream deferred," asked Langston Hughes in his poem "Harlem." "Does it dry up like a raisin in the sun?" Does it fester and stink, or sag "like a heavy load"? There is another possibility. A dream deferred, given time, will *explode.*

WHITE BACKLASH

The city was rezoned in 1961, further reducing the land for industry, still following those old maps drawn forty years earlier in the First Regional Plan. The Committee for Modern Rezoning, a group of real estate developers and execs, "narrowed the ring on manufacturing all over the city," wrote Robert Fitch, despite hundreds of protest letters sent to Mayor Robert F. Wagner from local manufacturers. At the same time, while manufacturing jobs were being destroyed, a powerful political shift was under way in America, and we cannot fully understand what is happening to cities in the twenty-first century without understanding that shift.

In the summer of 1964, President Johnson signed the Civil Rights Act into law, making segregation illegal and outlawing discrimination on the basis of race, color, religion, sex, or national origin. During the election that year, Republican challenger Barry Goldwater gave voice to an ascendant conservative movement opposed to such "big government" interventions. Segregation, he said, was the business of the states, and the president had no right to interfere. Johnson won the election in a landslide, but a new GOP was born—conservative, anti-government, pro-business, and invested in institutional racism. In a short amount of time, it would co-opt the working class and alter the course of socially liberal cities across the nation.

In *Chain Reaction*, Thomas and Mary Edsall paint a vivid picture of how conservative Republicans, beginning in 1964, used anxieties about race and taxes to turn the white working class against poor people of color and the social-democratic New Deal, simultaneously realigning their sympathies with big business and the wealthy elite—a tragedy that the nation still suffers from today. Adding gasoline to the fire, northern cities became acquainted for the first time with black rage, the explosion of a dream deferred. The peaceful civil rights movement became forceful. Race riots, many inflamed by po-

lice brutality, broke out in urban ghettos at the same time that violent crimes increased. As more frightened whites defected from cities, they also defected from the Democratic Party, withdrawing support for racial equality. Between June and September of 1966, bookends of one violent summer in the cities, white liberal support of civil rights dropped nearly by half. So began *backlash*.

In *The Ethnic Myth*, Stephen Steinberg points to the class-anxiety underpinnings of backlash. "At bottom," he writes, "the so-called ethnic backlash is a conflict between the racial have-nots and the ethnics who have a little and are afraid of losing even that." Race and ethnic conflict, he argues, becomes minimal to nonexistent "where there is social, economic, and political parity." But such parity would require a redistribution of wealth and power, exactly what the Elites didn't want. Once again, inciting racial conflict was their go-to method of maintaining control of the lower classes—and expanding their own wealth. As President Johnson said, "If you can convince the lowest white man he's better than the best colored man, he won't notice you're picking his pocket. Hell, give him somebody to look down on, and he'll empty his pockets for you."

Alabama governor George Wallace, further manipulating white working-class fear and resentment, introduced the spurious concept of "reverse discrimination" while recasting the left as the true power elite, a bunch of college-educated dictators who looked down their noses at workers. Many on the left complied with this characterization and *liberal* became a dirty word. Even while the white working class was doing better than ever, they now saw themselves as victims of a left-wing "establishment," as Joshua Freeman explains in *Working-Class New York*. They took on a tone of grievance, in which bootstrapping became a constant lament.

"Wherever there are large groups of white citizens of immigrant extraction," noted the *Times* in 1964, "one argument against the civil rights movement . . . recurs incessantly: 'Nobody helped us.'" In other words: we pulled ourselves up by our bootstraps and so should

they. In this complaint, which we still hear today, white ethnics forget or deny the reality that, while many European immigrants came in poverty, they came with something, and whatever pressures drove them to America, they did not come in chains. Centuries of black enslavement followed by segregation and institutionalized racism are disavowed—along with their connection to psychosocial consequences.

When public health psychiatrist Mindy Thompson Fullilove talks about root shock, she describes a complex traumatic stress reaction to urban renewal. The displacement of a physical and emotional ecosystem, she writes, "destabilizes relationships, destroys social, emotional, and financial resources, and increases the risk for every stress-related disease." Robert Moses's meat axe had torn apart the urban ecosystems that provided stabilizing social structures for people who could not flee to the suburbs. Fullilove concludes that urban renewal disabled black communities and led to "great epidemics of drug addiction, the collapse of the black family, and the rise in incarceration of black men," the very catastrophes that emerged in 1960s New York and contributed to backlash.

Those angry, frightened ethnic whites, while they had more options than people of color, were also traumatized by urban renewal. They lost their ecosystems, too. Their roots were also shocked. When they "exchanged wonderful urban neighborhoods for cars, malls, and lawns" in the alienated suburbs, writes Fullilove, "they abandoned not just the city but also the togetherness and sociability of their heritage." The emotional fallout of urban renewal was rage, for black and white, a painful loss still not grieved.

Reporting on white working-class New York's rage and loss in 1969, Pete Hamill wrote, "It is very difficult to explain to these people that more than 600,000 of those on welfare are women and children; that one reason the black family is in trouble is because outfits like the Iron Workers Union have practically excluded blacks through

most of their history; that a hell of a lot more of their tax dollars go to Vietnam or the planning for future wars than to Harlem or Bed-Stuy; that the effort of the past four or five years was an effort forced by bloody events, and that they are paying taxes to relieve some forms of poverty because of more than 100 years of neglect on top of 300 years of slavery. The working-class white man has no more patience for explanations." Hamill foresaw an explosion of white violence. It would not take long.

On May 8, 1970, gangs of white construction workers stormed Manhattan's Financial District—not to attack the fat-cat Elites who had engineered their trauma and loss, but to bust up a peaceful anti-war demonstration. They came from multiple directions, hundreds climbing down from the World Trade Center, then under construction. Wall Street office workers in suits and ties joined their forces. Together, the hard hats and suits formed a violent mob, attacking demonstrators and bystanders. The construction workers beat students with wrenches and tried busting down the doors of City Hall to get Mayor John Lindsay, the "limousine liberal" and "Red Mayor" they believed was giving all their tax money to demonized blacks. For the next two weeks, in what became known as the Hard Hat Riots, tens of thousands of Nixon's "silent majority" mobbed downtown. Laborers and Wall Streeters marched together, targeting young men with long hair, chanting "Kill the commie bastards" and carrying signs that read "Don't worry, they don't draft faggots." If there had ever been even a tenuous bond between the city's workers, socialists, and queers, it was now clearly broken. Brawling against progressive liberalism side by side, the working class entered the 1970s joined to the financial elite in a violent and vengeful covenant. Their backlash would change the city, giving rise to Mayors Ed Koch and Rudy Giuliani, both sons of the ethnic working class who would guide New York in a whole new direction. But first the city would burn.

WAR ON CITIES

"Goddamn New York," President Richard Nixon complained into the secret White House tapes of 1972. He looked to the chaotic city and saw a town filled with "Jews and Catholics and blacks and Puerto Ricans." He conjured Social Darwinism, making the argument that there is "a law of the jungle where some things don't survive," concluding, "Maybe New York shouldn't survive. Maybe it should go through a cycle of destruction."

As New York entered the 1970s, the Elites had not yet succeeded in taking the city back. Cranky ethnics and cantankerous lefties, rejecting suburbanization, would not give up. Homosexuals had started demanding human rights. But worst of all, for the Elites, were the blacks and Puerto Ricans. They had been segregated into slums and housing projects where poverty provides constant trauma, and still they would not leave. New York had too many flies in the ointment. The power brokers needed a new, multipronged plan of attack.

First, Nixon invented the War on Drugs. "The Nixon campaign in 1968, and the Nixon White House after that, had two enemies: the antiwar left and black people," John Ehrlichman, former chief of domestic affairs, told journalist Dan Baum in 1994. "We knew we couldn't make it illegal to be either against the war or black, but by getting the public to associate the hippies with marijuana and blacks with heroin, and then criminalizing both heavily, we could disrupt those communities. We could arrest their leaders, raid their homes, break up their meetings, and vilify them night after night on the evening news. Did we know we were lying about the drugs? Of course we did." The strategy worked to further poison the hearts and minds of America against the city, and to target urban spaces for policing.

In a 1970 memo to Nixon on the state of the American Negro, advisor Daniel Patrick Moynihan suggested "the issue of race could benefit from a period of 'benign neglect.'" In other words: do nothing. In the memo's section on "Social Pathology," he predicted that,

due to "the types of personalities that slums produce," American cities like New York would soon be facing a "genuinely serious fire problem." He blamed the problem on arson, fires set by what he called antisocial blacks. This idea came from the RAND Corporation. (When Eisenhower warned America about the military-industrial complex, he might have been talking about RAND, the Cold War think tank that guided U.S. policy in Vietnam and created "rational choice theory," the belief that humans are essentially individualistic and selfish, a key underpinning of the new ideology to come.) In partnership with RAND, the city created the Fire Project. Its goal was to save money by cutting back on fire services, and those cutbacks were made in poor black and Latino neighborhoods. The city let its most vulnerable people burn. Once again, it wasn't natural. It was policy.

All the details of this chapter in the city's history are revealed in Joe Flood's book *The Fires* and Deborah and Rodrick Wallace's *A Plague on Your Houses*. As the Wallaces note, Moynihan based the statements in his memo on RAND's conclusions—and those conclusions were false. The city closed firehouses, stopped fixing alarm call boxes and hydrants, and lengthened response times in poor minority neighborhoods. While Moynihan later defended and clarified his statements, "benign neglect" was taken as another way of saying *laissez-faire*, let nature run its course. But neglect is a plan of action. The burning of New York's low-income apartment buildings was just as racist and classist as deindustrialization, redlining, and urban renewal.

The Elites have always hated the tenement buildings of the city, where so much outsider culture was fostered. Robert Moses scorned the idea that the tenements built to house the poor and working class could have provided anything of value. "Social scientists," he scoffed in a 1956 speech, might argue "that since the slums have bred so many remarkable people, and even geniuses, there must be something very stimulating in being brought up in them." But such notions, he continued, make the "slum sound romantic." All Moses saw in the low brick buildings was "urban disease and decay." New York's

tenements, which he called "irredeemable rookeries," had to be erad-
icated.

In the 1970s, from the South Bronx and Harlem, to central Brook-
lyn and the Lower East Side, the night skies turned bright with tene-
ment flames. Politicians and journalists blamed it all on arson, but
"arson was never the major cause of fire damage in New York," says
Joe Flood in *The Fires,* and most incidents of arson—which peaked
in the late 1970s at less than 7 percent of all fires—occurred in build-
ings already abandoned or burned out by conventional fires. By and
large, the fires that destroyed homes and killed New Yorkers were
accidental, allowed to burn by City Hall. And for what? Flood notes
that several firefighters at the time believed the service cuts were part
of "a conspiracy to chase the blacks and Puerto Ricans from the city,
some kind of convoluted real estate grab." Flood also recounts a later
conversation between a firefighter and a high-ranking mayoral aide.
They were discussing how the city had encouraged the fires through
budgetary cuts. "Well, you can always look on the bright side," said
the aide. "The city got rid of a million and a half undesirables."

As the city burned, it was also declining into bankruptcy. The
Elites painted the poor as a waste of resources and humanity, blam-
ing them for socially liberal New York's financial failure, though
much was due to the reduced tax base thanks to white flight and
deindustrialization. Poor neighborhoods were deemed a cancer in
the urban system, and fire was the unspoken chemotherapy. But the
people kept hanging on. That's when men like Roger Starr and Felix
Rohatyn stepped in with their own ideas for what to do with the
city's ravaged neighborhoods.

Serving as housing and development administrator under Mayor
Abraham Beame, Roger Starr championed a scheme he called "planned
shrinkage." He had been pushing the urban starvation strategy for
about a decade, presenting it to real estate groups and in trade pub-
lications, but his ideas didn't come to wider public attention until a
1976 *New York Times* report. The *Times* explained planned shrinkage

as a scheme to withdraw city services from poor nonwhite neighbor-hoods to "induce" the people to leave. Which people exactly? Just prior to the *Times* report, Starr had outlined his plans to *Real Estate Weekly*. While no archives survive of the magazine from that time, Robert Fitch quotes Starr as saying: "Stop the Puerto Ricans and the rural blacks from living in the city . . . reverse the role of the city. . . . It can no longer be the place of opportunity. . . . Our urban system is based on the theory of taking the peasant and turning him into an industrial worker. Now there are no industrial jobs. Why not keep him a peasant?"

Like Nixon, Starr believed that New York, in its concrete jungle heart of darkness, should be allowed to die by letting "nature" take its course. After you shrink financial support for schools, hospitals, housing, maintenance, subways, and fire services, the poor would go elsewhere, leaving all that land for clear-cutting and redevelopment. Supporters of Starr's plan, reported the *Times*, "argued that the large empty stretches in the South Bronx and Brownsville offered excel-lent opportunities for the development of 'new towns.'" And what's more seductive to a real estate developer and his banker friends than a freshly bulldozed plot of cheap land? Just weeks after the *Times* re-port, investment banker Felix Rohatyn shared his thoughts on what to do with the burned-out Bronx. As chairman of the Municipal As-sistance Corporation (MAC), the organization brought in to bail out the bankrupt city, Rohatyn had advised City Hall to enact austerity measures. That belt-tightening, he suggested, could be accompanied by blacktopping. He told the *Times*, "Take a 30-block area, clear it, blacktop it, and develop an industrial park with the whole package of tax, employment, financing incentives already in place."

Congressmen Herman Badillo and Charles Rangel protested Ro-hatyn's comment. Said Badillo to the *Times*, "I would hate to think that he was using the subterfuge of economic development to imple-ment Mr. Starr's inhuman proposals for New York." Rangel added, "It amounts to an attempt to deport blacks and Puerto Ricans from

the regions that are vital to the commerce and transportation of our city." Too far-fetched? Robert Fitch recalls an interview in the mid-1970s with a public relations official from Rohatyn's MAC. When Fitch asked him what was causing New York's fiscal problems, the PR guy replied, "It's the fucking blacks and Puerto Ricans. They use too many city services and they don't pay any taxes. New York's in trouble because it's got too many fucking blacks and Puerto Ricans."

It's clear that Starr was not the only man in power to support planned shrinkage, but he was its spokesperson. Members of the City Council's black and Puerto Rican Legislative Caucus demanded his resignation and called his plan "genocidal, racist, inhuman, and irresponsible," as well as "ugly" and "vicious." Mayor Beame distanced himself and Starr resigned. But he did not go away. He went on to teach at NYU, where he was awarded the chair of Henry Luce Professor of Urban Values. He joined the editorial board of the *Times*, where he continued to shape the city's public policy on housing and economic development. In a multipage defense of planned shrinkage he insisted that the city clear entire tax districts of their people, namely in the South Bronx. "Better a thriving city of five million," he concluded, "than a Calcutta of seven." When Starr's book, *The Rise and Fall of New York City*, was published in 1985, *New York* magazine called it full of "puritanical vindictiveness," spiked with attacks on people of color, the poor, liberals, feminists, artists, homosexuals, and those who engage in "unconventional behavior." In one form or another, the Puritans were still with us.

Through it all, the unconventional soul of the city refused to die. It rooted to the rubble and thrived in the ashes. As parts of town turned into bombed-out war zones where stray dogs strolled and junkies shot smack, the counterculture blossomed. In the Village, street kids and transgender New Yorkers of color threw bricks and bottles at the Stonewall uprising, launching queer liberation. From the gang wars of the South Bronx came the birth of hip-hop and the art of graffiti. New York's tenements continued to breed remarkable

people and geniuses. In old redlined neighborhoods like the Lower East Side, in buildings abandoned by white-flighters, cheap rent attracted outcasts from the alienated suburbs and urban fringes of America. Living in squalor, they created and contributed to new music, writing, and art, feminism, and radical ideas that strained against the boundaries and rejected conformity.

The city was dirty. And dirt is fertile.

As the Elites prepared their next move, laying the groundwork for a new city, with a new psyche, all wrapped in a glossy sheen, there was probably no place more dirty and more fertile than the Bowery.

THE BOWERY

CBGB shuttered and covered in goodbye graffiti. *David EJ Berry, 2006*

WITH GREAT FANFARE, ON AN APRIL NIGHT IN 2008, MENS-wear designer John Varvatos, the inventor of the boxer brief, opened his high-end fashion boutique on the Bowery. The arrival of such a big-name luxury brand to New York's infamous skid row would have been disconcerting by itself, but what made it sacrilegious for many was Varvatos's bold choice of location. He had moved right in to the hallowed space that had been CBGB.

Two years earlier, after more than three decades of birthing and incubating legends of punk rock and new wave, from the Ramones to Blondie and Talking Heads, legendary club CBGB had shut its doors.

Owner Hilly Kristal had lost his fight against the landlord, Bowery Residents' Committee (BRC), a multimillion-dollar organization that serves the homeless. BRC's new director, Muzzy Rosenblatt, wanted to collect CBGB's debt, accrued over years of rent increases that Kristal claimed BRC never billed. Rosenblatt also wanted to double the rent from about $20,000 to $40,000 per month—though Kristal and others speculated that he wanted CBGB out entirely, so he could charge a new high-end tenant as much as $65,000. "I would love to preserve history," Rosenblatt told the *Villager*. "I have my own fond memories and sentimental moments at CBGB. But we all have responsibilities in life."

Fans and celebrities signed petitions, donated money, held a concert in Washington Square Park, and wore "Save CBGB" T-shirts. But the landlord reportedly declined further negotiations. Officially ousted, Kristal had plans to reopen CBGB in Las Vegas, but he never got the chance. He died just ten months after the doors closed, after Patti Smith sang the last song, and a real estate brokerage (representing "Rebel Rebel Realty") strapped a for-rent banner to the skinned metal ribs of the famous awning, its cloth stripped away and shipped to the Rock and Roll Hall of Fame in Cleveland. When news of Kristal's death spread, a spontaneous memorial appeared at the club's shuttered doorstep, with flowers, candles, and notes scrawled on the metal gate. "R.I.P. Hilly We'll Miss You," they said. "Bowery will never be the same."

Just three months after Kristal's death, and just one year, almost to the day, after CBGB's final night, John Varvatos announced he was moving into the club's space. His press release declared, "Varvatos Rocks the East Village," insisting that the boutique, with its rock-and-roll theme, was the ideal business for the sacred space of noise, scum, and rebel youth. With his "real reverence for the history of the space," explained the marketing materials, Varvatos would preserve CBGB, curating a cleaned-up version by securing a portion of its graffitied walls behind Plexiglas and selling pricey vintage records along-

side the fashions. He made the most of the new Bowery as a brand for luxury grit, developing a line of high-priced Bowery everything—Bowery Boots, Bowery Jeans, Bowery Sunglasses. He sold used rock T-shirts, too, the kind you find at church basement thrift shops for a buck apiece. Only these were vintage. That old Ozzy Osbourne T-shirt you throw on to clean your bathroom? It went for $350 at Varvatos on the Bowery.

On the night of the boutique's opening bash, I loitered outside like a gawker at a car wreck. The event, co-sponsored by Red Bull energy beverages, served as a combination press event, rock concert, and fund-raiser for VH1's "Save the Music" foundation. I watched in disbelief while a crowd of fashionistas and middle-aged ex-rockers made their way through the velvet ropes, checking in with clipboard girls dressed in black T-shirts that read: "Varvatos 315 Bowery . . . Birthplace of Punk," a safety pin piercing the letter *u*. What would the real punks have done with this, the ones who, night after night, crowded this same sidewalk, drunk and high, pissing on the concrete? They were hard-core in their armor of chains and spikes, kicking at life with steel-toe boots and adolescent angst. I was trying to imagine them there when I noticed Varvatos standing on the sidewalk. He was giving an interview to documentary filmmaker Ernie Fritz. In a stylish black blazer and T-shirt, with a day's growth of stubble on his face and a shaved head, he looked like someone's cool dad, standing with thumbs hooked into the pockets of his jeans. From one belt loop hung a silver wallet chain, glinting extra-coolness.

I got close enough to hear him talk about preserving the Bowery's history and saving the legacy of rock and roll from Starbucks and banks. That was the spin we heard endlessly that spring. Under the *New York* magazine headline "Varvatos Saved the Bowery from a Bank," the designer proclaimed, "I was in the space for no more than 15 seconds and said, 'You're not going to put a bank in here.'" He told MTV that CBGB "won't become a bank or a Starbucks." It quickly became a meme. In the *Times,* D Generation's Jesse Malin echoed, "I'd

rather see this than a Dunkin' Donuts or a Starbucks." And Blondie's
Clem Burke said, "It's better than if it was a Starbucks or a bank."

It was a tantalizing argument. Surely, preserving a bit of the old
punk club was better than watching it vanish completely into Frap-
puccino froth, even if it meant letting its soul get gobbled up and
stamped with a luxury brand. Or was it? And were those the only
two options? Not everyone agreed. I hung around that night to see
what would happen when activists Rebecca Moore and Reverend
Billy showed up. In the press, they had promised to bring signs with
slogans aimed at fighting "intense gentrification" and the "co-opting
of culture to sell overpriced luxury goods."

The pair soon arrived with a small group of protesters, armed
with signs that read "$800 Pants Kill Music in NYC," "One Small Loss
of a Music Space, One Giant Leap for Pants," and another meant to be
sung to the tune of the Ramones' "I Want to Be Sedated" that went,
"40-40-40,000 Dollars a Month, We're Gonna Be Evicted!" When I
asked Reverend Billy what brought him to the protest, he told me,
"I'm dismayed by the blasphemy of CBGB's being overtaken by what
looks like Soho. Are we gonna get Soho'd all the way to Alphabet
City? Where do we draw the line?"

At first, the protesters went largely ignored as they waved their
slogans at the crowd of jaded publicists, bygone celebrities, and former
punks. Sid Vicious, in a larger-than-life-sized Bob Gruen photograph,
growled over the shoulders of oblivious girls deep in communion
with their iPhones. Passersby muttered, "The Lower East Side is dead
anyway" and "It could be worse. It could have been a bank or a Star-
bucks." I considered heading home. Then the fight started.

Arturo Vega, the Ramones' artistic director, was telling Ernie
Fritz's movie camera about how Varvatos was good for the Bowery.
"It's natural," he said, loud enough for the protesters to hear. "Every-
thing dies and transforms. The excitement is still here. The tourists
will come. In there," he added, pointing to the boutique, "you're
closer than ever to rock 'n' roll." The protesters responded by turning

up their volume, drowning out Vega with the chant: "Down with eight-hundred-dollar pants! Down with eight-hundred-dollar pants!" Vega strode up to Rebecca Moore and shouted, "John is a nice guy! This store is the best thing that could happen to the CB's space. What would have been better, a fucking bank? A fucking Starbucks?"

Moore shouted back, "This is a whitewash!" Her group chanted, "Who cares if John's a nice guy! Who cares if John's a nice guy!"

Vega shook his head and walked away. Then Bobby Steele of the Misfits, in biker jacket and spiked hair, pushed into the protesters like he was thrusting into a mosh pit. Nose to nose, he and Moore shouted back and forth, with Steele fiercely defending Varvatos. One of the bewildered protesters said, "You're *punk*, man! Whose side are you on?" Steele responded, "I am on the side of New York City fucking rock 'n' roll!" Then he hocked up a big, fat, punk-rock loogie and spat it onto the "Luxury Up Yours" sign in the protester's hands. Overhead, in the BRC shelter, a weary homeless man leaned from the window and shouted, "Why don't you all shut up? We're sleeping here!"

This was the Bowery in 2008, a rapidly luxurifying skid row where middle-aged punks defended a multimillionaire fashion designer against a bunch of angry activists, and the bums complained about the noise. The world had turned upside down. A few blocks south, the *Village Voice* named the problem with a tall billboard that read: "Welcome to McHattan." If the city's most infamous cesspool of a street, along with its toughest artists, could be appropriated by the corporations, none of Manhattan was safe. That night, with the opening of Varvatos and the hocking of a loogie, it felt like a hundred years of rebel history had come crashing to a dazed and confusing end.

Since the late 1800s the Bowery had been the sleazy territory of outsiders—punks, artists, bums, queers, and dropouts, drag queens, tattoo artists, and con men. The street had already slid into vaudeville and vice when the elevated train tracks were erected in

1878, but the overhead El further plunged the district into darkness, and all that flowers in shadow was attracted to it. By the 1890s, the Bowery was filled with murderers, prostitutes, dance halls, and dives. Homosexuals and "androgynes" socialized openly, illegally crossing gender boundaries with rouge, powder, and campy wit. In the early years of the 1900s, more than twenty-five thousand homeless men lived on the Bowery, and by the 1930s it was officially where you went to hit the skids, an experience vividly chronicled in Lionel Rogosin's 1956 film, *On the Bowery*, the story of a transient railroad worker who mingles with the street's drunks and thieves. The movie was made just a year after the El was torn down, exposing the Bowery to sunlight for the first time in more than a generation.

Liberated from shadow, at a time when Greenwich Village was getting pricier, the Bowery appealed to artists, including Sol LeWitt and Mark Rothko, who found homes and studios there in the 1950s. At the northern end, in Cooper Square, the Five Spot jazz café opened in 1956, attracting abstract expressionists like Willem de Kooning and Franz Kline, along with Beat and New York School poets like Allen Ginsberg and Frank O'Hara, who beautifully recalled seeing Billie Holiday sing on its stage in his poem "The Day Lady Died."

In the 1960s, more artists migrated from the East Village, where rents were also rising. The *Times* set the scene in a 1965 article titled "The Bowery: Arty and Avant-Garde," a report on a cocktail party that featured a reading by William Burroughs in a former YMCA building that had become artists' studios. "A vision of Montparnasse replacing Skid Row glimmered Thursday night," wrote Harry Gilroy, describing the party's population of painters (Andy Warhol, Larry Rivers), photographers (Diane Arbus), poets (Frank O'Hara, Ted Berrigan), and eccentric characters (Beverly Grant, "queen of the underground movies"). As the party ended and the crowd headed out to the street, "The normal residents of the Bowery," that is, the bums, "looked as if they had been staring into the dream machine." Still, the neighborhood did not crumble under the bulldozers of gentrification.

Throughout the 1970s and '80s, the Bowery maintained its mix of bohemian and derelict. Robert Mapplethorpe and Jean-Michel Basquiat moved to the area. Punk musicians came, too. The flophouse drunks and madmen remained, joined by junkies and crack addicts. Often, artist and addict intertwined, as many who lived and played on the Bowery suffered from the same afflictions. In 1988, Basquiat was found dead of a heroin overdose in his studio. Mapplethorpe succumbed to AIDS in 1989. Keith Haring followed in 1990. The Bowery had begun emptying out.

As the 1990s got rolling, the area remained a district of artist studios, flophouses, dive bars, soup kitchens, restaurant supply shops, and rows of stores that sold nothing but lamps. For more than a century, this tough part of town with a bohemian edge had embraced whoever flopped upon it, providing space for the lowest of the low, as well as the up-and-coming. But that was all about to change.

When nightclub developers Eric Goode and Serge Becker opened the chic celebrity hangout Bowery Bar on the site of an old gas station in 1994, the locals got restless. The *Times* reported that members of the neighborhood association and community board argued "that the bar, and others they believe would open in its wake, will erode the character of the area by changing it from a haven for light industry and artists into a trendy night spot." *New York* magazine called the scene "an exercise in extreme cultural dissonance, evoking images of Calvin Klein and Linda Evangelista sipping Cristal on the inside as derelicts guzzle Night Train on the outside." The dream machine glimpsed thirty years earlier was becoming a reality, though a distorted one. It wasn't the coming of Montparnasse, the bohemian Left Bank, it was the arrival of superluxe Avenue Montaigne.

Activists and artists fought Bowery Bar, in the courts and on the streets. Right next door, in an old merchant's house turned apartment building, Carl Hultberg waged a one-man battle against the lounge

from a window of the rent-controlled apartment he'd inherited from
his grandfather, jazz historian Rudi Blesh. "In a few short months,"
Hultberg recalled to me via email, "Mr. Goode and Mr. Becker had
transformed our once sleepy Bohemian district into an open sewer of
mainstream American crap culture." He remembers the crowds of
"rich dissolutes" fighting to get inside Bowery Bar, and nights when
off-duty cops wouldn't let him and his neighbors leave their build-
ing because high-profile celebrities like Madonna were arriving. One
night, when the noise outside made it impossible to think, Hultberg
put his electric guitar amp in the window "and blew everyone back
ten to fifteen feet." He hung a large sign in the window that read:
"Cooper Union, how could you do this to our neighborhood?" (It was
the college that owned the property.) He then constructed a more
elaborate sign from a wooden Bolla wine box and a string of blink-
ing Christmas lights. On one side of the box, cut-out letters nightly
flashed the message "Lifestyles of the $ick & $hameless."

In 1995 a group of artists, rumored to be led by bicycle activist
George Bliss (who was also Hultberg's roommate), painted a trail of
footprints to the bar, marked with slogans like "Boycott the Bowery
Bar" and "Don't Party on the Poor." Bliss and other detractors argued
that the bar was operating without a zoning variance, doing business
on land zoned for light manufacturing, an environment conducive to
making art. In the *Times*, Eric Goode responded, "We're manufactur-
ing. We're manufacturing hamburgers."

The fight against Bowery Bar failed—and its most vociferous
critic was displaced. In 2004, Hultberg's building was sold to Mark
Scharfman, a man who'd made *New York Press*'s list of the "50 Most
Loathsome New Yorkers" (the paper called him "The Oil Can Harry
of modern-day New York and its prototypical heartless landlord").
Hultberg told me that Scharfman pressured him and his neighbors to
move, and after a year of fighting, Hultberg's lawyer recommended
he take a buyout and leave the apartment where he'd lived since 1981,
and where his grandfather had lived since 1944. He packed up his pro-

test signs and electric guitar and left the city. Scharfman leased the building, with an option to buy, to Bowery Bar's Goode and Becker. They purchased the multifamily dwelling and transformed it into the ultra-exclusive boutique hotel Lafayette House. Where Hultberg's window once stood in protest, there is now an elegant mahogany door atop a brownstone stoop that looks like it's been there forever. Presumably, no one at the hotel complains about Bowery Bar.

City planners and politicians had been trying to renovate the entire Bowery, starting with Cooper Square at its northernmost end, for decades. After the El came down in the 1950s, Robert Moses announced a redevelopment plan that would demolish eleven blocks of housing and businesses, putting thousands of people out on the street. His slum clearance plan was defeated by the upstart Cooper Square Committee, a community group that came up with its own plans to redevelop the neighborhood while minimizing displacement and providing as much affordable housing as possible. In the early 1990s the committee negotiated and compromised with the city, and a new plan was put in place to use sites around Bowery and Houston for the construction of market-rate condos and rentals. Regrettably, this meant that a monstrous new development was coming—in exchange for community space and a number of affordable units.

One person who opposed this Cooper Square plan was feminist author Kate Millett. She and a handful of other women artists lived in sweeping, inexpensive, and dilapidated loft spaces at 295 Bowery, a brick building with a storied past. In the late 1800s, it was home to a hotel and saloon known as McGurk's Suicide Hall, a name it had earned due to its back room's magnetic attraction to suicidal prostitutes, who regularly ended their lives by chasing mouthfuls of carbolic acid with rotgut whiskey. Millett moved there in 1973. In her memoir, *Mother Millett*, she described how there was nothing inside the place when she first arrived, no heat, no kitchen, no bathroom,

no windows. "I gave it plumbing," she wrote, "rewired it, painted it, sanded the floor, built bookcases and put in fireplaces." She recalled to the *Times*, "When my mother first visited me, she stepped out of the cab, over the bluejeaned hippies and the drunks passed out on the sidewalk and wept." By the late 1990s, most of the drunks were the type that came stumbling out of limousines, and the weeping was for other reasons—Millett's home was scheduled for demolition. She defended it, "trembling and swearing," at meeting after meeting. But in the end, she and her comrades failed to get the historic building landmarked. In the early 2000s, they were evicted and relocated to smaller, less storied locations.

In 2002, the *Times* announced: "Along the Bowery, Skid Row Is on the Skids." "It's a sad sight," wrote the reporter, tongue apparently in cheek, "what with all the designer bags, hipster cocktails and stylish, attractive young people. Look at them: on the corner of Bowery and East Second Street, luxury lofts with 11-foot ceilings and starting prices of $1.295 million. . . . What's going on?" The upscale nightlife scene predicted by Bowery Bar's opponents had arrived. Fusion restaurants were serving coconut martinis and steak tartare! DJs blasted techno from laptop turntables! And supermodel Heidi Klum threw Halloween parties while Louis Vuitton flaunted the latest bags down the runway. The match struck by Bowery Bar in 1994 had met gasoline. In the 2000s, the Bowery went supernova.

In came the art establishment. Not the ragtag artists toiling in coldwater flats, not the outré galleries smearing blood on the walls, but the Establishment. Sleek white walls and snobbish interns at the front desk. As one landlord-artist renting to a new gallery told the *Times*, "Unfortunately, now that the neighborhood is nice enough for galleries, there aren't many artists left." The New Museum of Contemporary Art announced it was leaving Soho to build a $35 million home on the Bowery, right next to the Sunshine Hotel, one of the last flophouses. Next to down-and-out men sleeping in cubicles with chicken wire for ceilings, the towering museum banged its way into

the sky. When it opened in 2007, a starchitectural stack of aluminum boxes wrapped in mesh, Paul Goldberger wrote in *The New Yorker*, "The New Museum may have left SoHo, but it is powerless to prevent SoHo from following it to the Bowery." Its gift shop became momentarily infamous for selling gold pills, gelatin capsules filled with edible gold leaf, three for $275. Designed by Ju$t Another Rich Kid, the pills were described on the New Museum's website: "Pure gold passes straight through the body and ends up in your stool resulting in sparkly shit!" The Bowery's nouveau riche were so riche, they crapped 24 karats.

When Millett's building came down, the Avalons started to climb. Built by AvalonBay Communities, a real estate development company with more than 170 (and counting) cookie-cutter buildings across the country, Avalon Chrystie Place and Avalon Bowery would soon make up a luxury mega-complex, each structure a dull and hulking glass box. With their imposing bulk, the Avalons wiped out great swaths of the rugged Bowery landscape. The first building, Avalon Chrystie Place, came with an extra-large, 75,000-square-foot Whole Foods supermarket. The *Post* reported that the national chain store's "opening was a mob scene, with shoppers clamoring around the in-house Italian and sushi eateries, the fromagerie, the gelato area and the pommes frites station." The *New York Sun* declared it "Not Your Granny's Lower East Side."

On the ruins of Millett's former home came Avalon's Bowery Place, with rents from $2,600 to $8,600, and marketing copy that crowed, "Avalon Bowery Place has arrived, and so have you. It's time to indulge in Manhattan living the way you always dreamt it would be. Set on the famed Bowery, this luxury rental residence puts you in the center of an all-encompassing lifestyle." Up until about thirty seconds earlier, the Bowery was famed for its squalor and sorrow, but the real estate machine has the power to rewrite history and, eventually, to alter collective memory.

When defending 295 Bowery, Millett had said, "If McGurk's is

turned to dust and supplanted with blank high-rise market housing, official power will have buried its past in order to expunge it. Then it will be as if it never happened." She was right. The Avalons were a blank force of erasure. And if the Avalon Chrystie was big, the Avalon Bowery was like a horror-movie Blob that kept on growing. It stretched along Houston Street, turned the corner, and spread all the way down the block of Bowery, turning east on First, where it continued to swell, pressing outward until it reached the tenement that held the infamous and beloved Mars Bar (more on that later). There, Avalon Bowery split, amoeba-style, and heaved forth its spawn, a second building that leaped across First Street and sprawled all the way to Second Avenue, vacant first-floor windows papered with billboard photos of men and women with sweaters tied preppie-style around their necks, hands full of shopping bags, grinning by the tagline: THE BOWERY REDEFINED. In *New York* magazine, architecture critic Justin Davidson wrote: "its aggressive blandness has a way of chipping at the soul."

Open for business by 2007, into this Avalon's ground-floor space went the Bowery Wine Company, the Blue & Cream luxury boutique, and a new French restaurant by uptown celebu-chef Daniel Boulud. Controversially, he called the place DBGB—short for Daniel Boulud Good Burger. Not only did the name copycat the dearly departed punk club that had vanished just one year earlier, just one block away, but Boulud's initial logo design used the club's iconic typeface, its western-style lettering created by Hilly Kristal's ex-wife. What some might call "homage" looks a lot like the appropriation of cool, a tactic used again and again on the Bowery and in other hyper-gentrifying parts of town. In this case, the CBGB estate's lawyer sent Boulud a cease-and-desist letter. He changed the design but kept the name, and went on to sell countless twelve-dollar hot dogs—along with jars of Marky Ramone's "drum-punk" Brooklyn tomato sauce. *The New Yorker* said of the place, "the clientele is more trading pit than

mosh pit," and "dining at DBGB can feel a bit like seeing your dad don a motorcycle jacket."

In came a pair of large luxury hotels—the Bowery Hotel and the Cooper Square Hotel. Developed by Eric Goode of the Bowery Bar, the Bowery Hotel rose seventeen stories, with $450-a-night views that were "positively grand," according to a writer at the *Times,* who added, "So what if you might have to step over a few vestigial bums to get there?" The hotel's doormen wear red waistcoats and black bowler hats, echoing the hotel's logo of a Bowery Boy, a member of the late-nineteenth-century, nativist gangs who went around Five Points beating Catholics and other immigrants. ("Somehow the ho- tel's crack 'historical' department missed, or ignored, this factoid," noted *New York.*) Soon after opening, a couple of the Bowery's ves- tigial bums broke into a knife fight on the hotel's doorstep, sending the doormen, hedge funders, and fashionistas running for cover. But there was no harm done. *New York* reported that the hotel's co-owner "seemed to find it good for the hotel's brand." He told the magazine, "We are trying to offer an Old New York experience."

A little farther up Bowery, developers demolished most of the block between Fifth and Sixth Streets for the $500-a-night Cooper Square Hotel, a twenty-one-story space-age tower made of milky white glass that would soon dominate the low-rise brick tenements that cowered at its feet. One of the tenements that the hotel could not demolish contained the home, since 1962, of Beat Generation poet Hettie Jones, who, along with her neighbor Katy Abel, refused to va- cate. The women's apartments are protected by law, granted artist loft status in the 1980s. Inside the banging and drilling, they stayed put as the hotel swelled around them, invading from every side. To- day the hotel wraps all the way around the tenement, hugging the bricks to its chilly flank as it stretches a glassy pseudopod around the back, pervades the ground floor with its lobby, and spreads its outdoor patio along the southernmost side. At the risk of overusing

the amoeba metaphor, the tenement looks like helpless prey engulfed inside the hotel's food vacuole. Jones used to grow tomatoes on the roof, but the hotel plunged her garden into shadow. She does, reportedly, dry her laundry there, however. The hotelier told the *Times* that it was an asset to have his guests "peer down on a tenement roof where laundry is being hung out to dry. 'That's the kind of thing people want to see,' he said." More of that Old New York experience.

From the beginning, the locals hated the Cooper Square Hotel, viewing it as an arrogant, entitled, fuck-you middle finger to the neighborhood. People protested its liquor license application, fought its guests' loud partying, and with impotent rage, hurled at it a number of insulting nicknames, including the Sore Thumb, the Giant Shampoo Bottle, the Dubai Dildo, and the Dildo of Darkness. But all that righteous anger could not bring the tower down, even when the developers' bank claimed they defaulted on $52 million in loans and filed a lawsuit to foreclose. The hotel was sold to Hollywood, Miami Beach, and Meatpacking District hotelier André Balazs, and renamed the Standard East Village, with a new restaurant aptly called "Narcissa."

Throughout the latter aughts of the 2000s, the old Bowery kept falling. The kitchen supply shops and lamp showrooms went fast. Artist holdouts shivered in otherwise emptied tenements, harassed but hoping to last the winter with no heat, before finally surrendering to their landlords' cheap buyouts. More condo towers, hotels, and high-end galleries went up. The Bouwerie Lane Theater, after more than forty years, sold to a self-storage mogul for $15 million and was converted into a single-family mansion. The Salvation Army Residence Hall, after serving the homeless for over a century, sold to a Parisian hotel group for $7.6 million, with plans for a flashy luxury hotel that the *Observer* called "More Shocking Than a Poodle with a Mohawk." Just two years later the building sold again for $19 million. The Salvation Army was demolished at the end of 2014 to make room for a thirteen-story tower of duplexes, triplexes, and—reportedly—

a car elevator that will bring residents' vehicles right into their condos. The penthouse has been priced at $17 million.

In the span of only five years, at least a dozen oversize, upscale developments had come to the old skid row. All around, the Bowery's little side streets similarly exploded with opulence, starchitect-designed hotels and condos replacing lumber yards and mechanic shops almost overnight. The building where Jean-Michel Basquiat made art and overdosed on heroin became home to a Japanese meat store that sold wagyu beef to the new neighbors at forty to fifty dollars a pound.

As the Bowery became ever richer, the symbols of its profound poverty continued to be appropriated for high style. Two real estate entrepreneurs bought a ninety-year-old single room occupancy (SRO) hotel and converted its upper floors into a swanky boutique hotel called Bowery House, where the decor plays on the flophouse theme with small, stylish rooms that mimic the miserable pens occupied by the destitute. Several homeless men continue to live on the hotel's second floor, in an unrenovated space, while the upstairs guests wrap themselves in Ralph Lauren towels and sleep in high-thread-count sheets. Like the Cooper Square hotelier pointing proudly to Hettie Jones's laundry line, Bowery House's co-owner called the downstairs tenants "an asset to the property." One of them, known as Charlie Peppers, had a guest room named after him. However, reported Dan Barry in the *Times*, "He has not been told by the hotel that a room upstairs is named after him, or that he is considered colorful, or that his cubicle lifestyle is being used as a P.R. come-on." When last we heard, Charlie was busy throwing bottles at the Bowery House's chic neon sign, smashing it to pieces.

A few years later, a few blocks north, a popular "pizza consultant" opened an upscale "pizza speakeasy" next to another flophouse-turned-tourist hotel and brazenly called it "SRO." A press invitation to the restaurant's unveiling promised: "A whimsical evening awaits as you travel back in time to a Bowery of yore, when Single Room Occupancy hotels lined the street."

Throughout the summer of 2008, a group called the Slacktivists fought back against the commodification of the poor, old Bowery. Organized by activist and photojournalist John Penley, a man described by the *Post* as "New York City's cuddliest anarchist," the Slacktivists protested at various sites, irreverently bearing cupcakes, that ubiquitous and despised symbol of gentrification, with chants of "Die Yuppie Scum." They protested Avalon's Bowery Wine Company, where the New York Young Republican Club held its social gatherings. One member of the club told Penley via the *Post*, "We're going to fill his neighborhood whether he likes it or not. We're coming with briefcases and BlackBerrys in hand to stake our claim." At an "Outsiders" art show, in a Bowery restaurant supply shop about to become another upscale pizzeria, Penley stuck dollar bills to the window, each scrawled with slogans like "worthless" and "eat the rich." To a rent-stabilized tenement building evicted and converted into a single-family mansion by real estate tycoon Alistair Economakis, the Slacktivists brought a guillotine and shouts of "Let them eat shit!" They marched on NYU dorms, the Christodora House, and the John Varvatos shop. And after each action, the Slacktivists would retire for drinks at Mars Bar.

Quite possibly the filthiest dive in town, the notorious Mars Bar opened in 1984 on the corner of First Street and Second Avenue, and while it was technically one block east, it was very much an extension of the Bowery, fed nightly by flophouse drunks and after-hours crowds of punks pouring out of nearby CBGB. It was also an art bar, with a revolving gallery hung crookedly on the battered walls, and murals painted on the outside bricks. It was the old Bowery that nurtured Mars, and it was the new Bowery that would destroy it—and then dance on its grave.

I first visited the bar when I was new to the city, introduced to its louche charms by the outlaw poet Jack Micheline (who hated be-

ing called a Beat, a group he saw as sellouts, once telling me, "Allen Ginsberg would sell his shit-stained underwear if someone wanted to buy it"). I didn't catch the name of the bar that first time, but in my 1994 journal I wrote:

> We went into a bar somewhere around 1st Street. Jack drank orange juice. We smoked and talked. He told me about Franz Kline, "Larry" Ferlinghetti, Janis Joplin, Ginsberg, and an ex-girlfriend of his who was cruel and mean, and later he found out she'd been college room-mates with Valerie Solanas, the woman who shot Andy Warhol. A song came on the jukebox by a woman Jack knows. Her band is called Nice Undies. He said he gave them a song he had written for Janis Joplin, but "Janis was into this heavy lesbian relationship at the time and it's a real hetero song." So Nice Undies got it. He told me about the time he was "shit-drunk" with Charles Bukowski. Jack pulled out a toilet plunger and kissed it. He said it blew Buk's mind. Jack told him, "If you can't kiss a toilet plunger, then you can't be a great poet."

Could there have been any greater thrill for a young poet fresh to New York City than to be in a place like Mars Bar with a guy like Jack Micheline? I thought I had arrived, that I was touching the edge of something great, something that would propel me into the life I longed for. Though I didn't kiss any toilet plungers, I went back to Mars Bar again and again, braving the feculent bathrooms, the bat-shit-crazy regulars, and the fat cockroaches that strolled brazenly across the knife-scarred bar. A sign on the door read: "Not for Everybody. For Madmen Only!" You had to be brave—or crazy—to drink in this joint.

Outside, the landscape consisted of crumbling tenements, empty lots overgrown with brown weeds, and a piss-stinking alley called Extra Place, which led to CBGB's back door. Throughout the 1990s,

the area looked like the 1970s and didn't change a bit until 2004, when it changed all at once. Formerly a menacing hovel in no-man's-land, Mars Bar was surrounded by a sudden shimmer. The glassy cliffs of Avalon blasted reflected sunlight on the dive bar's dirty bricks, exposing it to the new world. It sat there, out of place, a ramshackle remnant covered in graffiti, its checkerboard windows clouded with cataracts, and always a grizzled old man out front, smoking cigarettes in a busted chair, watching the new people parading past. You didn't need to be brave anymore to go to Mars Bar; you just needed to feel entitled. Celebrities showed up for photo shoots. Wall Street dude-bros went slumming, fearlessly striding in with pink sweaters around their shoulders. Gaggles of girls demanded unlikely cocktails, like watermelon vodka tonics, and then complained about fruit flies in the booze.

In 2009, a muralist painted the words "The East Village Is Dead" on the outside wall, flanking the message with a pair of grinning yuppies, and bathing the bricks in a shower of bloody red paint. It looked like a ghastly murder scene.

After CBGB closed, Mars Bar lost the big, post-show crowds. Still, with all the changes, we thought the place would survive, forever keeping the spirit of the old neighborhood preserved in its graffiti-crazed reliquary. We should have known better. At the end of 2010 we learned that Mars Bar would be demolished for a luxury condo building. As the eulogies poured in, the outside mural changed again and again. One artist painted "The End Is Near" in red letters over an image of the Cooper Square Hotel. Another painted a cartoon rat exclaiming, "Here comes the wrecking ball!" On the broken windows someone scrawled: "Save a city kill a yuppie." Finally, in the bar's last days, we were left with one simple message: "Thanks for the memories. Miss you all." In the summer of 2011, the New York City Department of Health took a sudden interest in the bar they had long ignored. Their inspectors counted 850 fruit flies in the place and shut it down. Mars Bar never reopened.

Once the legendary dive was destroyed, the nearby luxury boutique Blue & Cream launched a photo exhibit titled "A Tribute to Mars Bar." Blue & Cream is a Hamptons-based shop that sells designer clothing, including $140 sweatshirts with "Bowery" written across the front. For their Mars Bar show, they filled their shop with large, full-color photos by a fashion photographer. Pulled from Blue & Cream's "Back to the Bowery Lookbook" catalog, most of the photos featured a leggy model posing inside the bar. To envision "how a girl who has everything one could want in her wardrobe would dress when confined to this local dive bar," the model sprawled across the ravaged stools, peering out the window like a woman imprisoned, all while showing off high-end items, like a $1,050 black PVC dress and $550 motorcycle boots. The marketing copy explained that the photographer "captured the essence of this gritty and martyred establishment through her brilliant photos that will help carry on the Mars Bar essence, just as it should be remembered. After all, this is Blue & Cream's neighborhood." Another claim on turf? As the boutique's owner told journalist Alexandria Symonds, "everything in New York has changed, and we're not going to be able to stop it. So what we're doing here is kind of plant the flag."

To truly capture the gritty martyrdom, the show included several images of Mars Bar regulars. Above racks of thousand-dollar designer dresses, the men and women of the old dive hung like trophies on a wall. Artists, drunks, poets, raconteurs, they sat on their stools and clutched their drinks, ghosts of a lost world, unaware of the shoppers browsing below. I ventured in to witness the spectacle. As I stood looking up at the faces, I thought of my old friend Jack Micheline, who bought me a drink, borrowed my harmonica, and later died on the subway in San Francisco. I thought of the kid I was when I first stepped into Mars Bar and the hopes I held in that place. I thought: Wasn't it enough to conquer this neighborhood for their own? Did they have to put its people on display? I wanted to rip the dresses from their hangers. I wanted to shout something angry and

foul. Jack would have had something to say. Instead, I gritted my teeth and walked out, grabbing one of the show's promotional postcards. On it was a photo of that bloody Mars Bar mural: "The East Village Is Dead." Long live Blue & Cream.

The new building that has risen on the grave of Mars Bar is called Jupiter 21, a riff on Mars, but with a bigger, more powerful planet. In the space where the bar and its neighbors used to be is now an enormous TD Bank. On their opening day, a team of energetic employees danced on the sidewalk, handing out cookies and trying to entice new customers. They had hired a DJ, dressed him in a TD Bank polo shirt, and made him play soft, watered-down versions of 1980s punk and New Wave classics.

Punk might have been born at CBGB on the Bowery, but it was gutted and embalmed at the Metropolitan Museum of Art. In the spring of 2013, the Met's Costume Institute launched a gala show, "Punk: Chaos to Couture." The path that led museumgoers through the show began with a display of the infamous bathroom at CBGB. Created by artist Nick Knight, it was a tamed replica behind a Plexiglas wall, constructed of simulated filth on toilets, urinals, and sinks; facsimile grit on a tile floor littered with cigarette butts; and re-created graffiti on the walls. "CBGB was a dump," punk legend Richard Hell told the *Times,* "but for the Met to reduce its essence to a toilet is obnoxious." The show's curator argued that the toilets were just like Marcel Duchamp's readymades, "intended to challenge the limits of good taste."

I have to say that I only went to CBGB a handful of times, to support my friends and their bands. When it came to live music on the Bowery, I could more likely be found next door, in the tenement that held the Amato Opera House for sixty years (until it shuttered and sold for $3.7 million). I loved the amateur sets, the raffle tickets, the old lady who sold homemade brownies during intermission. I loved

when Rodolfo—the original bohemian—sang "Che Gelida Manina,"
and Mimi slowly succumbed to consumption while a rickety snow
machine squeaked overhead, dispensing flakes of white confetti. Still,
the music born at CBGB was the music of my youth, pumped from
eight-track tapes and scratchy vinyl records, through the dark foam
of Walkman headphones, mixed and shared on worn-out cassettes.
Blondie's *Autoamerican* was the first album I bought with my own
money. A turning point in life. "Rapture, be pure," Debbie Harry
sang as I danced in my preteen bedroom, pretending to be someone
else, somewhere else. "Take a tour through the sewer." CBGB was in
my soul, even if I didn't know it.

As I watched the tourists at the Met press their noses to the
Plexiglas, lifting their children for a better look at the counterfeit
CBGB pissoir, I felt a choking sensation in my throat. I hurried away,
through the halls of an exhibit that had everything to do with couture
and nothing to do with chaos. Forced to exit through the gift shop, I
stopped to gape at bracelets made of gold razor blades for $215, and
satin handbags covered in gold safety pins for $1,495. I stood watch-
ing while shoppers ransacked neatly folded stacks of CBGB T-shirts,
searching feverishly for their sizes. The saleswoman stood on her
toes and crowed, "These are the last CBGB T-shirts in existence! We
got the last ones from their warehouse! This is it!" From the shelves
of souvenirs, I grabbed a Sid Vicious pencil set and stared at it in dis-
belief. Each pencil was painted black and stamped with a Sid Vicious
quote. "I'm not chic," said one. "I could never be chic."

It gets worse.

In her essay "Cities for Sale," M. Christine Boyer writes, "a feeling
of social insecurity seems to breed a love of simulation." That inse-
curity, and its need for "spectacles of consumption," is manufactured
by an economic system that collects and monetizes our most potent
memories, stripping out the guts and arranging the shells on a pretty
plate for anyone and everyone to consume. Today, offering a potent
illustration of this system, in the climate-controlled nowhere zone of

Newark International Airport's Terminal C, the corpse of CBGB has been reanimated as a theme restaurant for tourists. Beneath a replica of the famed awning, travelers dine on wedge salad and chicken wings washed down with a cocktail called the Dirty Ashtray. A sanitized facsimile of the real, here is dirty New York without the dirt, without chaos or punk surprise. Just the empty shell. This is the triumph of neoliberalism over the city.

THE NEOLIBERAL TURN

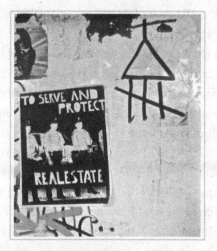

Sticker art with Lower East Side artist-activist Peter Missing's upside-down martini glass, a symbol of resistance against neighborhood commodification. *Jeremiah Moss, 2016*

NEOLIBERALISM, WHICH IS NEITHER NEW NOR LIBERAL, IS the invisible engine that drives hyper-gentrification. Author Rebecca Solnit saw it coming for San Francisco as early as 2000, when she wrote, "gentrification is just the fin above water. Below is the rest of the shark: a new American economy in which most of us will be poorer, a few will be far richer, and everything will be faster, more homogeneous and more controlled or controllable." Neoliberalism is that shadowy shark devouring cities across the globe. Yet few of us are aware of it. Most don't even know its name, a confusing one that sounds like a new sort of liberal, but isn't.

As George Monbiot wrote in the *Guardian* in 2016: "The ideology that dominates our lives has, for most of us, no name. Mention it in conversation and you'll be rewarded with a shrug. Even if your listeners have heard the term before, they will struggle to define it. Neoliberalism: do you know what it is?"

I had no idea what it was until I started writing this book, poring over academic articles, talking with professors of urban studies, digging deep into the roots of hyper-gentrification, asking the question, again and again: What makes today's transformation of the city different from the changes of the past? And why is it replicating, mimetically, in cities across the world? The answer had to be bigger than New York and bigger than gentrification. The answer had to be global, a force with enough power to grip much of human civilization.

Neoliberalism is an ideology and a set of economic policies, a brand of capitalism considered the lunatic fringe until it was popularized in the 1980s by Ronald Reagan and Margaret Thatcher—whose famous statement "there is no such thing as society" summed up a major tenet of the thinking, that is, the primacy of the disconnected, independent individual who pulls himself up by his bootstraps. The ideology crystallized in the 1990s, and by the dawn of the twenty-first century it had become a fait accompli of globalized life, largely unquestioned, barely visible, and resistant to critique. It has become the air we breathe.

Both Democrat and Republican, neoliberals believe in the unfettered free market, deregulation, privatization, reduction in government, and trickle-down economics. They often deny that this powerful system even exists. As Naomi Klein points out in *The Shock Doctrine,* "the ideology is a shape-shifter, forever changing its name and switching identities." Call it free-market fundamentalism, globalization, free trade, laissez-faire, it's all neoliberalism. Its followers will tell you that its effects are natural and inevitable. Gentrification? Natural and inevitable. Global warming? Natural and inevitable. They will echo Margaret Thatcher's mantra: "There is no alterna-

tive." But these are lies that have burrowed into our minds, altering the way we think and feel. As the Iron Lady also said, "Economics are the method; the object is to change the heart and soul." We have been made to forget that it hasn't always been this way.

THE NEW POWER GAME

By the early 1970s, New York City was becoming a social democracy. The economic Elites, watching their wealth and power decline, revolted. In 1976, Ken Auletta published a story in *New York* magazine titled "The New Power Game," an introduction to the city's ascendant overlords. "In the past year," he wrote, "a political revolution has begun to envelop New York." The city was changing from one dedicated to helping the underprivileged to one dedicated to helping the bankers. It was a "fundamental shift," a change in the discourse— and the plan of action. One labor mediator summed it up: "There was a period where what was done in the city was based on what was good for the blacks. Earlier, it was based on what was good for the immigrants. Now the question is what is good for the bond market."

All the work the power brokers had done over the years, ever since the Undesirables had started taking New York a hundred years earlier, was now paying off. The city had been reduced to ruins and needed rescuers. In his book *Bloomberg's New York,* urbanist Julian Brash writes that the fiscal crisis "was quickly seized upon by an alliance of New York City elites, led by bankers," along with corporate, real estate, media, and political supporters, "as an opportunity to reorient municipal policy and the city's political economy, as well as to restructure the city's ruling coalition by drastically reducing the power of labor and minorities."

This sudden reorientation was economic shock treatment, a form of the "shock policy" strategy devised by the neoliberal economist Milton Friedman for the Chilean dictator Augusto Pinochet. After

the violent, CIA-supported 1973 coup that destroyed the demo-
cratically elected socialist government of Salvador Allende, Chile's
economy was rapidly deregulated and privatized. The rich got much
richer and the poor got a lot poorer. In America, the neoliberal revolu-
tion could not be so obviously forced with guns, torture, and murder.
It would have to be psychologically stealthy, a war waged through
the manufacturing of consent. It would also need a crisis to exploit.
New York's fiscal crisis provided the perfect opportunity to intro-
duce Friedman's free-market fundamentalist shock treatment to the
United States. In his *Brief History of Neoliberalism,* David Harvey sees
a clear connection between the two crises, writing that the urban
takeover "amounted to a coup by the financial institutions against
the democratically elected government of New York City, and it was
every bit as effective as the military coup" in Chile.

Neoliberal New York had begun, a drastic change in course that
would lead us, first through Mayors Koch and Giuliani, to the twenty-
first-century city shaped by Michael Bloomberg.

COME EAST!

On the cold, gray morning of January 2, 1978, Ed Koch rode the bus
from his Greenwich Village apartment to City Hall, where he was
inaugurated as the newest mayor. In his speech he set the agenda for
decades to come.

"I do not exaggerate when I say that New York is unique in the
history of man," he said. "New York is not a problem. New York is a
stroke of genius! From its early days, this city has been a lifeboat for
the homeless, a larder for the hungry, a living library for the intel-
lectually starved, a refuge not only for the oppressed but also for the
creative. New York is, and has been, the most open city in the world.
That is its greatness."

So far, so good. But then the new mayor pivoted: "And that is

why, in large part, it faces monumental problems today." What starts off sounding like support of progressive social liberalism turns into a condemnation. New York's great openness and generosity, according to Koch, was also its failing; "mistakes," he said, "of the heart." This would have to change. His new city would provide "a healthy climate for commerce, business, and industry," hewing to the burgeoning ideology of neoliberalism. And it would open its arms to the very recent phenomenon known as gentrification.

Imagine being there, in that changing moment. The air is cold and the sky above City Hall is pigeon gray, the kind of sky that might start spitting rain as easily as breathing forth a flurry of snow. Koch leans in to the microphone and raises his voice as he calls the city back to the mid-1800s. The days before Gilded Age New York gave way to a city of immigrants, laborers, bohemians, and queers. It is time to go back, he says, to return to the city governance that existed before the heart took over. He looks to the hyper-gentrified future:

> Today, it is the City of New York where the urban pioneers of this generation are to be found. Today, it is in Flatbush and Flushing, in Bushwick and Bedford Park, and in all our neighborhoods, where people are working and sweating to restore the most exciting city in the world to prime condition.

Then he puts out the call, echoing Horace Greeley:

> I ask those who are not with us now, those who are seeking a challenge, to come east and join us. Come east, and grow up with the new pioneers, grow up with the new City of New York.

Pioneers. In the 2000s, we've seen that word everywhere, in the brochures and websites of luxury condos, in the real estate blogs,

in the magazine articles written by intrepid middle-class pilgrims moving into the Lower East Side, the Upper West Side, Harlem, and almost all of Brooklyn. Now we know where it came from. While Koch didn't use the word *gentrification* in his speech, he was talking about it. At the time, it was still a largely unknown foreign concept. Just a year earlier, the *Times* included it in their Weekly News Quiz: "Working-class people in London are resisting a process they refer to as 'gentrification.' What is gentrification?"

Gentrification and neoliberalism go hand in hand, and they both became public policy in New York for the first time under Koch. This was the next phase in the long game of restoring the power of financial Elites in the city—while pushing out the Undesirables. After the government and its planners had killed the working-class jobs, pushed the ethnics to the suburbs (where their children were assimilated and whitewashed for later use), and destroyed black and Latino neighborhoods by bulldozer and by fire, it was time to begin the work of repopulating the ruined city with affluent Middle Americans and set the stage for what would become the New Gilded Age.

"Only the reinvention of the city within the context of the new neoliberal global economy could save it," writes Jonathan Soffer of the policy makers' views in *Ed Koch and the Rebuilding of New York*. It was time to give welfare to the rich. Tax breaks and subsidies flowed to the developers of luxury real estate and office towers. Gentrifying neighborhoods, once neglected by the city, were now blessed with services long withheld, like garbage pickup, policing, and increased fire safety. This was not natural or inevitable. It was not the magic of "market forces." It was policy. At the same time, City Hall began wooing tourists, rebranding New York as "both exciting and safe." As Soffer says, it was all part of a "strategy to create a gentrified world city."

In 1984, Koch declared (in a cocktail party conversation about gentrification), "We're not catering to the poor anymore. There are four other boroughs they can live in. They don't have to live in Manhattan."

The following year, *New York* magazine published a sprawling cover story titled "The Yupper West Side." In that Jewish and Latino, lefty and working-class neighborhood, prices were skyrocketing. The yuppies had accepted Koch's invitation. Suddenly, everyone was an investment banker in a five-hundred-dollar pinstriped suit, guzzling twenty-eight-ounce Ridiculous margaritas at Caramba!!! (yes, with three exclamation points) while they bought up the real estate, displaced residents, and changed the culture of the neighborhood. In his 1981 essay "Quiche Blight on Columbus Avenue," Phillip Lopate wrote vividly about the sudden transformation, watching Columbus Avenue "go from a sleepy, gently decaying backwater to one of the city's major thoroughfares, a Via Veneto for swells and near-swells," where it was "no longer possible to carry groceries home without stumbling over the pointy shoe of some magazine-cover type watching the passersby with glass of white wine in hand at an outdoor table."

While residents and small businesses were harassed and evicted, the rents went up. Said one of the "very pro-development" swells to *New York,* "It makes me angry when people criticize a lot of the changes. The displacement is unfortunate, but where are we supposed to live? We have rights. We pay taxes. Whether people realize it or not, we're real assets to this community." The yuppies believed they were assets because City Hall told them so. Writing in 2013 on the 1980s shift from working-class grit to Wall Street arrogance, Steve Fraser said in *The Nation,* "A city that once admired the feistiness of seamstresses and stevedores and the hustling shrewdness of the family businessman came instead to admire its 'big swinging dicks.'"

At the same time that gentrifiers across the city were moving into renovated tenements and brownstones, apartments were rapidly emptying not only from rising rents and landlord harassment, but from mass death. In the early 1980s, AIDS began taking the denizens of New York's underworld—gay men, transsexuals, sex workers, poor people of color, drug users. It is clear that the city's and

federal government's slow response to the AIDS crisis reflected a homophobic, racist, classist, and anti-urbanist unwillingness to help these populations. It was policy. While he was at times a supporter of gay rights, and possibly a closeted non-heterosexual of one sort or another, Koch's financial response to the AIDS crisis, like President Ronald Reagan's, was murderously slow.

Nineteen-eighties New York was a time of both boom and austerity. It was boom for Wall Street, big business, and real estate, which got megabucks in tax breaks. As Soffer outlines, Koch gifted developers and corporations with the expansion of three kinds of tax abatement: J-51, giving subsidies to landlords to renovate apartments and increase gentrification; 421a, reducing taxes on luxury buildings to induce their construction in "underused" areas; and "individually negotiated tax reductions," giving hundreds of millions to corporations like AT&T to bribe them into doing business in New York. It was an expensive smorgasbord. According to urban anthropologist Roger Sanjek, "Between 1984 and 1989, J-51 and 421a tax losses together cost the city $1.4 billion." For the rest of the city, it was austerity—for the everyman hit with higher taxes and fewer services; for cultural institutions lacerated by cuts; for poor and working-class students now charged tuition at City University; and for public health, as hospitals lost funding, supplies, beds, and in some cases, their entire buildings. Money for AIDS? Forget about it.

Richard Kim pointed out in *The Nation* that "by January 1984, New York City under Koch's leadership had spent a total of just $24,500 on AIDS. . . . That same year, San Francisco, a city one-tenth the size of New York, spent $4.3 million." More benign neglect? In the documentary *Larry Kramer in Love & Anger,* AIDS activist Rodger McFarlane recalls a Koch administration deputy mayor who dismissed the tragedy by saying, "Don't talk to me about 300 faggots who fucked each other to death." For urban epidemiologist Rodrick Wallace, the spread of AIDS in the 1980s ghettos of New York was a direct outcome of the 1970s removal of services. The social condi-

tions following planned shrinkage, he argues, accelerated the rates of drug addiction and increased the AIDS epidemic. Infections followed evictions, as displaced people carried the virus wider and more rapidly across the city.

One seldom-discussed side effect of the AIDS crisis was its role in speeding up gentrification. Sarah Schulman outlines this phenomenon in her book *The Gentrification of the Mind,* in which she connects gentrification in New York with the loss of thousands of mostly gay men from the early 1980s through the mid-1990s. In what she calls the "process of replacement," Schulman describes watching her East Village neighbors get sick and die, one after another, and then witnessing their abandoned rent-controlled apartments deregulate and convert to market rate "at an unnatural speed." In one example, after a young dancer died, the rent on his apartment jumped from $305 to $1,200 a month. The higher rents then attracted people who could afford them, and these new residents were not "immigrants, lesbians, noninstitutionalized artists, gay men, and other sexually adventurous and socially marginalized refugees," says Schulman. Instead, they were Koch's new pioneers. This process, Schulman contends, occurred largely in Greenwich Village, the Lower East Side, Chelsea, and Harlem, the city's neighborhoods with the highest rates of AIDS—and, in part consequently, the highest rates of gentrification.

The loss to the rambunctious cultural life of the city is multiplied when you consider that many of the people who died from AIDS were artists and activists, upstarts and rebels, young people whose influence on the urban culture and the shaping of its future was abruptly terminated. Had they lived, these people likely would not only have created art and progressive politics in the decades to come; they also would have been its supporters. As Fran Lebowitz points out in the film *Public Speaking,* "An audience with a high level of connoisseurship is as important to the culture as artists. That audience died in five minutes."

It was yet another blow to the New York created a century before,

when "fairies" flounced along the Bowery, mingling with working-class, radical, and immigrant cultures. Still, by the 1990s, despite all the assaults against it, the city's seemingly unsinkable soul limped along, stridently unwilling to give up the ghost. And then Rudy Giuliani took City Hall.

ZERO TOLERANCE

If neoliberalized New York needed muscle, an enforcer to swing a nightstick, that was Giuliani. In a 1994 speech he stated his philosophy using Orwellian doublethink: "Freedom is about authority. Freedom is about the willingness of every single human being to cede to lawful authority a great deal of discretion about what you do."

With his zero-tolerance and quality-of-life campaigns, based on broken-windows theory and backed by a paramilitarized police force, the "Mussolini of Manhattan" inflicted severe damage on New York's unruly spirit. Giuliani went after squeegee men, panhandlers, graffiti writers, street artists, newsstand owners, and hot dog vendors—in a move that spurred the *Times* to accuse the mayor of "making war on the New Yorkness of New York City." His NYPD cruised through gentrifying parts of town and cracked down on minor infractions, like drinking a beer or urinating on the sidewalk. In broken-windows theory, it is believed that if you control small acts of disobedience, you can prevent more serious crimes. (The theory has since been debunked.)

Unruly forms of sex must also be tamed to tame a city. Giuliani swept through Times Square, leaving the tawdry old joint squeaky clean and dull as dishwater. While Mayors Koch and Dinkins had laid the groundwork to renovate Times Square, the linchpin Disney deal went through during Giuliani's reign, and change proceeded under his guidance. The adult bookstores, strip joints, and peep shows were pushed out and an all-American retail orgy commenced, obscene

in its own special way. In 1995, Giuliani succeeded in rezoning not just Times Square, but much of the city, to criminalize legal adult establishments. "There's a chill in the air that is antithetical to civil liberties and to First Amendment principles," said the director of the New York Civil Liberties Union. "It's a sign of the times and of a new repressive climate toward sexual expression that is totally contrary to New York's rich cultural history." The ordinance was fought in court to no avail. Sex shops across the city vanished—and sexual outlaws were exiled.

Obsessed with law and order, Giuliani attacked jaywalking, the common pedestrian practice of crossing against the light, a habit that author Luc Sante has called "a New Yorker's birthright, a minor but indispensable sign of his or her independence and self-sufficiency." The mayor increased the fine for jaywalking from two dollars to fifty dollars, but not all cops agreed to write tickets. One refusenik officer told the *Times*, "This is just taking hard-earned money from people who can't afford it, and I'm not going to prostitute myself for the Mayor or anybody else." Said another, "New Yorkers are New Yorkers, and this is a free spirit city." But the mayor would not tolerate disobedience. He wanted the jaywalking to stop, so he erected permanent barricades on busy Midtown corners to keep people fenced in like cattle. New York would no longer be a free-spirit city. Instead, it would be a free-market city.

On the Lower East Side Giuliani targeted the tenacious hundred-year-old heart of the counterculture with plans to bulldoze the neighborhood's squats and community gardens. As many as 114 of the city's 750 gardens, most created and tended for decades by locals on lots left empty from burned-down buildings, went up for auction. Lower East Siders protested, paraded, and chained themselves to garden fences. While most of the gardens were saved—by lawsuits, politicians, Green Guerillas, and Bette Midler—several others were handed to developers. Giuliani announced, "This is a free-market economy; welcome to the era after communism."

Like a good McCarthyite, the mayor sniffed out commies wherever they might be found. Blue-collar workers on strike, protesters, gardeners, supporters of public parks—Giuliani viewed them all as the Red Menace, remnants of the anarchic immigrant spirit. "There are people who want to cause anarchy," Giuliani proclaimed at a news conference. "Marxism unfortunately is still alive in parts of New York City." And yet, as John Kifner pointed out in the *Times*, Giuliani's red-baiting was "overlooked in the hurly-burly of daily governance." It could not, however, be overlooked in the neighborhoods he targeted.

In the summer of 1995, hundreds of cops in riot gear marched down East 13th Street to evict legal homesteaders from their buildings. The NYPD's "tank"—a fifty-thousand-pound armored personnel carrier, a veteran of the Korean War named "Any Time Baby"—smashed through the squatters' barricades while helicopters circled overhead and snipers perched on rooftops with their rifles. The battles continued through 1996 and 1997, when the city performed an "emergency demolition" of another squat on East Fifth Street. Defying a New York State Supreme Court order to cease and desist, the city's wrecking crane smashed against the brick walls with residents' pets still inside, along with a squatter named Brad Will. He came out alive, was promptly arrested, and later told underground local newspaper the *Shadow*, "I could feel the walls shake. I clung to the walls and started crying because it was a strong building and it was a shame to tear it down. I loved that building." Another tenement gone, another rookery eradicated. Throughout the 1990s, Giuliani's policies and police force assaulted, subdued, and evicted many of the rebels who might stand in the way of the new city to come. *New York* magazine wrote, "The East Village squatters are New York's last true bohemians. And they're in serious danger of extinction."

Still the soul of New York did not succumb. Not entirely. And it seemed, as the city swerved left again at the end of the 1990s, as Democratic mayoral hopefuls took the lead in the polls of 2001, New

York might recover itself, might hang on to what remained of its progressive social liberalism. In *Bloomberg's New York,* Brash writes of this moment in history: "post-fiscal crisis neoliberalization had managed to push the front forward but it had not won the class war. While New York City of the 1980s and 1990s was hospitable to upper professionals, as of the turn of the twenty-first century they had yet to find a true political champion."

There was still a chance for the New Yorkness of New York to prevail against the forces of the Elites who had worked so hard for so many decades to destroy it. As the summer of 2001 faded into fall, Giuliani's time as mayor was coming to an end. New York was done with the likes of him, and it seemed certain that the next mayor would be a socially liberal Democrat. I remember feeling hopeful. September 11 was Primary Day. The polls opened early that morning and New Yorkers began casting their votes. Then a dark and swiftly moving shadow passed over Manhattan.

Terror jerked the city to the right, knocking it off its left-going trajectory. In response to a major threat, fear and uncertainty can cause both liberals and conservatives to move rightward. This is called the "conservative shift." Whatever chance New York had to regain its social liberalism, the terrorists destroyed on September 11. As the city hunkered down into economic anxieties and immigrant jitters, Giuliani was repositioned as a heroic all-American mayor. He gave his golden endorsement to a long shot, the billionaire CEO Michael Bloomberg.

For more than a century, the Elites had been waiting for their supreme political champion to arrive. No one, in their worst nightmares, could have guessed that he would rise from the smoldering ashes of New York's sky-high monument to free-market capitalism.

LITTLE ITALY

Feast of San Gennaro, early morning, Mulberry Street. *Jeremiah Moss, 2013*

IN LITTLE ITALY, THE ANNUAL FEAST OF SAN GENNARO HAS BEEN going strong down the length of Mulberry Street since 1926. For eleven days every September, the streets fill with vendors hawking food, games, souvenirs; the air fills with the fragrance of sausage and peppers, fried dough, bracciole; and of course, there's a cannoli-eating competition. Singers perform on a portable stage, always a nostalgia band like Vito Picone and The Elegants ("Where are you, Little Star?"), always a Sinatra impressionist in dark fedora, and once the real Connie Francis with "Where the Boys Are" and "Who's Sorry Now" blasting through loudspeakers (Oh, Concetta Franco-

nero, I played your *Very Best* record to death in my Italian-American childhood). Draped in fluttering garlands of dollar bills, the statue of San Gennaro parades through the streets, accompanied by the brass and drums of the Red Mike Festival Band, a motley group of men led by Red Mike's widow, Louise Acampora, bedecked in miles of blue eye shadow, crashing her cymbals through a *Godfather* tarantella. Every day and night of the feast, the streets are packed. So it has been for nearly a century. Then, in the 2000s, the feast became a problem—for some.

In 2007, a group of angry neighbors, irritated by the sausage smell and the crowds, persuaded the local community board to reject the feast's permit application and do away with the celebration completely. "No one likes San Gennaro who lives here," said one board member to the *Daily News* as the paper reported that this assault was the first time in the feast's then eighty years that it "faced open rebellion from residents." The rebellion failed, with Mayor Bloomberg stepping in to put the kibosh on the destruction of this tourist-friendly event (Bloomberg would never stand in the way of anything beloved by tourists), but the anti-feast uprising would come again, a clear indication that something had dramatically changed for Little Italy in the twenty-first century.

Formerly part of the notoriously dangerous and squalid Five Points slum—made famous by Herbert Asbury's (and later Martin Scorsese's) *Gangs of New York*—and predominantly an Irish Catholic neighborhood, the part of downtown Manhattan that became known as Little Italy began filling up with Italian immigrants in the 1850s. By the 1920s, Little Italy stretched from Houston Street to Canal, and from the Bowery to Greenwich Village, expanding to accommodate the many thousands of Italian Americans who called it home by 1930. Their numbers began to shrink after World War II, as the children and grandchildren of immigrants opted to move to

the outer boroughs and the suburbs of Long Island and New Jersey. With the U.S. Immigration Act of 1965 admitting more people from Asia, the borders of Chinatown swelled, chipping away at Little Italy block by block. By 1981, the *Times* reported that Chinatown was "all but smothering Little Italy, which is now but a two-block relic amid a jumble of Chinese dry-goods stores, vegetable stands and tea shops." A bit of an exaggeration.

In 2000, the U.S. Census reported just 1,211 Italian-American residents in the neighborhood. By the turn of the twenty-first century, Little Italy had been gradually shrinking for more than fifty years, as one group of poor immigrants gave way to another. That has been the history of downtown Manhattan. The Irish and Germans moved out, the Italians moved in, and then they moved out and the Chinese moved in, each group jostling for space, clustering together in affordable tenements and storefronts where they held on to their native culture. But for the first time in nearly two hundred years, no wave of poor immigrants came to downtown Manhattan in the 2000s. (Chinatown, though it's slipping, is the only downtown neighborhood having any success resisting hyper-gentrification today.) Instead, Little Italy saw an influx of wealthy Americans who weren't moving to Little Italy, but to a fashionable new neighborhood called "Nolita."

It is pronounced like Nabokov's Lolita, with "the tip of the tongue taking a trip of three steps down the palate to tap, at three, on the teeth." No. Lee. Ta. It is short for "North of Little Italy," originally spelled to mark the abbreviation, NoLiTa, as it was coined by the real estate industry in the mid-1990s. The use of the nickname reportedly first appeared in a *Times* article in 1996, heralding the initial signs of gentrification, mostly along Little Italy's Elizabeth Street. Said Mr. Lombardi of the hundred-year-old Lombardi's pizza, "Twenty years ago you got a storefront for $80 a month. Ten years ago, the landlord

asked $700, and now it's $1,000 to $2,000." Apartment rents were also rising. Today, monthly rent on a studio apartment might cost you $3,025, but you can pay much more.

In the mid-1990s, I loved to walk along Elizabeth Street at night, often on my way back from poetry readings down in a semi-industrial area that later got swallowed up by pricey Tribeca. On dark Elizabeth, I would stand outside the mysterious building locally known as the Candle Building, a former carriage house covered in graffiti, and watch the many windows for signs of life. Every night, the building's sole resident would place a single lit candle between the white curtains of each window. A friend had told me that the man hadn't been seen since he first bought the place in the 1970s. What kept him in reclusion? Why did he light the candles each night? I wanted desperately to catch a glimpse. Each time I passed, after standing for several minutes, waiting for a fleeting shadow to move behind the glass, I'd give up and continue walking. The farther north I traveled, the sweeter the air turned with the smell of baking bread wafting out of G. LaRosa & Son's dark, brick bakery.

Of an evening in 1996, I wrote in my journal:

> Walking home, I stopped at LaRosa's on Elizabeth Street. I can't resist that smell of baking bread that fills the neighborhood. I stepped inside. The bakers were pulling hot loaves from the oven. I bought one for 50 cents, broke it open on the street, and ate it. The soft, white bread was like warm milk. I passed Bella's Luncheonette where you can eat cheeseburgers at the window and maybe see Jim Jarmusch walk by. Inside Albanese Meats, the butcher was working on a slab of beef, carefully trimming the fat. He stepped out to the street for a moment, the blood on his apron, wet knife shining in his hand. He looked around as if expecting someone, then nodded to me, and went back inside.

I bought veal cutlets from the butcher, Moe Albanese, with his silent, smiling, nonagenarian mother looking on, seated in the bentwood cane chair from which she never moved, until she was gone. As of this writing Mr. Albanese is still there, a sole survivor eyed by real estate speculators licking their chops, waiting for him to die and give up his prime property. I remember the moment I knew that Elizabeth Street would be ruined. It wasn't the arrival of the vintage housewares shop or the fancy glassblower or the artisan selling "hand-forged candlesticks" for ninety dollars, and it wasn't even the heartbreaking closure of Bella's Luncheonette, replaced by the trendy Cafe Habana in 1998. It was a scene I witnessed one warm summer evening somewhere about that time.

A new shop had just opened one or two doors up from Albanese Meats. I don't remember what the shop sold; if it's still there today, it has blended in with all the others like it. On that evening the shop owners were having a bash, maybe a grand opening, and they propped their door wide open, stereo speakers set outside to assault the street with ear-splitting music. A little old Italian woman sat on her own doorstep, right next to the speakers, peeling potatoes into a brown paper bag. I had seen the woman do this many times before, always in the early evening, scraping the peeler over each potato, letting the skins drop into the bag, darkening the paper with their wetness. It was a sight I loved, felt deeply inside myself like a cellular memory of my own Italian grandmother's mother on a distant city doorstep I'd never seen, but knew. And now it was about to be ruined. New people were arriving, people I'd never seen before on Elizabeth. "Where did they come from?" I thought as I watched them go stomping in and out of the shop, smoking cigarettes on the sidewalk, laughing with their big mouths, taking up space in a proprietary way, as if they owned the place. The old woman ignored them as best she could, doing the thing she'd always done, as if nothing had changed. But the quiet street wasn't quiet anymore. It had been "discovered." Then I saw one of the shop's stylish customers step over the

old woman's paper bag. The sidewalk was crowded with partygoers, she was in his way, so he lifted his long, limber leg and, without a word to beg her pardon, stepped over, as if she and her supper were a pile of waste he didn't want soiling his fine shoes. I began avoiding Elizabeth Street after that night. It was too heartbreaking to watch it die that particular brand of death.

By the middle of the 2000s' first decade, Elizabeth had become unrecognizable, like a plain, approachable girl who went on that *Extreme Makeover* show and came out wrapped in a shiny, plastic, Barbie-doll skin. She was a stranger to me. LaRosa's bakery closed and became the sales office and showroom of the impossibly high-end Elizabeth Street Gallery, selling reclaimed sculptures of goddesses and fountains. The mystery man emerged from the Candle Building and turned out to be a theatrical set designer named John Simpson, who had filled the place with Rube Goldberg devices designed to turn on his transistor radio and dispense his toilet paper. He sold the building to media magnate Rupert Murdoch's son for $5.25 million and disappeared into Europe. The building was buffed of graffiti, scrubbed to a high gloss, and put back on the market for $36.5 million. Nearby, "beautiful, bespoke" 211 Elizabeth went up, a luxury condo development with prices from $1,550,000 to $6,950,000 on units selling to celebrities like Billy Joel and Gabriel Byrne. More upscale shops opened, including luxe chain Tory Burch and boutiques with names like "Trust Fund Baby" and "La Petite Princesse." Stretched around the scaffolding on yet another luxury building rising nearby, a sales banner announced, "Elizabeth Street Is Da Bomb" and "You are now entering Nolita."

In 2001, an executive vice president at real estate brokerage Douglas Elliman defined Nolita to the *Times:* "Little Italy still signifies cannolis and pasta. NoLIta means fashion and hip. If you can brand an area, it increases the real estate value by 20 percent." While brokers and journalists were still trying to figure out where to put the capital letters in Nolita, many residents were trying to ban the label completely. The local community board adopted a resolution

requesting that the city government "denounce this trend toward trivialization." Afraid that their neighborhood would become a high-priced shopping mall, they asked newspapers and the Real Estate Board of New York to stop using the nickname. No one listened. The Medici Foundation of Italian-Americans got into the fight. In a press release they wrote, "our ancestors' neighborhood deserves the rec-ognition and the honor by having their 'historic neighborhood' not be unjustly relabeled as NoLita for the economic gain by various city capitalists." But the Nolita name kept spreading, and the neighbor-hood kept changing, becoming more expensive every day.

After almost one hundred years of preserving and disseminat-ing Italian-American culture, the sprawling music and imports shop E. Rossi was forced out of its large space when a real estate group bought the building, along with four others, and hiked the rent to $25,000 per month. Part of the same portfolio of properties, Paoluc-ci's restaurant, opened in 1947, was driven out when the new own-ers raised the rent from $3,500 to $20,000 per month. Into Paolucci's space went the hipster bar Mulberry Project, described by the *Times* as "a speakeasy-style lounge with mixologists, locavore plates and an in-crowd that revels in its erudite tastes." The Novogratzes, the fam-ily whose name became a verb for gutting and gussying up proper-ties, took over Centre Market Place, a street of tenement buildings that had once housed crime reporters, including the famous Weegee, along with a collection of gun shops dating back a hundred years. The Novogratzes bought a large chunk of the block and Novogratzed it in no time. "We look for the most condemned, gross places we can find," said Cortney Novogratz to the *Daily News*. "We couldn't believe we had a chance to get half the street," said her husband, Bob. Patrissy's Italian restaurant, in business since 1906, was taken over by a new owner and renamed Nolita's. A restaurant called Nolita House opened on Houston Street and started serving "libations" and "arti-san cheese." And into John Gotti's Ravenite Social Club went a high-end shoe designer.

The first Nolita pioneers could not keep up with the breakneck pace of rising rents. In 2005, *New York* magazine wondered if the bubble had already burst, as storefronts began emptying along Elizabeth, Mott, and upper Mulberry. As the boutiques' leases expired, landlords opted to rent their spaces to national chain stores, like Ralph Lauren and Nike. Nolita's bubble just got bigger, bringing in more tourists and new residents with no sense at all of the neighborhood's history. Martin Scorsese, who grew up on Elizabeth Street, recalled to *New York* a visit to Di Palo's Food Shop, in business since 1903. Mr. Di Palo told him "some student who had just moved to the area came in and asked . . . 'What made you open an Italian cheese shop in a Chinese neighborhood?'" Robert Ianniello Jr., then president of the Little Italy Merchants Association, told the magazine, "what I really fear is Starbucks. If they tried to open here, we would do everything we could to stop them." To which he added, "I'm tired of Iowa."

M any newcomers not only had no understanding or affection for Little Italy's history, they also harbored undisguised contempt for it. After the recession of 2008 hit the boutiques hard, a number of businesspeople blamed the San Gennaro Feast for their financial troubles. The owner of a "do-it-yourself jewelry lab" on Mulberry told *New York* that the feast had been killing her business since she opened shop in 2002. "Those two weekends in September are really important," she said; "everyone is back from the Hamptons and women are excited to get shopping again." She tried to stay open during the feast, but the "horrid sausages" outside her door forced her to close for the duration. In 2011, the anti-feast faction rose to power once again, and those controversial sausages became part of their war cry.

One boutique owner told DNAinfo, "We close down for San Gennaro. You don't want people coming in with greasy sausage fingers." The owner of a lingerie shop told the *Post* that she "sprays Febreze on the lacy undies to kill the smoky odor." Together with some

residents, a group of these disgruntled merchants persuaded the community board to urge the mayor's Street Activity Permit Office to shorten the physical length of the feast, cutting off its northernmost section "so as not to disturb the emerging business community in Nolita."

The Italian Americans fought back, holding meetings and rallying in the streets. They printed up No Nolita stickers and started a Facebook group called "Little Italy and San Gennaro Under ATTACK." The group gained four thousand members and provided a place for people to vent. Said one member, "I'd love to go 'window' shopping in all these rats stores. We need a list of the complainants and there [sic] local businesses." Said another, "never stop against the yuppies. Let's send them packing." Another called for cool heads, saying, "They want us coming in like we are portrayed in movies and TV shows. Let them see that people who come from little Italy are a class act." San Gennaro Feast board member John Fratta put together a video on YouTube, an impassioned call to Italian Americans not only to save the feast, but to stop anti-Italianism. At the beginning of the video, longtime Little Italy activist Carmelo Tramontano explained, "You gotta have the guts to tell these people: 'Get outta here. You don't like? Get outta here.' You gotta be strong that way. Don't be gentle, you gotta be rough. 'Cause otherwise they're gonna take your bread and water."

Similar fighting words stirred the community one night at a meeting of the Northern Little Italy Neighborhood Association, the group that had successfully defeated an invasion by the hyper-popular Shake Shack chain. At the meeting, as reported by DNAinfo, angry residents argued that anti-Italian bigotry and classism were at the heart of the attack against the feast. One called the newcomers "trust-fund babies." The prominent owner of two Italian restaurants said, "If they don't like it, they can leave. The people that move in from Montana can go back to the fucking mountains and ride their horses."

The feast had been on Mulberry Street for eighty-five years. The

boutique owners had just arrived, but they continued to press for the feast to be shortened. In the end, the feast's organizers conceded to a number of compromises, including a ban on the sale of mafia-related T-shirts. That year and ever since, the feast has been physically shorter, with the traditional Italian booths pushed south, while trendy new restaurants take the space closest to the main entrance to the north. Major Food Group, a young company that has run a number of fashionable restaurants, including Torrisi, Parm, and Carbone, organized a gourmet takeover of the northern section. In 2011 they sponsored the first "Beast of the Feast" event, serving fried wonton "nachos" and Chinese-style spare ribs, while the Breslin gastropub offered roasted red peppers with goat cheese, and someplace called Byggyz served Yacht Club Golden ginger ale at twelve dollars a pop. Another one of the booths at Beast of the Feast belonged to a restaurant group called Little Wisco. Short for Little Wisconsin, a Middle Americanized version of Little Italy, it's a clear message about who the new "immigrants" have become. The feast offerings at Little Wisco, reported the *Times*, included "featherweight falafels with molten Cheddar hearts ($8) and sriracha-doused chicken meatballs on a potato pancake with the perfect ratio of spring and sponge ($10)." Fried food. But none of the boutique owners complained about the grease and smoke.

I n 1945, as a sixteen-year-old brunette beauty in white gown and rhinestone tiara, Adele Sarno was named Queen of the San Gennaro Feast. In 2015, she was evicted, ordered to vacate her home of over fifty years at Mulberry and Grand Streets. She was paying $820 for her rent-controlled apartment when her landlord—painfully, ironically, the Italian American Museum—raised her rent to $3,500. At the age of eighty-five, Adele was living on Social Security and food stamps. But the Italian American Museum had plans. Two years earlier, Joseph Scelsa, the museum's president and director, told the

Times that he and the board of the museum hoped to sell the building to developers for $12 million. And everyone knows it's easier to sell a building once it's empty of rent-regulated tenants. Sarno was simply in the way.

Lawyers and community advocates rallied around Adele. She was living history. A last survivor of a fading place. Two Bridges Neighborhood Council, Good Old Lower East Side, and #SaveNYC, the grassroots activist group I'd recently launched, all organized protests outside the museum's door. Italian-American actors Annabella Sciorra and Frank "Butch the Hat" Aquilino joined our protest. Filmmaker Sandi Bachom interviewed Sarno in her apartment, providing an intimate portrait.

In the interview, among her many trinkets and Catholic icons, wearing her false eyelashes and a brunette wig, Adele Sarno sat in an overstuffed easy chair, smoking a long, slender cigarette. At eighty-five she was what you'd call a spitfire. With true New York style, she told the story of her eviction. "Don't throw us away like we're garbage," she said, wondering aloud about the humanity of her landlords. "They got mothers. Do they put them in the street?" She talked about politics and mayors, and showed a copy of her eviction notice. Due to a bureaucratic mistake, Sarno's apartment was not registered as rent-controlled, though it should have been. "I'm gonna fight this bastard till the end," she said.

But the end of the fight, which had started years earlier, came soon after. Tired of the battle, Sarno reached a settlement with the landlord. "It took too much out of me," she told the *Times*. It was time to move on. She searched for a smaller, affordable apartment in Little Italy, but apparently found none among the condo conversions and other luxury developments. She became an exile. Last I heard, she left her lifelong neighborhood and moved in with a granddaughter on Staten Island. With that, Little Italy lost another little piece of its Italian heart.

SEPTEMBER 11

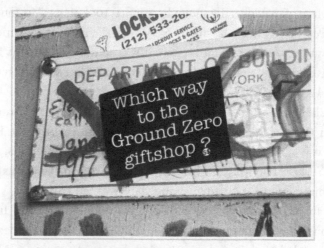

Sticker art. *flickr.com/girlposse, 2009*

U NTIL SEPTEMBER 11, 2001, NEW YORK WAS NOT QUITE AMER-
ica. From its Dutch beginnings, the city existed as a space
apart. Exceptionally able to tolerate, and celebrate, a mul-
tiplicity of cultures and ways of living, it had been both the gateway
to America for foreign immigrants and the escape from America
for those who never fell in line with the American way of normal.
New York was a liminal space between inside and outside, a thresh-
old neither here nor there but ultimately itself. It was a city that
permitted transgression, the crossing of old boundaries, whether
that meant a Jewish immigrant from Russia casting off her wig, or

a young man from Nebraska putting his on (with false eyelashes to match).

In *The Island at the Center of the World*, Russell Shorto writes, "It was no coincidence that on September 11, 2001, those who wished to make a symbolic attack on the center of American power chose the World Trade Center as their target. If what made America great was its ingenious openness to different cultures, then the small triangle of land at the southern tip of Manhattan Island is the New World birthplace of that idea, the spot where it first took shape." Its multicultural receptivity arguably made New York the most truly American city, but not the Heartland version. It was something else. As Djuna Barnes said in 1916, it was "the only city where you can hardly find a typical American."

When Al Smith, the Italian-Irish New York governor from the Lower East Side, campaigned for U.S. president in 1928, the Heartland rose against him as a Catholic, the son of immigrants, and a New Yorker. The Ku Klux Klan burned crosses on the tracks when his train came to their towns, and they warned constituents to be ready for Smith's arrival, crying "America is for Americans!" In publications, they howled about the Roman Catholic "alien hordes" that had "invaded America," determined to destroy democracy. "Already they have captured many large cities." And no city had been more corrupted by alien hordes than New York. From his radio pulpit, Rev. John Roach Straton denounced Smith, accusing him of everything the Protestant American Heartland believed was wrong with New York: "card-playing, cocktail drinking, poodle dogs, divorce, novels, stuffy rooms, dancing, evolution, Clarence Darrow, overeating, nude art, prize-fighting, actors, greyhound racing, modernism."

This view of the modern city was not fringe, but rather the extreme expression of a common American sentiment, one that would endure for decades. In 1977's *Annie Hall*, Woody Allen might have had Straton's speech in mind when he joked, "The rest of the country

looks upon New York like we're left-wing communist, Jewish, homo-sexual, pornographers." In *New York Calling*, urbanist Marshall Ber-man recalled the anti–New York venom that streamed from 1970s America, when politicians asked their constituents, "Should New York live or die?" And their constituents chanted, "Die! Die! Die!" The city had reached its modern-day pinnacle of exceptionalism—and delinquency. For much of the nation, and for the conservative leaders in Washington, New York was a perversion, a dirty town full of dirty people, and now it would be punished and reprogrammed.

When President Gerald Ford essentially told the city to "drop dead," denying a federal bailout to prevent bankruptcy, a presiden-tial spokesman likened the city to "a wayward daughter hooked on heroin." Like a rebellious teenager kicked out of the house, the city dis-identified further from the mother country, elevating itself in the process. If America was rejecting New York, then New York would reject America. Saul Steinberg's 1976 *New Yorker* cover, *View of the World from 9th Avenue*, famously expressed the city's sense of superi-ority with a map in which Manhattan is detailed, central, important, while the rest of the country, crammed between the Hudson River and Pacific Ocean, is just an insignificant sketch. In "My Lost City," Luc Sante recalls, "in the 1970s, New York was not a part of the United States at all. It was an offshore interzone with no shopping malls, few major chains, very few born-again Christians who had not been sent there on a mission, no golf courses, no subdivisions. Downtown, we were proud of this, naturally."

That vaunting pride did not endear New York to Middle America, where many saw the city as a hive of elitists. Talking to Ric Burns for his *New York* documentary, architecture critic Ada Louise Huxtable explained: "The combination of power and money and creative vital-ity has created a city that we New Yorkers are very chauvinistic about and rather disliked for all over the world; we're considered just not in touch with the rest of the world. Well, maybe we're not, and maybe

that's a good thing, maybe the fact that we are doing all this creative work is something that is so unique, and so special, that it does make New York a city unlike any other."

As late as the 1990s, after more than a decade of City Hall working to make New York more likable to the average American, the heart of the Heartland still wasn't having it. *New York* magazine published a 1995 cover story that explained "Why America Hates New York." In short, we were liberal, multicultural, and bereft of right-wing Christian family values. "New York is more than ever considered Sodom on the Hudson," wrote the magazine. "More chillingly, [right-wing America's] hatred for us is commingling with the conviction that New York is anachronistic, vestigial, and on its way to being expunged." The Protestant American right, after disparaging the liberal city for a century, now saw a future in which New York would be overtaken by their values. "New York is a dinosaur," Georgia politician Gordon Wysong told *New York*. "We're the power now. These suburbs, built on white flight, are only going to become more conservative and more powerful. New York has been deposed." Revenge was in the air.

The conservatives of America could see the changes coming, and they were gleeful. In the spring 1995 issue of *City Journal,* a publication of the neoliberal, neoconservative Manhattan Institute, David Brooks published a critique on "out-of-step New York," scolding snobbish city folk for looking down on Middle America. "Over the longer term," he wrote, "New Yorkers might—dare I say it?—change. New York liberalism will gradually dissolve; cultural attitudes will drift toward the mainstream."

Looking back from a post-9/11 and post-Bloomberg position, these words offer an eerily prophetic message. But how could we ever have imagined the expunging of New York? Drift toward the mainstream? The city's utter queerness—if we take "queer" to mean everything eccentric, suspicious, and strange—acted as a repellent that kept out the dull and unimaginative. Being hated by America

was good for the city. And, ultimately, good for America. Every family needs a black sheep to keep it interesting.

And then.

On the morning after 9/11, in a cloud of dust and despair, the fractured, frightened city awoke to find itself cradled in the arms of the nation. In their murderous act of terrorism, the attackers managed to strip away New York's grandiose exceptionalism and, humbling the city, made it accessible. Beneath the collective grief, America was enervated by the trauma, moved to a state of heightened arousal that pulled it magnetically toward Ground Zero, a smoldering hole that quickly became a tourist attraction, complete with grisly souvenirs. The attack was a colossal taking down a peg for wayward, arrogant New York. In the dark privacy of the human heart, who doesn't feel a bit of schadenfreude when a swaggering giant falls? Milton Glaser, creator of the "I ♥ NY" logo, put it less cynically when he said of the post-9/11 city, "A powerful giant is one thing. A vulnerable giant is much more lovable."

Into wounded, lovable, suddenly huggable New York rushed the Heartland with its homemade chicken soup for the soul. After that day, we heard the phrase "We are all New Yorkers" echoed across the country—and the globe. The statement appeared in Britain's *Guardian,* France's *Le Monde,* and in the program for a Carnegie Hall concert of the Berlin Philharmonic, echoing JFK's famous "We are all Berliners" speech: "At this terrible moment, we are the ones who say with you, 'We are all New Yorkers.'" America was attacked, but it was the city that fell to its knees. Capturing the touristic national sympathy, a cartoon in the regional newspaper *Florida Today* painted a suburban scene: houses displaying American flags, one man watering his lawn in an "I ♥ NY" T-shirt and Yankees cap, another pushing a lawnmower in a "Times Square" T-shirt, and a woman walking her dog with "NYC" spelled across her chest. For good measure, the dog wears one of those foam-rubber Lady Liberty crowns that tour-

ists love. They're waving to each other, as folks in Florida do, above the caption, "In light of recent events, we're *all* New Yorkers." It's a supportive message that yet contains an ominous proprietary undertone. The city is ours. Here we come.

In 2004 the Republican National Convention came barging into liberal New York for the first time in history. Deep in enemy territory, with angry protesters howling at the gates, George W. Bush supporters banged the drums of 9/11, waving the tragedy like a flag. Governor George Pataki told the delegates, "On that terrible day, a nation became a neighborhood. All Americans became New Yorkers."

The Big Apple, the Rotten Apple, was done for. The vulnerable, diminished city became as acceptably American as apple pie. Soon after 9/11, the *New York Observer* announced, "The Heartland Loves New York," claiming it had become "the most American of all cities." A year later, *The Economist* called New York a "sweeter Apple" and "a nicer place" since the attacks. Sweet and nice? Those two words, I would wager, had never in the city's long and turbulent history been seriously used to describe the unwieldy, throbbing thing that was New York. Something was changing in the civic atmosphere. While terrorism alone didn't turn the tide of America's sentiment toward New York, it surely accelerated a process already in place. In *The City's End*, a history of America's murderous fantasies toward New York, Max Page observed, "City leaders had made much of Manhattan safe and clean for tourists. A nation far more willing to be sympathetic to New York was fully on the city's side after 9/11. Pity after the disaster bloomed into a surge of love for New York."

But what did Heartland America love about New York? Did they love its openness, its diversity, its countercultural bent—its "left-wing communist, Jewish, homosexual, pornographers"? Or were they looking at New York and seeing not the true city, but a projection of their own values? There was a moment, just after 9/11, when the city was draped in American flags. You never saw them before, but now they were everywhere—hanging from tenement windows,

slapped to the sides of city buses, stuck to the bumpers of taxicabs, even decorating stacks of toilet paper in drugstore windows. It was such an unusual sight I went around taking pictures of the flags. For a little while, I draped one from my own fire escape. For many New Yorkers, the flags were an expression of solidarity, not nationalistic pride, but a symbol of our collective emotion, and probably a wish to be held by mother country. To outsiders, it must have looked as if New York had finally gotten with the program. The wayward city at last reformed. I believe that is the New York that America fell in love with after terror, not the true city, but an imaginary one that would soon be made real.

America, in its heart of hearts, doesn't like the nature of cities. The nation's anti-urbanism goes back to the Puritan colonists and has lingered since. Urbanist William H. Whyte once wrote on the urban renewal of the 1950s and '60s that, while more people were moving into cities and rebuilding them, it was "not the same thing as *liking* cities." The people doing the rebuilding, he said, "don't like cities. They do not merely dislike the noise and the dirt and the congestion. They dislike the city's variety and concentration, its tension, its hustle and bustle." Builders, planners, and politicians aren't the only ones with the power to change what they don't like about the city. Around the time of 9/11, a new sort of newcomer was arriving in New York. Steeped in conservative, consumerist suburbia, they were attracted by the rehabilitated, crime-free image of the city under Giuliani and came wielding credit cards as weapons in the fight for its soul. Terrorism didn't begin New York's transformation into a giant suburban shopping mall, but I believe it did give that transformation a boost.

In response to the attacks, "Consume!" became the city's anxious war cry. The Fashion Center Business Improvement District (BID) launched the Fight Back NY campaign to encourage people to defy terrorism and forget sorrow by spending more money. They gave out

buttons and T-shirts that read "Fight Back NY! Go Shop!" and "Fight Back NY! Spend Money!" The slogans appeared on banners mounted to light poles all over Midtown, making the message hard to miss. This was a constant theme. On September 12, while we choked on dust and horror, Giuliani told New Yorkers, "Take the day as an opportunity to go shopping." Weeks later, President Bush told America to "Get down to Disney World." This is not a helpful response to fear and grief, but it is a common one.

After 9/11, Americans began spending excessively and compulsively, mostly on luxury goods and big-brand products. This is one typical reaction to terrorism, according to several research papers. Social scientists who study terror management spend a lot of time thinking about mortality salience, our awareness that we will die. They find that when many people are confronted with death, they feel anxious, and cope with that anxiety by becoming more conservative, self-centered, and materialistic. Terrorized, filled with existential dread, they turn into super consumers, eating, drinking, and shopping to excess. This mortality anxiety is mostly found in people who worry about living up to cultural norms, especially in public. They want social approval, to be seen as rich and powerful. The conspicuous consumption of luxury goods is their go-to defense.

New York was always a commercial town, prone to flamboyant displays of wealth, but was it ever so corrupted by everyday consumerism as it became after 9/11? In *Psychology Today*, marketing psychologist Utpal M. Dholakia looked at the body of research on America's post-9/11 spending habits and concluded that terror-driven changes to consumer behavior can be catastrophic for small businesses, while upscale brands win big. He wrote, "for luxury brand marketers, terror attacks are clouds that come with thick silver linings." New Yorkers have witnessed this phenomenon firsthand. We have lost our local mom-and-pop shops while a tsunami of luxury brands and national chains deluges the city. Again, while this has largely been the result of a change in public policy, terrorism did its part.

At the turn of the millennium, New York stood at a critical juncture. After two decades of mayors making the city friendly for Disneyland Suburbia, with crime rates dropping, Heartland America was giving the place a try. At the same time, many New Yorkers had grown tired of conservative leadership. Giuliani's tenure was nearly over and there were signs that the city was correcting course, moving back to the left. In the tug-of-war battle for New York's soul, the two sides stood in a taut moment of tension. The events of September 11 would decide the game, pulling the city to the right.

As one *Daily News* reader wrote to the paper's editor on the tenth anniversary of the attacks, "Our city suffered two tragedies a decade ago: the 9/11 attacks and the election of Mayor Bloomberg. The former tried to destroy New York City; the latter succeeded."

GREENWICH VILLAGE

Demolition of artist's studio, Greenwich Avenue, May 19, 1960.
Courtesy Estate of Fred W. McDarrah

I T'S DIFFICULT TO SAY EXACTLY WHEN GREENWICH VILLAGE GEN-
trified. It didn't happen in one fell swoop as it did for parts of
town like the Bowery. New money came early to the Village,
so that by the twenty-first century, the doors to the neighborhood
were already shut. Still, I include it here because it is where New York
bohemianism was born and from which it disseminated. The Village
also serves as an example of what happens to a neighborhood late in
the hyper-gentrification process, when vultures pick the last scraps of
meat from its bones.

Greenwich Village was "a zone of rogues and outcasts from the

start," according to John Strausbaugh in *The Village*. A center for New York's black community from the 1640s through the 1800s, it was home to working-class Irish and Italians, along with prostitutes, female cross-dressers, and "fairies," as well as wealthy white families clustered in elegant townhouses around Washington Square. The neighborhood began attracting bohemians in the 1850s, when Walt Whitman was hanging with the literary crowd at Pfaff's beer cellar on Broadway near Bleecker Street. In the 1910s came the first golden age, with artists, writers, and assorted characters making their mark, including Eugene O'Neill, Edna St. Vincent Millay, Djuna Barnes, and Joe Gould. Artists have long served, often unwittingly and unhappily, as urban attractors, exposing an "undiscovered" neighborhood to outsiders, drawing tourists and investors, thus raising the price of real estate. Some, who might be labeled fauxhemians, actively participate in the process. This is not a new phenomenon. Strausbaugh has detailed how new Villagers began commercializing the Left Bank scene, marketing the culture and themselves to tourists, as early as 1915. As Malcolm Cowley put it, they had "fled from Dubuque and Denver to escape the stultifying effects of a civilization ruled by business," only to open their own businesses, filling the Village with tea shops, bookstores, nightclubs, and real estate offices. Immediately, newspapers and magazines proclaimed the end of Village Bohemia.

"By 1917," wrote Strausbaugh, "the *Times* noted a growing exodus of artists from the neighborhood, driven out by the rising rents the new tenants were able to pay," and "[b]y 1922 the *Times* was reporting that artists were in full flight," replaced by well-dressed bourgeois people who had nothing to do with art. Said one painter to the *Times*, "Young artists are being forced out of the city by the hundreds." By the late 1920s, even the *Christian Science Monitor* had declared, "Greenwich Village Too Costly for Artists to Live There," as bohemians were pushed out by mainstream Americans with middle-class money. And where were the newcomers coming from? The Midwest. *Ladies' Home Journal* joked that the Village was becoming "the cob of the cornbelt."

After the 1920s, rising rents were pushed back by the Great Depression and World War II, making it possible for a second golden age to blossom, a renaissance of artists, iconoclasts, and queers. Exiles from America, seeking a refuge nothing like their hometowns, they fled to the Village in droves to become the Beats, the Abstract Expressionists, the New York School poets. In his book *New York in the 50s* Dan Wakefield recalls moving to Jones Street in 1956, three years after the *Partisan Review* had declared "the death of bohemia" thanks to new apartment buildings for the middle class replacing coldwater flats. "It wasn't easy," Wakefield recalls, to find an affordable place. "Reasonable rentals (forget about cheap) were still possible but damnably scarce." By the 1960s, they'd become scarcer. The beatnik, with beret and bongo drum, had become a caricature in mainstream culture. He had also become a selling point. Tourists and fauxhemians flooded the Village yet again. Rents went up. But the radicals hung on. In his 1963 guide to the city, *Cue* magazine editor Emory Lewis described how the neighborhood retained its artistic, revolutionary spirit even while well-heeled Organization Men from uptown were moving in, dressing like beatniks in their off hours while their wives filled the parks with baby carriages and "well-manicured" poodles. Lewis wondered, "Will the Village become a pleasant, rich man's Bohemia with an arts-and-crafts quaintness, an easy tolerance for slight deviations from the norm but with little or none of the fire and none of the intensity of the true artists? Has Bohemia been housebroken?"

After the bohemians came the hippies, folk music, Bob Dylan, and gay liberation. In the 1970s, while gay men engaged in raw sex on the Hudson River piers, financial crisis kept the rising rents at bay. They rose again in the 1980s and '90s, when AIDS emptied the old Village apartments and filled the hallways of St. Vincent's Hospital, and then cemeteries, leaving vacated real estate for newly minted yuppies. (That indispensable hospital would shutter in 2010 after 161 years of service. According to the *Post*, the Manhattan district attorney's fraud unit investigated "whether honchos purposely tanked its

finances so it could be sold to a private developer." But the contro-
versy soon evaporated, the hospital was demolished, and up went
Greenwich Lane, a sprawling complex of ultra-luxury condos with
prices as high as $45 million. At its feet sits a shiny new park with an
AIDS memorial, a piece of modern art inscribed with Walt Whitman
quotes.) For nearly a hundred years, with each passing decade, Bohe-
mia had been declared dead. But, every time, she had rallied, hanging
on to live another day, to birth another movement in art, writing,
music, dance. In the 2000s, however, the radical old Village finally
gave up the ghost.

When I moved to the city, I thought I would live in Greenwich
Village, but affordable apartments were no longer scarce, they
were nonexistent. Still, aching to be part of a scene already vanished,
I searched the Village for the bohemianism I longed for. I had read
about the White Horse Tavern, the place where writers once gath-
ered and Dylan Thomas whiskied himself to death. The first time
I walked in, I was shocked to find a crowd of Wall Streeters in dark
suits, making their animal herding noises around the bar. But if I
went to the White Horse early in the afternoon, I could sit alone in
the quiet middle room, under the portrait of Dylan Thomas, and
nurse a pint of beer while writing poetry and chatting with an el-
derly woman named Sunny who also liked to sit in that room and
nurse a drink or two. Sunny was such a regular the White Horse
hung her framed photograph on the wall. She would tell me about
her husband, a Hollywood screenwriter who specialized in bullfight-
ing movies, and I would read her my poems.

Over time, I would discover the few authentic places of the Vil-
lage that remained uncontaminated. But loving those bars, cafés, and
restaurants has been a dangerous and painful affair. In the 2000s it
seemed that every time I fell for some place it was snatched away,
given over to a successful restaurateur to be gutted and glamorized.

A virulent trend has been sweeping the Village, and the city, in which upscale restaurateurs take over vintage spots, refurbish them, and turn them into exclusive locales, keeping their names and capitalizing on their history. It's an invasion of the body snatchers. The old places look like themselves, sort of, but there's no soul inside. The blog Grub Street called the trend "fauxstalgia."

It first happened to the Waverly Inn and the Beatrice Inn, prompting the *Times* to write about the practice in 2010. The Village, they said, "has become like a theme park of the past, as these restored standards offer a vision of a lost bohemian New York—albeit with a well-heeled clientele and prices to match." The body snatchers came next for the Minetta Tavern, originally opened in 1937 and long a hangout for writers, artists, and eccentrics, including Ernest Hemingway, Eugene O'Neill, and E. E. Cummings. The owner of Minetta's was forced to close in 2008 when the landlord hiked the rent, and the lease went to neighborhood-changing restaurateur Keith McNally. He removed the walls of ragtag memorabilia, scoured it clean, and put it back shined, curated, and just so. He took away the red-sauce Italian food and replaced it with French cuisine (plus the twenty-eight-dollar Black Label Burger). Any bohemians left in the neighborhood were unlikely to get in—reservations were impossible, prices were high, and the bar was packed with posh people who looked like they were schmoozing at the Hampton Classic Horse Show cocktail hour, all knotted sweaters and blue blazers. A muscular bouncer guarded the door, offering visual discouragement to those of us whom the blog Thrillist called "the joint's wizened, soon-to-be-muttering-outside-angrily ex-patrons."

Still, I braved the new Minetta one evening, squeezing in early to see what it had become. When I took a seat at the bar, a woman in pearls snatched the stool between us, glaring as if daring me to challenge her. When her friend arrived, also in pearls, they commenced a grueling, lockjawed discussion about the properly made Pimm's Cup. I looked away, scanning the meticulously re-created room, and no-

ticed something missing. The old Minetta's "house bohemian," as the
great Joseph Mitchell called him, was Joe Gould, aka Professor Sea
Gull, author of the mysterious *Oral History of Our Time*. For decades,
Gould's portrait had hung prominently on the wall across from the
bar. That tobacco-stained oil painting of the toothless old man with
wild gray hair and beard, mouth open to tell a tall tale, must not have
fit the new clientele. Gould had been evicted.

Fedora was another classic restaurant that fell. The first time I
ventured under the pink and green lights of its battered neon sign,
walking down the steps into the dark little Italian joint, I fell instantly
in love. I had come home, it felt, to a halfway subterranean room lit
by rosy light, walls covered with dusty memorabilia, Playbills, and
photos of handsome young men in midcentury black and white. The
room was quiet, a few tables occupied by gray-haired gay men either
in couples or dining alone on the $13.95 dinner special, a full-course
meal that might consist of antipasto with iceberg lettuce, chicken
tetrazzini, and homemade pie. The food was nothing special, but I
didn't care. It was the place that mattered, the feeling of it. You knew
it was special the minute you sat down to be greeted by George, the
acerbic veteran waiter, who snapped, "Give me a hundred minutes"
because "I've only got two hands" (on a later night, he would bark
at me to "Eat your beets," adding sympathetically, *sotto voce*, "I hate
beets"). You knew the place was special when Fedora Dorato, the res-
taurant's namesake and owner, made her nightly entrance, an event
for which everyone put down their forks to give a delirious round of
loving applause. She was a star. White-haired, slightly stooped, and
elegant, Fedora would make her rounds, greeting everyone, many by
name. "And how are you tonight, Jane," she asked the woman who
sat always at the bar milking an enormous pink cocktail served in
what looked like a fishbowl on a stem. "And how are you, my dear
friend Charlie," she said to the tremulous, elderly man who dined
with his West Indian nurse by his side. Fedora didn't know me, but

she placed a hand on my shoulder as she passed and gave me a warm welcome. I went back every chance I got.

The restaurant had been in the family for many years, opened by Dorato's father-in-law as a speakeasy in 1919. After the repeal of prohibition, Charles Dorato turned it into Charlie's Garden. When his son Henry took over, it was renamed Fedora, after Henry's wife, in 1952. In the days before and after gay liberation, the restaurant welcomed homosexuals, and into the 2000s it remained an accessible, welcoming space for men of a certain age. A regular for fifty years, local historian Warren Allen Smith told me, "Fedora's was definitely a refuge where the waiters were gay, you could camp it up and be yourself, and no problems occurred." He explained what was special about the place: "Nowhere else is there such a bargain. Nowhere else can you use a rotary pay phone. Nowhere else is change limited to installing a new lightbulb. Nowhere else can you carry on a conversation with someone several tables away, and others will join in. Nowhere else do you love being insulted by the witty waiter. Almost nowhere else can you find deviled eggs as an appetizer."

But all of that vanished in the summer of 2010 when the increasingly frail Fedora was encouraged by her family to retire and the place was rented to a new owner, the successful young restaurateur Gabriel Stulman. It seemed promising at first. "While presenting his case for a liquor license transfer," reported the blog Eater, "Stulman gave an eloquent speech on the history and importance of the eatery in the neighborhood." He appeared interested in preservation, and Fedora herself approved of him. "As it was described," Eater continued, "Fedora 2.0 will undergo a renovation similar to that of the Minetta Tavern: a few structural overhauls will be put in place, but the space will basically remain exactly as it appears today." That's not quite what happened. Once he got the liquor license, Stulman gut renovated the place. He did keep and refurbish the antique bar, along with a few other choice items, but otherwise he changed the

interior completely, outfitting the space with diamond-tufted leather banquettes and Richard Avedon prints. Just as McNally had done to Minetta's, he upscaled the menu from red-sauce Italian to French cuisine, and raised the prices high.

The last time I saw Fedora Dorato, a few days before the closure, her place was packed with farewell wishers. She was busy clearing the tables of used plates and glasses. At ninety, she still had her seemingly unstoppable energy. I asked her what she would do without the restaurant, and she replied, "I don't know. Every day, for sixty years, I baked and I cooked. Now what?" One year after the restaurant left her hands, Fedora passed away. For a little while, in homage, Stulman's drink menu featured a cocktail titled the Fedora Dorato, aka "The Spirit of the West Village." It was a mix of Grouse Scotch, Cynar, and Cocchi Americano, a favorite aperitif among craft bartenders. The drink sold for twelve dollars, nearly the cost of an entire full-course dinner at the old Fedora.

As the fauxstalgia trend continued, *New York* magazine wrote about how fashionable, moneyed restaurateurs "seem to be in a race to acquire New York's oldest, most storied properties," as if some bloodthirsty crew were hunting down the last remaining survivors, like millionaire trophy hunters who pay to prey on endangered species so they can add a rare head to their collection. Uptown, the fashionable restaurateurs overhauled the wonderful Bill's Gay 90s, in business since 1924. In the East Village, they tried to take John's of 12th Street, an Italian place unchanged since 1908. And back in Greenwich Village they gutted Rocco Ristorante, yet another red-sauce Italian joint, on Thompson Street since 1922.

Run by the original Rocco's great-nephew, Antonio DaSilva, the place was simple and affordable. In 2011, according to DaSilva, the landlord raised the rent from $8,000 to $18,000 per month. "We're fighting it," he told Eater. But the landlord gave the lease to Major Food Group, those successful young restaurateurs who created the gourmet "Beast" of the San Gennaro Feast. In the *Times,* Frank Bruni called

them "the newest darlings of the New York culinary set." With the same "it was going to be a bank" argument we heard over CBGB, the team talked in the press about how they were saving Rocco's by keeping it an Italian restaurant and paying tribute to its history. "People want to talk about New York vanishing," one told the *Observer*. "I think we're rebuilding it." In the *Times*, partner Jeff Zalaznick added, "What's it going to become? A Chase? A Duane Reade?" Renaming it Carbone, they turned Rocco into an exclusive simulacrum of its former self. *Times* restaurant reporter Jeff Gordinier called it "engineered to conjure up the feeling of a lively night downtown, circa 1958 . . . the middle of the last century as interpreted by chic players from the early part of this one," complete with Schnabel-curated art on the walls and waiters in "vintage-style" uniforms by a high-end fashion designer. They even ripped out Rocco's antique tile floor and put in a new tile floor modeled on the idea of an antique—in fact, modeled on a floor in the film *The Godfather*. Why replace the real thing with a copy of a copy? No matter. Carbone was an instant success among the wealthy and the celebrated, like Kim Kardashian, Beyoncé, and Jay-Z.

If Greenwich Village was becoming "the cob of the cornbelt" in the early 1900s, by the early 2000s it was the whole field. Midwesterners get a bad rap in the city. Those of us who come from someplace else in America are often branded with the label, no matter how geographically inaccurate it might be. Years ago, returning from a trip, I walked out of the Port Authority bus terminal with a battered vintage suitcase in my hand, looking very much like the greenhorn I was. As I stepped onto 42nd Street, a local shouted at me, "Go back to Ohio!" I didn't like it. But I understood. "Ohio" was a figure of speech, a stand-in for the unexceptional zone north, south, and west of the Hudson, the boonies and sticks, all that stuff on Saul Steinberg's 1976 *View of the World from 9th Avenue*. Still reeking of my own backwater, I had not yet become a New Yorker. I would have to keep working at

it. And I came to understand that busting on the Midwest is a New Yorker's birthright, like jaywalking and a good pastrami sandwich. This is just the way it is. We transplants mustn't take it personally.

In the 2000s, the script flipped. Midwesterners were no longer underdogs. They were conquering New York. Suddenly, people were proud to be identifiably "Ohio." They wore their hometown names on T-shirts and set up a colony in Greenwich Village. Unlike those who had fled their stifling hometowns to become Villagers, these newcomers unabashedly brought the Midwest with them, re-creating and celebrating its culture. The Kettle of Fish wasn't just a former Beatnik bar turned frat bar; it became renowned as the home away from home for Green Bay Packers football fans. A place specializing in "Wisconsin Cheese Melts & Frozen Custard" opened on once-wild West Eighth Street. And Fedora's Gabriel Stulman told the blog Eater that he and his restaurant team wanted to claim an entire section of Greenwich Village for the state of Wisconsin. He said, "We want to rebrand this, like, little pocket, the three blocks from West 4th Street down where Fedora is all the way down to, like, Christopher and Sixth Avenue. I'd like to rename this little area 'Little Wisco.' . . . You know they've got a Little Italy, I think we should make a Little Wisco in the West Village."

For the "midwesternization" of the Village, many New Yorkers blame New York University.

Tensions between NYU and local Villagers go way back. They heated up in 1947 when the school bought and demolished an entire block of buildings, evicting nearly three hundred people, many of them artists, to make room for their Law Center on Washington Square. They razed the "House of Genius," a rooming house where the likes of Theodore Dreiser, Stephen Crane, Willa Cather, and many other writers and artists had lived. In 1949, NYU took over a parcel of buildings on Washington Square North, including one oc-

cupied by the painter Edward Hopper and his wife, Jo. In a small studio on the top floor, Hopper created many of his most famous works, including *Nighthawks*, a scene inspired by the streets of Greenwich Village. NYU hiked the rents by 20 percent and refused to renew leases, according to Hopper biographer Gail Levin. Facing eviction, Jo accused the school of "Hitler-like aggression." The Hoppers fought NYU for twenty years. Edward died in his studio before the school could take it from him.

In the 1950s, NYU benefited from Robert Moses's slum clearance program, acquiring so-called blighted properties for a bargain and replacing them with a student center and a cluster of apartment buildings. In 1957, under the headline "Bohemian Flair Fades in Village," Ira Henry Freeman wrote in the *Times* about NYU turning Washington Square into their campus: "The mellow old landmarks of Greenwich Village are rapidly disappearing beneath modern glass monuments to the bourgeois respectability against which the Bohemians revolted forty years ago."

In the twenty-first century, NYU has planned a colossal expansion with a sprawling, high-rising $6 billion scheme to add approximately two million square feet of new construction by the year 2031. With support from Mayor Bloomberg and Council Speaker Christine Quinn, the City Council approved NYU's plan in 2012, despite major opposition from community and preservation groups, and even from within NYU itself, as the faculty rallied against what they called the Sexton Plan after the school's president, John Sexton, an aggressive expansionist whose reign was dubbed "The Imperial Presidency" by *The New Yorker*. In 2000, when the school demolished Edgar Allan Poe's house, Sexton told the *Times* that the building was not special and "we do not accept the views of preservationists who say nothing can ever change." In 2010, *New York* magazine called NYU "The School That Ate New York," and rhetorically asked if John Sexton was the city's new Robert Moses.

Also during the Bloomberg years, Washington Square Park got a

very expensive, very fussy makeover. Located at the center of NYU's inflating campus, the large public park had long been a gathering place for beatniks, bohemians, folk singers, drug dealers, pigeon lovers, poets, and protesters. Originally a potter's field and place for public executions, in the 1800s the park became a green hub around which wealthy families built their mansions, townhouses that were later broken up into apartments and artists' studios, and then taken over by NYU. After World War II, the park filled with young people and musicians, their numbers growing over the years. By 1961, neighbors had had enough of the bohemians, urging the parks commission to put an end to the music, and to the racial mixing that went on around the bongo drums, as recounted by John Strausbaugh in *The Village*. The ensuing protest, an occupation of the park's large central fountain, was captured in the documentary film *Sunday* by Dan Drasin. In black and white, the protesters fight for their right to play folk songs, carrying signs that read "Keep Strumming." Arguing with police, one young man says, "Real estate's at the bottom of this." Another says, "They're trying to kill the Village." The musicians won that battle, but those in power would continue trying to kill the bohemian soul of the neighborhood.

The Bloomberg administration's renovation of Washington Square Park, with landscape architect George Vellonakis, began in 2007. One of the more controversial changes was the plan to move the fountain from its 137-year-long location and push it about twenty-three feet to the east, bringing it into alignment with the Washington Arch, which opens onto Fifth Avenue. In the Washington Square Park Blog, Cathryn Swan argued, like many others, for the continuing nonalignment of the fountain and arch. She wrote, "Something about the fountain not being connected to Fifth Avenue works when you enter Washington Square Park: you escape the city—yet you meld with your neighbors within it in unimaginable and unique ways." The new design, she said, "aspires to destroy that." But the people who supported the new design cried out for symmetry, for

tidiness, as if they were compulsively straightening objects on a coffee table, aligning a stack of glossy magazines with a bowl of decorative pinecones. "That fountain is just off," said a supporter of the redesign at one of the many public hearings. "It's just off." In the new Washington Square Park, just as in Bloomberg's fussy New York, nothing was allowed to be "off." In Matt Davis's documentary *Square: Straightening Out Washington Square Park,* Vellonakis argued that the "poor tourists" had to struggle to get good photos of the arch and fountain lined up together. In 2009, the fountain was moved, giving the tourists their perfect postcard shot.

Hot dog vendors were another problem for the affluent bunch residing near the park. In 2013, Cathryn Swan revealed on her blog the existence of a private group of "wealthy women" who had incorporated themselves into "a little friends group" they called the Washington Square Park Conservancy for the purpose of keeping the park "clean, safe, and beautiful." Swan uncovered the fact that this group was interfering with the park's long-standing hot dog vendors. The president of the conservancy, socialite Veronica Bulgari of the international luxury brand, explained to the *Post,* "We got some word from our neighbors that [the hot dog vendors] were unsightly. We suggested moving them." The vendors were moved out of "the Arch view corridor." Again, something was off. Next the conservancy lobbied to remove the hot dog vendors completely, replacing them with more upscale food carts, including one from celebrity restaurateur Mario Batali that would be allowed to remain. Batali just happened to be on the board of the little friends group. Swan organized a pro–hot dog protest at the fountain, garnered high-profile press, and shared the good news on New Year's Day 2014 that the socialites had been defeated by public pressure. The hot dog vendors would stay.

In January 2014, immediately after Bill de Blasio became mayor, a judge in the state Supreme Court in Manhattan ruled that the city had broken the law when the Bloomberg administration acted "in violation of the Public Trust Doctrine" by illegally agreeing to give a

handful of small public parks to NYU for their expansion. The green spaces included Mercer Playground and LaGuardia Corner Gardens, a community garden full of flowers and fruit trees. "This is a huge victory for the Greenwich Village community," the attorney for NYU's neighborhood opposition told the *Daily News*. But the celebration was short-lived. NYU appealed and won. In October 2014 the state's highest court, the Court of Appeals, declared that the little parks were not parks after all. They gave NYU the green light to demolish and keep expanding.

We all lose when cities lose their countercultural zones to the mainstream. "It isn't possible to quantify the extent to which society and culture are indebted to Bohemia," wrote Christopher Hitchens on the destruction of Greenwich Village in 2008:

> In every age in every successful country, it has been important that at least a small part of the cityscape is not dominated by bankers, developers, chain stores, generic restaurants, and railway terminals. This little quarter should instead be the preserve of—in no special order—insomniacs and restaurants and bars that never close; bibliophiles and the little stores and stalls that cater to them; alcoholics and addicts and deviants and the proprietors who understand them; aspirant painters and musicians and the modest studios that can accommodate them; ladies of easy virtue and the men who require them; misfits and poets from foreign shores and exiles from remote and cruel dictatorships.

What happens when the cruel dictatorships are inside the city? Poets, misfits, and deviants, with their restaurants, bars, and shops, go out the window, pushed to the edges, where they momentarily

coalesce, then scatter in exile. For a progressive society, this is a major death. Creative and political movements require human connection. The Internet is useful, but it can't replace what happens in coffeehouses and bookstores and tenement kitchens. "Dissent cannot happen in a vacuum. Nor can social or aesthetic movements grow in one," Cynthia Carr wrote of New York's evaporating bohemian diaspora in 1992. "Community is the fabric that sustains experiment."

BLOOMBERG

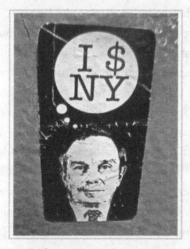

Sticker art. *Jeremiah Moss, 2010*

N O ONE GAVE MUCH SERIOUS ATTENTION TO MIKE BLOOM-berg and his mayoral run until after September 11. When he entered the race, the Republican billionaire was a novelty item. Journalists agreed he would never win. He was seen as prickly and uncharismatic, an egomaniacal mogul with three sexual harassment lawsuits swirling around him and his company, a mumbler who could not put his political platform into words. Said one constituent to *The New Yorker* after a Bloomberg speech, "He seems not quite able to articulate why he'd want to be mayor . . . other than the fact that he wants to win and he doesn't like losing."

During his campaign, Bloomberg turned people off with several offensive statements—about women, police officers, money—even insulting Staten Island, the city's most Republican borough. Then the joke book came to light. Discovered and confirmed by *New York* magazine's Michael Wolff, *Portable Bloomberg: The Wit and Wisdom of Michael Bloomberg* had been created a decade earlier by the CEO's staff members as a birthday gift to their boss. The thirty-two-page booklet included several pages of insults against gays, Jews, and women—and, even more damaging to a mayoral hopeful, against the outer boroughs. "I make it a rule never to go to Queens," read one, "and since that eliminated both airports, I don't travel a great deal." In the section on women, Bloomberg is quoted, "If women wanted to be appreciated for their brains, they'd go to the library instead of to Bloomingdale's." Referring to his computer system, the Bloomberg terminal, he was said to quip to his employees, "It will do everything, including give you a blowjob. I guess that puts a lot of you girls out of business."

With Bloomberg already on the ropes, the joke book could have knocked him out. News of this potential campaign killer broke in the first week of September 2001, just before the primaries. Michael Wolff had prophesied, "there is no turn of events at all, no leap of logic whatsoever, that could make Michael Bloomberg New York's next mayor. . . . We don't have to worry." On September 9, in the televised Republican primary debate, Bloomberg's opponent Herman Badillo slammed him with the joke book, calling him a sexual harasser. Bloomberg said he didn't remember making any of the statements, dismissing them as "a bunch of Borscht Belt jokes." He added, "Let's move on." Of course, forty-eight hours later, that's exactly what the city had to do. Events had turned.

The terrorist attacks didn't just change how America saw New York; they also changed how America, and the city, saw its controversial mayor, Rudy Giuliani. In an instant, he went from "the Mussolini of Manhattan" to 9/11 hero. For his handling of the tragedy, Oprah

Winfrey baptized him "America's mayor," Queen Elizabeth knighted him, and *Time* magazine named him Person of the Year. With all that fuss, Giuliani decided he was indispensable to a city in turmoil. We needed him, he reasoned, and only a man with his experience could lead us through the difficult days ahead. With his tenure up at the end of 2001, he suggested overturning term limits so he could have another four years in office. It was, he said, for "the good of the city." But he failed to get the necessary support. As Ed Koch told CNN at the time, extending Giuliani's term "would be very, very anti-democratic and that would never fly."

In the final campaign week of the mayoral election during the fall of 2001, a race already grievously disrupted by the events of 9/11, Giuliani endorsed Bloomberg as his replacement. The *Times* called it "the crown jewel of endorsements," due to Giuliani's post-9/11 popularity, and it propelled the novice Republican ahead of front-running Democrat Mark Green. The people of New York, frightened and traumatized, put their trust in Giuliani's judgment, allowing themselves to be convinced that only a billionaire CEO could dig Wall Street from the rubble, captivate the tourists, and avoid social chaos. New York, we were told, was in danger of going back to the "bad old days" of the 1970s. People were scared.

In *The Shock Doctrine*, Naomi Klein reveals the way neoliberal politicians and economists exploit crisis to force their agenda. She speaks to the national impact of 9/11 when she says, "What happened in the period of mass disorientation after the attacks was, in retrospect, a domestic form of economic shock therapy." I would add that nowhere was that mass disorientation more profound than in New York City. For months we wandered in a haze of smoke and trauma, waiting for another explosion, anthrax in the mailbox, sarin gas in the subway, a dirty bomb. How disoriented were we? I had spent the 1990s protesting Giuliani, but that fall I thought he wasn't so bad. I was momentarily delusional. I was not so far gone, however, as to vote for Bloomberg.

With the metallic taste of dust still in the air, in a city distracted and dissociated, Bloomberg was elected mayor on November 6, 2001, narrowly surpassing Green, 49 percent to 47 percent. The *Times* editors wrote, "It was Mr. Bloomberg's identification with Mayor Giuliani that was his most powerful weapon. New Yorkers are still traumatized by loss. . . . They need a mayor who can restore the ambitious optimism that is the core of the city's character, and over the past two weeks more and more voters began taking Mr. Giuliani's word that Michael Bloomberg was the man who could do that."

Without the events of 9/11, Bloomberg never would have come to power. What kind of New York would we have had under Mark Green? It's impossible to know, but a nervous op-ed from the *Post* in August 2001 offered some speculation. "Green's entire career has been devoted to bashing 'big business' and 'corporate abuse,'" said the editorial. "He wants big government to combat big bad business. How? By regulation and litigation. Look at the titles of his books: 'Corporate Power in America.' 'The Consumer Bible.' 'Taming the Giant Corporation.' 'The Big Business Reader: On Corporate Power' . . . Indeed, the concept of a free market is anathema to Green."

Had Green become mayor and run the city the way the *Post* feared he would, New York would be a very different place today.

I n *Bloomberg's New York*, Julian Brash provides an in-depth analysis of what he calls "the Bloomberg Way." In an interview I conducted with the author, Brash succinctly explained the Bloomberg Way as the apotheosis of neoliberal ideology: "a notion of governance in which the city is run like a corporation. The mayor is the CEO, the businesses are clients, citizens are consumers, and the city itself is a product that's branded and marketed." What kind of product? Bloomberg described it himself: "If New York City is a business, it isn't Wal-Mart—it isn't trying to be the lowest-priced product in the market. It's a high-end product, maybe even a luxury product."

What this meant for the working class was that they were no longer considered "the heart of the city," as they had been for generations. City Hall no longer had to placate them. As Brash put it, the Bloomberg administration communicated, in essence, "Sure, we need people around to fight fires and serve sandwiches, but it's not their city. It's really a city for the well-off." And that meant the whole city. From the beginning of his regime, the mayor made it clear that his goal was to dramatically remake New York into a luxury product that would attract and sustain the superrich, as well as those who could aspire to be superrich. He began with a far-flung plan to rezone huge sections of the city, from borough to borough.

Brash showed me a brochure he'd picked up at a 2004 speech given by then–deputy mayor Dan Doctoroff. In the brochure, titled "Bloomberg Administration Major Economic Development Initiatives," the grandiose strategy was laid out, with before-and-after reimaginings of neighborhoods, along with a map of the entire city. Its development-targeted sections marked in livid purple, the map is covered in bruises from Throgs Neck to Bayside, down to Coney Island and across Bedford-Stuyvesant, with a contusive belt cinched tight all the way around Manhattan, and much of the city south of Central Park darkened by the shadows of "initiative." No place would be untouched by Bloomberg as he pushed a furious development agenda that Brash called "Robert Moses–type stuff."

Like Moses, the Bloomberg administration would hack into the city with eminent domain. Governor George Pataki helped. "Why can't anyone fight developers anymore?" asked Karrie Jacobs in New York. "Because builders have discovered that if the state likes their proposals, Pataki will tear down whatever is in the way. . . . New York State has the most developer-friendly eminent-domain laws in the country."

The task of taking New York back from the working class, begun in the 1920s, was effectively completed by Bloomberg. His administration converted big chunks of functioning industrial land to upscale

residential and commercial use. In the first decade of the 2000s, in-
dustrial employment dropped twice as fast in New York as it did in
the rest of America. As Bloomberg said to the *Financial Times* in 2003,
"New York City should not waste its time with manufacturing."

In 2013, at the end of Bloomberg's tenure, Amanda Burden, direc-
tor of the Department of City Planning, released a new map: "Neigh-
borhoods Count: Celebrating DCP Rezonings." Compared to the
map of a decade earlier, the later one is almost halfway covered over
in bright splotches marking successfully "revitalized" areas. Cover-
ing more ground, the splotches look like a disease that has metasta-
sized. Bloomberg accomplished his original goals and then some, in
the end rezoning 40 percent of the city.

The rules were changed for thousands of city blocks. Some of the
new rules were meant to preserve neighborhood character by lim-
iting growth (an act that often raises property values), while many
others aimed to open territories for higher rents and bigger develop-
ment. The former is known as *downzoning* and the latter as *upzoning*.
How did the Bloomberg administration decide where to downzone
and where to upzone? Looking at 2010 research from NYU's Furman
Center for Real Estate and Urban Policy, Sarah Laskow at *Politico New
York* discovered: "Upzoned lots tended to be in areas that were less
white and less wealthy, with fewer homeowners. Downzoned lots
tended to be areas that were more white and had both higher in-
comes and higher rates of homeownership." That meant "more privi-
leged people were more likely to have the city change the zoning
of their neighborhoods to preserve them exactly as they were." Less
privileged people got upzoned out.

Reading the city's descriptions of the rezonings is an exercise in
deciphering doublespeak. The planners congratulate themselves for
"balancing growth and preservation," ensuring that "future devel-
opment is consistent with neighborhood character," while fostering
"new opportunities for residential development" and encouraging re-
tail uses. That amounted to an all-you-can-eat buffet for developers—

and the new New Yorkers they attracted. Here are just a few highlights from the DCP's rezoning timeline:

2003: 109 blocks of Manhattan rezoned, mostly in Harlem and East Harlem, along with hundreds more in Brooklyn, Queens, and the Bronx.

2004: Nearly 1,000 blocks rezoned in Queens, another 500 in the Bronx, and 429 in Brooklyn, including the luxury rezonings of Williamsburg, Greenpoint, and Downtown Brooklyn.

2005: The Hudson Yards and West Chelsea/High Line sections in Manhattan are rezoned for luxury high-rise development that radically changes the West Side.

2007: A whopping 1,409 blocks rezoned in Queens—including plans for the corporate retailing of Jamaica—and 206 blocks in the Bedford-Stuyvesant section of Brooklyn, designed to provide opportunities for the construction of taller buildings.

2008: Harlem's 125th Street is rezoned in a highly controversial "revitalization" that the local community fights—and loses.

2009: 19 precious, heartbreaking parcels of Coney Island are given over to multinational corporations.

2010: North Tribeca is rezoned to get rid of its holdout manufacturing area and replace it with upscale development.

2011: 18 blocks of Hell's Kitchen are rezoned because the neighborhood is now considered a "desirable place to live."

In the middle of 2013, pushing hard to drive his brand deeper into the city's hide before he was done, Bloomberg and an army of real estate developers started flooding the DCP for approvals on dozens of "legacy" projects, including: an outlet mall and giant Ferris wheel for Staten Island, a commercial rezoning in the Bronx, a 73-block rezoning and destruction of the neighborhood around Grand Central Terminal (the *Times* called it "The Plan to Swallow Midtown"), a $350 million soccer stadium, a tower of extra-small

"micro apartments" that have been deemed bad for mental health and technically illegal due to their small size, and the redevelopment of the Domino Sugar factory, with plans to replace the Brooklyn waterfront property with a cacophony of glittering new buildings. The total cost was expected to surpass $12 billion, with millions coming from taxpayer subsidies. As of this writing, these legacy projects are still working their way through the government machine.

When you operate in an overbuilt metropolis," Robert Moses famously said, "you have to hack your way with a meat axe." Like its predecessor, the Bloomberg era meat axe swung with fury. According to the Rent Guidelines Board's 2013 Housing Supply Report, nearly 25,000 buildings were demolished during the Bloomberg years of 2002–12. Here's a staggering bit of information from the report that might put things in perspective: "the number of buildings demolished between 2005 and 2007 alone was almost triple the number demolished in all the years from 1990 to 1999 combined."

In the wreckage of human evictions and devastated multigenerational businesses, about 40,000 new buildings went up, another big number. Many of those buildings were dull Midtown-style towers, all polished glass, sheet metal, and edge. Some of them came out so shiny, their skins blinded motorists driving by. In their eerie blue shadows the old brick buildings collapsed. The streets, once warmed by masonry's earth tones, grew sterile and chilled, paved in stainless steel like the etherized insides of operating rooms.

The colorful, idiosyncratic newsstands of the streets were also forced to fall in line. In 2003, Bloomberg signed the street furniture bill, aiming, in his own words, "to rationalize the streets of the city, where right now it's a hodgepodge of unattractive things." (Hear the echoes of the RPA men who yearned in 1929 to "rearrange the hodgepodge" of the working-class city and "put things where they belong.") The city seized hundreds of stands from their owners, re-

placing them with identical stainless steel and glass boxes by Cemusa, a Spanish advertising company. As the *Times* explained, "Before 2003, newsstand operators paid the city a licensing fee, but owned and paid for their newsstand. . . . Now the newsstands are owned by Cemusa." At one point, Bloomberg reportedly wanted the mom-and-pop operators to pay for the new stands—at a cost of up to $40,000 each. That's like the government seizing your house, building a new house you'll rent from a corporation, and then charging you for its construction. Luckily, that didn't wash, but the old stands still fell. A lawyer for the Newsstand Association called the bill "an unconstitutional taking of private property." The courts sided with Bloomberg. The old stands were bulldozed. Many had been in place for decades, passed down through generations of owners, each one personalized. They were human-sized, weather worn, painted in candy colors—red, green, blue. Now our sidewalk newsstands are dead-faced iceboxes, clones that mirror the towers that rise behind them, all part of the city's new anesthetized aesthetic.

Through gut renovation, the city is becoming a dull landscape of Anyplace, USA, in which New York looks less like New York and more like downtown Denver, Dallas, Toledo. Same towers, same coffee chains, same mega-mall typefaces and cinnamon-bun compulsions, buildings made of shiny surfaces that face each other, admiring themselves in their neighbors' empty reflections. In those endless repetitions, that recursive loop of nothingness, we walk through a hall of mirrors, disoriented and dislocated.

On April 25, 2006, in the middle of all the meat-axe swinging, New York's patron saint of neighborhood preservation, Jane Jacobs, died. Something shifted in the ether. Just months later, her nemesis, the Goliath to her David, rose from the dead, resurrected and redeemed. Robert Moses, long considered a villain, suddenly had admirers coming out of the woodwork. The "master builder"

received his own upscale renovation with many favorable reapprais-als, including *Robert Moses and the Modern City: The Transformation of New York*, a book by historian Kenneth Jackson that accompanied an academic conference and large-scale exhibition celebrating Moses's impact on the city. In the *Times*, Phillip Lopate asked, "If the city is surviving so well, to what extent should we attribute its resiliency to the changes wrought by Robert Moses? If we truly love New York, how can we hate Moses, since he did so much to reshape the city into the one we enjoy now?" Was this the same brute who ripped out the city's guts and tore apart countless communities?

Meanwhile, the soul of Jane Jacobs was continually co-opted by the planners in Bloomberg's administration. Amanda Burden claimed to think like Jacobs while behaving like Moses, an impossibly absurd contradiction. At a forum on Jacobs and Moses at the CUNY Graduate Center in 2006, Burden said, "It is to the great credit of the Mayor that we are building and rezoning today once again like Moses on an un-precedented scale but with Jane Jacobs in mind." Jacobs had only been dead six months—from what I can tell, this phrase was never uttered while she was alive. Burden said it again to the *Times*: "I like to say that our ambitions are as broad and far-reaching as those of Robert Moses, but we judge ourselves by Jane Jacobs's standards." (Upping the Frankensteinian ante, Bloomberg has since called Janette Sadik-Khan, who was his Department of Transportation commissioner, "the child that Robert Moses and Jane Jacobs never had," bringing to mind a rather unsavory libidinal image.) Yet the Bloomberg admin-istration seemed to use Jacobs's standards only when it suited their agenda. "What mattered most to the administration," writes Scott Larson in *Building Like Moses with Jane Jacobs in Mind*, "was producing an ascendant global city whose quality of life was a selling point and an object of consumption. When Jacobs and Moses could be bent to serve those purposes, they were."

I wonder if Amanda Burden, a former socialite and heiress to the Standard Oil fortune, felt any ambivalence about comparing herself

to old Jane, a middle-class woman whose aunts did not marry Astor, Roosevelt, and Whitney, as Burden's did, and who was born plain Jane Butzner in Scranton, Pennsylvania, to become the "crazy dame" housewife who saved the Village from destruction in the 1950s and '60s, and who still had the fight left in her, right up to her death. In 2005, responding to the city's proposed rezoning of the Williamsburg-Greenpoint waterfront, Jacobs wrote an angry letter to Bloomberg and the City Council. She said: "the proposal put before you by city staff is an ambush containing . . . destructive consequences, packaged very sneakily with visually tiresome, unimaginative and imitative luxury project towers. How weird, and how sad, that New York, which has demonstrated successes enlightening to so much of the world, seems unable to learn lessons it needs for itself." This may have been Jacobs's last word on New York. The Bloomberg administration did not keep it in mind. They were unapologetically pro-development, as Burden would admit to the *Times* in 2012, saying, "What I have tried to do, and think I have done, is create value for these developers, every single day of my term."

I n 2008, nearing the end of his legally allowed two terms in office, Bloomberg hatched his own scheme to change the law on term limits and keep himself in power. It was a reversal of his own opinion, which he stated clearly in 2005: "The public wants term limits . . . deliberately saying to the public 'we don't care what you think' is, I would use the word disgraceful." But 2008 had brought another crisis to New York City, and Bloomberg argued, just like Giuliani after 9/11, that the city needed him. He was the only man who could steer us through the latest catastrophe. Had New York been attacked again? Had thousands of people been murdered? No. Wall Street had created an American nightmare and brokers were losing their bonuses. Something had to be done and we needed a billionaire CEO to do it. A majority of the City Council agreed, including Speaker Christine

Quinn, and after only two days of hearings, without a public referendum, they voted to temporarily abolish the limits so Bloomberg could have a third term. The mayor himself signed the bill into law. On the day of the vote, councilman and future mayor Bill de Blasio of Brooklyn stood up to say, "George Orwell in particular would love the arguments being made today by the Speaker, the Mayor, and others. . . . The people of this city will long remember what we've done here today, and the people will rightfully be unforgiving. We are stealing like a thief in the night their right to decide the shape of democracy."

But the people of New York did not remember, or they were too frightened, again, in the grip of shock. They didn't rise up in the streets, didn't mob City Hall, didn't storm Gracie Mansion with pitchforks (which would have been pointless, since Bloomberg never deigned to live in the two-hundred-year-old mayoral residence, opting for his eleven other homes across the city and the globe). In 2009, New Yorkers voted once more for the man who had spent more than $260 million of his own money to win three elections. He knew best.

The paternalistic attitude of the mayor created what became widely known as the Nanny State of New York City. Bloomberg started early by banning cigarettes in bars and restaurants, followed by public parks, beaches, and pedestrian plazas. He tried to block the sale of sugary drinks in sizes larger than sixteen ounces—with special dispensations for large corporations, of course. (The state Supreme Court called his ban unconstitutional, a violation of the separation of powers.) He tried to stop the U.S. Department of Agriculture from letting poor people use food stamps to buy soda of any size. He led an assault on salt, banning food donations to city-run homeless shelters because the sodium and other nutritional content could not be measured. The clean-freak Bloomberg administration gave letter grades to restaurants and sent out the Health Department to white-glove-

test the city. In the East Village they forced the venerable McSorley's saloon to clean the hallowed dust from the wishbones that have dangled above the bar since doughboys left them there for luck in World War I. The saloon's cat, Minnie, affable descendant of a million Minnies, also got the boot (as did Matilda, beloved lobby cat of the Algonquin Hotel). As *Times* writer Dan Barry put it at the time: "old New York and new New York remain in conflict, and old New York is losing." While old New York was not about salt, cigarettes, and gallons of Coca-Cola, it was about freedom and permissiveness.

In *The New Yorker,* satirist Andy Borowitz joked, "To a lot of people, Mike Bloomberg will be remembered for reducing smoking and improving people's diets. But that shouldn't overshadow his greatest accomplishment, creating unaffordable housing throughout New York. When Mike took office, this city was teeming with regular working people. Today, it's a magnificent tapestry of investment bankers, real-estate developers, and Russian oligarchs."

After the mayor's third term, his right-hand woman, Council Speaker Christine Quinn, ran for City Hall, promising to extend the Bloomberg way for another four years. Endorsed by all the major city papers and backed by Bloomberg, Quinn was widely considered the frontrunner. But as the increasing inequality of the city became more obvious, New Yorkers decided they didn't want more Bloomberg. In the Democratic primary, Quinn swept the superrich Manhattan corridor of lower Park Avenue through the Upper East Side, but barely got on the map in the outer boroughs. The majority of the city went with Bill de Blasio, the Brooklyn councilman who had invoked the consciousness of George Orwell back in 2008 at the hearing in which Quinn voted to abolish term limits. Finally, the city said no more.

Weeks later, by a landslide, New Yorkers elected Bill de Blasio mayor, defeating Giuliani's Republican deputy Joe Lhota 73 to 24 per-

cent. After twenty years of living under the thumbs of Giuliberg and Bloomiani, New Yorkers were done. Bill de Blasio had sold himself as the anti-Bloomberg, promising higher taxes on the rich, protections for small businesses, an end to corporate subsidies, and an attempt to heal the "tale of two cities," the gaping rift between rich and poor. He and his family looked free, unconventional, even transgressive. With his African-American, former lesbian, feminist poet wife and his mixed-race kids, the Italian-American de Blasio looked to many of us like the old city we missed and hoped to resurrect. His son's outsized Afro, a splendid poof of untamed hair, became an evocative symbol of what the new administration might be: unfurled, a little radical, old-school, maybe even fun—the 1970s city, but with a smile. On election night, as the mayor-elect walked to his victory speech, teen singer Lorde's "Royals" played over the loudspeakers, a song that criticizes lust for money. "We'll never be royals," goes the refrain, "it don't run in our blood, that kind of luxe just ain't for us." The Post called the choice "a strong message of class consciousness that many listeners took to be a slap at the current billionaire mayor, if not all wealthy New Yorkers." The slapping continued into Inauguration Day.

In his address at City Hall, de Blasio spoke critically of the luxury city, the 1 percent, and trickle-down economics, saying, "We are called to put an end to economic and social inequalities that threaten to unravel the city we love. And so today, we commit to a new progressive direction in New York." He invoked the names of Al Smith, Fiorello La Guardia, and Eleanor Roosevelt. Public Advocate Letitia James, the first woman of color elected to citywide office, put a sharper point on it, saying, "We live in a gilded age of inequality where decrepit homeless shelters and housing developments stand in the neglected shadow of gleaming multimillion-dollar condos."

Cheers went up from the crowd. A man waved a sign that read, "The End of an Error." For many of us standing on the sidelines that day, it was a thrilling moment, filled with hope. We believed—falsely,

it would turn out—that we were getting our New York back. But not everyone cheered. Cameras cut to Bloomberg seated onstage, arms crossed and lips clamped tight. He had good reason to look perturbed. The event was engineered as a repudiation of his vision. The *Times'* editorial board called many of the inaugural speeches "graceless and smug." They argued, "Mr. Bloomberg had his mistakes and failures, but he was not a cartoon Gilded Age villain."

After his time in office, Bloomberg formed Bloomberg Associates, an international nonprofit consulting service made up of his best and brightest, including Amanda Burden and Janette Sadik-Khan. Together they are spreading the Bloomberg Way across the globe.

11

THE GOLD COAST OF BLEECKER STREET

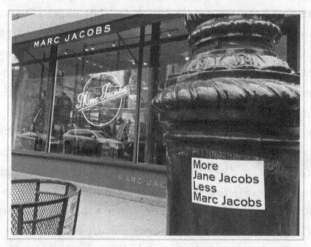

Bleecker Street, "More Jane, Less Marc" by Mike Joyce. *Jeremiah Moss, 2017*

IN THE YEAR 2000, THE HBO SHOW *SEX AND THE CITY* FILMED A scene outside the Magnolia Bakery on Bleecker Street in Greenwich Village. Carrie Bradshaw took a carefree bite of a pink-frosted cupcake, crumbs falling from her lips, and the world shook. Tourist fans of the show came clamoring to stand in long lines at the bakery, many of them disgorged from *Sex and the City* tour buses in orgiastic mobs. The crowds grew so unruly, the bakery hired a linebacker-sized bouncer to stand at the door and maintain control.

Until that cupcake craze, the westernmost end of Bleecker Street

was quiet, a largely residential stretch with mom-and-pop shops—
dusty antiques stores, small boutiques, delis, a bookstore, a few ca-
sual restaurants, all independent businesses. But with one bite of a
cupcake, the winds violently changed, and someone smelled poten-
tial in the wafts of buttercream. The Marc Jacobs company opened a
shop across the street from Magnolia in 2001. Said a Jacobs represen-
tative to the *Villager* newspaper, "Our goal was to take advantage of
the huge concentration of young people who flooded into the area,
especially with the *Sex and the City* show." The larger plan could not
have been more simple, or more ambitious. Said Jacobs president
Robert Duffy, "If I could have 20 stores on Bleecker Street, I would."
They came pretty close. Marc Jacobs soon opened another store on
Bleecker, followed by another, and another, and another, their spores
spreading and multiplying like mushrooms after a heavy rain. Ralph
Lauren, Intermix, and other upscale chains followed. By 2005, just
four years after the first Marc Jacobs store opened, the *Times* reported
that retail rents on Bleecker were going for $300 per square foot, up
from only $75 in 2002, with monthly retail rents shooting as high as
$25,000. Wrote *New York* magazine, "Soho took fifteen years to be-
come a handbag colony. Bleecker took only three."

Many locals were not happy with the rapid changes. They grew
tired of the ruffled paper wrappers that tourists tossed to the side-
walk after eating cupcakes, and tired of the armies trooping from
the bakery to a townhouse on Perry Street where the Carrie Brad-
shaw character "lived" on *Sex and the City*. The owners of the house
stretched a chain across their stoop and hung a NO TRESPASSING sign
to dissuade tourists from posing for snapshots. It didn't work. The
out-of-towners climbed over the chain. One tenant reportedly tried
to keep people away by sitting outside and screaming "Idiot! Idiot!
Idiot!" over and over. It was a shared sentiment. As one local said to
the *Villager* on the topic of *Sex and the City* tourism, "it's pointless and
stupid. It is such a failure of imagination. Why would people visiting
New York City waste their time with a fake location on TV?"

Bleecker Street's plastic transformation became a rueful joke, a symbol of how quickly—and stupidly—the city was changing. David Rakoff referred to it when he called New York "[a] metropolis of streets once thriving with local businesses and services now consisting of nothing but Marc Jacobs store after Marc Jacobs store and cupcake purveyors (is there anything more blandly sweet, less evocative of this great city, and more goyish than any other baked good with the possible exception of Eucharist wafers than the cupcake?)." Even Sarah Jessica Parker, who played Carrie Bradshaw, lamented the changes. Understanding that people blamed *Sex and the City* for wrecking the Village, she told *New York* how she and her husband, Matthew Broderick, miss the 1970s, when the city was wide open. She said, "there's just so much money now, and the city is so affluent, and all the colors, all the shops, the look of a street from block to block is just terribly absent of distinguishing coffee shops, bodegas. All of that stuff that made it possible to live in New York is gone."

In quiet protest, bright yellow postcards started popping up around Bleecker, propped in store windows, on café counters, even pinned to the shirtfronts of senior citizens sunning on park benches. In black Helvetica type, the postcard read: "More Jane Jacobs, Less Marc Jacobs." A guerrilla campaign created by graphic designer Mike Joyce, the slogan went onto T-shirts that quickly sold out. Joyce told me in an interview, "Probably the biggest question I am asked is 'Who's Jane Jacobs?'"

The western end of Bleecker Street was soon nicknamed "Rodeo Drive East" and the "Gold Coast," as every last one of the small businesses from Tenth Street to Hudson was pushed out by skyrocketing rents. By 2008 the prices had jumped again, to $550 per square foot, with some retailers reportedly paying $80,000 per month just to be on the street paved in gold.

Nusraty Afghan Imports was forced out after thirty years on

Bleecker when the landlord raised the rent to a reported $45,000 a month. When I visited the elder Mr. Nusraty he was sitting in his colorfully cluttered shop, surrounded by Persian rugs, beaded necklaces, and wooden statues. He was busy polishing a ring for a customer. "It's his grandfather's ring," he told me. "It was broken. I sent it to be fixed in Brooklyn. I charged the kid ten dollars. Nothing. I make nothing from this. But he is happy." He explained his business approach: "I do it for the pleasure, not to make a million dollars," he said, holding up the ring. "This doesn't make me rich." Later, Nusraty found a new location several blocks away, but moved again a few years after, perhaps still seeking the stability he knew for decades on Bleecker. As for his original spot, Brooks Brothers moved in, stayed for a while, and then left. For months now, it's been sitting empty and for rent, apparently asking more than even Brooks can afford.

The Biography Bookshop, after twenty-five years, was priced out of its prime location in 2010 when the rent increased eightfold. I worked nearby at the time, and went often to browse the well-stocked discount tables and selection of new titles. It was a rare occasion when I didn't walk away with at least one book in hand. I was heartbroken when I heard of their move (they ended up on the slightly more affordable—for now—eastern end of Bleecker, several blocks across town). It felt like a breaking point. As one of the store's employees told the *Observer,* "The locals have no reason to walk down this street anymore, I mean, who wants a thousand-dollar purse?" To which a customer added, "The neighborhood will be a retail wasteland hellhole" without the bookshop. And what moved in to their space? Another Marc Jacobs store. This time, instead of a clothing boutique, Jacobs hatched a bookshop called Book Marc. When I ventured in to report on it, I found fashion accessories where books used to be, including $88 leather bags, branded totes, key chains, and blank notebooks with covers that dumbed down classic titles from literature. "Moby's Dick (LOL)" was one title. "As I Lay Tanning" was another. What books they had on the shelves were heavy on images and light

on words. The handful of wordy books were arranged not by author or title, but by the colors of their spines, so that *The Letters of Sylvia Beach* alternated with *House of Versace*, creating a striped pattern in olive green and black, the hot color combination of that fall season.

As the decade turned, the anointed Gold Coast of Bleecker was choked with more tourists and more high-end shoppers. They stepped out of chauffeured cars, walked while fingering their iPhones, and knocked you in the stomach with oversize bags. More old businesses fell away. The Treasures and Trifles antiques shop shuttered after forty-four years (said the co-owner to the *Observer*, "Bleecker Street is a mall now. They've ruined the Village, as far as I'm concerned"), Leo Design antiques closed after fifteen years, and the Toons Thai restaurant closed after twenty-five to become a European boutique.

In 2012, walking along the four blocks of Bleecker between Hudson and West Tenth Street, I counted forty-five retail spaces taken over by upscale shopping mall chains. The last two holdouts on that stretch vanished within months of each other. After thirty-six years, a ragtag art gallery and framing shop called A Clean, Well-Lighted Place shuttered. The realtor crowed in the listing, "This is the 1st time in over 3 decades this Store has become available! Located in the heart of the Far West Village Gold Coast Retail Mecca." The gallery was replaced by Maison Martin Margiela, specializing in Parisian avant-garde fashions. Later that summer, the Arleen Bowman Boutique lost its lease and closed after twenty-five years. When I asked Bowman why she thought her landlord had denied her a lease, she replied, "because the landlord was not interested in having me as a tenant anymore. They are only interested in high-profile companies." The juggernaut of luxury continued to press east, pushing out the great Manatus diner in 2014. Since 1985, Manatus had been a haven for the LGBTQ communities and now it was the last affordable place to eat for blocks around. According to a neighbor, they were denied

a lease renewal and their rent was hiked to $50,000 per month. The place sat empty for years.

I n all that banality, there was one strange, bright spot. For a few years, in the fall, a group of dancers called Unison Fetish kicked their way through the tourists on western Bleecker. The troupe consisted of a half-dozen women and men, all attired in matching hot-pink dresses and tap heels, each holding cupcakes in their fists while they sang to the tune of "God Bless America":

> God bless Magnolia
> Cupcakes we love
> Stand in line here
> For a time here
> Buy a treat Carrie Bradshaw would love
> Bless Ralph Lauren
> And Marc Jacobs
> All the global luxury brands!
> God bless Magnolia
> Temptations so sweet
> God bless Magnolia
> And the New Bleecker Street!

As the dancers trotted past, clicking through their routine in front of the bakery, the meaning of their words seemed lost on the shoppers, who all smiled and snapped photos. Did they think the dancers' proclamation of "Upscale shoppers unite" was a serious call to arms? Maybe the satire was too subtle—or confusing. I heard a little tourist boy ask his mother, "Why is there a man in a dress?" His mother, perhaps unappreciative of the Village's history as a haven for the queer and the whimsical, answered derisively, "Because people are weird." Where on earth was I?

PART TWO

I arrived at the tail end of an era when New York had remained basically unchanged for thirty years—a real city, a dangerous one for the unwary transient, feared and detested by the rest of America. The ersatz, provincial, "post-9/11" New York is a holiday camp for university students and a pied-à-terre for Chinese billionaires, a place any young painter, writer, or musician would be wise to avoid, since it's no longer possible to live there on slender means.

—GARY INDIANA, FROM *I CAN GIVE YOU ANYTHING BUT LOVE*, 2015

IN THE NEW NEW YORK

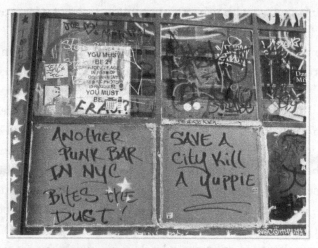

Graffiti on windows of Mars Bar. *Jeremiah Moss, 2011*

I T WAS PROBABLY AROUND 2005, THREE YEARS INTO BLOOMBERG'S tenure, when I began to notice that something was not right with New York. While it was true that small shops, bars, and restaurants had always come and gone, they seemed to be going faster than ever, replaced by national chains and upscale businesses. More old buildings were tumbling down and more new ones were rising up, all looking the same. But it wasn't just the physical body of the city that was changing so dramatically; it was also the atmosphere. I couldn't quite put my finger on it, but I could feel it.

The psyche of the city was shifting.

Throughout the twentieth century, New York's tone was set mostly by the children of immigrants, both working-class wiseguys and neurotic intellectuals, as Joshua Freeman notes in *Working-Class New York*. The city's style was argumentative, ironic, and often funny. "Wherever you looked," Freeman writes, "there was a know-it-all, a smart aleck, somebody looking for an angle." New York was brash and opinionated, but also open and democratic. It was a disposition I knew from my own family of working-class Italians, a language of toughness mixed with warmth, the taunting kind of tolerance, and a talent for storytelling. *Colorful* is the word.

In the 2000s, this color and warmth was rapidly draining from the city, replaced by something dull and cold. Where there had been gruff affability, there is now chilly disdain. Where there had been mutual recognition, there is disregard. And that famed rudeness of New Yorkers, really a combination of urban impatience and healthy suspicion, has been replaced with the icy aura of contempt. It's as if your best friend, that warm, funny, irreverent person, went away to summer camp, hung out with all the wrong people, and came back mean. Your friend is now your bully. That was the change I began to feel in the early 2000s.

I complained to everyone who'd listen—until they got tired and stopped listening. *It was 9/11*, I'd say. *It's Bloomberg. You can feel it in the air. Walking down the street. Something is happening to the city.* But no one believed me. Native New Yorkers, more than anyone, told me, "The city is always changing. This is normal." But I knew it wasn't normal. I became obsessed, an unrelenting Cassandra, a grumbling Jeremiah that no one paid attention to. I needed an outlet. I launched my blog in the summer of 2007 and called it Vanishing New York. While I wrote about lost dive bars and greasy spoons and bookshops, I also tried to analyze a new personality in the city, a type I called the Yunnie, for "Young Urban Narcissist," an obvious play on *yuppie*. It wasn't quite right, but I was trying to get at something that's hard to get at. I still am.

I was surprised to find that people were actually reading the blog. By October of that year, I appeared in the *New York Times* for the first time, described as "a frustrated man," talking on the topic of the vanishing city. More readers tuned in and I realized I was not the only one to notice that something dreadful was happening to the soul of the city.

That same October, at the Donnell Library on West 53rd Street, the Municipal Art Society held a panel discussion titled "Is New York Losing Its Soul?" Tickets for the event quickly sold out and people loitered outside the library hoping for scalpers. Inside, the audience was restless, ready to be whipped into an angry froth. The moderator, Clyde Haberman of the *Times*, started off by saying there was an implied "yes" to the question of the night, New York *is* losing its soul. You feel it, he said, "under the relentless bulldozer of homogenization . . . as you see one small shop, one small restaurant after another just basically ground down and replaced by—does it have to be one more bank? Does it have to be one more Duane Reade or CVS? People on the Upper West Side are nearly in revolt, but they won't revolt because they'll just go to Starbucks and take care of that." After an enthusiastic round of applause, he continued, crediting the soul loss to "an administration that has yet to meet a developer to whom it wishes to say no." At the end of the panel discussion, several older audience members acted like true New Yorkers, standing up to yell out their opinions. It was colorful and it was good.

That night, we had no idea that the Donnell Library itself was about to be soul-murdered. Just weeks later, Paul LeClerc, president of the New York Public Library, announced that the building would be sold for $59 million, demolished, and replaced with a luxury hotel tower. Built in 1955 and still the second-busiest branch of the NYPL, the Donnell had long been a center of culture, featuring films, lectures, and poetry readings. A. A. Milne's original Winnie the Pooh doll lived there, sitting in his threadbare fur in a bulletproof, climate-controlled glass cube. Like Pooh, the Donnell was on the scruffy side,

a fact that made it accessible—and vulnerable to those who insist that everything must be shiny and new. LeClerc told the *Times*, "We're very conscious of the quality of design that is presently on that street. We're not going to be the poor, shabby neighbor anymore."

A tragic symbol of the city's shift from public to private, community to corporate, shabby to flashy, the Donnell was shuttered in 2008. It sat empty until 2011, when, against public protest, it was demolished to make room for a fifty-story, $403 million combination hotel and condo tower. Opened in 2015, the Baccarat Hotel & Residences boasts rooms for $899, a suite for $18,000 per night, a restaurant that caters to "Eurotrash, oligarch wannabes, and hedge-funders" (*New York Post*), and "a boutique store selling crystal with price tags up to $10,000" (*Wall Street Journal*), all topped by a $60 million penthouse where "the master bedroom is large enough to house two New York studio apartments" (*Forbes*).

At the base of the hotel, buried underground, a new public library opened in 2016. It is sleek, stark, and only one-third the size of the original. People sit on designer bleacher seats, staring blankly into space or checking their phones, not reading books. There aren't many books here to read. Instead, a large screen plays videos of the city, including several scenes of luxury towers going up. *Times* critic David Dunlap wrote that the library "may remind you of the 10th Avenue Square and Overlook on the High Line in Chelsea. Or the Prada store at Broadway and Prince Street in SoHo." It will not, however, remind you of a library.

I visited the place when it opened and then went upstairs to the Baccarat's second-floor bar and lounge. I wanted the full dystopian experience. The lounge is luxurious, decked out in white leather chairs, soft carpeting, and tall vitrines of crystal. When I entered, the hostess gave me a haughty look and tried shuffling me off to an uncomfortable back corner. I resisted, taking a seat at the center, feeling like a bold street urchin in my sneakers and T-shirt. I did not order the $375 super-premium cocktail "Le Roi," but just a regular over-

priced drink. When he placed it on the table, the waiter instructed me to "taste the glass." I obliged and said, "Mmm," though the glass just tasted like glass.

The people around me all looked bored, done with life, as they stared into their iPhones. When they talked, they talked only about money and real estate, as if nothing else existed. I sat back and breathed in the extravagant air of the globalized, lobotomized nouveau riche that filled the room like chilly vapor. This was the air I had begun detecting years ago, the stuff that seeped quietly into choice corners of the city where it had not been before. I felt it in the East Village and Greenwich Village. I felt it on the Bowery. In the chapters to come, between visits to the dramatically altered neighborhoods along the west side of Manhattan, I will try to illustrate and analyze that psychic shift. A city's personality, after all, comes from its people.

HIGH LINE 1:
THE MEATPACKING DISTRICT

Atlas meatpacking plant, Washington Street.
Gregoire Alessandrini (www.nyc90s.com), 1994

I N 1997, *NEW YORK* MAGAZINE PUBLISHED A COVER STORY TITLED "The Wild West," asking: "Can lawyers and club kids and drag queens and butchers find happiness together in Manhattan's meatpacking district?" It was a turning point between the old world and the new.

The old world was meatpackers. They'd been there since the late 1800s. In the 1970s, there were nearly two hundred businesses handling meat on the streets along the far west side of Manhattan just south of 14th Street. Under metal awnings, sides of beef hung

on hooks, dripping blood and fat onto sidewalks, where men in red-smeared smocks toiled in predawn darkness. The old world was underground sex. In the 1970s, queer and kinky sex clubs began opening—the Anvil, the Spike, the Hellfire, and the Mineshaft, whose shadowy corners were brought into the spotlight by the 1980 Al Pacino film, *Cruising.* And the old world was transgender sex workers. The cobblestones were their stroll. They worked in groups for safety, took coffee breaks at Dizzy Izzy's bagel shop on West 14th (since 1938), and bought their outfits at Lee's Mardi Gras, a neighborhood store that catered to cross-dressers. For decades, the Meatpacking District was the unpoliced, muddy edge of Manhattan's universe, and nobody paid much attention to what happened there.

Ivy Brown moved to the neighborhood in the 1980s. When I interviewed her at her gallery/apartment in what's known as the Triangle Building, she told me about life before hyper-gentrification. The Hellfire club was located in the basement of Ivy's building, along with her fuse box. During a sudden blackout one night, she hurried down in bathrobe and slippers to get help from Hellfire's beloved manager, Lenny Waller, a cigar-chomping leather daddy with a big Santa beard. "There was a three-hundred-pound woman chained to the ceiling and a guy with a cat-o'-nine-tails whipping her," Ivy recalled. "Turns out our fuse box had exploded. We had to call the Con Ed emergency guy. So I'm standing there, trying to make polite conversation with Lenny while all these people are beating each other. My slippers are sticking to the floor. I mean it's like Elmer's glue everywhere. They've got a chain-link spiderweb along the wall. So I say, 'That's a really nice piece.' And Lenny says, 'Yeah, it's great, it holds two people!'"

On the first floor of Ivy's building was a transgender crisis center called Project First Step. Ivy gave clothing and makeup to the sex workers, and kept a mirror on the bicycle she parked outside so the girls could check their lipstick. She remembers one named Taxi. "Whenever she crossed the street, all the others would scream, 'Taxi!

Taxi!' And cabs would stop. They got a kick out of that." The trans women looked after Ivy. "The girls always saw me to my door and made sure I got home safe." One night, in an ice storm, Ivy fell on the sidewalk. "All of a sudden, I was like a kitten being picked up by the scruff of the neck. Two big girls lifted me up and carried me home. They never asked me for anything. Never crossed a line. They had my back."

In 1985, during the AIDS crisis, the state gave permission to Mayor Koch to padlock all of the city's gay bathhouses, bars, and clubs where "high-risk sexual activities" were taking place. City inspectors ventured into the Mineshaft and witnessed "patrons engaging in anal intercourse and fellatio" to the "sounds of whipping and moaning," reported the *Times*. Koch was appalled and the Department of Health closed the club for "violating the new anti-AIDS regulations." That same year, gay restaurateur Florent Morellet opened a French-American diner in a shuttered Depression-era luncheonette called the R&L. He named his place Restaurant Florent and it became a sensation, an after-hours spot for leathermen, transsexuals, and trend-seeking slummers. Things were changing. Morellet himself has credited the restaurant with bringing the first touch of gentrification.

By the 1990s, the meatpacking plants had dwindled, thanks to supermarkets and refrigerated freight. Vacancies opened and rent was cheap, as low as six dollars per square foot. In came artists, like John Currin and Matthew Barney, and art galleries. New queer clubs opened, like the gay club Lure, along with lesbian bash Clit Club, and a weekly party called Jackie 60, an anything goes, nonexclusive scene for drag, punk, performance art, poetry, and theme nights with names like Pimps and Whores, Lesbians in Latex, Rubber Nurses, and Penis Envy.

In 1992, Hogs & Heifers came to the neighborhood. The biker bar attracted celebrities like Brad Pitt, Gwyneth Paltrow, and Julia

Roberts, who danced on the bar and donated her brassiere to their collection. Relations between Hogs and the working girls of the streets could be tense. When two of the bar's regular guys were beat up by a group of transgender sex workers, reportedly after they called the girls "niggers" and threw a bottle at them, Hogs owner Alan Dell told *New York* magazine in 1995, "I pioneered this fucking spot. There was nothing here before me. . . . It's a war zone. There's nothing I'd like more than for the police to deputize me." Dell explained how he'd flash a spotlight on the sex workers from his Bronco, saying, "You flash anything on them and they run like cockroaches." The trans women were afraid to go by Hogs at night. Said one, "It used to be safe for us to come down here and make a living—now we're losing business."

A tipping point came in 1999. Markt and Fressen, two fashionable restaurants, opened shop. Reviewers were not gung ho for fine dining on streets that reeked of blood and rotting offal. At the *Post*, Steve Cuozzo wrote, "Take the Meatpacking District—please. The streets smell like one big pancreas. . . . The meat hooks and transvestite hookers give the bridge-and-tunnel brigades a cheap whiff of Manhattan menace." But the whiff of money was stronger. Next came the high-fashion retailers, pioneered by Jeffrey Kalinsky, a former shoe buyer for Barneys. In an industrial space once occupied by Nabisco, Kalinsky opened Jeffrey New York, selling Gucci, Prada, and Dolce & Gabbana. "It's the last frontier of New York," his realtor told the *Observer*. "All of the buildings are going to be converted. The restaurants are always the first ones in. I keep getting calls about it. Every developer is trying to get in."

Keith McNally's Pastis came next, another restaurant often blamed—or credited—with the death of the greasy old Meatpacking District. The moment the bistro opened in early 2000, people were lining up, waiting as long as three hours for a table. In an interview with *Vanity Fair*, McNally claimed that Pastis would be "bohemian and unfussy, a kind of workingman's place." (The *Times* later called it

a "proletarian myth.") Pastis catered to the well-heeled celebrities and fashionistas looking for a taste of the next new thing. At the end of that *Vanity Fair* piece, a transgender sex worker walked up and asked McNally, "What's that place gonna be?" He replied, "A restaurant." She excitedly responded, "Oooooh! That's what I like! That'll bring a new clientele!" Pastis did bring a new clientele, but they weren't the type who wanted trans girls anywhere near their playground.

In the Meatpacking District's death by a thousand cuts, another slice came on August 13, 2000. In episode number 310 of *Sex and the City*, Samantha moved into the district and started fighting with the transgender sex workers noisily throwing shade outside her windows. The working girls had been there first, but like many newcomers to gentrifying neighborhoods, Samantha wanted the old-schoolers out. Over a breakfast of egg-white omelets, she complained to her friends, "I am paying a fortune to live in a neighborhood that's trendy by day and tranny by night!" The transphobic jokes ensued, the usual "half man, half woman," "chicks with dicks" commentary. By the end of the episode, however, Samantha was throwing a rooftop party for the trans girls and everything was going to be just fine—for Samantha and her pals, anyway. The TV show helped bring a flood of wannabes to the area, just as it had with Bleecker Street. They tottered over the cobblestones in their Manolos and Jimmy Choos, slipping in the blood and fat. The sex workers were pushed out by real-life Samanthas, exiled to the margins, where they collided with another enemy. Residents of the upscaled neighborhood on the southern border of the Meatpacking District formed Residents in Distress, aka RID, a name redolent of insecticide. The RID people joined the Greenwich Village Block Association and petitioned the police, who formed "Operation West Side" to clean the streets of undesirables. At the time, I was volunteering as a counselor at the Gender Identity Project of the LGBT Community Center, located at the edge of the neighborhood. We were constantly hearing about transgender women getting targeted for harassment and arrest, whether they were at work on the

stroll or simply walking through to visit friends. Eventually, the sex workers were pushed far away, into parts of town more dangerous.

The Meatpacking District exploded. It was rechristened "MePa" by the real estate industry and a tsunami of high-end shops, designer boutiques, bars, and restaurants flooded in. Keith McNally bemoaned the changes. "Florent and I are busier now," he told the *Villager*, "but it's about quality of life. I wish there was more diversity in this very fragile neighborhood. I feel very hypocritical—because I own a restaurant." In 2000 Florent Morellet cofounded a preservation group called Save Gansevoort Market, for the neighborhood's historic name. They set out to landmark the district, but what exactly did they want to preserve? Jo Hamilton, Morellet's co-chair in the campaign, told the *Times*, "Save Gansevoort Market is not to stop gentrification. It's to preserve the unique character of the place." As always, we must ask: for whom? As Hamilton later told the paper, "The sidewalks smell from bloody animal parts. . . . Can you imagine walking over there with your Manolo Blahniks? You say 'cool' when you move in, but then you try to maneuver your baby stroller between all those [meatpackers], and you rush home to call 911."

Long-held, neglected properties were sold off for millions, for demolition or redevelopment. Upscale hot spots opened in the gutted remains of vanished sex clubs. In 2004, *New York* magazine described the cocktail lounge that took over the basement where Hellfire used to be: "You'll enter a luxe, dungeon-like space. . . . But you won't find any gruff prisoners among the abundance of svelte women and groomed men—just good-looking, well-heeled New Yorkers in their late twenties, happy about how, well, good-looking they are." Into the Lure's old space went Bagatelle, instantly infamous for its "bacchanal brunches," where young, bailed-out Wall Streeters might spend $20,000 on a Saturday afternoon to entertain their friends with magnums of Veuve Clicquot and Dom Pérignon. In photos of the bacchanals, glossy young women dance on chairs and open their mouths

so the hedge fund guys can fill them from giant, double-magnum jeroboams of champagne, liquid gold to be gagged on and spat out in fountains of flagrant waste. Later, blackout drunk, the girls would wobble their way across the cobblestones, screeching as they fell off their Louboutins and passed out in cold puddles of animal fat. *Chelsea Now* reported in 2007 that residents of the area were sick of the "[g]aggles of drunk girls in those heels," and being "overrun by screaming, drunken children all night long."

I n 1999, Joshua David and Robert Hammond founded the Friends of the High Line, campaigning to preserve the stretch of derelict elevated train tracks that ran above the Meatpacking District, through western Chelsea, and up into the train yards at 30th Street. David was a freelance magazine writer and Hammond was an entrepreneur, but they would become two of the city's most celebrated citizen preservationists. They would also help to push the Meatpacking District into hyperdrive and radically change the face of Chelsea's west side, from a scrappy neighborhood of blue-collar businesses to a shimmering pleasure dome for tourists and oligarchs, what many would call "Dubai on the Hudson."

In 1931, steelworkers began the construction of an elevated viaduct that would remove dangerous railroad tracks from the street and lift them thirty feet into the air. It was part of Robert Moses's West Side Improvement project, and for the next half century, the elevated line would ferry freight cars into the city, carrying milk, eggs, meat, and produce to warehouses along the West Side. In 1980, after making their last deliveries, the unused tracks fell into disrepair. While some sections were demolished, what remained became an urban ruin and an accidental meadow. Wildflowers and trees, their seeds carried by bird and breeze, claimed the tracks. So did graffiti writers, homeless people, and sexual adventurers. The avant-garde

synthpop band Art of Noise filmed a music video up there, in which a little girl punk directs three men to destroy musical instruments with chainsaws. By the 1990s, property owners and Mayor Giuliani were calling the elevated track blight. They wanted it demolished. But David and Hammond had other ideas. Envisioning an elegant public promenade, they saw potential in the High Line. They were not alone.

In the Bloomberg era, politicians and developers salivated over the promise of what the ratty old tracks, once spruced up, would bring: a colossal spike in property values, tourism, and consumer spending. In 2005, the *Observer* declared, "Welcome to the great High Line development cash-in! While the elevated railway itself is still just a rusty, weed-covered insurance liability, speculators and developers are already squeezing money from it. The towers of West Chelsea are on their way!" Writing in the *Times* in 2006, Nicolai Ouroussoff glimpsed the future, linking the High Line to hyper-gentrification when he wrote: "the artists who bemoaned SoHo's gradual reinvention as a tourist mecca in the 1980s would have been dumbstruck by the pace of gentrification wrought by the High Line . . . the frenzied activity surrounding the High Line shows how radically the development climate in Manhattan has accelerated. No longer content to allow gentrification to proceed at its own tentative pace, developers now view even the humblest civic undertaking as a potential gold mine." The park hadn't even opened yet.

Diane von Furstenberg, a powerful Friend of the High Line, opened her flagship boutique close to the tracks in 2007, complete with a garage to hold her hunter-green, $275,000 Bentley Mulsanne, right up against Atlas Meats' packing plant with its buckets of offal and pungent slabs of hanging beef. Furstenberg allegedly pumped perfume from the store's air vents to cover the stink of the street with her own "exotic mix of Mandarin flower, violet leaves, and lychee." A passerby described the perfume to the *Post* as "putrid, awful . . .

something you'd find on a 60-year-old matron." Soon enough, the offending meatpacking plant would be demolished, taking its odors with it.

In 2009, after years of giddy anticipation, hyped by marketing campaigns and a design competition that had whipped trend-seekers across the city into a hot-and-bothered froth, the first stretch of the newly refurbished High Line opened to the public. I experienced a moment of excitement. I had often wondered what it would be like to climb that graffiti-splashed trestle with its wild urban meadow. I'd seen the architectural renderings and knew not to expect the secret wilderness shown in the breathtaking photos by Joel Sternfeld, taken years before and exhibited at the Pace/MacGill Gallery in 2001. Still, the idea was enticing: a public park above the hubbub, a contemplative space where nature softens the city's abrasiveness. Today it's difficult to remember that initial feeling. The High Line has become a tourist-clogged catwalk and a catalyst for some of the most accelerated displacement and redevelopment in urban history.

As I ascended the stairs on my first visit, I was immediately skeptical. The designers had scrubbed the graffiti and tamed the wildflowers. The original willful, windborne plants had been yanked and harvested for their seeds, then cultivated in a Staten Island nursery and placed with fastidious planning in the new park. The restrained gardens I walked through were filled with the domesticated descendants of the line's earlier anarchists. They were now precious. Guards admonished me when my foot moved too close to a weed. Signs everywhere offered the mixed message: "Keep it wild. Keep on the path." Was this a park or a museum? I felt like I was in the home of a fussy neatnik with expensive tastes, afraid I would soil the furnishings. While I didn't feel entirely comfortable on the new High Line, I was in the minority. The park was a tremendous hit. Fashion models strutted up and down. Men in polo shirts carried golf clubs to the driving range at Chelsea Piers. Conspicuous consumers from

the Meatpacking District boutiques commandeered the benches, surrounded by a phalanx of luxury shopping bags. I felt underdressed. That initial rarefied state didn't last, however. As the High Line's hype grew, the tourists came clamoring.

Today the High Line is another stop on the must-see list for out-of-towners. More than 7 million people visit every year, most of them tourists. Originally meant for running freight trains, the High Line now runs people, except where they jam together like spawning salmon crammed in a bottleneck. The park is narrow and there are few escape routes. I've gotten close to a panic attack, stuck in a pool of stagnant tourists at the most congested points. It was this over-crowding—of the High Line and the streets around it—that began to turn the tide of sentiment about the park. In the spring of 2012, an anonymous local set off a media firestorm by posting fliers that read: "Attention High Line tourists. West Chelsea is not Times Square. It is not a tourist attraction." Soon after, the *Times* asked me to write a critique of the High Line. My op-ed ruffled feathers.

The Friends of the High Line wrote a rebuttal in the *Times* and posted many letters of support for the park on their website. Most of the responses my op-ed received, outside of my like-minded blog readers, were angry, offended, and flabbergasted. I also got a number of discreet emails of thanks and congratulations. But few supporters came out publicly. ArtInfo wrote, "Jeremiah Moss did something that few have thought to do: he openly criticized the High Line." One commenter on my blog wrote, "It needed to be said, but everyone else was afraid to say it." What were people afraid of? Why couldn't the High Line be criticized? As powerful as they are, it's not like the Friends of the High Line are mobsters who would have somebody whacked. Right? But the High Line was—and, to some extent, remains—a sacred cow. We're only supposed to see it as a triumphant icon of neighborhood preservation, a beautifully designed public space, and not as the hyper-gentrification juggernaut it also happens to be.

Today the High Line has several more critics, but the most color-

fully caustic has got to be art critic Jerry Saltz. Writing in *New York* magazine in 2015, he gleefully ripped the park:

> Popularity not withstanding, not only do I feel oddly creeped out by its canned, fabricated naturalness, closed in by its conveyor-belt-narrow walkways, and irked at its romance with ruins, for me, the High Line is the harbinger of a bad pathogen now transforming public space into fussy, extra-busy, overdesigned, high-maintenance mannered playgrounds, curated experiences, and crowd-pleasing spectacles. Like most transplanted New Yorkers, I love the city, and the madness and chaos of its crowds. But the High Line has never felt to me to truly be a part of New York. It's an undead limbo; protective custody for tourists who traverse this artificial highway while reaching scripted architectural incidents and overlooks. Going there is a form of volunteer rendition into a comatose puppet show.

Amen. (Though walking the park on a quiet winter's night can be a pleasure.) It's not just tourist crowding and designer curation that makes the High Line so pathogenic. It also helped to overhaul neighborhoods and displace New Yorkers as it grew. And that wasn't accidental. While it began as a grassroots endeavor—albeit a deep-pocketed one—the High Line quickly became a tool for the Bloomberg administration's creation of a new, upscale, corporatized stretch along the West Side. As Melva Max told me when her twenty-eight-year-old French restaurant, La Lunchonette, was forced to close for more luxury development along the park, "The High Line was a Trojan horse for the real estate people. All that glitters is not gold." Even the park's co-founder Robert Hammond has expressed regrets, admitting to *The Atlantic*'s CityLab in 2017, "We wanted to do it for the neighborhood. . . . Ultimately, we failed."

Like the meatpackers they replaced, many of the first-line gentri-
fiers could no longer survive in the MePa they'd helped create.
On Gay Pride Day in 2008, restaurant Florent closed its doors, forced
to shutter after twenty-three years when the landlord raised the
rent from $6,000 to $50,000 per month. On his famous menu board,
Morellet spelled out an optimistic thought in white plastic letters: REAL
ESTATE GOES DOWN/NYC SURVIVES. At the restaurant's closing party, fans
celebrated and wept for the end of an era, for a place that provided a
space to "political drag queens, suicidal libertines, secular surgeons,
transvestal virgins, lunatic ravers, steroidal saviors, twelve-stepping
two-steppers, infidel lepers, sadistic humanists, lunatic sensualists,
wondering Jews, multicultural views, leftist rituals, and delectable
victuals." Morellet later told Channel 13, "I'm all for change done
the right way. But they have completely destroyed the Meat Market,
the Village, and the New York I loved so much when I moved here."
Next up, Pastis closed in 2014 when its building was sold and slated
for demolition. Keith McNally vowed to rebuild. And in the sum-
mer of 2015, also after twenty-three years in business, Hogs & Heifers
shut down. Mega-developer Thor Equities bought their building for
$100 million and raised the rent from $14,000 to $60,000 per month.
"There is no room for the small, independent business in New York,"
co-owner Michelle Dell told the *Daily News*. "This is a city that is
throwing its history to the curb."

McNally expressed remorse for his role in hyper-gentrifying the
area. He told the *Villager:* "If Pastis was something of a catalyst for
the changes in the Meatpacking District . . . then I should be ashamed
of myself. I can't bear most of the changes there. The area has be-
come ugly and excruciatingly one-dimensional." In 2013, the *Times*
reported that Morellet had moved on to Bushwick, Brooklyn. "Cities
change," he told the paper. "Young people are going to be pioneers in
neighborhoods and make them livable. Wealthy people are going to
move in and young people are going to move to the next neighbor-
hood, and the next neighborhood. We have tons of neighborhoods to

rebuild. Yes, the prices are going up. That's great." Earlier that year, a celebratory sculpture of Morellet was christened on the High Line.

Rents in the Meatpacking District climbed ever higher. I spoke to Dionisios Manesis, owner of the holdout Hector's diner, the oldest—and the last—place to get an affordable meal in the neighborhood. "Maybe ten, fifteen years ago," Manesis told me, "the landlords were giving it away. Rent was almost free. Three hundred or four hundred dollars a month. Now there's nothing less than twenty-five thousand dollars a month." He pointed out the window at the boutique across the street: "Fifty-five thousand dollars a month." He pointed to another: "Seventy-five thousand dollars a month." Then he pointed to a salon down the block: "One hundred and five thousand dollars a month."

Rising prices and a changing consumer demographic meant the tide was surging yet again. Even the luxury designers that had helped make the area a glittering playground could no longer survive. The starchitect-designed Whitney Museum was under construction, promising more tourists and even higher rents. But tourists weren't buying $2,000 purses and $1,500 shirts. They wanted to shop at suburban-mall chain stores, so the chains moved in—Levi's, Sephora, Patagonia, Uggs—while the high-end designers moved out, as many as a dozen in just a year, as soon as their decade-long leases were up. In 2012, the *Wall Street Journal* announced, "The Meatpacking District is going from boutique to bourgeoisie." Designers like Stella McCartney and Rubin & Chapelle closed shop and migrated to Soho, seeking more "grown up" neighbors and a more discerning clientele. J.Crew moved into Florent's old space.

Along with the chain stores have come hundreds of thousands of square feet for office space and big-brand corporate showrooms. *Crain's* reported in 2015 that developers were "remaking the postage-stamp-size neighborhood into a destination for New York's deep-pocketed and ever-growing venture-capital class, as well as for mature tech and financial businesses that can pay the district's hefty rents."

In a staggeringly short span of time, the Meatpacking District ended its two-hundred-year history of packing meat, wiped out its infamous sex trade and party scene, became ridiculously trendy, and settled down to a dull but expensive existence as yet another outpost of corporate-suburban America, with the personality to match.

As Ivy Brown told me, "I miss my neighbors, the people who've been thrown out. I miss the neighborhood. I used to walk to Western Beef, where the Apple Store is now, in my pajamas and a pair of boots to get a quart of milk. Now if I go out without my hair combed, everyone's looking me up and down." Maybe she should douse herself with High Line perfume. Bottled by Bond No. 9, the High Line fragrance combines notes of bergamot and rhubarb to create "the scent of wildflowers, green grasses . . . and urban renewal."

THE NEW GILDED AGE
AND THE ENRON SOCIETY

Graffiti on demolition plywood, Soho. *Jeremiah Moss, 2014*

NEW YORK CITY HAS LONG ATTRACTED THE WEALTHIEST—
and the wannabe wealthiest—people from around America
and the world. From early Dutch fur traders to nineteenth-
century robber barons to 1980s yuppies, it's been a town powered
by ambitious capitalists since Peter Minuit hustled Manhattan from
the Lenape tribe for twenty-four dollars' worth of goods. Prosperous
philanthropists have added beauty to the cityscape and culture with
museums, parks, and other public treasures. The rich have always
been with us. But New York City hasn't *only* been dedicated to the ac-

cumulation of wealth. In the past, that urge was counterbalanced by others, like the urge for freedom and a creative life. Standing in the harbor, the Statue of Liberty doesn't say, "Give me your vivacious, your rich." She does not beg for Russian oligarchs. But in the New Gilded Age city, the mayor did just that.

"We want rich from around this country to move here. We love the rich people," Bloomberg announced on WOR-AM radio in 2009. He repeated himself in *New York* magazine a few years later: "If we can find a bunch of billionaires around the world to move here, that would be a godsend. . . . Wouldn't it be great if we could get all the Russian billionaires to move here?" And again, in another radio interview, "If we could get every billionaire around the world to move here it would be a godsend that would create a much bigger income gap."

For the economic elite, billionaires are the saviors of the city. They consume goods and pay high taxes, the reasoning goes, and that trickles down to everyone. During the Reagan years, when trickle-down theory took hold, economist John Kenneth Galbraith likened it to the horse-and-sparrow theory of the first Gilded Age, explaining, "If you feed the horse enough oats, some will pass through to the road for the sparrows." At least old Marie Antoinette offered cake.

Attracted by generous tax breaks and other incentives, the oli-garchs heeded Bloomberg's call. From Russia, China, Saudi Ara-bia they came. Hiding behind LLCs, they dumped their ill-gotten bounty into the needle-thin, stratospheric "supertall" towers that surged skyward across the city, casting their mile-long, dark shad-ows as they blotted out the sun in Central Park (a potential cool-ing benefit, as some architects have shockingly argued, in a time of global warming). In a major report, the *Times* discovered that many of the priciest residential properties in the city were bought through shell companies, and several of the "secret buyers" have been the fo-cus of government inquiries, charged with fraud and environmental corruption. These investors have been "a powerful force behind the

luxury condominium boom reordering New York City's skyline." But the oligarchs didn't move here; they only moved their money—and it does not trickle down. As James Parrott, chief economist at the Fiscal Policy Institute, explained to the *Times*, "In terms of the local economy, you don't have people who are going to plays, going to restaurants. They're not spending at the dry cleaners, the grocers and all of that, so it deprives New York of all that local multiplier effect." The superrich typically interact with cities in a very limited, controlled way, moving through the urban environment in the protection of what urbanist Rowland Atkinson calls a "plutocratic cloud." As for the towers that the billionaires helped build, they stand empty and dark, vertical ghost towns in the sky. Did I mention that the Bloomberg administration trademarked the slogan "The World's Second Home" for marketing the city to tourists and investors? I guess "The World's Pied-à-Terre" was too obvious.

When the venerable old Plaza Hotel went condo in 2008, out-of-towners bought the units, but most didn't bother living in them. One night, a lone resident went to throw out her trash in the garbage room. The door jammed and trapped her inside. According to the *Post*, she "Bloodied her hands beating on the door and cut her fingers to shreds trying to claw her way out." Panicking about her Fabergé egg—she'd left the door to her condo wide open—she screamed for seven hours. But no one was there to hear her. No one was there to steal her egg, either. Her neighbors all lived out of town.

I think of John Updike's poem "Slum Lords," in which he said, "The superrich make lousy neighbors" because they're never in town, always visiting their many other properties. "The essence of superrich is absence," he wrote. "They like to demonstrate they can afford / to be elsewhere. Don't let them in. / Their riches form a kind of poverty."

Into this desolate scene appeared New York's "poor door," a separate entrance for the lower-class residents of new luxury buildings. Many developers around the city have included a token number of

"affordable" units in their buildings to qualify for corporate welfare, like the controversial 421a tax exemption and the "build it bigger" bonus under the Inclusionary Housing Program. Lower-income residents are money in the bank, but they're treated like undesirables.

At 101 Warren, a thirty-five-story ultraluxury condo tower in Tribeca with a rooftop forest of 101 white pine trees, the lower-income renters have a separate address with its own entrance at 89 Murray Street. The developer was given $15 million in incentive money by the Lower Manhattan Development Corporation to put in those "low-income" units, but the people living in them aren't poor. The rentals at 89 Murray are for New Yorkers making $73,166 to $150,325. In the luxury city, making six figures means you need affordable housing and, to get to it, you'll have to enter through the poor door.

Some of the city's poor doors are especially unpleasant. The sixty-story Silver Towers on far West 42nd Street have their affordable units in a structure at the rear. The *Daily News* reported, "The towers boast spacious and luxurious lobbies and the biggest indoor pool in the city. The affordable building has a dark, tiny lobby that faces the back of an MTA bus depot and the entrance to the Lincoln Tunnel." Lower-income residents of such buildings not only get a miserable poor door; they're also denied access to amenities enjoyed by their neighbors. They can't swim in the pools, sunbathe on the terraces, or read books in the private libraries. When Extell's glassy One Riverside Park opened in 2016, the *Post* called its poor-door policy "New York–style financial apartheid." The rich exclusively enjoy a gym, a climbing wall, a bowling alley, a big-screen movie theater, and an indoor swimming pool. They also have what's called a common courtyard, but the commoners can only gaze upon it from their windows while the upper class strolls through the greenery. If they're even in town.

One of my blog readers described life in the affordable section of one of these Dickensian towers. Asking me to maintain her anonym-

ity for fear of retribution from her landlord, she described apartments outfitted with cheap and shoddy materials: "No wallpaper in hallways. Lights burn out and stay out for days. Hallways rarely cleaned. Cracked drywall never patched. Walls dirty." The "poor" tenants are not permitted to join the building's gym. Even if they can afford the annual fee, they are told, "It's only for the people in the tower."

The poor door was bad enough, but perhaps nowhere is the "tale of two cities" more grotesque than in the scheme to build luxury towers atop the playgrounds, gardens, and green spaces of the city's public housing projects, run by the New York City Housing Authority (NYCHA). Hatched at the end of Bloomberg's tenure, the original plan called for more than four thousand upscale apartments to be rammed onto NYCHA land in Manhattan. Under Mayor de Blasio, the plan has been reduced, but still moves forward.

Developers say luxury housing on or near NYCHA land will elevate the pride and spirits of the poor, who should feel fortunate to be so close to upscale properties and residents. The new buildings, they say, will attract amenities, like trendy boutiques, specialty coffee shops, and high-end restaurants. Won't the poor be thrilled? A 2015 city-sponsored study on the effects of gentrification on NYCHA residents said: No. Gentrification is not a godsend for the poor. Living in fear of being priced out, they mostly feel alienated from their own neighborhoods as everything and everyone they know is displaced.

Imagine glistening towers squashing the only open spaces available in the overcrowded housing projects of the city's most disenfranchised residents, blotting out playgrounds and gardens. What will that be like, to be a single mother living on food stamps, losing the one spot where you could breathe to a luxury tower that blocks your views, plunging your apartment into darkness? What will it be like to watch the new people, arms full of designer shopping bags, traipsing through the spot where your tulips once grew? "It's appalling," said Aixa Torres, a NYCHA tenant association president. "We won't have

any sun. They're going to literally squeeze my residents like they're roaches and then they're going to build this huge beautiful complex. You want to talk about the 'Tale of Two Cities'?"

At the very bottom of the socioeconomic ladder, the homeless population exploded during the Bloomberg years, with numbers unmatched since the Great Depression. In his *New Yorker* magazine exposé on the subject, Ian Frazier reported that by 2013 the city had enough homeless people to fill Yankee Stadium and then some.

Despite the provision in the state constitution that "the aid, care and support of the needy are public concerns and shall be provided by the state and by such of its subdivisions," Bloomberg's policies withheld affordable housing from the homeless. For decades, people who applied through the city's shelter system were given priority for federal housing programs like Section 8. But the Bloomberg administration believed in a "perverse incentive" for homelessness, namely, that New Yorkers were making themselves homeless just to get cheap housing from the government. They replaced the Section 8 priority with a short-term subsidy that became a revolving door, forcing families out of their new homes and back onto the street. The mayor complained that too many people who didn't need help were taking advantage of the shelter system. On WOR radio he shared his fantasy, saying, "You can arrive in your private jet at Kennedy Airport, take a private limousine and go straight to the shelter system and walk in the door and we've got to give you shelter." The Coalition for the Homeless reported: "Since Mayor Bloomberg took office, the NYC homeless shelter population has grown by 61 percent and the number of homeless families has increased by a shocking 73 percent."

But where were they, those down-and-out crowds that could overfill Yankee Stadium? Whitewashed Manhattan didn't see the homeless during the Bloomberg years because the homeless were kept far away. The police harassed them from the gleaming streets. The city bought them one-way bus tickets out of town. The commissioner of homeless services even flew to the Bahamas on Bloomberg's

private jet to inspect a fleet of retired cruise ships, considering them as floating shelters. "We would have to remove bars and discos which are inappropriate for a shelter," the commissioner told the *Times*, perhaps enthralled by the idea of floating the homeless into New York Harbor—and depriving them of disco balls.

At the end of Bloomberg's third term, in 2013, the *Times* surveyed New Yorkers, asking their thoughts on the state of the city. A majority said the mayor favored the rich and that housing had become less affordable during his time in office. Eighty-five percent of residents answered yes to the question "Do you think New York City is becoming too expensive for people like you to live in?" That number included those making between $75,000 and $100,000 annually. Meanwhile, the city's poverty rate was the highest in a decade. And the income gap in Manhattan, according to the *Times*, rivaled sub-Saharan Africa.

By 2016, the median rent on a New York City apartment had risen to $3,185. That's more than $38,000 a year in a city where the median income is around $50,000. People are surviving by hanging on to the dwindling stock of rent-regulated apartments, but developers keep pushing. In 2016, a NY1/Baruch College poll found that a majority of New Yorkers, including people making over $100,000 a year, believe they will soon be priced out of their homes and neighborhoods. While most people can't afford to live in New York, they also can't afford to do business here. From 2004 to 2014, the average commercial rent in the city increased 34 percent. Some storefront rents shot from $4,000 to $40,000 a month, making it impossible for any business but a corporate chain or a bank to exist.

It is undeniable that New York has been remade into a city for the superrich. Among the many effects of this transformation has been a profound shift in the everyday psyche of the city—how it feels to walk down the street, eat in a restaurant, even move through the

hallways of your own building. As Updike said, the superrich can be lousy neighbors.

In *The Death and Life of Great American Cities*, Jane Jacobs wrote about the way that people living in tenements and working out of mom-and-pop shops keep a close watch over the streets, while newer, richer residents turn a blind eye. She told a story about a scene in Greenwich Village when it looked like a strange man was about to kidnap a little girl. Before she could intervene, Jacobs saw the butcher's wife emerge from the butcher shop, followed by the man who ran the delicatessen and two guys from a nearby bar. People poked their heads from tenement windows. They weren't going to let a kid get dragged off. But something different was happening in the upscale new buildings. "Throughout the duration of the little drama," Jacobs explained, "no eyes appeared in the windows" of the new buildings. "The high-rent tenants, most of whom are so transient we cannot even keep track of their faces, have not the remotest idea of who takes care of their street, or how." (Did I mention that Jacobs's house on Hudson Street is now a realtor's office?)

We hear the same theme echoed in many more stories today, the chilly experience of what happens when high-rent—and often transient—newcomers move in. In a 2013 article for *Salon* called "Priced Out of New York," native Lower East Sider and author Cari Luna recalls major change on St. Mark's Place: "Our building was a small, vital community. We knew each other's names and took care of each other's pets and hung out on the stoop in the evenings and always, always held the door for each other because we were neighbors. As the cost of living in Manhattan rose and the turnover in our building increased, vacated apartments got bumped up to market rate and the new residents, who paid a premium for their cramped tenement spaces, didn't learn our names, didn't sit on the stoop, would let the door fall closed in your face."

In every neighborhood taken over by the nouveau riche, and by those who aspire to be nouveau riche, a new breed of human is shaping the twenty-first-century gestalt of the city. They may or may not be actually wealthy, but their character is shaped by a civilization obsessed with wealth.

I'm a member of a group called Das Unbehagen. A collective for people interested in psychoanalysis, its name is taken from the original German title of Freud's *Civilization and Its Discontents*. *Unbehagen* means discontents—also discomfort, malaise, and anxiety. In 2016, the group sponsored a lecture by the Belgian psychoanalyst Paul Verhaeghe, author of the book *What About Me: The Struggle for Identity in a Market-Based Society*. It was from Verhaeghe's work that I found a way to better understand the people I'd been calling Yunnies, and why the city of the 2000s had come to feel so mean, so cold, so malignantly narcissistic.

As Verhaeghe explains, different societies produce different psychologies. During the Victorian era of Freud's day, people became neurotic in response to a society that prohibited expressions of individuality and sexuality. As society changed, human identity changed with it. Verhaeghe calls our current era the Enron Society, after the corrupt American corporation that exemplifies it. In the Enron Society, begun in the 1990s and spawned directly from neoliberalism, there is only one dominant discourse—the economic. In this society, we are obligated to be successful. Everything and everyone is a product. Inequality increases exponentially. Ruled by the myth of meritocracy and embroiled in endless, heartless competition, the individual in the Enron Society is a winner-take-all consumer. "Meritocratic neoliberalism," Verhaeghe says, "favors certain personality traits," including competitiveness, cynicism, aggression, vengefulness, and sociopathy. People who exhibit these traits have the best chance of becoming the most successful, accru-

ing the most money and power. With that, they set the tone of our
environments.

For the record, I don't believe that money is the root of all evil. I
like making money and I'd be glad to make more of it. While I come
from a non-college-educated, working-class background, through
my education and profession, I work and socialize with people who
come from higher socioeconomic spheres. Some of my best friends
have trust funds. They still manage to be thoughtful, empathic
people who contribute to the greater good. And there are those one-
percenters, like Bill Gates and Warren Buffett, who give away billions
and beg for higher taxes. I am certainly not saying that the rich are a
bunch of bad apples. At the same time, as I explore the psyche of the
New Gilded Age city, I would be remiss not to point to the body of
research that reveals the negative impact that wealth and its pursuit
can have on human behavior and attitudes.

In the 2012 paper "Higher Social Class Predicts Increased Unethi-
cal Behavior," Paul Piff of the University of California, Berkeley, con-
ducted several studies that showed that members of the upper class
were far more likely to break driving laws, make unethical decisions,
steal, lie, and cheat. These tendencies are accounted for by the sub-
jects' "more favorable attitudes toward greed." For example, drivers
of luxury cars, compared to drivers of lower-status cars, were less
likely to stop for pedestrians at a crosswalk. Wealthy subjects also
took candy from children.

In a 2013 paper by Piff, "Wealth and the Inflated Self: Class, Entitle-
ment, and Narcissism," he found that upper-class individuals possess a
greater sense of entitlement and exhibit more narcissistic tendencies,
agreeing with statements like "I honestly feel I'm just more deserv-
ing than others" and "I like to look at myself in the mirror." (During
the study, the upper-class subjects almost always looked at themselves
in a mirror.) Piff noted that the disadvantage that comes with being
lower class likely "promotes other-focus and interdependence, which
enhance egalitarianism and diminish entitlement."

But rich or poor, *just having money on your mind* can alter your attitude. Researchers find that MBA students think of greed as good, give less to charity, and are more likely to be dishonest for personal gain. "Just thinking about economics," wrote Adam Grant in *Psychology Today*, "might be enough to inhibit compassion and concern for others." Money-induced sociopathy appears to be contagious, up and down the socioeconomic ladder. And that's the really important point here. No one is immune. When lower-class subjects are *primed to think* about money and the positive aspects of greed, they behave just as unethically as upper-class subjects. In a 2013 paper, the University of Chicago's Eugene M. Caruso and others found that after looking at images of money, people will believe that "socially advantaged groups should dominate socially disadvantaged groups" and "victims deserve their fate." They'll also strongly endorse free-market capitalism. Just by putting the symbols of money in people's faces, through TV advertisements and reality shows, for example, you can get them to support an unethical system of social inequality.

In the end, having wealth does not make you behave like a psychopath, but glorifying the acquisition of wealth just might. This is exactly what our Enron Society has done to people's minds. It has primed us to see greed as good, making our society less empathic, which then allows for more greed. It's a self-perpetuating loop. As people support selfish public policies, the rich get richer, the poor get poorer, and the income gap widens. As inequality grows, the "winners" are further distanced from the "losers," and that distance, it turns out, makes people even more competitive, greedy, selfish, and sociopathic.

Richard Wilkinson, a social epidemiologist in the United Kingdom, has long studied the impact of economic inequality on public health. He has written on the extensive research that shows how the most unequal societies breed social dysfunction, including higher rates of violence, drug abuse, and mental illness, along with malignant narcissism. I got in touch with Wilkinson and chatted with him

over Skype. "Inequality makes us more antisocial," he explained. Living in a place with a wide income gap makes people withdraw from community engagement. We trust each other a great deal less and we become less willing to help vulnerable people, like the elderly and disabled. "Downward prejudices," Wilkinson added, "become stronger" in such a society, so that people with higher social status openly display more negative attitudes toward lower status groups. So if you feel disregarded on the streets of the city, treated with contempt by many of the new people moving in, you're not imagining it. It is one cost of living in a city with a vast income gap.

This is all very depressing. But it helps to remember that this social system is not natural, it wasn't always this way, and therefore, it can come to an end. When New York City had a strong working class, people built and sustained community connection. Competition was always part of the city's ethos, but it wasn't the winner-take-all, destroy-your-neighbor, Ayn Randian brand of today. Many of the people attracted to the luxury city subscribe to the Enron Society's values. Riddled with status anxiety, they've come not to be citizens, but consumers, making as much money as possible while they stomp out the "losers." I try to tell myself it's not their fault. They've been brainwashed in the digital glow of Kardashian-Trump pseudoreality, baptized by brands that tell them to "Be Stupid" and "Just Do It" "Because You're Worth It." Unfortunately, we all suffer for it.

Entitlement, cutthroat competition, disregard—this meanness contaminates everyday social interactions. It's the shopper who pays for her goods while talking on her cell phone, never acknowledging the cashier. It's the Citi Bike rider who dings his bell at a slow-moving old lady as he blows through a red light. It's all the people who knock into you on the sidewalk while they type a text. Haughty hostility has become the city's atmosphere.

To escape, I go into faded coffee shops, dive bars, and bookstores,

the refuges of New Yorkers who have not been brainwashed by the ethos of the New Gilded Age. In these places, you can feel the old city, the brash, opinionated, neurotic, human city that once was. In these places, I can breathe, rejuvenated by the presence of strangers who are actually present. But every time I get attached, the blessed place is ripped out by rising rents. Its people scatter. Where can we go? Patti Smith told us to "find a new city," but what city is safe? The Enron Society is everywhere. So we stay, those of us who won't let go, who hold out hope that New York always cycles and its egalitarian spirit will prevail. The Gilded Age of the late 1800s gave way to the Progressive era. Maybe it will happen again. Even as we complain, we remain eternal optimists. We wait, ears pressed to the asphalt, listening for a sign that the hot-blooded heart of New York will beat again.

CHELSEA

Chelsea Hotel, closed to guests, lights off, shrouded in scaffolding. *Jeremiah Moss, 2017*

I SLEPT IN THE CHELSEA HOTEL JUST ONCE, ON THE FINAL NIGHT of its century-long, gloriously decrepit, bohemian life. Opened as a utopian cooperative in 1884, the hotel remained true to its roots, providing a home and a way station for creative iconoclasts, from Dylan Thomas to Bob Dylan, Simone de Beauvoir to Sid Vicious, Mark Twain to Madonna. My stay was brief, the night of July 30, 2011. I booked a room when word came out that the hotel had been sold and would be closing for a major renovation. No one knew exactly when. Checking in at the beat-up wooden desk, I was told by the clerk, "You're lucky to be here tonight. Everyone's getting kicked

out in the morning. We just heard. No more guests. This is the last night."

I'd always wanted to spend a night in the legendary hotel, but it felt like an extravagance on my income over the years—first as a cleaning person, then an editorial assistant, a freelance copywriter, and a social worker. I was finally making decent money, and the hotel's rates were not bad. Where else in Manhattan could you get a room for $139 a night?

My room on the second floor smelled of cat piss and a hundred years of funk. The doorknob jiggled listlessly in the door. The floorboards creaked underfoot, sinking with each step like they were made of sponge cake. Cracks meandered down the walls and the ceiling peeled, all of it adding up to a romanticizable squalor. I opened the tall double doors to the balcony to let in some air. Twenty-Third Street honked. I had arrived. To prepare for my night, I'd made a playlist, a sort of sad attempt to heighten the atmosphere with the help of Nico, the Velvet Underground, Patti Smith, Joni Mitchell. "Chelsea Girls" and "Chelsea Morning." I knew it was a bit corny, this orchestration of emotion, but I turned on the music anyway and smoked cigarettes on the balcony, sitting in a knockoff Louis XV chair with broken springs, wondering if anyone had died on its ruined red velvet. The hotel's famed neon sign brightened, sizzling phosphorescence in the fading summer light.

In general, my associations on such occasions don't go to punk rock, so instead of Sid and Nancy I thought of the poet James Schuyler (I think of him as "Jimmy," not because I knew him, but because I knew people who knew him, and they called him Jimmy) living in the hotel at the end of his life, writing his marvelously floral nature poems in the middle of the denatured city. On the cover of his *Collected Poems,* in a watercolor by Darragh Park, he appears in his sixth-floor room with the balcony's wrought-iron flowers in the background. I'd wanted to get near those metal petals ever since I first read about them in Jimmy's poem "Beaded Balustrade," in which he describes

the black flowers as "chrysanthemums, perhaps, / whorly blooms and leaves" below a railing laced with rainwater "crystal, quivering." I'd bought the *Collected Poems* when it came out in 1993, my first year in New York, from a bookstore somewhere on Astor Place that has long since closed. Schuyler was already two years dead. His publisher mounted a plaque in his honor on the hotel's façade: "Dedicated to the memory of," etc. I'd arrived to a city of memorial plaques, a city already becoming a museum of itself. Now here I was, inside a celebrated wing of that museum, with my own soundtrack playing, my own tepid performance of cool.

When night came, I roamed the halls and climbed the great staircase, looking for ghosts. Finding nothing spectral, I hoped for a last-night hurrah, a sense of finality, a party to crash, a drunken brawl, but the hotel was quiet. People simply slept. I tried sleeping, too, but the floor vibrated from the bass line assault pounding up from the nightclub in the basement. With its electronica music and $450 bottles of Patrón topped with sparklers, the Chelsea Room had opened the year before, prompting the *Times* to call it "a harrowing vision of the future" of the hotel. I got out of bed and leaned over the balcony to glimpse that future. Flocks of bachelorettes tumbled drunk from stretch Hummer limousines, hugging jumbo penis balloons to their breasts. I watched as they tried to beg and whine their way past the velvet ropes of the club, where bouncers in tight pants contemplated clipboard lists. "It's my bachelorette party," one bride-to-be wailed in her vocal fry. "You gotta let us in. Come on. I'll totally pay you." Throngs of high-heeled girls and boys in unbuttoned shirts poured past them, clouds of cologne spreading through the steamy air. "Fuck you!" one spurned bachelorette finally screeched. "Fuck this place! It's shitty anyway!" She and her entourage stumbled back to their limo, tripping, skinning their knees on the pavement, all sloppy sad, without poetry or punk. As the limo pulled away, the blushing bride rolled down her window, leaned out, and flipped the bird, screaming, "Fuck you and your fucking club! We didn't want to be here any-

way!" Then she thrust her jumbo penis from the window, stabbing it at the sky in a final gesture of impotent rage.

In the morning, the hotel's lobby filled with evicted guests, beached on the couches and chairs with nowhere to go. A few of the hundred permanent residents stood around gossiping. While the guests were kicked out, the residents would remain—for now. They were a collection of old-school artists and writers, photographers and musicians, queers, eccentrics, and activists, people with AIDS, and elders at the end of long, wild lives. They were New Yorkers. In the lobby, one of them claimed that someone had sabotaged the plumbing pipes. "It's harassment," she said, "plain and simple. But I'm ready for the fight." The residents had been fighting for the past four years, ever since Stanley Bard, who had been gently managing the hotel for fifty years, was forced out in 2007 by the board of directors and the hotel was put up for sale. Bard had helped to keep artists in the hotel by accepting paintings in lieu of rent, but that kind of altruism didn't wash in the new New York. The board wanted profits. At the time, the hotel's resident blogger Ed Hamilton shared the news on his blog "Living with Legends," writing, "now that this area is one of the most desirable in New York, the temptation to cash in has apparently proved too compelling to ignore. The other owners—outsiders who have no stake in the Chelsea—would just as soon turn the building into a boutique hotel and rent the rooms to rich tourists." In the *Daily News*, actor Ethan Hawke, who once lived at the hotel, said, "Chelsea Hotel is the last man standing. It's the last beacon of, 'Not gonna fall to corporate America.' And it looks like it just fell." Rumors swirled about potential buyers, managers came and went, and the residents fought the soul-murder of the hotel, which included the destruction of beloved rooftop gardens and the eviction of dozens of artists, writers, and the poor. In the summer of 2011, the hotel was sold to the Chetrit Group, in partnership with Ed Scheetz's management company King & Grove, a "lifestyle hotel brand defined by modern luxury with eclectic influence."

After that last night, with the Chelsea closed to guests for the first time in its 127-year history, the lights on the famous neon sign went dark. The handful of residents waited for the next shoe to drop as they wandered the empty hallways. "I feel like an old lady on the frontier," said one to Sherill Tippins, author of *Inside the Dream Palace*, the definitive history of the hotel. "I am crying as we speak," said another. "The housekeeping staff are not here; the thug security people are gathering in the lobby like they're ready for urban warfare." The new owners soon began the renovation process. From Ed Hamilton we learned about reports of dust and poisonous lead in the air, electrical wires hanging from the ceilings, water shutoffs, flooded hallways, art removed from the lobby, armies of rats, and more evictions. The Chelsea was doomed.

Outside the hotel, the Chelsea neighborhood had been rapidly changing. Just like the rest of the city's most desirable parts, in the 2000s it filled with luxury condo towers, expensive restaurants, and chain stores. For decades, old-fashioned gentrification had been moving gradually through Chelsea.

In the 1970s, the area just north of 14th Street and roughly west of Sixth Avenue was home to a mix of poor and working-class New Yorkers, mostly Irish and Latino, with a smattering of gay men who'd been pushed out of the Village by rising rents. Some of those men opened businesses along Eighth Avenue, including the Camouflage boutique in 1976, where celebrities like Mick Jagger shopped for designer pants, and the Rawhide leather bar in 1979, where pants were optional. At the McBurney Y, then across from the Chelsea Hotel, the Village People were inspired to pen "YMCA," their classic ode to boys. It was clear that gay men were changing Chelsea—but they weren't yet changing it into an upscale destination. In an article for local gay paper *LGNY*, Michael Shernoff recalled the burgeoning of gay life in Chelsea, the fight against frequent bashings, and the build-

ing of a queer activist community, efforts that resulted in the Anti-Violence Project, the Gay Men's Health Crisis, and the Callen-Lorde Community Health Center, where I would work as a social worker for nearly a decade.

In the early 1980s, rent was cheap and space was plentiful. Loaded with vacant storefronts now filling up with restaurants and boutiques, the length of Eighth Avenue from 14th to 23rd Streets became known as the Strip. *New York Metro* called the avenue "shabby, abused, and ignored," until mid- to upscale restaurants came "[s]prouting like orchids among the dun-colored avenue of bodegas, fried fish, pizza, and hand-rolled cigars." Over the years came Bright Food Shop, the Bendix Diner (whose motto was "Get Fat"), Big Cup, Paradise Café, Rainbows & Triangles, and many other gay-centric businesses. In 1995, Chelsea hit the tipping point with a *New York Times* Real Estate section profile. The headline called the neighborhood "Gentrified, Yes, but Still Unpretentious," as the article highlighted accelerating, but still affordable, prices and "signs of renewal," like French bistros, espresso bars, and art galleries. By this point, the latest crop of young men flooding into the neighborhood became known as "Chelsea Boys." Unlike the skinny, strung-out bohemians of Warhol's film, and Nico's song, "Chelsea Girls," the waxed and gym-built Chelsea boys had nothing to do with the hotel.

In 2000, the McBurney Y—where the Village People said you could go when you're short on your dough—moved to 14th and the old building went up for sale. Across from the Chelsea Hotel since 1904, it sold for $8.5 million, and then sold again in 2003 for $12.5 million. The upper floors of the old Y were converted into large "ultraluxury" condos, while the lower floors became the David Barton gym. In the *Times*, the new building owner said the gym would be a "one of a kind luxury spa." *Village Voice* columnist Michael Musto attended the grand opening. He reported, "scantily clad guys and gals sported the motto 'Look better naked' in body glitter or on T-shirts, and five wackos dressed like the Village People pranced around a

steamy stage as 'YMCA' boomed out of the sound system." It was a new take on the old Chelsea—no more the Bendix Diner's "Get Fat" slogan, Barton's mantra was "No pecs, no sex."

Chelsea's Latin-Chinese restaurants, including the beloved Sam Chinita's, fell away, along with many of its affordable coffee shops and greasy spoons. In 2007, the Bright Food Shop was pushed out by a rent hike. Customers wept and built a sidewalk memorial. More businesses from the 1980s and '90s era shuttered: Big Cup, Bendix, and Paradise Café, where the rent doubled.

In 2013, after thirty-four years, the Rawhide bar shuttered, breaking the hearts of generations of gay men. According to one customer, the new landlord had nearly doubled the rent, from $15,000 to $27,000 a month. Known as the oldest Levi's-and-leather bar in the city, the Rawhide smelled of beer and motor oil, due in part to the broken-down motorcycle that hung from chains over the pool table. The walls were painted black and decorated with sexually explicit Tom of Finland posters. At night, go-go boys danced on the bar. In the afternoons, when the sunlight tried in vain to enter through shaded windows, the bar was quiet, populated by older men, survivors of another time. On one afternoon, a man told me about a night at the bar in the 1980s. The Rawhide showed movies back then and that night they were showing Disney's *Bambi*. "All down the length of the bar," he said, "there was this line of tough customers, all dressed in full leathers, and every one of them had tears streaming down his face. On the screen, Bambi's mother had died, but it was the time of AIDS, and those guys were crying for other reasons." On another afternoon, I went by to interview the bar's owner, Jay Goudgeon. We talked about the neighborhood and the history of the bar. "When the Rawhide opened in 1979," Jay recalled, "it was the first gay bar in Chelsea and the neighbors were incensed. At eight in the morning, they'd start throwing bricks at the windows. Every day. Then some of the customers brought cartons of eggs, and they'd throw the eggs at the brick throwers." Eventually, the battles ended. The bar sur-

vived hatred, the AIDS crisis, and Giuliani, but it could not survive hyper-gentrification juiced by the High Line and Bloomberg's luxury vision. As Jay told me, "Bloomberg is chipping away at the fabric of this city."

In 2014, the twenty-year-old Rainbows & Triangles gift shop announced their closure when the landlord refused to renew the lease. The Camouflage boutique shuttered after thirty-eight years on the Strip. Their rent had more than tripled, from $7,000 to $24,000 a month. Owner Norm Usiak blamed the nearby High Line. He told *Chelsea Now* in January 2014: "When you bring in five to seven million tourists, the commercial landlords understand that means more people walking by their property. They calculate that as a reason why they're raising the rent to these levels." On the state of Eighth Avenue, the paper reported, "Of the 115 ground level properties along that nine-block strip, nearly a third are chain stores, franchises or banks. Starbucks has three locations. Subway, GNC and Chase appear twice—with single locations of Banana Republic, American Apparel, CVS, Rite Aid and Duane Reade."

DNAinfo reported that in just one year, from 2013 to 2014, "More than a dozen businesses on that stretch shut down," and many of the storefronts sat vacant while landlords waited for deep-pocketed tenants. Gay Chelsea was over. Worse off, however, were the people who had little else to sustain them and nowhere to go.

One block west of the Strip, on Ninth Avenue between 17th and 18th Streets, stood a handful of longtime, mom-and-pop businesses that catered to locals and residents of the NYCHA projects across the way. From north to south along the block there was Tamara Cleaners, the New Barber Shop (hardly new), the 9th Ave. Gift Shop (a bodega, not a gift shop), the Famous Deli & Grocery (not in any way famous), the New China Chinese takeout joint, Chelsea Liquors, and the Sweet Banana Candy Shop, plus a Moneygram check-

cashing place, eight businesses in total, all on the ground floor of one large building filled with rent-regulated tenants.

In 2007, Fortuna Realty bought the Ninth Avenue building for $31.4 million. According to the *Observer*, Fortuna planned "to renovate and upgrade, hoping to lure high-end retail to the storefronts on ground level." Activists held a rally for the block's businesspeople. A crowd of locals gathered in the street, holding signs while state senator Tom Duane spoke about the need for small businesses in a place where "not everybody is rich"; state assembly member Dick Gottfried made a plea to bring back commercial rent control, saying, "A neighborhood is not a neighborhood if it's overrun by high-end boutiques, banks, and chain stores"; and Manhattan Borough President Scott Stringer proclaimed, "This isn't about a single store, but an entire neighborhood and the city as a whole." People from the nearby housing projects spoke of their need for the small businesses, the last places they could afford to shop in the area. From her wheelchair, Phyllis Gonzalez, a president of the projects' tenants association, said, "I can be outside any of these stores and in minutes someone comes out and says, 'What can I get for you, Ms. Gonzalez?'" She recalled how her children could run for safety into these same shops and their keepers would shelter them. The national chain that was sure to come would not provide such neighborly assistance. But these arguments fell on deaf ears.

Chelsea Liquors was the first to go. In business since about 1940, according to the owner, the lease had ended, the rent was hiked 300 percent, and they were given thirty days to vacate. Over the next few years, some of the businesses fell while others hung on, relying on month-to-month agreements until the final axe came down. Upstairs, the building's apartments were renovated. Stories circulated of residents being evicted. In 2012, the building sold again, this time to the Stonehenge Group. They renamed the building "Stonehenge 18," wrapped a red banner around it announcing, "Where Chelsea Meets the Highline," and delivered letters of termination to all of the

remaining businesses. At the time, I worked around the corner at the Callen-Lorde Community Health Center. For several years, I got my hair cut at the barbershop, got my lunch at one of the delis, took clothes to the seamstress at Tamara, and bought nickel and dime candies at Sweet Banana (Chick-O-Sticks were my favorite). For me, these places were convenient, affordable, and friendly. But for many of the people in the area, they were much more—strong links that held a community together.

At the barbershop, a customer called Flaco explained to me, "You can't find another barbershop like this. It's full of characters. Like me. In the day, we got the daytime characters. At night, after we close, we got the nighttime characters—the homeless guys come in then—and we all just hang out." When the barbershop and all the other businesses were gone, he said, "We'll have no place to go." At Sweet Banana, run by "Candy Lady" Patricia, a woman named Hassie sold homemade empanadas for a dollar apiece. She made them in her kitchen on 22nd Street, where she'd lived her whole life. She told me how Patricia kept prices low so the neighborhood people could afford to shop, and how much both women liked to watch the kids come in from the junior high and high school nearby. "We watched them grow up," she told me. "From little kids, they go to college and come back, and they visit. They always come back here." But after the Stonehenge Group terminated all the shops, there would be no going back. Every link in that vital chain was broken. By the spring of 2013, all eight businesses were gone and their spaces gutted. Stonehenge slicked and unified the strip, marketing it as "120 Ninth," with 5,400 divisible square feet that could go to multiple new businesses or one large company. On a vinyl banner atop the dull glass façade, where all those colorful and useful little shops used to be, Stonehenge posted architectural renderings of what might come, stereotypical clothing boutiques with made-up names—"Reckless & Daring" right next to "Establishment"—illustrating the impossible paradox that the new New York tries so desperately to pull off. As of this writing four

years later, where the tailor and barbershop once stood, there is now a Wells Fargo bank. The other spaces still sit empty.

Six months after the closure of the Chelsea Hotel, word leaked out that Patti Smith had performed a private show in the ballroom of the hotel for the friends and family of the new owners and their architect. Smith scheduled a second show for residents, but the residents boycotted. On his blog, Ed Hamilton wrote, "Patti must not know that the person sponsoring her upcoming event, Joseph Chetrit, is the same developer who took Stanley Bard's beloved Chelsea Hotel away from him and his family. And surely she is unaware that this is the same Joseph Chetrit whose demolition crews recently gutted over a hundred historic Chelsea Hotel rooms. Finally, if she hasn't been in some way deceived, we know there's no way in hell Patti would give a concert in support of a man, Joseph Chetrit, who is presently trying to evict almost thirty Chelsea Hotel residents using both housing and Supreme court. We love Patti and her music, and we would love to see her concert, just not under these circumstances. And so we call on Patti, now that she knows the truth, to cancel this event."

Smith responded to the outcry, writing on her website, "I am an independent person, not owned or directed by anyone. My allegiance is to the Hotel itself, and I have done nothing to tarnish it." But many residents believed the concert was merely bread and circuses, a way to get them on board with the developer's plans. On Hamilton's Facebook page, concerned readers—myself included—planned a die-in protest. On the night of the concert, protesters would drop "dead" on the sidewalk in front of the hotel, hold up lighters, and recite the lyrics to Smith's song "People Have the Power." In the end, there would be no protest. Smith canceled the concert. "My motivation was solely to serve the tenants," she wrote on her website. "If this serves them better, then I am satisfied."

People still wondered how Patti Smith could cater to the hotel's new owners, a group of men working to turn the hotel into a place where struggling artists could never afford to stay. Some believed she was unaware of the evictions and had simply bought Scheetz's compelling sales pitch that he would return the hotel to its former bohemian glory. On Scheetz's Facebook page that week there appeared a photo of Patti Smith in the embrace of Robert Mapplethorpe, but Mapplethorpe's face had been photoshopped out and replaced with the face of Ed Scheetz, his arms locked tight around Smith. It seemed to be a homemade birthday card made and signed by friends or employees. The caption read: "Hotel Chelscheetz."

In 2013, Scheetz bought out Chetrit for majority ownership. In a letter to tenants, Scheetz promised to improve the living conditions. Soon after, *The New Yorker* took a walk through the hotel with him and historian Sherill Tippins. The developer outlined his plans: a shopping gallery, a bar, an upscale restaurant, and an artists-in-residency program. He talked about wanting to make the hotel accessible to artists and people with little money. The writer of the article explained that Scheetz would create "small bedrooms, hyperbolically designated as 'artists' lofts'—priced at two hundred dollars a night" (more than the $139 I paid for a good-sized room with a balcony)—"next door to rooms that will cost a thousand." With rooms running for $1,000 per night, it was clearly the end for the Chelsea Hotel's century-long bohemian history. Like Varvatos's version of CBGB, it might have some look of authenticity—Scheetz wanted to keep "the feeling that it's a little bit worn"—so the tourists can step inside to admire the furnishings and take a picture, but it will ultimately be a place for the very rich. (The hotel would change hands yet again in 2016—this time for a partial condo conversion.)

At the end of *The New Yorker* article, Tippins noted that the hotel "has now been bought by exactly the kind of developer that Bloomberg encouraged so much in our recent past." She concluded, "I feel like as the Chelsea goes, so goes the city."

ON THE SIDEWALK

Stencil street art by Adam Dare. *Jeremiah Moss, 2016*

I T IS OFTEN WHILE WALKING ON THE SIDEWALK THAT WE COME crashing into the new psyche of the city. Literally.

Years ago, when I was still new to New York, I saw an old woman bark at a young man who had just passed her on the sidewalk. "Walk on the *right!*" she shouted. "In New York, we stay to the right!" He obeyed. Walking on the right was something I had been doing instinctively, but now I knew—it was a rule.

Mostly unspoken, except when broken in the presence of a forthright New Yorker, the rule exists to keep the sidewalks of the city flowing. It makes sense. After all, in the United States we're condi-

tioned by vehicular law to travel on the right. In a city of hurried millions, if everyone followed their own random desire lines, there would be almost constant collision. Unfortunately, today that's what we're getting. New York is more crowded than ever, crammed with new arrivals who don't care to adapt to the city's rhythm and tourists who don't know how to move through cities. They walk however they want. They drift diagonally, stop short, and congregate in packs, forcing everyone to sidestep around them. They walk three and four abreast, taking up the entire width of the sidewalk. They stop still at the tops of subway stairs and escalators, causing rear-end pileups. And, God help us, they willfully, infuriatingly walk on the left.

Pedestrians didn't always do this.

I'd say the sidewalk scofflaws started floridly flouting the rules in the early 2000s—you know, when everything went to hell in a hand-basket. Until then, the sidewalk was an orderly place. Not orderly in an obsessive, fussy sort of way, but in a New York way, which is to say that it looked chaotic from the outside, but within its stream you felt the deep, abiding patterns of its organization. It was like dancing in a complex ballet, crowded and frenetic, with a lot of leaping around, but all the while making sense, with no one crashing into anyone else because you and the other dancers possessed and maintained an attunement to one another. We sidestepped and shuffled, ducked and swiveled. I could thread through a Midtown crowd at rush hour, knowing I would not collide with another living soul, because all the other living souls were walking with the same skill and attunement. It could be a joy, walking in the crush, to feel all those bodies respond to your own, bending and weaving in concert. We all knew the cho-reography and agreed to perform the dance together.

Remembering that feeling, I think of a line by the poet Edwin Denby, who also happened to be a formidable dance writer: "We are all pleased by an air like of loving / Going home quiet in the subway-shoving."

Throughout the 1970s and '80s, urbanist William H. Whyte stud-

ied city sidewalks. He concluded that New York pedestrians were the best. "They walk fast and they walk adroitly," he wrote. "They give and they take, at once aggressive and accommodating." In his 1988 book, *City*, Whyte has an entire chapter on the Skilled Pedestrian in which he paints a portrait of a person who is awake, attuned, and cooperative. "What is most impressive about the individual pedestrian is the skill with which he adapts his moves to the moves of others. The simple avoidance of collision . . . is really a rather remarkable demonstration of cooperative effort."

I can attest that the newest New York pedestrians are neither accommodating nor cooperative. Many of them take, but few of them give. Whyte did not mince words when he noted, "Pedestrians usually walk on the right. (Deranged people and oddballs are more likely to go left, against the flow.)" So what happened between Whyte's time and today? Have New Yorkers become deranged, as in "removed from order," detached from reality? How did walking together go from cooperative to uncivil?

I n the late 1990s the horror of the cell phone came to the city. On every sidewalk, in every public space, we were forced to contend with loud, mind-numbing conversations that invaded and interrupted the internal flow of thought—and annihilated the social contract. Not long ago, I was sitting in Madison Square Park on a winter morning, admiring the way the rising sun burnished the Flatiron Building where a wisp of moon still hung in the hard blue sky. I was alone. It was 8 A.M. on a Sunday. I was thinking, lost in reverie, when a woman talking on the phone wandered over and stood not three feet from me. She could have stood anywhere. The whole park was empty. But she stood next to me. Talking. About nothing. (Cell phone conversations are never the sort you *want* to overhear.) Did she not see me? Was I invisible? Did I even exist?

With smartphones, people walk with their heads bowed to the

shrine of technology, eyes glued to tiny screens, thumbs in jittery flight. I call them iZombies, for obvious reasons. They drift and lurch across the concrete, careening into other people, tripping over dogs, knocking down the elderly. They are blunt obstacles that don't seem quite human. They bump you and walk on. If you manage to enter their awareness, they look like people awakened from a dream, sleep-walkers not fully alive.

It's a lonely feeling being among the iZombies. Walking the city used to be a joy. I miss the social dance. I miss being seen by my fellow walkers, to be accommodated just as I accommodated them. I know I'm not the only one who feels erased and dismissed. I even heard a sidewalk wino put words to the collective frustration. "Get off your cell phone!" he shouted to the passing crowd. "I don't want to hear about your life. Keep your miserable life to yourself. I got my own problems. You wanna talk? Fine! I don't want to hear it. Shove it up your ass. And put it on fucking vibrate. Do I make myself clear? Loud and clear?" Commenters to a 2007 *Times* article on the homogenized city remarked: "What once were streets filled with people who actually spoke to each other, now replaced by androids," and "I only wish whatever laboratory that is manufacturing these creatures would install a chip in them that would make them a bit more, well, human . . . there should be a massive recall."

As David Carr noted in the *Times* in 2014, "texting and walking is inconceivably rude. The last few benevolent human beings on earth who are just trying to make it down the street are forced to move out of the way for thousands of inconsiderate people." On the urban sidewalk, what was once a shared responsibility is now a burden on the nontexting population. It used to be, I swivel, you swivel, each of us doing our part to avoid collision. Today, texters selfishly demand that the rest of us do all the work. And it is constant work.

A study published in the journal *Gait and Posture* showed that "[c]ell phone use among pedestrians leads to increased cognitive distraction, reduced situation awareness and increases in unsafe behav-

ior." People who walk and text lose velocity and direction. They veer off course by as much as 61 percent. Avoiding them can take up all of an alert pedestrian's focus. They even crash into our minds. If zombies eat brains, then iZombies eat thoughts. They distract those of us who don't want to be distracted. Clay Shirky has compared the contagious mental distraction of screens to secondhand smoke. For many of us, this is enraging. New York street artist Adam Dare puts the rage into words when he stencils sidewalks with the message: "FUCK YOUR PHONE—KEEP YOUR HEAD UP!"

As I see it, the walking and texting habit—and the attitudes and actions that go with it—is another symptom of our Enron Society. A 2016 study seems to back this up. In their paper "Social Class and the Motivational Relevance of Other Human Beings," researchers from NYU found that higher-class pedestrians pay less attention to people on the sidewalk than lower-class pedestrians do. Those who self-identified as higher class were less likely to find other human beings "motivationally relevant"; in other words, they quickly assessed that most people simply weren't important, so they visually ignored them—and they weren't even holding smartphones. It stands to reason that this "attentional neglect" would intensify on the sidewalks of hyper-gentrified neighborhoods as more higher-class people move in, pushing more attentive lower-class people out, and that it would lead to increased collisions.

When an iZombie steps into an open manhole, walks into oncoming traffic, or crashes into someone, they often blame someone else. The cars, manholes, and other elements of city life, including people, are not supposed to be there. In 2015, a Keith Haring sculpture titled *Self Portrait, 1989,* was installed on a street corner at Astor Place. A splash of lost local color in the bland corporate plaza, Haring's bright green figure raises its fist and kicks a foot high in the air, looking like an alert and determined New York pedestrian. Soon after its installation, the sculpture kicked an NYU student in the head. Or, rather, an NYU student rammed the sculpture's foot with her skull.

She was walking and texting. When her father saw the welt on her forehead, he filed a complaint about the artwork with the city of New York. I guess it was not supposed to be there.

In the battle for the sidewalk, another powerful group claims the space as their own—the army of the "stroller mommies" (and daddies). In the 2000s, formerly slim baby strollers swelled to enormous proportions, in both size and price tag. With rugged all-terrain tires and a sidewalk-hogging double-wide girth, they became the entitled SUVs of the urban pedestrian highway, some costing upwards of a thousand dollars. Expensive strollers, wrote the *Times*, "are in-your-face, in-your-way status symbols. They say, 'I paid for this stroller, to say nothing of my three-story town house, which authorizes me to take up nine square feet.'"

Many New Yorkers have at least one story of being assaulted, physically or verbally, by a certain type of stroller-pushing parent. My most memorable encounter occurred on a bright morning while walking to work along West 12th Street, on a narrow and quiet sidewalk flanked by townhouses and London plane trees. A young mother raced toward me, pushing an upscale, supersized baby stroller. I slipped as far to the right as I could go. She did not budge an inch, though she had at least six to spare. I twisted sideways. My face smashed into an azalea bush as my backpack brushed the heavy-duty roof of the stroller. She shrieked, "You fucking asshole!" On another occasion, a Meatpacking District dad dressed in Burberry plaid pants came from behind and sideswiped me so hard with his Bugaboo he left a bloody gash down my arm. He was also on the phone.

"Out of my way," wrote Denise Albert in the *Metro* paper in 2010. "I'm a mom! Yes, I have mommy rage. I don't hide my feelings, and if you make me angry you will know it." With that, Albert gave words to the stroller aggression many of us had witnessed. We no longer had to guess what these people were thinking when they rammed us. Albert explained, "I know what I want, what I like, and how to get it done."

In the New Gilded Age, where extreme inequality makes people more antisocial, withdrawing into cellular pods, I wonder what effect the neoliberalized psyche has on the physical body of the city. Think of all the entitled people, cruising the sidewalks inside their narcissistic shells. What do they care for the landscape going by? They don't even look at it. Day after day, the city's old brick buildings and colorful hodgepodge of small businesses are destroyed, replaced by a seamless and smooth repetitive aesthetic. All silvery gloss and shimmer, the monotonous blocks of condos and chain stores offer a sea of mirrors into which the narcissist gazes to see only himself. Which came first? Did people turn away from the city—or did the city turn away from them?

In his 1995 essay "The Generic City," writing on the state of global urbanism, architect Rem Koolhaas riffs on the blankness of contemporary urban homogenization. An "endless repetition," the Generic City offers a sedative, freeing people to ignore the world around them. "Close your eyes," he suggests, "and imagine an explosion of beige." I'd rather not. The Generic City, suggested Der Spiegel in 2011, could be "the face of neoliberalism." It alienates us from each other and from ourselves. For Danish urbanist Jan Gehl, the blank structures of this globalized environment are "self-absorbed buildings." He concluded, while watching people walk faster past generic architecture, "Cities no longer hold appeal for pedestrians."

Many people, including many newcomers, want to see the old city torn down, the brick patchwork destroyed for more glass façades. They like the generic. Maybe the city is filling up with blank structures because too many of the people are blank. They require the surfaces of the city to be blank, one void reflecting the other. This is New York as a hollow hall of mirrors, an empty recursive loop. And it's making us all sick.

Cognitive neuroscientist Colin Ellard studied what happens to people on the sidewalk when they stand in front of a bland glass façade. He placed human subjects in front of the Whole Foods gro-

cery store on the Lower East Side, strapped skin-conducting brace-
lets to their wrists, and asked them to take notes on their emotional
states. He reported, "When planted in front of Whole Foods, my par-
ticipants stood awkwardly, casting around for something of interest
to latch on to and talk about. They assessed their emotional state as
being on the wrong side of 'happy' and their state of arousal was close
to bottoming out." The instruments on their wrists agreed. "These
people were bored and unhappy. When asked to describe the site,
words such as bland, monotonous and passionless rose to the top of
the charts." Ellard then moved the group to another site nearby, "a
small but lively sea of restaurants and stores with lots of open doors
and windows." Here, these same people felt "lively and engaged."
Their nervous systems perked up.

In his book *Happy City*, Charles Montgomery calls this "an emerg-
ing disaster in street psychology." The loss of old buildings and small
businesses, the homogenization from suburban chains and condo
boxes, is more than an aesthetic loss. It is damaging us psychologi-
cally and physically. Montgomery writes, "The big-boxing of a city
block harms the physical health of people living nearby, especially
the elderly. Seniors who live among long stretches of dead frontage
have actually been found to age more quickly than those who live
on blocks with plenty of doors, windows, porch stoops, and destina-
tions." The Generic City is killing us.

In a New York where people are reconceived as consumers, not
citizens, it is most profitable to keep everyone moving and discon-
nected. This is what the hyper-globalized, ultracompetitive city looks
and feels like. I saw the perfect word for it scrawled on a wall in the
East Village: *blandalism*. Sleepwalking inside digital bubbles, the
iZombies hustle through the city without looking. And you can't re-
ally have compassion for a thing—or a person—without beholding it.

Looking and empathy are intertwined. The German word *Ein-
fühlung*, from which *empathy* comes, was a term from aesthetics,
referring to the way a viewer would "feel into" a work of art or ar-

chitecture, identifying with the object. As infants, we develop our capacity for empathy by finding it in our caregiver's gaze. She or he looks at us, sees us, reflects us back to ourselves with love, and our brains blossom with mirror neurons. Without eye contact, our ability to empathize can be impaired. (Blind children are taught empathy through words.) The caregiver who turns inward more often than not, who withdraws into her own narcissism, depression, psychosis, may create in the child a psyche that likewise turns away, retreating into his own hollow world of self-reflecting mirrors. This is not unlike the walker in the city who turns away from his fellow walkers, and from the environment around him. He projects a kind of psychic deadness, an absence of mind that can be painful for those who remain awake.

Without talking, touching, or even making eye contact, the human mind seeks the presence of other human minds. When we encounter psychic deadness or disturbance—derangement—we feel it. It unsettles us. I think of the Uncanny Valley, that measurement of discomfort we feel in the presence of a figure that falls somewhere between human and inhuman, not quite dead and not quite alive. We feel it when confronted by moving images of androids and zombies. Their strange behaviors unsettle the mirror neurons in our brains. They disturb our attempts to empathize. I wonder if the same thing happens on the sidewalk when confronted by iZombies with their undead, android-like behaviors and psychic absence. I feel irritated and off-kilter whenever they're around.

As a former poet, I'm prone to the pathetic fallacy and often attribute emotion to the inanimate. It's a lifelong thing with me. I won't reproach myself for feeling into the emotional force of objects. Old buildings, especially, are full of life. The touch of the human hand gives them vitality, in the scrollwork below a tenement's windows, in the faces carved between bricks, and in the bricks themselves, each one molded and fired by men and not machine. Look. That elderly building on the corner has been animated for 150 years by genera-

tions of New Yorkers, by their sounds and smells, their arguments
and lovemakings, their private nighttime sorrows, their quaking
souls passing into and out of their bodies. How do you not feel into
this? The scruffy tenements and disheveled shops serve as necessary
reminders of our mortality. We are not androids. But not everyone
wants to be reminded. Too many would rather be surrounded by
shiny new boxes. The cool, glittering mirrors of glass buildings and
screens make it easier to deny the reality of our own decline and
death. Eventually, every aspect of the city's humanity will be disap-
peared. We must open our eyes and look.

HIGH LINE 2:
WEST CHELSEA TO HUDSON YARDS

Hudson Yards rising over the High Line. *Jeremiah Moss, 2016*

O N JUNE 8, 2011, THE FRIENDS OF THE HIGH LINE, ALONG with Mayor Bloomberg and other supporters, cut the ribbon to open Section 2 of the elevated park. It continued where the first section left off at West 20th Street, extending out of the Meatpacking District and up into the industrial blocks of the far western edge of Chelsea, all the way to West 30th Street, where its tail curls around the Hudson Yards like a python encircling its prey.

While the first section of the park had opened in a neighborhood already changed into a destination for tourists and luxury consumers,

the second section invaded near-virgin territory, parts of town barely touched by hyper-gentrification. On Chelsea's westernmost edge, the High Line would go off like an atom bomb.

When the park's co-founders, Joshua David and Robert Hammond, first started working to preserve the elevated train tracks, they could not have foreseen the destructive impact it would have on the surrounding area, but they got a glimpse once they began collaborating with the Bloomberg administration. In their book *High Line,* David recalls his initial response to the High Line deal, which stipulated that, in order for the city to save the tracks, the air rights above them would have to be sold to luxury developers. He told Hammond, "If the result of doing the High Line is that you end up with all these tall buildings that you wouldn't have had otherwise, I don't want to be a part of it." But David eventually came around—"my perspective changed," he wrote—and the wheels on the big machine moved forward. As Joseph Rose, then chairman of the city's Planning Commission, told the two preservationists, "The High Line had been an impediment for so many years. You and your group changed it into a catalyst."

At the same time, the Bloomberg administration started pushing plans to rezone several blocks of what they called West Chelsea, a chunk of the old city between 16th and 30th Streets, along Tenth and Eleventh Avenues, all with the High Line at its core. This section of Chelsea, more recently filled with big-name art galleries, was a longstanding industrial area of working auto body shops, warehouses, gas stations, and greasy spoons. Many of its small businesses had been there for multiple generations, like Veteran's Chair Caning and Repair, since 1899, and Brownfeld Auto, begun as a horse-and-buggy repair shop, also in the 1890s. Known as Gasoline Alley, it was a stable working-class neighborhood. But the Bloomberg planners wanted to replace it with luxury high-rises and global brands, a new neighborhood that would feed the ultraluxe Hudson Yards soon rising at 30th Street.

In 2005, with support from the Friends of the High Line, the city successfully rezoned the area, calling it the Special West Chelsea District, and granted permission to the property owners along the High Line to sell the air above the tracks, transferring it to the developers of high-rise buildings within the zone. These property owners were located within what was called the High Line Transfer Corridor. A sheath of land around the second section of the park, running from 19th up to 30th Street, the corridor contained about one million buildable square feet—and everything caught within its net could vanish. Except the art galleries. Art is good for gentrification, so the city granted the galleries unique protections.

In the zoning resolution, the planners wrote out the explicit purposes of creating this special district. Aside from encouraging development and promoting the "most desirable" use of land, one purpose was "to facilitate the restoration and reuse of the High Line" as a public space, through, in part, "High Line improvement bonuses and the transfer of development rights from the High Line Transfer Corridor." Bonuses along the corridor meant that if a luxury developer provided improvements to the High Line itself, such as stairways and public restrooms, that developer could build their condo towers even bigger. The High Line and the rezoning worked together, creating a recipe for what might be the biggest, fastest, most expensive development boom in New York City history. Snaking north, the park would act like a long irrigation hose threaded through what City Hall and developers viewed as a fallow field, soaking the soil and prepping it for an explosion of unimaginable growth—and destruction.

The opening of the High Line's second section heralded a mass extinction event, like the impact of the K-T asteroid that wiped out the dinosaurs. That same month, the 10th Avenue Tire Shop was pushed out, soon followed by the Bear Auto body shop, the Mobil gas station, and Brownfeld Auto, all fallen for uses related to upscale development.

I visited with Alan Brownfeld in December 2011, just before he

was forced to close shop after nearly a century in business. A friendly biker with long hair, a thick handlebar mustache, and oil-stained hands, Alan could just as easily be imagined drinking with the Hell's Angels as putting on a Santa suit for needy kids—which he did every year on his motorcycle with Toys for Tots. His busy garage was greasy, loud, and strong with the smell of motor oil. It was also decorated with paintings, the walls covered with canvases that Alan had salvaged from the streets. He jokingly told me that he hung the paintings so his garage could be "part of the trendy art block." Now that trendiness was pushing him out—he didn't own the building and his landlord was not renewing his lease, "because of the High Line people," Brownfeld had told the *Post*.

"This is more than just an auto body shop," he explained to me as he greeted the many people who stopped in to chat. "It's a social club for friends, family, and customers to hang out morning, noon, and night. People don't go home after work. They come here." A suited businessman on his way home to Jersey arrived, then a firefighter in uniform, followed by a biker in leathers. They all greeted Alan and each other with handshakes and back slaps, and then hung around, smoking and shooting the breeze. A young woman named Amy walked in, gave Alan a big hug, and grabbed a beer from the stocked cooler. She told me, "You come here and feel like part of a family. Alan is a New York City icon. Everybody knows his name. He's got a big heart and what's happening to him is an injustice. The neighborhood will suffer greatly."

"Even people without cars will miss us," Alan said. "They'll miss our Friday barbecues. I feed the whole neighborhood—homeless people, workers from the other shops, anyone who comes by."

He pulled a chain from his neck and showed me the gold replica of an antique leaf spring, worn in honor of his heritage. "When my grandfather built this place as a horse-and-buggy business, we were fixing wooden wheels and the springs on stagecoaches," he said. "The New York City streets have been good to me," he continued.

"The potholes have been good to me. Things were great until Bloomberg came into office. He decided to build his own fucking park and he called it the High Line. It's for the city's glamorous people—and it's pushing Gasoline Alley out of Chelsea."

Brownfeld's shop was demolished soon after it closed, and Gasoline Alley kept crumbling. The Lukoil gas station on Tenth Avenue sold for $23.5 million. The scrapyard on West 28th, in business since 1927, got $65 million. Within a shockingly short amount of time, the warm, ragtag character of the neighborhood was decimated by cool glitz.

In 2011, in a love letter to the High Line, Phillip Lopate wrote, "Much of the High Line's present magic stems from its passing through an historic industrial cityscape roughly the same age as the viaduct, supplemented by private tenement backyards and the poetic grunge of taxi garages. It would make a huge difference if High Line walkers were to feel trapped in a canyon of spanking new high-rise condos, providing antlike visual entertainment for one's financial betters lolling on balconies."

That is exactly what happened.

Rushing into every space along the upper High Line Transfer Corridor came the mega-towers, jammed together cheek by jowl, pressing against the High Line's flanks as they soared into the air. Some darkened the streets with dull, blocky, mausoleum-like designs, while others made headlines with retro-futuristic swoops and boomerangs, Space Age architectures conjuring sleek hybridizations of *The Jetsons*, the iPhone, and the latest Tom Cruise post-apoc flick. One broker told the *Post* in 2013 that the High Line area is "Dubai in New York. I've never seen such a landscape change so quickly. It's like they're building a whole city within the city." A developer estimated that there were, at that moment, three thousand apartments and condos under construction across the neighborhood—most with price tags in the millions. Exploiting and paying homage to the park that spawned them, many buildings were named after the High Line.

There is the Highline, a double tower that rises on both sides of the park; the Soori High Line, where each unit enjoys its own private, heated swimming pool; HL23, with slanted glass walls that lean out over the High Line to show off the posh interiors; and, finally, there's AvalonBay's monstrous AVA High Line, a sunlight-obliterating blockbuster that helped push the queers off West 28th Street.

Just a few weeks after the ribbon cutting for the High Line's second section, on what was then a nondescript block of far West 28th, the Folsom Street East Fair held its fourteenth annual street party. A smaller version of San Francisco's Folsom Street Fair, Folsom East is a one-day celebration of leather, fetish, and BDSM culture, and it attracts the queer and kinky from all over. Men, women, gay, straight, transgender, and otherwise gathered together that warm June afternoon, dressed for the fest in leather chaps, jock straps, corsets, and latex cat suits. They did what they've always done, eating corn dogs and drinking Budweiser in the sunshine, watching blindfolded men lick the boots of leather daddies, while groups of girls in fishnet stockings arranged themselves into spanking daisy chains. Folsom East is the one time when members of this subculture can come together in the light of day to appreciate and be appreciated by one another. Pushed out of the Meatpacking District years before, the Folsom crowd had found this forsaken block, right in front of the Eagle gay leather bar, surrounded by scrapyards and auto body shops, the perfect place to have their party unobserved by outsiders. The High Line had always been there, once a weedy abandoned overpass just above the fair's main stage. But now the overpass wasn't abandoned. For the first time, it was loaded with tourists.

They gawked, pointed, and laughed down at the kinksters, pressing themselves against the western railing of the High Line for a better look. If the train trestle had been a ship, it would have listed to port from all the unbalanced weight. I stood up there that day and listened while grandmothers exclaimed, "Oh no, their bee-hinds are hanging out!" Fathers covered their children's eyes, saying, "Don't let

the kids look." Others uttered the time-honored statement, "Only in New York." But they would not have long to be titillated by that taste of the dirty old city.

"Cities have sexes," wrote feminist author Angela Carter in 1982. "London is a man, Paris a woman, and New York a well-adjusted transsexual." I imagine what she meant is that New York City is a boundary-crossing mash-up of sex and self-expression, transgressive, though well-adjusted and, therefore, confident in its identity. I like thinking about New York this way, but I would not have been aware of this quote had I not read it on the promotional website for the +aRt luxury condo, a building that opened a few months earlier on that once-quiet block.

As soon as they moved in, the +aRt residents started complaining about Folsom East—even while the developers capitalized on the neighborhood's edginess, painting the front window of the building with the slogan "Chelsea is . . . the home of bad behavior." Some of the condo residents tried to kill off the kink fest, handing out fliers and circulating petitions, urging the local community board to evict the festival because, as one anonymous condo owner told me, "fetish fairs shouldn't be allowed so close to so many residential buildings." Of course, the fair had been there long before the residential buildings. But the new people were upset. They worried about their children. According to the resident who talked to me, parents were deeply disturbed by the fair's "lewd conduct and nudity." But the fair didn't actually allow lewd conduct. Burlesque acts were performed, but nothing legally definable as "lewd," and there was no full nudity permitted. Still, the stroller brigade didn't like the fair. The sentiment was mutual. Folsom East made posters that read, "Get your stroller out of my face. This is New York Fucking City."

The following year, the flood of tourists to the increasingly popular High Line had increased. During Folsom East, they overflowed the viewing platform and staircase that leads down to 28th Street. Bible thumpers appeared out of nowhere to scream about sin. And

more towers climbed into the sky. The biggest was AvalonBay's AVA High Line, a 60,000-square-foot, 710-unit blockbuster made of two buildings stuck together in the general shape of a morbidly obese giraffe without legs. At Eleventh Avenue, the head and neck rose thirty-one stories while the thirteen-story body stretched back along 28th Street, reaching almost all the way to Tenth Avenue. Avalon proudly called itself "A Catalyst in Changing Neighborhoods." As AVA's construction darkened the street and crowded the sidewalk, the organizers of Folsom East announced that the next year's fair would be canceled. On their website they wrote: "the ever-growing construction on the north side of 28th street has made it impossible for us to successfully and safely hold our annual street festival."

The next summer, with no fair, I went to the Eagle Bar's Memorial Day roof-deck barbecue. I walked along West 28th Street through an unfamiliar landscape. The once wide and sunny block had been plunged into shadow by the AVA High Line. It felt claustrophobic. The scrapyard, along with all the taxi garages and their "poetic grunge," had shuttered. Through a gap opened by demolished buildings, I could see to the hole in the ground where Alan Brownfeld's garage used to be. It had all happened so fast.

From the roof of the Eagle, enjoying a burger and a beer, I looked up at AVA's tower section as it loomed over the heads of the last Mohicans of the city's queer leather community. Many of the men around me were old enough to remember the old Meatpacking District, the underground clubs of the 1970s, sex under the decrepit High Line, the AIDS raids of the 1980s, friends and loved ones dying. They remembered the old Eagle, at 21st Street and Eleventh Avenue, closed in 2000 after thirty years. The new Eagle opened in 2001, on this desolate block where no one, they thought, would ever bother them. Today the Eagle remains, but I wonder how long it will take the new residents to start complaining. As for the Folsom East Fair, it has successfully relocated one block south, to a spot where the High Line tourists can't see it so well. The park does not have a viewing plat-

form or staircase on 27th Street, so the eyes of children need not be shielded. Folsom East continues to keep a piece of New York's unconventional soul alive. For now.

From the Special West Chelsea District in the 20s, the High Line continues into its final section, taking a sharp left to wrap around the Hudson Yards at 30th Street. Another purpose of the West Chelsea rezoning, according to the city's resolution, was to "create and provide a transition to the Hudson Yards area to the north." In essence, Special West Chelsea was created to provide a link between the Meatpacking District below and the new neighborhood above, all with the High Line running through like a conveyor belt ferrying tourists and money up and down.

Back in 2001, in *Fortune* magazine, Joshua David laid it all out. The High Line would make New York "more prosperous," he wrote. "It can be a unique attraction that tourists will want to see. It can provide fertile ground for architects to design innovative buildings that interact with public space. It can add value and convenience to our isolated convention center." That convention center is the Jacob Javits, located just above Hudson Yards, the formerly open rail yard where the Metropolitan Transportation Authority parks its commuter trains. The Javits Center was always difficult to reach by public transportation; the subway didn't go that far west, and on foot you had to traverse the overpasses and underpasses that wind about the roaring roadway to the Lincoln Tunnel, walking through a blue-collar district filled with auto body shops, warehouses, and dusty old stables that house Central Park's carriage horses. The Department of City Planning called the area a "bleak pedestrian environment" in need of revitalization.

This quiet and underpopulated, otherworldly realm miraculously exists just a few blocks from bustling Times Square, and yet it feels a million miles away. Mechanics sit on piles of rubber tires, smoking

cigarettes while they wait for the next flat to fix. Strippers head to work at a nearby gentleman's club. The carriage horses stand on the sidewalk to be hosed down by shirtless stablehands who groom their hides with battered brushes. The air smells deliciously of wet straw and horse manure. Down below, locked behind a chain-link fence, Amtrak's Empire Line railroad cut runs beneath the overpasses, its strange, dusty pathway bordered by a large exposed outcrop of Manhattan schist. Mostly unseen among the buildings and streets of the city, the schist is Manhattan's bedrock, its backbone, anchoring the skyscrapers in place. Here, an impressive palisade of tawny rock, glittering with mica flakes, tumbles down from behind a lumber yard and weedy lot. Walking past it will remind you that you are close to the earth, attached to its geology, stepping across an island gouged out of the sea by glacial push. If it looks unfinished, it won't be for long.

Major development plans have been in the works for the rail yards since the 1980s, including ideas for a new Yankee Stadium, a new Madison Square Garden, and an Olympic Stadium. They all failed. Until Bloomberg. From the beginning of his administration, he and his deputy, Dan Doctoroff, pushed hard to redevelop the yards. In 2005, along with Special West Chelsea, city planners rezoned a broad expanse around the yards, encompassing about forty blocks from the doomed Garment District to Hell's Kitchen. The administration called it the Special Hudson Yards District and stated that its purpose was to "facilitate high-density office development," and to "create a vibrant, 24-hour community"—all financed with corporate welfare.

"With just 19 days left in office," reported the Gothamist blog in December 2013, "the Bloomberg administration has bestowed a sloppy goodbye kiss on the giant developer Related Companies in the form of $120 million in tax breaks," $76.5 million of which was earmarked for their forty-nine-story Hudson Yards tower. And there was more. The mayor-appointed New York City Industrial Development Agency (NYC IDA) had granted $328 million and $106 million

in tax breaks to Related, all for the construction of Hudson Yards. The Independent Budget Office projected that Hudson Yards would cost the city more than $947 million. In the *Village Voice*, James Parrott, deputy director of the Fiscal Policy Institute, said, "It is the height of fiscal irresponsibility for the NYC IDA to provide massive taxpayer subsidies to a Manhattan luxury mall." But the Bloomberg crowd craved more luxury malls, viewing them as spiritual centers of urban life. Hudson Yards "will shift the heart of the city," said Related's chairman, Stephen Ross, to the *Daily News*. He explained, "If you look at where all the young people are today, where they want to be, where all the money is going, it's the West Side of Manhattan. The yards will be the epicenter of all that."

The epicenter of youth and money, the cold artificial heart of new New York, Hudson Yards appears in the architectural renderings as a jagged explosion of glass, silver splinters bursting from the concrete far below, like Superman's Fortress of Solitude erupting from the arctic tundra. It is colossal. In one shot, the Empire State Building stands to the side, looking diminished and aged, a dowdy old girl put out to pasture.

On Related Companies' original Hudson Yards website, the slogan is "The New Heart of New York." The site explains that this 13-million-square-foot fabricated neighborhood will be "the center of New York's shopping universe," with five levels of "globally renowned retail brands." There will be "food concepts" prepared by well-known chefs in open settings that offer "gourmet voyeurism" to anyone walking by. Living here will be beautiful, with so many amenities you'll never leave. There will be a Public Square with "brand installations," "wine events," and mass yoga classes that look choreographed by Ayn Rand. You'll even have your own private streets on which to park your car. Of course, you can work here, too, but only if you're innovative, because the office spaces have been "designed for visionaries." And no self-contained luxury corporate-living campus would be complete without a high-class spa for dogs. But the pièce

de résistance will be the titanic, $250 million sculpture that Related's chairman Ross claimed "will be to this city what the Eiffel Tower is to Paris." It is currently titled *Vessel*. The designer's rendering of the fifteen-story structure depicts an Escher-like basket of 154 inter-woven flights of stairs that thousands of tourists will climb at once, creating a human hornet's nest of looping and buzzing. Its creator, British designer Thomas Heatherwick, said he wanted a piece that would highlight its visitors, to "celebrate ourselves" and "showcase us." So the intended view is not so much outward to the city, but in-ward, tourist facing tourist, a hall of living mirrors. Ross nicknamed it "the social climber."

For all this, the High Line gets the thanks. The New York City Economic Development Corporation published a study stating that before the High Line was redeveloped, "surrounding residential properties were valued 8 percent below the overall median for Man-hattan." Between 2003 and 2011, property values near the park in-creased 103 percent. Related Companies gives even greater credit. As their website reads, the new West Side's growth "can be attributed to the success of the High Line which has spurred $2 billion of private investment." All since opening in 2009. Not even four years. That's the time it took to flatten multiple neighborhoods and replace the whole thing with a manufactured plastic habitat. A dreamworld of exclusion, Hudson Yards will be one of those places Mike Davis de-scribes in *Evil Paradises:* "where the rich can walk like gods in the nightmare gardens of their deepest and most secret desires." It will be what Norwegian urbanist Jonny Aspen calls "zombie urbanism," a neat and tedious stage set, regurgitating global clichés about mod-ern urban life, "in which there is no room for irregularity and the unexpected."

In 2013, the Friends of the High Line and Coach Inc. announced that the luxury brand had donated $5 million to the park. In exchange, the Friends promised to name a section of the park's final stretch after the company. Coach would be moving its global headquarters into

10 Hudson Yards, a fifty-two-story glass building that now straddles the park like a horseback rider standing in the stirrups. This illustrious crotch, lined with giant screen advertisements, has been christened "Coach Passage." I will not be surprised if the smell of calfskin leather is one day feverishly pumped through hidden vents. On that day, the Coach brand's horse and carriage logo might be the only reminder that this neighborhood was once, and for over a century, a center for the city's horse-drawn carriage stables.

In the spring of 2014 I stood at a second-story window of Central Park Carriages on far West 37th Street with stable owner Cornelius "Neil" Byrne, a Hell's Kitchen native and second-generation carriage man, descendant of Irish immigrants. Dressed in a scally cap and barn jacket, Byrne looked much like the Irishman he is, pink-cheeked with heather-gray eyes, but instead of a brogue he spoke in a New York accent, dropping r's and saying "hunert" for hundred, as in, "There's carriages running around Central Park for a hunert and sixty years." He bought his old brick stable building in 1979. It holds a fleet of seventeen horses and carriages, including Byrne's father's 1902 hansom, painted Brewster green and filled with memories of its days rolling through the city behind a mare named Sunshine Shannon.

This is one of a few stables left in the neighborhood. They're all being threatened by the High Line–Hudson Yards gold rush, as the properties around them have been snatched up by big developers, as well as by Mayor de Blasio's vow to ban carriage horses from the city, citing animal cruelty in a (now apparently defunct) plan that just happened to be backed by a real estate magnate.

While Byrne and I talked about the changes, a butterscotch gelding named Cowboy kept us company, moving about his stall in the bracing aroma of horseshit and hay. The rest of the building was empty, all the other horses gone to work with their drivers in Central Park. Byrne and I looked out through the dusty glass to the gigantic

Hudson Yards site just a few blocks south. A tangled crowd of construction cranes stabbed the sky, swinging back and forth like giant knitting needles stitching together the mega-development.

"I keep looking out at those cranes," Byrne said. "You don't have to be a real estate expert to see what's going on. So much is gonna follow those cranes. Unprecedented growth, they say. I know why Bloomberg called this neighborhood the new Gold Coast. That's change out there. And it's change that's eliminating me." Cowboy sighed in his stall. Soon, Byrne said, "this neighborhood's gonna be in full bloom. And that's why they want my property. We're in the way. But I don't want to leave New York. This is my New York, too."

THE TROUBLE WITH TOURISTS

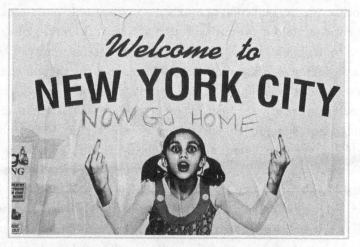

Street art by Ivan Orama, with added graffiti, a contemporary take on
the classic anti-tourism slogan. *Jeremiah Moss, 2014*

GROUSING ABOUT TOURISTS HAS LONG BEEN A NEW YORKER'S
right and social obligation. Historically, the rube in sandals
with a camera around his neck was a mark, someone gull-
ible enough to buy a watch from a thief's open trench coat or get
suckered into a game of three-card monte. In Neil Simon's 1970 film,
The Out-of-Towners, it's a laugh riot when Jack Lemmon and Sandy
Dennis's suburban Ohio couple goes through the New York wringer
of muggings, garbage, and exploding manhole covers. In 1975, cops
and firefighters used tourists as cannon fodder in their war with City
Hall. When Mayor Beame planned to lay off thousands of officers,

their unions took revenge by printing up a harrowing leaflet designed to make New York's 16 million tourists very nervous. "Welcome to Fear City" featured a grim reaper on the cover and told visitors to stay off the streets after 6 P.M. and "never ride the subway for any reason whatsoever." There was nothing sacred about tourists. Then the city government remade New York, putting the needs and desires of tourists over residents.

With Milton Glaser's new "I ♥ New York" logo in hand, Mayor Koch made the seduction of tourists, along with big businesses, an essential strategy in the reconstitution of New York for the globalized age. In her book *Branding New York*, Miriam Greenberg reveals how, for the first time in history, New York began to fervently market itself in the late 1970s, selling a cleaned-up image for the purpose of commodifying the city for a new clientele of middle-class suburbanites and corporations. To reorient the city after fiscal crisis, as Greenberg explains, "the standpoint of the out-of-towner and the imagination of the average tourist became overwhelming preoccupations for the established and emerging leadership of New York." Especially when Ronald Reagan pulled federal funds for cities. The resulting rise of mass tourism, like gentrification, was planned. Through a grand campaign, Greenberg says, the city was reframed, packaged, and branded as "one that was almost entirely white, Manhattan-centric, and decidedly not working class." It was another maneuver in the battle for New York, another advance of the neoliberal shift.

In the early 2000s, after twenty years of popularity, an iconic T-shirt vanished from the streets. "Welcome to New York," it read. "Now go home." Its disappearance mirrored the disappearance of a caustic attitude. In Bloomberg's city it was no longer kosher to complain about tourists. We were told we needed them after 9/11. With the Americanization of New York after the attacks, with Ground Zero turned into a morbid attraction, and with the mayor hyperfocused on increasing tourism, out-of-towners made themselves very comfortable. They began pouring in, slowing down the trains

and clogging the sidewalks. Fran Lebowitz had earlier complained, "What a nightmare! No one who isn't from New York knows how to be a pedestrian. Pedestrians don't mosey. And they don't walk five abreast. I'd like to make New York unsafe for tourists." But it was too late. During the 2000s, the impact of mass tourism—bringing tourist-ification and "tourism gentrification"—would do its part to change the psyche of the city's streets.

In 2006, with the creation of the tax-exempt corporation NYC & Company, Bloomberg pledged $15 million to the already $22 million launch of a multipronged marketing plan to bring a record-breaking 50 million tourists per year to New York by 2015. The plan, called "50 by 15," was headed by a branding and advertising exec who'd previously worked for clients like Disney and Coca-Cola. New York, Bloomberg kept reminding us, was a brand, a product that everyone around the world should consume. At 42 million, the city's tourist numbers were already high, but Bloomberg wanted more. His aim was to make tourists feel at home in the city—and to make New Yorkers give them respect. In 2007, reported *New York* magazine, Bloomberg said to the head of NYC & Company, "New Yorkers think tourists are just a pain in the ass. We have to do something about it." So they created the "Just Ask the Locals" campaign, "designed to get New Yorkers to be nicer to visitors." We were to be on our best behavior. The campaign posted ads of local celebrities, like Robert De Niro and Ivanka Trump, giving tips on how to hail a taxi and use the subway, while volunteers stood on street corners to help tourists with their questions.

Bloomberg's "50 by 15" goal was surpassed in 2011, four years ahead of schedule. In every year since, the record has been broken again. In 2016, the number climbed to over 60 million, double what it was in the 1990s. With all those tourists, combined with a record-high population of 8.5 million, the city is being destroyed by its own so-called success. Cities are crowded by nature and density is an ur-ban value, one that Jane Jacobs extolled. But when Jacobs celebrated

density, she wasn't talking about a hellish human traffic jam. Today our public spaces are overrun. Locals avoid the city's art museums because they're jammed with tourists clamoring to take selfies with the masterpieces. Our parks on a temperate weekend afternoon are unbearable. The green-jeweled oasis of Central Park is "being trampled to death," as former parks commissioner Adrian Benepe told the *Times* in 2016. And still City Hall wants more. The latest goal is 67 million tourists per year by 2021. So many tourists are not good for a city. (In 2017, NYC & Company predicted a decrease in foreign tourism due to negative feelings about President Trump. Domestic tourism, however, would increase.)

Dear reader, if you are sometimes a visitor to New York, you might take some of what I say here personally. But why identify yourself with the bad tourist? Since you're reading this book and you've stuck it out this far, you're probably not that sort. Remember, there's a big difference between tourists and travelers. As Paul Bowles put it in *The Sheltering Sky*, an "important difference between tourist and traveler is that the former accepts his own civilization without question; not so the traveler, who compares it with the others, and rejects those elements he finds not to his liking."

With mass tourism, it's not just overcrowding that's damaging civic life, it's the way mainstream tourists consume. Spending money only on the safe and familiar, imports from their own civilization, they help to leech New York of its more biting flavors, reducing it to a tepid broth that won't upset the unseasoned stomach. Even in its once most edgy neighborhoods, the streets of New York have been tamed by the same chain restaurants and stores you find in Anywhere, USA: Applebee's in Times Square, 7-Eleven in the East Village, Patagonia on the Bowery. This is where the tourists flock. Why would anyone come to New York to shop and eat in the same places they can find at their local mall back home?

"Present-day New York has been made to attract people who didn't like New York," said Fran Lebowitz. "That's how we get a zillion tourists here, especially American tourists, who never liked New York. Now they like New York. What does that mean? Does that mean they've suddenly become much more sophisticated? No. It means that New York has become more like the places they come from."

Travelers, on the other hand, are attracted to the true city. They seek out the local and the idiosyncratic. They comport themselves as guests should. They are ashamed to be taken for tourists, who behave these days as though the city belonged to them, barging in like bad guests who help themselves to the refrigerator and put their feet on the coffee table. At the 9/11 Memorial, tourists spill their Starbucks coffee on the names of the dead as they gather for grinning selfies—at least once with inflatable sex dolls in their arms (I'm not kidding). The Brooklyn Bridge has become a "Times Square in the sky," crammed with tourists. During peak hours, the *Times* reported, two thousand people crossed the bridge per hour in 2015, quadruple the number in 2008. The city's transportation department is considering widening the pedestrian walkway to accommodate more traffic. Meanwhile, parts of the bridge are languishing beneath the weight of tourists' "love locks," a reverse souvenir—instead of taking home some keepsake kitsch, they leave their own behind so New York can remember *them*. It's no wonder we've seen the arrival of a T-shirt that twists Glaser's "I ♥ NY" to say "NY ♥'s Me."

James Wolcott, writing in *Vanity Fair*, noted: "One key difference between the 70s and today is that in the 70s the tourists looked *scared*. Getting back to the hotel alive was one of the main items on their checklists. Now they beam as if they find everything on display cute and flaunt their bulging shopping bags like hunting trophies, their Midtown experience confirming all of their Carrie Bradshaw expectations."

Cities need visitors, and visitors need cities to discover other ways

of life that can open their minds, but a city engineered expressly for tourists ceases to care for its own citizens. The streetscape of New York has been reconstructed for a transient population. Grocery stores, Laundromats, gas stations, shoe repair shops—the things locals need—are vanishing. In their place have come suburban-mall chain stores, along with businesses that cater to passing moments of fun, the sort of thing that people on vacation enjoy. Case in point: New York is drowning in sugar. Instead of local diners, we have a million ice cream shops. Instead of bookstores, we have candy shops. Instead of bohemians in cafés, we have people lining up for cronuts, the expensive hybrid of a croissant and a doughnut. Throughout the 2000s, a profusion of cupcake chains opened, some replacing decades-old local businesses pushed out by hiked rents. Penny Arcade asked, "How did New York go from people coming to New York because they wanted sex, they wanted glamor, they wanted experience, they wanted to expand their horizons, they wanted to reinvent themselves? How did it go from that to people who want to come to New York because they watch *Sex and the City* and they want a cupcake? New York's gone from being the Big Apple to being the Big Cupcake." The reconstructed city, dulled for the palates of out-of-towners, has become cute and consumable. Out with urban grit, in with sugary goo.

Coming down off their sugar highs, tourists need someplace to sleep. In 2011, Bloomberg announced that New York would soon reach a record number of hotel rooms—90,000—a 24 percent increase since he began his tourist-driving initiative in 2006. Our streets are blandalized by new jumbo hotels, while our SROs and flophouses are emptied of low-income residents, gutted, and turned into hipster boutique hotels.

The Chelsea was not the only artistic residential hotel to have its longtime tenants booted and its insides gut-renovated for deep-pocketed tourists. In the West Village, tenants of the old Riverview, including many poor, elderly, and disabled people, along with several

artists, received eviction notices as the building was converted into the Jane Hotel. At a protest against the new owners, one tenant said, "It used to be a good place to live. Nothing fancy. Just friendly. Now it's full of assholes. They come in and out of Socialista screaming 'fucking faggot' at people and peeing on our door." (Socialista was the hotel's swank café and nightclub—with a Cuban peasant theme.)

On Broadway and West 29th Street, for over half a century the SRO Hotel Breslin served as a rent-stabilized haven for artists—along with writers, transgender women, glove makers, people with AIDS, anyone who might not easily find a comfortable and affordable home elsewhere in the city. Then the former Tin Pan Alley neighborhood was rechristened "NoMad," for North of Madison Square Park, and the Breslin began its conversion into a luxury hotel under the ownership of the GFI Development Company. Tenants reported harassment, got organized, and posted signs on their doors that read: "We will not move." GFI publicly responded, "There are a small handful of tenants in the building that are spreading false information in order to attempt to get large buyout payments." The tenants went to court and lost. Alex Calderwood, founder of the Ace Hotel chain, took over management of the building in 2008. The Breslin became Ace Hotel New York. The fights went on, with the *Observer* reporting that tenants were "repeatedly hounded to accept a payoff and move out." Calderwood defended the conversion, saying, "we're trying to celebrate New York as much as possible." Soon, all of the old ground-floor businesses vanished. I walked around the block one day and counted seventeen small businesses gone. Mostly perfume, jewelry, and clothing shops run by African, Asian, and Middle Eastern immigrants, part of the Wholesale District's hubbub, they were replaced by Ace's preferred businesses, upscale hipster mini-chains like Portland's Stumptown Coffee Roasters and Seattle-born Rudy's Barber Shop, along with an oyster bar and gastropub that took the Breslin name. Theme-parking New York's bohemian past, on the wall of the Ace Hotel's lobby hangs Allen Ginsberg's photograph of Harry

Smith, "painter, archivist, anthropologist, filmmaker, and hermetic alchemist," on his last day at the old Breslin, where Smith resided until 1985. The Ace Hotel's website proclaimed that Smith's "spirit still speaks to us, within these walls." And if the boozing, pill-popping bohemian had been living in the Breslin when the Ace moved in? Good luck Harry.

Even without Bloomberg, NYC & Company keeps pushing, hungry for more tourists. In 2014, they designated pop singer Taylor Swift as the city's "Global Welcome Ambassador." The campaign included billboards splashing the slogan "Welcome to New York: It's Been Waiting for You," the refrain of Swift's theme song. Many New Yorkers took offense. Swift had moved here just one year earlier. Weren't there better choices to represent the city? On *The Tonight Show*, Jimmy Fallon asked, "How could we let a woman who's not even from New York welcome people to the city?" In the *Times*, Ginia Bellafante called the song "bloodless" and another reason to "despair over living in New York of late." In the *Voice*, David Colon wrote a scathing critique of the song's depiction of a New York "where anything interesting or difficult is smoothed away into digital handclaps and Auto-Tune. The New York of 'Welcome to New York' is what you would get if you populated it entirely with humans raised in the Times Square Bubba Gump Shrimp Co., then let them out into the world with only a penthouse apartment, an Amex black card, and leopard-print Prada luggage to guide them."

Just look at the difference between the slogans "I Love NY" and "It's Been Waiting for You." In the first, the city is an object of affection to the outsider who takes the role of lover. In the second, the roles reverse. The outsider has become the beloved for whom the city has been pining like a lonely teenager waiting for the phone to ring on Saturday night. This is a gross misrepresentation of the city. New York waits for no one.

Writing on inhumane cities, sociologist Richard Sennett noted that spaces in the modern city are either "limited to and carefully orchestrating consumption, like the shopping mall, or spaces limited to and carefully orchestrating the experience of tourism." These two modes amount to a "reduction and trivializing of the city." And they are not accidental. In the 1990s, Michael Sorkin outlined the emerging characteristics of the modern American city. Its relation to the "local physical and cultural geography" had become destabilized, he wrote. Its ties to specific space had been loosened. "Globalized capital, electronic means of production, and uniform mass culture abhor the intimate, undisciplined differentiation of traditional cities." So the new city has been departicularized, filled with copies of copies and featureless façades, attracting people in search of a curated and controlled theme-park experience, all for the purpose of commodifying the city.

Disneyfied and assembly-lined, twenty-first-century New York is becoming a pale imitation of its former self, a Potemkin village of what a city used to be. It is not alone. A symptom of globalized capitalism, mass tourism's homogenizing force is a worldwide pandemic—and it has stimulated a global backlash. "A rapacious tourist monoculture threatens Venice's existence," Italian art historian Salvatore Settis argued in the *Times* in 2016, "decimating the historic city and turning the Queen of the Adriatic into a Disneyfied shopping mall." In cities like Barcelona, Reykjavík, and Amsterdam, leaders are taking steps to slow the influx of tourists, and city dwellers are doing their part. In *Coping with Tourists*, Jeremy Boissevain observed Europeans engaging in "covert, low-key resistance" to tourists, that is, "sulking, grumbling, obstruction, gossip, ridicule, and surreptitious insults." In Berlin, the anti-tourist outcry has been especially fierce, with protests and graffiti slogans that say "Tourists Fuck Off" and "No More Rolling Suitcases." In a backlash to the backlash, tourist sympathizers argue that tourists are just like immigrants or refugees, and that anti-tourist sentiment is the same as xenophobia, casting protesters as fas-

cists. This is a false equivalence. Tourists and immigrants/refugees occupy very different positions of power, and people on vacation do not come to cities seeking sanctuary. They come seeking selfies and souvenirs.

Compared to Europeans, New Yorkers have been mild in their response to mass tourism. Maybe it's because we pride ourselves on being an open city. Maybe we confuse tourists with immigrants. Or maybe Bloomberg's pro-tourism propaganda really worked.

On a spring day in 2010, the performance art group Improv Everywhere used white landscape chalk to divide a length of Fifth Avenue sidewalk into two lanes, one stenciled TOURISTS and the other NEW YORKERS. Actors disguised as Department of Transportation workers directed people into the appropriate lanes. Many New Yorkers, desperate for their own space, applauded the lanes. In the *Daily News* and on AM radio, Mayor Bloomberg denied that the sidewalk prank could have come from frustration with the growing number of tourists. He insisted that the prank was "a nice thing to do" for visitors, generously giving them their own lane, and anyone who thought it was a criticism of tourism had to be "a pretty sick person."

As for me, I once tried to do my small part by walking around Times Square in a "Go ♥ Your Own City" T-shirt. But it didn't scare anyone. Emboldened tourists just laughed and asked me to pose for selfies.

TIMES SQUARE

42nd Street marquees with Jenny Holzer's "Truisms."
Gregoire Alessandrini (www.nyc90s.com), 1993

FTER A DAY OF LOOKING AT DINOSAUR BONES, ICE SKATERS, and a singing, dancing little orphan Annie, I stood holding my mother's hand in the middle of Times Square. On that cold evening in 1978, I was a seven-year-old tourist on my first visit to New York and I had never seen anything like this. It was night, but not dark. The Howard Johnson's flashed its orange and turquoise neon beneath the Gaiety men's burlesque theater, next to a faded sign for the "all live whirly girly revue." A giant bottle of Gordon's gin splashed silvery booze onto Bond clothiers, where A&P's Eight O'Clock Coffee cup steamed. The nearby movie marquees

announced *The Swarm* and *Saturday Night Fever* in second run, along with *1,001 Danish Delights,* a dirty movie served with a "box lunch," which is not as innocent as it sounds. Nothing I saw or heard bore the remotest resemblance to anything I knew from my small town, back in Massachusetts, where the nights were black and the noisiest moments came in the mornings when tractor trailers rumbled down off the highway, and a rooster crowed in a neighbor's yard.

I loved Times Square instantly. I'd been primed to love it before ever setting foot upon it, having read and reread *The Cricket in Times Square,* imagining myself as the intrepid adventurer who survives the streets on moxie and luck. My mother's vise-grip on my hand as we hustled up Broadway told my seven-year-old heart that this was a place where *things happened,* and even then I knew I wanted to be where *things happened.* We stopped to watch a street performer. Dressed in a threadbare red-and-white-striped jacket and a straw boater, like a reject from a barbershop quartet, the man tap-danced on the gum-stained concrete, or maybe he played the trumpet, or sang a song. I don't remember what he did, only that he did something wonderful, and I wanted, like him, to be part of that place.

Some fifteen years later, after I moved to New York, I returned to 42nd Street every chance I got. I walked back and forth with a notebook and an old 35-millimeter camera, ducking into porn shops, joke shops, and oddball shops that sold an assortment of harmonicas, knives, sex potions, and samurai swords. I stopped every time for a hot dog at the Grand Luncheonette, a gorgeous, grimy little swivel-stooled lunch counter tucked under the ruined marquee of the Selwyn, a theater built in 1918 that had gone from Garbo to grindhouse. Painted high up on its bricks, the Selwyn boasted my favorite ghost sign: "Cooped Up? Feelin' Low? Enjoy a Movie Today," it read. In between the words, a depressed moon-shaped face frowned behind prison bars.

It was hard to see in 1993, but 42nd Street, aka the Deuce, was already in the midst of "renewal." I had, again, arrived too late. The

crumbling movie palaces had been seized via eminent domain and shuttered, their gray shells temporarily turned over to the nonprofit arts organization Creative Time for a sprawling installation called "The 42nd Street Art Project," in which several artists filled the lobbies, ticket booths, and façades with public art. In the former space of Papaya World, Karen Finley installed a mural of a happy family, skin covered in the Kaposi's sarcoma lesions made ubiquitous by AIDS. Jenny Holzer took over the block's marquees to mount her truisms in black letters: MURDER HAS ITS SEXUAL SIDE and BOREDOM MAKES YOU DO CRAZY THINGS. But my favorite was "Soft Sell," Diller & Scofidio's video installation of a giant female mouth projected on a screen behind the glass doors of the Rialto. "Hey, you," the mouth said. "Wanna buy an unobstructed view of the skyline? Hey, you. Wanna buy a timeshare at the beach? Hey, you. Wanna buy a piece of the American dream?" The mouth was a prostitute, calling from the shadows, enticing passersby with her commentary on consumer culture, the commodification of sex, and its more powerful replacement, real estate. (Ironically, Diller & Scofidio would later design the new High Line.) As I walked 42nd, through the unhinged atmosphere of a street languishing in its prolonged, reverberating death, I kept returning to that mouth. An obsessive chronicler and note taker, I brought my portable tape recorder to record its voice, sensing a sinister relevance in the words. But as a newcomer to the city, I was too naïve to understand their true significance, that the presence of public art heralded the demise of 42nd Street.

The Creative Time installations lasted for two years. In 1994, Holzer's marquee truisms were replaced by haiku. I copied down favorites in my battered spiral notebook, unaware that the poems, and other installations, were being used by the Forty-Second Street Development Corporation to help sell the Deuce to real estate investors, the way artists are often used, to show "potential," a future of crime-free streets full of tourists and their attendant brands of commerce. Art critic Peter Schjeldahl called the project a "deathwatch

ensemble," noting that "artists are crows to carrion" and this spells doom for idle buildings. Artists are often brought in before the bull-dozers to brighten up the temporary blight created by politicians and developers after they've evicted and shuttered what came before. At the time, knowing nothing about such evil plots, I thought it was the perfect combination—art and smut—all bundled together on one block. It couldn't get any better. On that point, I wasn't wrong. Times Square only got worse.

By 1995, the art was gone and the buildings were being prepped for the wrecking ball. That summer I sat in the Grand Lun-cheonette and wrote in my journal, "It's already changing—Disney has begun shutting it down for good. Thanks to Giuliani, there soon will be no places to see naked women in New York City." The mayor had signed a new zoning code outlawing adult establishments within five hundred feet of schools, houses of worship, residential areas, and—most critically—other adult establishments. After two years of playing hardball, the Walt Disney Company finally signed an agreement to renovate the New Amsterdam Theater on 42nd, a sweetheart deal that came with millions in subsidized, low-interest loans and tax breaks. Said Giuliani's president of the Economic De-velopment Corporation, "We subsidized it to get the other activity on the street. In the retail business, it's what you call a loss leader." The strategy worked. That other activity came in fast and furious, even though, fifteen years earlier, after viewing initial plans to redevelop Times Square, Ed Koch had warned, "New York cannot and should not compete with Disneyland—that's for Florida. We've got to make sure we have seltzer instead of orange juice."

In *Times Square Roulette,* the comprehensive book on the subject, Lynne Sagalyn explains in detail the Disney deal and its impact on neighboring businesses. In short, Disney did not want its squeaky

clean image tarnished by even a smudge of 42nd Street's grit, so they pressed the city to wipe it out. Sagalyn writes, "At the family entertainment giant's insistence . . . all adult uses had to be removed from the street" and "at least two 'nationally recognized and reputable companies'" in the entertainment business had to sign agreements to open on the block. With that, a single corporation was allowed to dictate the character of a New York neighborhood. Out went the peep shows, dirty magazine shops, and topless joints. Even the legit movie houses that remained were deemed unclean and unsafe, and so pushed out. In came the first of what would become a glut of "nationally recognized" chains. From Kansas City came the AMC Multiplex cinema. From London came Madame Tussaud's wax museum. And from Anaheim came the Disney Store, the ultimate symbol of the street's American-style sterilization. In 1997, performer and activist Reverend Billy got his start when he barged in to stage a "retail intervention," preaching to the tourists, "Mickey Mouse is the Antichrist! The Disney store is turning Manhattan into a theme park!"

The city began a mass demolition, tearing down almost the entire block, toppling one antique building after another. As the bricks tumbled, the innards of porno houses were left exposed. On a second story, above the bulldozers, decorative mirrors glinted on a broken wall, arranged in diamond shapes, winking in the sun next to signs that read: "Do not touch the girls." In the bright light of day, these vestigial traces of smut looked almost ashamed by their indecorous exposure. I wanted to give them my coat.

There was so much pounding from demolition, the entire front of the Selwyn Theater collapsed one morning in December 1997, shocked by the relentless hammering of its elderly neighbors. No one was injured, except for the "Cooped Up? Feelin' Low?" sign, which looked bitten in half, its sad moon face sadder than ever. Just two months earlier I had stood under the Selwyn's scabby marquee, looking in at the evicted Grand Luncheonette. I took out my journal and wrote:

I loved this little hole-in-the-wall. Through the gated
window the signs still say: Fresh Donut 60c, Hot Sau-
sage $1.50, Beef Pattie with Cheese $1.75, Chili Dog
$1.25, Knish Potato Pie $1.25, Hot Chocolate 75c, All
Franks on a Bun $1.00. An ancient sign is suddenly re-
vealed: Frankfurter with Sauerkraut and Onions 5c.
The last charge rung up on the old register reads: $1.00,
commemorating the last frank served after decades on
42nd Street. A whore stops by, fixes her hair in the dark
glass, and walks on. Soon, there will be nothing left of
this world.

You should know, if you don't already, that I am willingly af-
flicted with a benign strain of *nostalgie de la boue,* a "yearning for the
mud," or what journalist Herbert Muschamp called "the sentimental
attachment to decrepitude and sleaze . . . a venerable urban tradi-
tion." (In 1996, Muschamp asked about Times Square: "Where have
they gone, the chicken hawks and stiletto knife displays, the peep
show shills, pickpockets, coke heads, winos, pimps and tramps? We
had a world class gutter here. Must we trade it in for a shopping strip
of chain retail outlets?")

With its buzzing flies, greasy surfaces, and hot dog–eating pimps,
the Grand Luncheonette satisfied my muddy yearning. The little
lunch counter had been going strong since 1939, opened by the father
of its owner, Fred Hakim. He and his family didn't want to close the
place, but they were forced out by the Times Square redevelopment
project. At the *Daily News,* Mark Kriegel opined, "This is bigger than
42d St., bigger even than the Disney Corp. This is about New York
being colonized by The Gap and Banana Republic and Starbuck's [sic]
and all the rest. If new and improved Times Square is any indication,
the standard for Italian cuisine will be the Olive Garden chain."

In the *Times* on December 31, 1997, Dan Barry wrote of the "urban
metamorphosis" that had besieged Times Square: "Entertainment

and media corporations continue to vie for choice locations in a once-seedy swath of New York City that the heartland now sees as a jazzy alternative to Busch Gardens and Disney World." The changes were coming faster than the human mind could process, and they were of a very different nature from anything that had come before. Barry quoted the author Nik Cohn, who said, "Times Square has always changed every 20 years. But this time it's changed to a corporate, generic American city that doesn't particularly express the uniqueness of New York." The completion of that unprecedented change would happen in the decade to come.

After the dust cleared on 42nd, the strip was unrecognizable, like a foreign city risen anew after an atom bomb's annihilating blast. Time and again, I walked the block in a state of disorientation, unable to anchor myself in any sense of place. Almost nothing of the old Deuce remained. Corporate America had spread its seed, and kept on spreading it, from 42nd to Seventh Avenue, Broadway, and Sixth, and eventually over to seamy Eighth Avenue, the last holdout. Disney begat Applebee's, which begat Dave & Buster's, which begat Red Lobster, M&M's World, Toys "R" Us, Bubba Gump, Olive Garden, T.G.I. Friday's. When the largest McDonald's restaurant in the world opened, Junk Food News (yes, that exists) reported that 42nd Street was renamed McDonald's Way for the duration of the opening ceremonies. Without shame, the owner declared, "The restaurant is designed to be a natural fit with our famous Broadway neighbors, both in its architectural design and in the fun and excitement we'll provide." Such fun and excitement comes from an armada of plasma-screen televisions—forty-five, to be exact—all playing at once while customers gobble Big Macs and supersized fries, anesthetized in the greasy glow.

As we settled into the Bloomberg era of the 2000s, a pale shadow of the true Times Square remained, but not for long. On July 31, 2002, Peep-O-Rama, the last adult emporium on 42nd Street, shuttered. The small theater had reportedly been in the adult movie business

since 1950. It managed to survive the 1990s largely because it wasn't on Disney's block, but farther east, near Sixth Avenue, where it served as a lone outpost of the smuttiest smut around. In dark video booths, for the price of a dollar, you could see consenting adults getting it on with all things zoological, as well as "crip" porn, midget porn (no politically correct terminology there), and unsettling images imported from Germany that branded themselves onto your neurocircuitry forever. It was as if all the filth of 42nd Street had been swept east and come running through the drain of Peep-O-Rama, leaving the dregs to settle, each booth a time capsule containing the city's darkest, and most fascinating, perversions. On closing day, the owner told the *Daily News*, "People need sex. Everybody. Everybody! You. Me. Everybody!" But the Durst Organization did not see the same value in Peep-O-Rama. They had bought up the block for the purpose of demolishing it to make room for their billion-dollar, fifty-five-story Bank of America tower.

The center of Times Square soon filled with sleek office towers, and by 2003, demolition and construction spread west, to Eighth Avenue across from the Port Authority bus terminal. The Empire State Development Corporation condemned one whole block, the east side stretch between 40th and 41st, even though the buildings were stable and filled with thriving businesses. The state of New York then seized the properties from their owners via eminent domain, which is meant for so-called public use, as required by the Fifth Amendment of the U.S. Constitution. "Public use" usually means bridges, highways, hospitals, any construction that benefits the public, but today the federal courts permit a looser interpretation. In compensation, the eleven owners of the seized properties were paid $86 million in total, well under market value—as one owner later told the *Observer*, "They gave us 20 cents on the dollar for what the property was worth." The state handed the property to the Forest City Ratner

Companies for a private development: new headquarters for the *New York Times*, a fifty-two-story tower that swelled against the boundaries of the zoning laws until they bent. Along with $29 million in tax breaks from the city, the New York Times Building LLC was given a ninety-nine-year lease at a price well below market rate, along with a provision that permitted them, after twenty-nine years, to buy the property for just ten dollars. You can't even get a crosstown taxi for ten bucks in New York City.

The *Times* itself reported, "Blight is what state officials see on the block of Eighth Avenue between 40th and 41st Streets: a shabby blend of sex shops, prostitution, loitering and drug dealing that scarcely welcomes the world to the new Times Square," but that's "not all that would disappear from the block in the wake of this project." In fact, that's not *most* of what would disappear. Among the many tenants kicked out were, yes, one peep-show joint called the Playground, as well as two schools, a student dormitory, a sixty-year-old fabric store that catered to Broadway costume designers, and a third-generation family-owned hat shop.

Arnold Hatters had been in business for more than forty years when it was forced out by the government. It had a prime spot, right across from the bus station, and a beautiful set of windows. Two deep displays flanked the entrance, with the front door set back so you walked along a wide, tiled path through an abundant corridor of hats. In that outdoor foyer, men stopped and gazed around, spellbound by the spectacle of dozens of fedoras and derbies and homburgs, boaters and cowboys and pith helmets that seemed to float in midair, hanging from strings of fishing line or revolving on mechanical glass platforms, each with a neatly hand-lettered sign proclaiming its name: El Dorado, Lindy, Astor, Summit, Big Apple, Belmont, Untouchable, Red Rider, Stinger, Silk Finish Eleganza, and one dazzling name that could have graced a burlesque stripper—Galaxy Velour! Inside, autographed photos of semi-famous customers decorated the shop, including sideshow performers like the Human Pincushion, a

wrestler called the Haiti Kid, and circus ringmaster Norman Barrett, an elegant man dressed in a red cutaway coat and a black-satin top hat that provided a perch for his performing parakeets.

The hat shop rented the space, and in eminent domain grabs, renters are out of luck. They relocated to a less charismatic spot a few blocks south. Business never recovered. In 2007, I talked to co-owners Peter and Mark Rubin, sons of Arnold and great-nephews of the original owner. They told me about their struggle since the move to 37th Street. Mark said, "Manhattan's funny. We're just four blocks away, but it's another world down here. We're down forty percent of what we did in our last year in the old location." Peter recalled the pain of losing the hat shop's home, saying, "My great-uncle built all the shelves in the old place. They were solid. He made them with white oak. We wanted to take them for the new place, but the city wouldn't let us. They said the shelves were permanent fixtures and we'd have to buy them back." He shook his head with anger at the thought, and continued, "I wish I was the city. I wouldn't do stuff like this."

Two years later, Arnold Hatters went out of business. Mark Rubin told me that the damage from the move, along with the struggling economy, put them under. "I'm positive," he said, "if I was still in the old location, I'd be weathering this economy. Instead, with three kids and a mortgage, I'm writing the first resume of my life." He had never worked anywhere but in his great-uncle's store. After the shop closed, a 7-Eleven took over the space.

On Eighth Avenue and 42nd Street, the thirty-year-old XXX emporium Show World Center closed in 2004 and became a family-friendly entertainment center. After Giuliani's 1995 zoning ordinance, Show World had soldiered on, its naughty bits whittled away piece by piece. By 1998, the live girls were gone and the theater space was leased to an off-off-Broadway company that performed Chekhov plays on stages where naked girls once performed live sex acts, including Face Shows—as the sign said, "Let our girls sit on your face." The live sex show cost ten dollars and didn't include much in the way of actual

sex by its end. The last time I was there, in 1996, it was Fleet Week and the place was full of sailors, their white suits glowing violet in the black lights. During the "two-girl show," two girls named Pebbles and Samantha danced together and simulated oral sex with each other, tongues fluttering the air, touching nothing, while the sailors jerked off to Alanis Morissette asking, "Isn't it ironic?"

In 2005, the last Howard Johnson's in Times Square stopped serving its signature clam strips and milk shakes, and shuttered after nearly fifty years in business. Its building, 1551 Broadway, had long been owned, rather unambitiously, by Morris Rubinstein, who told the *Times* in 1988, "As long as the Lord will spare me in this world, it's not for sale. . . . What am I going to do with the money? I already give to charity. What else do I need? What would I do with $20 million? Would I have a better cup of coffee? Would I get a better sandwich?" But the good Lord could not spare Morris for eternity and, after his death, the new generation did not follow his way of thinking. When author James Traub told Morris's son Kenny Rubinstein that he would include Howard Johnson's in his book on Times Square, *The Devil's Playground*, Kenny replied, "I wouldn't wait too long if I were you." He and Morris's other heirs sold the building for more than $100 million to a development corporation called Wharton Properties.

I adored that crummy old Howard Johnson's and was heartbroken by the news. I always sat in one of the front booths, with its broad view of the bustle of Broadway, and ordered my usual cheeseburger deluxe and root beer float. An oasis of realness in the plasticizing Disney crush, the place made you feel as if you'd slipped into a time capsule, a hermetically sealed bubble beyond the reach of development. Hojo's was a chain restaurant, it's true, but it hailed from the time before chains had smothered the city, when they came by the few, not the hundreds. The music that played was Frank Sinatra, Perry Como, Petula Clark. The waitresses were friendly and brusque, Eastern Europeans, always taking their cigarette breaks in the swivel stools that lined the ice cream counter. And those flavors? There was nothing

trendy or artisanal about maple walnut, butter pecan, and rum rai-
sin. The exterior of the place was wreathed with signs bleached by
sunlight, tempting passersby: "It's cocktail time at Howard Johnson's.
May we suggest a decanter of . . . Manhattan, Martini, or Daiquiri."
You could order a cocktail with pancakes for dinner and I sometimes
did. At night, the lounge in the back was the place to drink, away
from the tourists, where you might meet someone with an interest-
ing story to tell.

The whole building was a throwback to Times Square's tawdry
old days. Above the Howard Johnson's, on the second floor, was the
Gaiety gay burlesque. It shuttered, too, that year, closing down a cen-
tury of history. In 1923, when the place was Wilson's Dancing Studio,
the author Henry Miller fell in love with a dancer named June, his fu-
ture muse. Later, it became the Orpheum Dance Palace, a taxi-dance
hall that closed in 1964 and turned into the Follies Burlesk, which
went from an "All-Live Whirly-Girly Revue Big-Time Vaudeville"
house to a hard-core joint where live sex acts were performed on mat-
tresses saturated with body fluids.

In the 1980s, a sign by the Gaiety's entrance advertised the "Unique
Futuristic Apollo Room" and "7 Boys 5 Times a Day." Until its last
day, the doors opened at ten in the morning for films and live shows.
You climbed the stairs to a ticket window where a matronly woman
sat behind the glass and took your seventeen-dollar admission fee
through a slot. That price allowed you to stay all day. The theater
was small, with rows of seats and a stage with a runway that reached
into the audience. The dancers, most of them muscled and tanned,
stripped onstage, taking tips into their boots or g-strings. Next to
the runway, for the price of a dollar tip, a customer could sit and tilt
back his head, like Tantalus beneath the fruit tree, while the dancer
crouched close enough to give off the scent of talcum powder, sweat,
and cheap cologne. Once nude, the dancer would disappear behind
the blue tinsel curtain, and the audience would wait. And wait. The
first time I witnessed this, I had no idea what we were waiting for.

Had something gone awry? Men left their seats to socialize and cruise in the snack room, where dancers leaned against the vending machines and made small talk while munching Doritos. Above the stage, a creaky old movie screen unfurled from the ceiling, squeaking on its roller. A projector snapped on, showing an ancient porn flick to keep people in their seats. After a few minutes, the projector clicked off, the screen whined its way back up to the ceiling, and the dancer reemerged. Now I understood. He'd been trying, with apparent difficulty, to get wood. As he showed his erection to the audience, they enthusiastically applauded the hydraulic achievement, and the dance went on.

In 2007, Wharton Properties demolished the 112-year-old building, shattering Howard Johnson's, the Gaiety, and the communities that gathered around them. They put in an American Eagle Outfitters, that suburban shopping mall chain store, building it into a skeletal structure that is more a pile of TV screens than an actual building. *The Real Deal* called it "the defeat of architecture," made up, as it is, of almost nothing but giant, high-definition digital LED panels stacked upon a twenty-five-story metal frame. All day and night, the screens flash images of designer jeans, jackets, and T-shirts, along with hollow slogans like "Live Your Life" and "Leave Your Mark."

Back on Eighth Avenue, the great McHale's was crushed. Run by the McHale family since 1953, it was ideal for a burger and beer, with meat patties the size of dinner plates, dwarfing the buns that tried to contain them. The place was decked out in dark wood and chrome, with neon signs, dusty sports memorabilia, globe lights giving off a blushing glow above the oak bar, all of it combining to create a musty patina of a lost place and time. The landlord sold the building in 2005. Jimmy McHale got thirty days to vacate and the place he called his living room was demolished for Platinum, a forty-three-story luxury condo tower marketed as a "power residence," a "rarified world etched in water and fire, stone and glass . . . and power."

Across the avenue from McHale's old spot, the Playpen still stood,

but not for long. The peep emporium was forced to close in the summer of 2007, sold to Tishman Realty to be demolished for a luxury hotel. A group formed to fight the demolition, arguing that the Beaux Arts theater was valuable because it had opened as a vaudeville house in 1916. Later, as the Cameo and Adonis, it became a porn theater, but retained its rococo details. As you browsed the racks of dirty DVDs, or visited the buddy booths in the former balcony, you could look up to see a ring of plaster goddesses dressed in sheer, white robes, clutching festoons of fruit, covered in porn palace glitter. The preservationists lost. That summer, knowing it was the end, I splurged on a show from one of the last "live girls." I sat in the booth and lifted the grimy telephone off the hook to talk to "Marilyn" on the other side of the Plexiglas. For $10 plus an additional $20 you got a strip show, she explained, but for $10 more, you could see the "full masturbation show." Since this was my last visit, I opted for the full treatment. I slipped my money through the slot. Marilyn tucked the bills into her boot, sat back in the chair, and commenced her show. While she did what she did, I asked about her future plans. She sighed with grief and told me that she felt depressed to see the Playpen go. She planned to move down the block to the peep booths of Gotham City while she looked for "something legit." Together, as Marilyn gloomily went through her lubricious maneuvers, we lamented the changes that had leveled Times Square. And then my time was up.

The Funny Store shared the Playpen's space, and its demise. Originally opened by the Tannen brothers in 1957, the joke shop had been peddling whoopee cushions, hand buzzers, and fake doggie doo in the Times Square area for half a century. It was the last of the old-fashioned novelty shops. (A *Daily News* article on the closure offered the tongue-twisting headline: "Flashy Flats Force Out Fake Flatulence Mecca.") Before it closed, I bought some X-Ray Specs and joke ice cubes, and talked to owner Arnold Martin. He tried to sell me a rubber chicken as we, too, lamented the changes to the neighbor-

hood. He said, "Soon this will all be nothing but towers. You won't even be able to see the sun."

When the old theater and its many goddesses had been destroyed, the bloated InterContinental hotel rose on its grave. In the place where Marilyn and countless other girls had performed their steamy routines, where boys gripped each other in buddy booths, and the ghosts of vaudevillians tap-danced and slapsticked through the ether, Danny Meyer planted his umpteenth Shake Shack, an international burger chain with locations as far-flung as Dubai and Beirut. On the day it opened, hundreds waited in line for an upscaled Big Mac that pales in comparison to the masterpiece you could get across the avenue at McHale's.

B y the end of the first decade of the 2000s, it was clear that Times Square had been tamed and was ready for the next phase—complete suburbanization. Bloomberg's transportation commissioner, Janette Sadik-Khan, shut down Broadway in the very heart of the square, blocking traffic to create a brightly painted, polka-dotted pedestrian plaza filled with suburban-style plastic lawn chairs. Tourists loved them. New Yorkers felt mixed. In the *Times,* Nicolai Ouroussoff noted that those "apparently nostalgic for the seediness of the 1970s version of the square, denounced it as another step in New York's transformation from the world's greatest metropolis to a generic tourist trap." At the *Post,* Andrea Peyser called the pedestrian plaza "a butt-littered suburban parking lot," and worried that Times Square would suffocate in a fart cloud of tourists gassed up on "Starbucks venti chocolate mint frappuccinos." But Bloomberg loved the human parking lot, so it stayed. Its presence attracted more shopping mall stores, helping to hike retail rents in Times Square by 71 percent in just six months, according to Sadik-Khan. It was, she said, "the largest increase in the city's history."

When you walk through the pedestrian plaza, you feel out of step with Times Square. It feels wrong to be sauntering down the center of Broadway, now a magnet for people dressed as syndicated cartoon characters—Elmo, Mickey Mouse, Spider-Man, and many more. The place is lousy with these toons. At first glance, you might think they're part of the Disney tourist machine, but on closer inspection you see the dirt, rips, and sweat stains on their costumes, and you realize that they are what remains of Times Square's grim and tawdry spirit. Unauthorized and unregulated, the toons are territorial, unpredictably violent, and sometimes quite mentally ill. They've been known to punch, shove, and sexually grope the tourists. One infamous Elmo liked to stand outside Toys "R" Us screaming, "I work for John Gotti! Fuck you!"

But the true scuzziness of Times Square has been defanged and caged in a museum. In 2011, the Times Square Alliance, founded in 1992 as the Times Square Business Improvement District, came into possession of Peep-O-Rama's neon sign. It was salvaged, refurbished, and installed in the Times Square Visitor Center, where it hangs like a hunting trophy, glowing above the "Fantasy and Desire" exhibit: three peep booths with video screens showing slide shows of Times Square's lost sleaze—PG-rated photos of adult bookstores, grindhouse marquees, prostitutes loitering on the Deuce. As their parents shop for souvenirs, tourist children play in the booths, turning them into places for games of hide-and-seek. Oddly debased by the kiddies, the peep booths seem sheepish and apologetic, looking like they wish they could creep back into the shadows and perform the function for which they were built. Again, I want to give them my coat.

Today, only a few holdouts of the old Times Square remain. There are a dwindling handful of video peep joints on Eighth Avenue, including one with live girls and another with a semi-secret, all-male back room. There is Sardi's, opened in 1927 and famous for its walls

full of celebrity caricatures. It is worth visiting, especially its Little Bar, but only during a quiet hour when the tourists haven't swamped it. There's Jimmy's Corner, a dive bar filled with boxing memorabilia, run since 1971 by former boxer and trainer Jimmy Glenn. But that's all I want to say on this subject. I am superstitious, knocking wood as I write. To name these fragile places as survivors is to tempt the fates. I've already had to delete Rudy's Music Stop and Alex Carozza's accordion shop, the last music stores to shutter on Music Row, a legendary block of 48th Street where musicians shopped for nearly one hundred years. The city is vanishing so fast, I can't keep up. Unlike a blog, writing a book is slow going—and New York is going faster. When I began this chapter, I had another survivor on the list. The unparalleled Café Edison.

In early November 2014, I heard from two different informants that Café Edison was being forced to close. "Drop a bomb on Times Square," I wrote when I broke the news. "It's over." For years, I had been dining at this stunning spot, affectionately known as the Polish Tearoom, with its steaming bowls of matzo ball soup and plates of latkes, its swivel stools and Naugahyde booths, its gruff but loveable waitresses. In that greasy cathedral of sky-blue ceilings and powder pink walls, festooned in plasterwork cherubs and frothy filigree, you had the sensation of being inside a giant wedding cake. Someplace otherworldly. It felt like a secret, a diorama Easter egg tucked inside the Edison Hotel on West 47th Street. It felt like a rare gift, the old hotel's grand dining room given over to the common folk for the eating of peasant food.

It had been this way since 1980, when the hotel's owner, Ulo Barad, first offered the spot to Harry and Frances Edelstein. All three were Holocaust survivors from Poland, and they made a sacred handshake deal. Barad told the Edelsteins not to worry, that as long as their family wanted it, they would always have the coffee shop. But that changed when Barad passed away at age eighty-eight, and his son, Gerald, took over the hotel. Management had already denied a

new lease to the owners of the Rum House, the hotel's bar for thirty-seven years (the current Rum House is not original). Next to go was Sofia's Italian Restaurant, in the hotel for thirty-five years (Luca Brasi went there to sleep with the fishes). I started to worry about Café Edison, but refused to believe it could go. The place was too celebrated and beloved—by New Yorkers and tourists, the Broadway community, local cops and laborers, celebrities, and a legendary group of magicians. How could the hotel let it go? As Conrad Strohl, son-in-law of the Edelsteins and co-owner of the coffee shop, told me, "They don't want us here." What the hotel wanted, he said, was something more upscale.

Within hours of my blog post going live, the news ripped through the mainstream media, sending reporters and photographers from the *Times, Post,* and *Daily News* running to the coffee shop to get follow-ups. A theater fan named Jason Bratton started a petition to save Café Edison and it quickly filled with names, many from celebrities, including Susan Sarandon, Glenn Close, and Matthew Broderick. I started a Save Café Edison Facebook group and used it to plan actions, kicking off with a Lunch Mob that brought more than six hundred patrons and protesters to the coffee shop. They carried signs that read "Don't Bust My Matzo Balls" and "Matzo Ball, Not Wrecking Ball." Each weekend, for the next several weeks, I planned more Lunch Mobs, with magicians, klezmer music, and a theater group doing scenes from Neil Simon's *45 Seconds from Broadway,* which takes place in Café Edison. Members of the Facebook group reached out to local politicians, and we received letters of support from Manhattan Borough President Gale Brewer, City Council member Corey Johnson, state senator Brad Hoylman, and state assemblyman Richard Gottfried. Each letter went to the hotel's owner, asking him to grant a fair lease to Café Edison. The story ran on NBC and NPR, going international via the BBC and Al Jazeera. The petition gained more than ten thousand signatures. Politicians and protesters rallied in the street. Our fight reached the office of Mayor de Blasio, who person-

ally telephoned the coffee shop's owners, telling them, "Your family is beloved and my team will do everything it can." We allowed ourselves to hope. I should have known better. There was nothing that anyone, even the mayor, could do.

On Sunday, December 21, 2014, around seven in the evening, Café Edison closed its doors after thirty-four successful years. With all that had recently been lost, this was the last place on Broadway—*the last place*—to get an affordable and authentic, old-school New York meal, in a *haimish* environment away from the discombobulating clusterfuck of Applebee's, Olive Garden, Bubba Gump, and the rest of those manufactured "fun" zones where the human soul goes to die.

Over those final few nights, I dined alone at a small table next to the counter, lingering over latkes and matzo ball soup, chocolate egg creams and blueberry blintzes, watching the people come and go, listening to the music of clattering silverware. I tried to absorb as much of the place that my nervous system could hold. I wanted to remember everything. The golden bowls of soup emerging from the kitchen. The businessman flipping his necktie over a shoulder to keep it from getting wet. A woman encircling her soup with both arms, holding a book in one hand, spoon in the other, the lenses of her eyeglasses fogged with steam.

Again and again, owner Conrad Strohl walked by. Making his rounds, he moved like a restless animal, circling the room, lingering over a dying companion. I watched each time he ran his hand along the Formica length of the counter, and knew that he wasn't wiping away crumbs. He was caressing it—for the ten thousandth time, for the last time—lovingly and compassionately, with his whole palm, the way you'd stroke the neck of a good horse whose time has come, helping to ease it into death. It was then that I broke into tears, fighting to hold back my grief for that place and its people, but also for all of Times Square, and for the whole lost city. As I wept over blueberry blintzes, I asked myself, as I often did, What is left to love about New York?

About a year after Café Edison shuttered, it was announced that the popular, gluten-free mini-chain Friedman's Lunch would be taking its place. The real estate broker on the deal told the *Daily News*, "This is going to be everything the Edison Café was—just a few decades later." Hardly. In case you think some family named Friedman runs the joint, think again. According to the restaurant's website, the name is a tribute to Milton Friedman. You know, the modern-day father of neoliberalism. The man who advised Pinochet to "shock" the people of Chile with radical economics. The free-market fundamentalist whose theories became policy under Reagan and Koch, leading to vast inequality and the hyper-gentrification of cities.

Sometimes I feel like I'm living in a satire. I keep asking, "Is this real?" In our culture of copy, the real is getting harder to find.

Now and then I'm tempted to go to Times Square. The fizzy feeling of the old place lingers in my memory, a three-dimensional residue. Then I stop and remind myself: it's gone. I feel the loss again, like when grieving people forget their loved ones are dead and reach for the phone to call. I have to keep telling myself: it's gone. Completely converted into a suburban shopping mall, stripped of all its weird beauty, there's no Times Square there anymore.

SUBURBANIZING THE CITY

Village Voice billboard on the Bowery. *Elie Z. Perler/Bowery Boogie, 2008*

THROUGHOUT THIS BOOK, I'VE TALKED A LOT ABOUT CHAIN stores and their takeover of the city. But how did they get here? And why are they hugely popular today when they weren't in the past? Once again, we can't just blame "market forces" and leave it at that. We have to look at people, their deepest fears and desires, and how they've helped change the character of the city.

In *Mutations,* a 2001 exploration of urbanization by Rem Koolhaas and the Harvard Project on the City, the authors summed up a major element in the urban psychic shift at the turn of the twenty-first century when they wrote: "The city has twice been humiliated

by the suburbs: once upon the loss of its constituency to the suburbs and again upon that constituency's return. These prodigal citizens brought back with them their mutated suburban values of predictability and control." That reversal of white flight, what urbanist Richey Piiparinen calls "white infill," is a piece of the human puzzle that is helping to alter the tone and character of New York today.

It's true that many people still come to New York because they like what the city has always represented. They like the dirt and diversity, the anonymity and permission, the surprise of bizarre moments that wrest you from your reality. Many newcomers continue, like E. B. White's settlers, to give New York its passion, its "high-strung disposition," and "poetical deportment." But many others come not liking cities much at all. They might *think* they love New York, but the city they consume is something that's been packaged and commodified, corporatized and sanitized. Many newcomers freely admit they would rather be back in the suburbs. Homesick for life elsewhere, they do their part to bring the suburbs to the city. It wasn't always this way.

In 1982, 7-Eleven closed their last location on the island of Manhattan. This emblem of suburbia had tried for years to penetrate the city's tough center, but Manhattanites of the time would not be seduced by its Slurpee siren song. They had an abundance of corner grocers, cafés, and newsstands. For what did they need 7-Eleven? But times have changed and, in 2005, testing the new climate, the chain launched a fresh offensive, planting a store on 23rd Street and Park Avenue South. At the grand opening, crowds of people lined up to get in, thrilled by the experience of waiting for free Slurpee samples. The *Times* credited the warm reception to city dwellers' nostalgia for their "suburban pasts."

The floodgates opened and 7-Elevens began appearing all over Manhattan. They were popular. But not every New Yorker embraced them. When one announced its arrival on East 84th Street, a protester posted flyers urging locals to "do everything possible to prevent

this monstrosity, this carbuncle, from ever opening" where it would "totally destroy the quality of life." The store opened anyway—and more came with it. When another appeared on countercultural St. Mark's Place, anarchists smashed the windows with bricks, activists formed the group "No 7-Eleven," and Manhattan Borough President Gale Brewer commented, "if I see one more 7-Eleven, I'm going to throw up." The resistant spirit of the East Village exulted when that location eventually closed, but another had latched on to Avenue A. The fact is, many newcomers to the city not only do not vomit at the sight of another 7-Eleven—or another Dunkin' Donuts or another IHOP—they get a warm, fuzzy feeling deep inside.

Chain love is a foreign emotion to me. While I admittedly shop at chains, I do it sparingly and often begrudgingly, out of convenience or lack of options now that so many small-business alternatives have been forced to close. I certainly don't do it out of nostalgia for my small-town past. For generations, many expatriates to New York left suburban America without looking back. We wanted New York, with all its unpredictability and variety, its filthy beauty and emotional collisions. We wanted to be cosmopolitan. But there's a new sensibility that has since arrived in New York, and it is passionately attached to all it left behind. Continually puzzling over it, I'm grateful to the writers who have publicly described their emotional attachment to chains.

In the millennial blog Spoiled NYC, Sara Sherr grapples with her own devotion to chains. "7-Eleven makes me feel safe," she says, "because there was a 7-Eleven a few miles from the house I grew up in, and there was a 7-Eleven a few miles from my apartment on Long Island last year, and now, in NYC, there's a 7-Eleven just a few blocks away from my apartment." Every human being, she concludes, loves comfort.

In an essay for local paper *Our Town,* newcomer Megan Finnegan Bungeroth wrote that "New Yorkers from Elsewhere" eat at places like IHOP, Denny's, and Applebee's because it "speaks of other-state

suburbia" and "reminds you that you are from Somewhere Else, and for a half hour you can settle back into your accent and some mediocre but utterly familiar food."

In the *Observer*, one Ohio transplant explained, "When I first got here, I was pretty homesick. I used to go to the Target at Atlantic Terminal [in Brooklyn], sometimes when I didn't even need to buy anything. It has the same feeling as the one at home—that fresh-baked cookies smell."

Comfort, familiarity, and home. But something's not right here. The idea of home has been perverted. For the young woman wandering nostalgically through Target, home is not associated with anything authentically Ohioan, or truly homey, like the smell of fresh-cut grass or evenings spent sitting on a porch sipping lemonade. Instead, what is longed for is a corporate-created atmosphere, the plasticky trappings of a mega-retailer, the smell of cookies baked not by Grandma, but unwrapped from a frozen box and warmed by a resentful teenager making minimum wage at the food court. Still, the love for chains can be intense.

When the Southern Baptist fast-food chain Chick-fil-A opened in Manhattan in 2015, people lined up in the rain to be the first ones inside. It didn't matter that Chick-fil-A had been boycotted for its right-wing antipathy to LGBTQ marriage equality: this was the Heartland come to the city. "I have been waiting for this for a year and a half now since I came to New York," said one Georgia-born twenty-four-year-old to the *Post*. "I took off work today to come here. . . . I might be on the verge of tears. I love Chick-fil-A."

For some, asserting a suburban identity in the city may be a reaction to what is perceived as urban elitism. In a *Time Out New York* article from 2015, Carla Sosenko wrote in praise of the chaining of Williamsburg, Brooklyn, one of the most rapidly hyper-gentrified neighborhoods in the city. "I love Williamsburg right now," she wrote, "in all its J. Crew–laden, Starbucks-tastic glory." She explained how she and her friends from suburban Long Island used to visit

Williamsburg in the earlier 2000s, when it was still more hipster than basic bro, and they "never felt cool enough." Sosenko prefers the neighborhood today, now that the "pockets of cool kids have shrunk" and "folks like me . . . have stepped in." While she allows that it would be "nicer" if mom-and-pops weren't pushed out, she says chains are "a little bit comforting. It sounds gross, but it's true. I like knowing I can get a venti iced coffee in Williamsburg and predict what it'll taste like." She's far from alone. Starbucks has 307 locations in the city. There's one every 5.5 blocks in Manhattan. And Starbucks CEO Howard Schultz has said he gets many emails from New Yorkers asking for more.

Chain businesses have long existed in New York. Howard Johnson's, Chock Full O'Nuts, and Woolworth's are all places about which New Yorkers have fond memories. The Horn & Hardart Automat, a darling of urban nostalgics, was once ubiquitous. But they were nothing compared to today. As chains multiply, small businesses are targeted for extermination. While it's always been tough to run a small business in the city, and many fail naturally, none can survive today's rents. During the Koch administration, according to real estate lawyer Steven Barrison, approximately 2,300 small businesses closed per month. In the Bloomberg years, that number shot to 10,000 per month—and it keeps climbing.

New York City once had commercial rent control, from 1945 to 1963, to cap the heights to which a landlord could raise the rent on a business. There are currently no regulations for commercial rents. I've talked to countless small business owners who've been forced out when their rent suddenly doubled, tripled, quadrupled, even increased by a factor of ten. In many cases, the landlord simply denies a lease renewal. It doesn't matter that the business has been in the space for twenty, fifty, ninety years. "I don't want any small businesses in my buildings," the landlords say. "Only chains."

If the chains don't come right away, the space sits empty and wasted. In some neighborhoods, vacated storefronts are so numerous they've turned streets into ghost towns of "high-rent blight." Named by Tim Wu in *The New Yorker*, high-rent blight refers to the blocks of empty spaces that sit for months and years, warehoused by landlords who wait for chains. And it's not just high rent they want. Landlords kick out mom-and-pops to increase property values. In 2016, *Bloomberg News* said, "Blame the banks for all those boring chain stores ruining your city." Banks, they reported, place a higher value on buildings with chain tenants, while devaluing those with small businesses. And corporate chains actually pay less: "National retailers are often rewarded for their perceived credit worthiness with lower rents." In this rigged system, Mom and Pop can't win. By devaluing small business people, banks are committing a kind of class discrimination, another version of redlining, and no one is nailing them for it.

Big chains also get tax breaks. The city's Industrial and Commercial Abatement Program, formerly the Industrial and Commercial Incentive Program, has granted multi-year subsidies to national retailers like CVS, McDonald's, Home Depot, and Target. In 2008, the *Times* reported, big chains received $7.5 million. They weren't using the money to create jobs, said Manhattan Borough President Scott Stringer, but only to displace independent shops.

Business Improvement Districts (BIDs) bring in chains, too. Many neighborhoods are managed by BIDs, private organizations that take over City Hall's responsibility for maintaining public space. In essence, BIDs privatize and control the streets, raising property values and increasing inequality. They may have started off benign, but in the 1980s, as Sharon Zukin notes in *Naked City*, they got bigger and richer. Then Bloomberg encouraged them to expand their power and wealth. Many of today's BIDs are run by major real estate developers and, as Zukin explains, they "use their collective influence to push out" mom-and-pops and bring in corporate retail. "BIDs," she says, "are an oligarchy; they embody the norm that the rich should rule."

A balance between big retailers and local businesses would be ideal, but there is no balance. The corporate model insists on relentless growth. Most of us shop at chains some of the time. I try to patronize mom-and-pops when they're there, and walk out of my way when they're not. But with fewer options, shopping locally can be a laborious task. In 2015, blogger Matt Falber attempted to unchain himself, shopping only at independent businesses. He didn't last a month. Trying to find small businesses constantly forced him to travel several blocks out of his way. In Manhattan's Union Square, he got overwhelmed. Of the 47 storefronts he counted on Union Square Park, only 9 were independent businesses. (Update: Since Falber's 2015 experiment, four of those have been evicted, leaving only five at the time of this writing.) As for the chains, he listed them all: Walgreens, Best Buy, Best Buy Mobile, Nordstrom Rack, Duane Reade (owned by Walgreens), Citibank, Whole Foods, Forever 21, Designer Shoe Warehouse, Burlington Coat Factory, Strawberry, Bank of America, Reebok Fithub, Staples, Lululemon, Skechers, American Eagle, McDonald's, Starbucks, Pret A Manger, PetCo, Barnes & Noble, AT&T Store, Capital One Bank, Sephora, the W hotel, Wok to Walk, Dunkin' Donuts, Maoz, the Children's Place, T.G.I. Friday's, the Vitamin Shoppe, Babies "R" Us, (another) Starbucks, GNC, Panera Bread, Au Bon Pan, and FedEx Office.

The suburban-style homogenization of urban space is not unique to New York. It is sweeping Western cities, as the authors of *Planetary Gentrification* point out, creating a kind of "sub-urbanity" in which "the vitality of the city has become hybridized with the comforts of suburbanization." This is not some inexplicable trend. It is the work of the global economy. As Louise Erdrich told the *Paris Review* in 2010, "We now see what barely fettered capitalism looks like. We are killing the small and the intimate. We all feel it and we don't know quite why everything is beginning to look the same. . . . We are losing our individuality. Killing the soul of our landscape."

Unfortunately, not everyone feels it. For many younger people, there is no imaginable alternative. A world filled with chains is not only comforting and familiar, it's normal. Once upon a time, even the suburbs were unchained. In my own 1970s childhood, my small town was full of mom-and-pop shops. We knew the druggist, the corner grocer, the couple who ran the hardware store. Now Wal-Mart, Home Depot, Costco, and other big-box giants have moved in, bulldozing the forest for their oceanic parking lots, sucking life from the town square. How can anyone born after the advent of corporate dominance have hope of wanting better? If you grow up on Target's cookies, of course they taste like home. In the persistent suburbanite's psyche, chain love may be, at the core, a desire to be safe, held securely in something that feels like family, even if it isn't. Some of these newcomers to New York may eventually become urbanized, while others will go back to where they feel most comfortable. But there's another group that will stay and do their part to kill the city's soul.

Let's call the first bunch suburbophiles, people who love aspects of suburban life and want to find them in the city, but don't necessarily hate the city. The second group might then be classified as urbanophobic. Anti-urbanism, as I've discussed, dates way back in the history of America and reasserted itself in the 1990s. I see the urbanophobes of today as part of that revanchist tradition, the post–white flight suburbanites come back to get revenge on the city their grandparents abandoned. In their consumer choices, in the opinions they express on blogs and websites like Yelp, they make plain their distaste for the true city and its messy, unpredictable, discomforting soul. The last thing they want to be is urbanized. "They came," as Sarah Schulman notes, "not to be citified, but rather to change cities into places they could recognize and dominate."

Many stay separate from the city's contamination by living in quasi-gated communities. One resident of a luxury building loaded with suburban amenities told the *Observer* in 2008, "Everything's al-

ways convenient, always safe, always clean. You don't have to worry about gross things. Like mice! And creepy things like that." Said another, "It sometimes feels like I'm not in New York when I'm in the building. . . . It's trying to have things that a suburban housing complex would—everything at your fingertips, where you don't have to leave [the building] much if you don't want." Some newcomers keep cars not just for transportation, but to ward off urbanization. One told the *Observer* in 2007 that a car "definitely makes me feel more . . . well, not like such a city person." The worst urbanophobes hate everything old about the city. They consider old small businesses to be unsightly and unseemly. Others, as we've seen, take aim at city people and their traditions, working to eradicate them.

Suburbanization is a tool of social control. When the federal government first lured ethnics out of the city with the promise of white Americanization, there was a catch. In order to become white, they would have to assimilate, give up their cultures, languages, and left-leaning politics. They would have to surrender. As William Levitt, the pioneering developer of quintessential suburbia, said, "No man who owns his own house and lot can be a communist. He has too much to do." Homeownership is a way to restrain people. As the authors of *In Defense of Housing* point out, the Privy Council of England, while trying to control colonial America, declared in 1772, "Experience shows that the possession of property is the best security for a due obedience and submission to government."

The suburbs, with their emphasis on homeownership, homogeneity, safety, and political conservatism, are human refineries, taking in darker strains and bleaching out the impurities. Recall old Cubberley's insistence on the breaking up of ethnic groups, "to assimilate or amalgamate these people as a part of our American race, and to implant in their children, so far as can be done, the Anglo-Saxon conception of righteousness." Those children and grandchildren have been

successfully implanted. Now they are lured to the city to do their part to cleanse dirty, alien New York.

Some say this migration is natural, like birds returning north in summer. Some say it's due only to the decrease in crime; that cities, made safer, are simply swapping places with the suburbs. It's far more complicated. And the wider result is a class and racial resegregation of America, with working-class and lower-income black, brown, and immigrant people exiled to the suburbs as more affluent whites take the cities. In his essay "Vanilla Cities and Their Chocolate Suburbs," Jeff Chang writes of these new "geographies of inequality," where the colorized suburb now receives the brutal treatment the inner city once did—neglect, predatory lending, and paramilitarized policing that too often ends in the murder of black people. "The fate of Brooklyn," Chang writes, "tells us about the fate of Ferguson." The violence of hyper-gentrification ripples outward.

Alan Ehrenhalt calls this demographic shift the "great inversion," as the affluent flood into urban centers and the poor are pushed to the suburbs. As a result, he writes, "we need to adjust our perceptions of cities, suburbs, and urban mobility." I'm not ready to make that adjustment. I'm not ready to give up on the city. Even Andrés Duany, the father of New Urbanism, sees a problem here. He complained to *The Atlantic* in 2010 that suburban young people are "destroying the city," coming in like locusts with a "destructive monoculture." These people "love cities desperately," he said. "And they're loving them to death."

I'll ask again: What, exactly, is being loved? It's not the cranky Italian sisters at Manganaro's Grosseria, opened in Hell's Kitchen in 1893 and closed in 2012 because, in part, many newcomers couldn't tolerate its gruff New York attitude. Said one sister to the *Observer*, "People call me all sorts of names. If you went on Yelp, you'd have a heart attack." The urbanophobic newcomers aren't loving the smell of Katz's pickles or the Feast of San Gennaro. They don't love the blocks of walk-up tenements, the coffee shops that defined "coffee

shop" before Starbucks came along, or the richly fragrant bookstores rapidly vanishing ("Books smell like old people," they scoff, clicking at their sterile iPhones). I had my fortieth birthday party with the sisters at Manganaro's. They were warm, delightful, and bitterly funny. I walk by Katz's just to inhale that pickle smell and, well, you know the rest. This is how you love a city. Not by insulting its history and tearing it down. Not by replacing it with the assembly-line façades of Anywhere and Everywhere and Nowhere, USA. That's not loving New York. That's revanchism. As Fran Lebowitz said, "America has gotten its revenge on New York, because it's moved right in. Now it is a mall."

Dear reader, if you are a young person who came from a suburb or a small town, as I did, to become a New Yorker, to love the city in all its unpredictable and unfamiliar discomforts, then please stand up. The city needs you to look past the shiny plastic façades to the true New York. It needs to be seen and loved. Without new generations to fight for the wild, diverse, open New York, the very idea of the city will perish, crushed in the rubble of another gutted piece of its soul. In 2008, writing on the death of bohemian Greenwich Village, Christopher Hitchens put it well when he said, "On the day when everywhere looks like everywhere else we shall all be very much impoverished, and not only that but—more impoverishingly still—we will be unable to express or even understand or depict what we have lost."

HARLEM AND EAST HARLEM

Lenox Lounge, shuttered and stripped. *Randall Herrera, 2015*

IN THE WINTER OF 2013 I SAT IN THE LENOX LOUNGE FOR THE last time, having a drink. The bar was quiet, as it always was on the few visits I'd made, the late afternoon sun going low and golden, streaming across the wide-open space of the vacant lot across the way, a weedy field that would one day be crammed with condos and chain stores. But, for now, wilderness. At the bar, older black men sipped bottles of beer, downed shots of Johnnie Walker, and softly talked. A few couples, mostly mixed-race, sat in duct-taped booths sipping neon-vibrant cocktails and eating fried catfish while reading the papers. The bartender explained to a couple of white tourists ex-

actly what made the Lenox Lounge so special. "All kinds of people come in here," she said. "All ages and ethnicities. On any night you can find a doctor, a lawyer, sitting next to some guy with no teeth."

The bar felt easy. A slowed-down neighborhood joint decked out in faded glamour. The Art Deco walls, paneled in tarnished chrome and buffed blond wood, recalled the deep past. In the back room, where Billie Holiday, Miles Davis, and John Coltrane once played, and where jazz still ruled the nights, the walls were papered in zebra stripes. Located on Lenox Avenue, just off Harlem's famed 125th Street, the Lenox Lounge opened in 1939. Now it was closing. The landlord had doubled the rent from $10,000 to $20,000. The lease went to Richie Notar, the jet-setting entrepreneur behind the Nobu luxury restaurant chain. "I don't want to change a thing about how it looks," he told the *Daily News,* adding that his renamed Notar Jazz Club would be "not too much different than what it is now." The fauxstalgia craze that gripped lower Manhattan, upscaling our classic restaurants and bars, had spread to Harlem, riding in on the potent dose of hyper-gentrification that the Bloomberg administration injected directly into the neighborhood's central artery.

Considered the Main Street of Harlem, 125th Street runs across the width of upper Manhattan, from river to river, tracing a geologic fault line that now and then makes the city shiver in its schist. The wide thoroughfare has long been a place for shopping and entertainment, first for Irish, Germans, Jews, and Italians, and then—most famously—for African Americans, who turned twentieth-century central Harlem into what author and activist James Weldon Johnson called "a city within a city, the greatest Negro city in the world." Southern blacks of the Great Migration helped create the Harlem Renaissance of the 1920s, from which came the great flowering of African-American culture in art, literature, music, dance, and intellectual life. Author Ralph Ellison, who came north in 1936, said, "The very idea of being in New York was dreamlike, for like many African Americans of the time, I thought of it as the freest of American cit-

ies and considered Harlem as the site and symbol of Afro-American progress and hope." Manhattan was Paris, and Harlem "a place of Left Bank excitement."

Starting in the 1930s, Harlem suffered under redlining. In the 1950s, as Robert Moses's slum clearance destroyed black neighbor-hoods across the city, Harlem swelled with displaced poor and working-class families, bringing with them the symptoms of root shock. Disinvestment followed. Benign neglect. By the 1960s, Harlem was a slum. Yet it remained a place of creativity and radical politics. There were riots, too, each one starting as a protest against police brutality. And then, in the 1980s, gentrification came knocking.

Where did it begin? It's never easy to pinpoint these things, but there are certain moments that stand out. In 1985, Senator Alfonse D'Amato and Mayor Koch broke ground on the Towers on the Park condominium project, a pair of twenty-story buildings at the south-ern edge of central Harlem. Protesters sang songs and held signs, in-sisting that this development, built with millions of private and public dollars, would begin the process of displacement. Senator D'Amato glared at the protesters and said, "I'd like to sing, too." Then he broke into song: "Gen-tri-fi-ca-tion. Hous-ing for work-ing peop-le. A-men."

Those towers, today marketed as luxury housing, set off a build-ing boom. One realtor saw the future clearly, telling the *Los Angeles Times*, "The yuppie comes to where the action is. He will creep fur-ther and further north." He added, "Harlem is going to be developed by white people." While black people lived in Harlem, they mostly did not own it, thanks in large part to racist practices in banking. The slum buildings were owned, and neglected, by white landlords. That began changing in the mid to late 1980s, as black professionals started moving to Harlem and purchasing homes, but the socioeconomic shift remained small-scale and sporadic, the old-fashioned sort of gen-trification. In a 1986 paper, Neil Smith and Richard Schaffer explained that in order to transform Harlem "from a depressed island of disin-vestment into a 'hot spot' of reinvestment," the neighborhood would

need two things: lots of white people and tons of private financing. If this happened, Harlem would undergo tremendous change and "large numbers of community residents would face displacement."

Mayor Giuliani, vowing to rid the city's streets of sidewalk vendors, set his sights on 125th Street, smack in the middle of the newly designated Upper Manhattan Empowerment Zone (UMEZ). A revitalization plan authored by Congressman Charles Rangel (who fought planned shrinkage in the 1970s) and signed into law by President Bill Clinton in 1994, UMEZ came with a hefty infusion of cash, hundreds of millions in federal, state, and city money to provide tax breaks, low-rate loans, and other financial incentives to businesses moving into the zone. While some money went to small local businesses, most of it ended up in the coffers of corporate banks, national chains, and big developers. In 2000, the *Wall Street Journal* reported that only 16 percent of the financing went to small-business development. The suburban shopping centers were coming. But first the zone's main street would have to be swept clean of Undesirables.

Through its decades of disinvestment, 125th Street was kept alive by street vendors. In the 1990s, with increased immigration from Africa, the number of vendors grew to about a thousand per day. They sold books, tube socks, bean pies, African kente cloth, incense, body oils, and cassette tapes of Motown and gospel music. Mayor Giuliani, with his militarized police force, viewed the vendors as a blight on New Yorkers' quality of life. While a few local merchants had been complaining about the vendors, as Robin D. G. Kelley notes in *The Suburbanization of New York*, "it is not an accident that the first military operations against them coincides with initiatives to woo Gap and Starbucks into opening shop in Harlem."

On a bustling Sunday in October 1994, more than five hundred police officers in riot gear swept 125th Street, pushing out the vendors. Store owners kept their gates down. Fights broke out. A group of 150 protesters marched across 125th. Dozens were arrested. After the clearance, the street lay beneath a strange, stressed stillness. The

vendors were gone. The only life that remained, reported the *Times*, were "police officers standing along the street in clusters of three, with metal barricades on the sidewalks, giving 125th Street an air of an area under siege." Said one bookseller to the newspaper, "You never see this kind of police force used to raid a crack house. You would think that Saddam Hussein was invading Harlem. All we want to do is make a living."

The 1990s ended with major deals from the Abyssinian Development Corporation, the real estate wing of Rev. Calvin Butts's Abyssinian Baptist Church. For the past decade, they had been buying and rehabbing properties all over Harlem. They also built public schools, ran homeless shelters, and developed affordable housing. Many New Yorkers credit Abyssinian with the revitalization of Harlem—for better and for worse. In 1999, with millions in cash and incentives from UMEZ and the city, Abysinnian helped bring a Pathmark supermarket to the eastern end of 125th Street at Lexington Avenue. Thousands signed a petition against it as small local grocers worried that the big competition from Pathmark would kill their business. Community organizers rallied against Butts for working with Republican governor George Pataki. They compared him to Judas Iscariot and said he was a "slave catcher" who would "help Pataki take over Harlem." Reported the *Times*, "Pathmark's popularity is having a big impact on the neighborhood. Not only has it altered the fortunes of the unsightly intersection where it is located, it is also helping to spur development across 125th Street." Karen A. Phillips, the chief executive of the Abyssinian Development Corporation, told the *Times* that Pathmark was intended to be the eastern anchor of a glittering new shopping district along 125th Street. The supermarket, she said, has "done what it was supposed to do—inspire new commercial development." The western anchor in Abysinnian's plan would be Harlem USA, a 275,000-square-foot suburban-style strip mall where the Disney Store was the first to sign a lease. As big chains attracted more big chains, commercial rents went up and small businesses were pushed

out. The face of 125th was changing, and it wouldn't look much like Harlem anymore.

In 2008 the Bloomberg administration rezoned 125th from river to river. The plan was the brainchild of city planning director Amanda Burden. As she told the *Times*, her eureka moment came after a Roberta Flack concert at the Apollo Theater. She and her local companion were hungry, but where would they eat? "Downtown," said the friend. They agreed there was no place to eat in all of Harlem. Not even at Sylvia's, Manna's, Bayou, or the Spoonbreads of Miss Maude and Miss Mamie? That's when Burden realized that the neighborhood would have to change. "There should be a million different eateries around there," she said, "and this is a once-in-a-lifetime opportunity to frame and control growth on 125th Street."

A million eateries for whom? In her book *Harlem Is Nowhere*, Sharifa Rhodes-Pitts recalls sitting in a new Harlem café listening to a conversation between two middle-class white men. One lived in the neighborhood and one was visiting. "This is fabulous," the visiting friend exclaimed. "Really, you have to do something to get the word out. There need to be more *people* up here!" As Rhodes-Pitts points out, the men were "afflicted by that exuberant myopia common to colonists." For them, the existing people—poor, working class, black, Latino—did not exist. Just as for Burden there were no eateries in Harlem.

From neighborhood to neighborhood, throughout the Bloomberg years, we heard the same exuberant myopia from Burden. Her low opinion of pre-rezoned Harlem came through once more in a 2008 interview with the fashion editor of the *Palm Beach Daily News*. As the editor explained, "The historic street, home of the Apollo Theater, was described [by Burden] as a dull succession of one-story buildings with no cultural center, no residential development and no restaurants." As Brooks of Sheffield, the blogger at Lost City, added in

a post on this article, "WTF!" Before the rezoning, 125th Street was very much alive, filled with people and a diversity of small businesses and restaurants, many of them long-lived. It was not "a dull succession." As we know from the work of Colin Ellard, small, old buildings full of local businesses are the opposite of dull. They stimulate the nervous system and keep us alive. What kills us, literally shortening our life spans, are the blank boxes of condos and chains. But the Bloomberg administration had its own definition of "alive."

The people of Harlem fought back. They'd seen how Bloomberg's 2003 rezoning of Frederick Douglass Boulevard raised housing prices, spurred development, and dramatically changed the population—white people flooded into the rezoned area, their numbers increasing by 455 percent from 2000 to 2013, while the black and Latino populations declined from displacement.

Rhodes-Pitts recalls the first presentation to the community of the city's rezoning plan. "By the city's own estimate," she writes, "the rezoning would increase the residential capacity of 125th Street by 750 percent. The majority of this housing would be market rate." She recalls a long line of angry Harlemites waiting for the microphone, their "testimonies growing more and more heated." Dressed in a T-shirt that read HARLEM IS NOT FOR SALE BECAUSE HARLEM'S ALREADY BEEN SOLD, one man looked each urban planner in the eye and promised, "Whatever you build, we'll burn it down." The crowd burst into shouting. The planners shut down the meeting. They didn't want emotion. At meeting after meeting, when hundreds of Harlem's people enumerated their sorrows and concerns, Rhodes-Pitts recalls the chairwoman of the City Planning Commission responding only with "a semi-robotic smile" and the phrase, "Thank-you-will-you-please-submit-your-written-testimony-for-our-consideration."

At the City Planning Commission meeting where the rezoning was approved, community members spoke out again. Harlem author, historian, and preservationist Michael Henry Adams pointed the finger directly at Amanda Burden and shouted, "You're a rich, rich, rich

horrible person. You're destroying our communities. You're a rich, rich socialite. You're a rich, rich socialite. How dare you! You're destroying Harlem. You're getting rid of all the black people!" He was escorted out. His conclusion was echoed by Craig Schley, executive director of VOTE People, an organization formed to combat the rezoning. He told the *Times*, "This would be signing Harlem's death warrant. . . . They intend to remove people in this area, plain and simple."

The city knew very well that their plan would mean the displacement of people. In the Environmental Impact Statement, City Planning stated clearly that the rezoning would likely result in the displacement of 125th Street's existing population. "The projected increase in new market rate housing," reads the statement, "could potentially add a substantial new population with different socioeconomic characteristics . . . and could introduce a substantial amount of a more costly type of housing." The statement also reported that several small businesses would be removed, through both direct and indirect displacement. In total, City Planning expected 71 small businesses along 125th Street to be directly displaced by 286,218 square feet of planned retail development—how exactly this would happen is not specified. The report's list of these businesses includes restaurants, jewelry stores, drugstores, and clothing stores, along with an HIV/AIDS prevention and testing center and an educational institution. About 975 jobs would be lost. However, the report assures, new jobs would be gained. One assumes that means pouring macchiatos, folding jeans, and ringing up the registers in global shopping mall chain stores.

The statement concludes that the businesses to be displaced do not contribute significantly to the character of the neighborhood; therefore, the rezoning would not lead to "adverse effects" on the business life of 125th Street. The displacement of a mom-and-pop business, the report explains, is "not a significant adverse environmental impact," because the City Environmental Quality Review (CEQR) Technical

Manual says so. Speaking more generally, the CEQR asserts that the displacement of residents and businesses does not, by and large, "constitute a significant adverse socioeconomic impact" on a neighborhood. The manual goes on to provide criteria for determining the relative value of human beings and their contributions to city life. In the end, City Planning essentially determined that the people of 125th Street, their homes and businesses, weren't worth much at all.

Opened in 1946, Bobby's Happy House was one of the first black-owned businesses on 125th. After serving in World War II, the southern-born Bobby Robinson, grandson of slaves, went to New York. He was looking for something to do. "I'd sit on a fire hydrant at the corner of Eighth Ave. and 125th St.," he recalled to the *Daily News*. "And I'd count the people going by. There was a hat shop there, and I thought it would be a good place to open a business." So that's what he did, getting his savings together to open a record shop down the block from the Apollo Theater, home of Billie Holiday and Ella Fitzgerald, where the Duke Ellington Orchestra told people to "Take the A Train" up to Harlem. Plugged in to the local music scene, Robinson became a producer, helping to launch the careers of groups like the Shirelles and Gladys Knight and the Pips. Robinson's shop became legendary, a place where black music was both created and shared, and where neighborhood people gathered together. Over the years, the Happy House survived disinvestment, high crime, and riots, but state-led hyper-gentrification would prove to be a much more formidable foe.

In 2007 Robinson received an eviction notice. His building, along with several others, had been purchased by the multinational real estate development team of Kimco Realty and the Sigfeld Group. The Bloomberg administration had just completed their extensive study to support the rezoning of 125th. Kimco and Sigfeld, no doubt knowing what the future would bring, paid $30 million for the par-

cel, which comprised about a third of the block, with plans to de-
molish the whole lot and put in a mixed-use development complex
of hotels, condos, and national chain stores. Locals protested what
they called the "ethnic cleansing" of Harlem. Tenants filed lawsuits
against the developer. Some received settlements. In the end, they
all moved out.

I went by Bobby's Happy House in 2007, hoping to meet the silver-
haired gentleman who favored velvet suits topped by a black fedora. I
walked along 125th Street, belly full of fried chicken and waffles from
Sylvia's soul food lunch counter, where the menu proudly proclaimed
they "survived the social unrest of the 60s, the recession of the 70s,
the decay of the 80s, the Renaissance of the 90s, and the devolvement
of the Millennium." Maybe they meant "development," but "devolve-
ment" was right. Along 125th, I witnessed that devolution, passing
a mix of older small businesses rapidly outnumbered by new chain
stores. Plywood walls surrounded vast empty lots where developers
had already begun demolishing the so-called dull succession of little
brick buildings, places where African women braided hair and store-
front preachers spread the gospel. I went into Men's Walker's, a shop
specializing in hats and shoes made of stingray, alligator, and ostrich
skins. In business since 1970, owner Kevin McGill remained unfazed
by the pressures of gentrification. "When you're black," he told me,
"you always feel the pressure. This is just a different beast." He hoped
there would be a place for him in the new Harlem. (From what I can
tell, there was not.) I stopped by the Harlem Record Shack. Run since
1968 by Sikhulu Shange, it was fighting eviction. A sign on the door
said, SAVE THE SHACK! Outside, a young man urged passersby to sign
their petition. "Come on y'all!" he shouted. "Come save the Shack!"
Flash forward: though the petition gathered many signatures, Mr.
Shange was forced to close in 2008 and become a street vendor, sell-
ing CDs from sidewalk tables. Wrote the *Times*, "Customers chance
upon him, surprised, then walk away shaking their heads. A few
leave with tears in their eyes." Shange was eventually able to find a

new location for the shop nearby. Bobby's Happy House would not enjoy the same happy ending.

When I reached Frederick Douglass Boulevard, I turned the corner and headed for the faded red awning of Bobby Robinson's record store. In the front window, decorated for maximum shimmer with aluminum foil and strings of Christmas lights, a collection of trophies, plaques, and proclamations attested to Robinson's value to the music industry and the neighborhood—a fact that the City Environmental Quality Review Technical Manual would likely refute. A dusty television in the window played a video of Michael Jackson in concert, the bass line of "Billie Jean" thrumming to the street over speakers. On the sidewalk, three men gazed through the glass, their feet moonwalking and tapping as they mirrored Michael's moves. Inside the shop, autographed photos lined the walls: Smokey Robinson, Fats Domino, James Brown. It was quiet. Bobby was out. Friends and family members sat around eating lunch and watching TV. I bought an Ike and Tina Turner compilation and asked the cashier when she thought their last day would be. She told me, "The first of the year." They would last just a few weeks longer, closing on Martin Luther King Jr. Day in 2008.

The shop's façade was quickly stripped and boarded up. Along with its evicted neighbors, it sat that way for years as Kimco dragged its feet through the recession, unsure about Harlem's future after all. They considered scrapping their plans, telling the Wall Street Journal in 2010 that they were thinking of selling the site and walking away. The plywood that covered the shop's windows gathered graffiti tags and the clutter of random handbills. Garbage collected in drifts.

Robinson died in January 2011, at the age of ninety-three, as older people often do soon after their businesses are forced to shutter or their homes are taken. (While I've not found any studies to back this up, anecdotally it is evident that the stress and grief of eviction and displacement hasten the deaths of older people. Cynthia Cornell, a housing activist in San Francisco, calls eviction a form of elder abuse.)

On the closed gate of Robinson's wasted shop, friends and neighbors built an impromptu memorial of notes, posters, and funeral wreaths, including a large arrangement that spelled out BOBBY in red and white carnations. Demolition began that summer as Kimco got back to business. The parcel of buildings that held the Happy House ran the entire length of the block along Frederick Douglass Boulevard, wrapping around to 125th and 126th Streets. It all came down at a breakneck pace. On the site today stands a large, nondescript box filled with national chains—Party City, DSW, Capital One Bank. The bank is long and sleek, taking up the entire block where Robinson's shop used to be.

I n the fall of 2015 I went up to 125th Street to walk its entire span, from the Hudson River to the on-ramp of the Triborough Bridge, to see what had changed since the Bloomberg rezoning. To the west, Columbia University had taken over a large section of the area known as Manhattanville. The mostly industrial land was an eminent domain gift to the school from the city and state. There had been hunger strikes and holdouts, New Yorkers fighting to hold on to their property. Robin Middleton, professor of architecture at Columbia, called the school's plans "simply monstrous, like an Orwellian, Stalinist, or dystopian campus of factories." Still, Columbia won. Now their Science Center, designed by starchitect Renzo Piano, rose into the sky, a hulking silver box that seemed to be off-gassing, humming with alien energy.

I headed east, carrying a notebook and pen while I counted 77 national chains, including two Starbucks just a few blocks from each other, a Banana Republic, Gap, Red Lobster, Dunkin' Donuts, CVS, Rite Aid, and a plethora of cell phone stores. I found 15 commercial banks in addition to those 77. Remember that the city planning manual predicted the loss of 71 small businesses. The final number will be much larger. More chains are coming. Rents continue to rise. A few

independent businesses hang on—pawnshops, African hair braiding salons, discount stores with names like Lady Love, Ballers, and High Rollers, shops that speak the vernacular of Harlem with signs that say "Match Your Kicks with Snapbacks." Street vendors have returned, filling the sidewalks with tables loaded with kung-fu DVDs, dashikis, pan-African flag medallions, tubs of shea butter, incense, and posters, including one of a cavalry of African-American heroes charging on horseback: Barack Obama, Martin Luther King Jr., Harriet Tubman, Tupac Shakur.

The tourists come in droves, unloading from buses to flood gospel churches where black congregations are dwindling, thanks to displacement. Soon there will be more tourists than black Harlemites at the services. In reports, the tourists are rude and disrespectful, taking photos and getting up to leave in the middle of sermons. The Harlem Chamber of Commerce's Lloyd Williams told *Slate,* "It's like you're going through a safari, and we're the animals as you are on the bus riding by, pointing at the zebras."

As middle- and upper-class whites change the color of Harlem, it's important to understand that displacement can be direct, like eviction, or indirect, what Peter Marcuse calls "the pressure of displacement." In his 1985 paper "Gentrification, Abandonment, and Displacement," he writes, "When a family sees the neighborhood around it changing dramatically, when their friends are leaving the neighborhood, when the stores they patronize are liquidating and new stores for other clientele are taking their places," etc., then it's only a matter of time before they move out, "rather than wait for the inevitable; nonetheless they are displaced." So when people speak of lower-income people of color "wanting" and "choosing" to move out of their neighborhoods, or out of the city, we have to think more deeply about that. What might look like a choice may actually be surrender to the pressure of a rapidly changing and increasingly alienating environment.

Back in 1995, when Giuliani raided Harlem, Rev. Al Sharpton

said, "There is a systemic and methodical strategy to eliminate our people from doing business on 125th St." City Hall, he said, intended to "change the color of New York." He was right. The *Times* reported in 2010 that, for the first time since 1930, blacks were no longer the majority population in Harlem: "The 1990 census counted only 672 whites in central Harlem. By 2000, there were 2,200. The latest count, in 2008, recorded nearly 13,800." As those numbers continue to climb, the shift has a major impact on the character of the neighborhood, not just the shops and the architecture, but the feeling of it. While some newcomers mix with the culture, others react violently to it, turning up the pressure of displacement.

A group of African-American drummers have played in Marcus Garvey Park every weekend since 1969. Their presence helped keep the park safe through tough times. Until 2008. Then a luxury condo went up nearby. The new residents—"most of them young white professionals," according to the *Times*—started complaining about the drums. They called the police and circulated racist emails "advocating violence against the musicians." The drummers agreed to move from their traditional spot. Marcus Garvey Park, named after the black nationalist in 1973, was rechristened by realtors and newcomers with its original nineteenth-century name, Mount Morris Park. No one is quite sure who Morris was, but you can bet he was a rich white man.

. Today, when talking about Harlem and other gentrifying neighborhoods of color, we often hear the refrain "White people were here first." In 2015, the *Columbia Spectator* published an op-ed titled "Is Columbia Really Destroying Harlem's Authenticity?" Written by a first-year student, it supported the school's expansion into Harlem, made possible by eminent domain. The author argued that Harlem's authentic culture is not African-American, but one of ever-changing cultures dating back to the Dutch. He argued, "it is immoral to limit a neighborhood's natural progress by desperately defending a concept of 'authenticity' that is not even properly defined. Why is pre-

serving Harlem's present identity more important than preserving any of its former identities?"

It's a question often asked and I will answer with the words of local historian Michael Henry Adams, who responded best when he said, "Harlem has numerous lovely old buildings reflecting varied cultures, even former synagogues. But throughout history, nothing about Harlem has made it renown, world-wide, apart from black people. One may talk all one likes about other earlier Harlems populated by people who were not black. By contrast, these white Harlems were insignificant. African Americans alone—our culture, drive, and creativity—have accorded Harlem a status as fabled and fabulous as that held by Paris or Rome."

Race and class tension in Harlem today is not a riot, but it is palpable in the blogosphere and on the streets. As I continued my walk across 125th, black Muslims stood outside Banana Republic urging black people to boycott the chains during the holiday shopping season, an extension of Adam Clayton Powell Jr.'s "Don't Shop Where You Can't Work" campaign of the 1930s. To the Banana Republic shoppers, the protesters called, "Buy black before Black Friday!" But no one seemed to listen. They all wanted new khakis. Taped to a brick wall, a sign read: "White people and gentrify-ing people of color. Please, do us all a favor and get the fuck out of Harlem. No more colonization. Go back downtown." As I rounded the corner to Lenox Avenue, a black man muttered a similar sentiment in my direction. What did I look like walking through Harlem? Gentrifier or tourist?

I turned momentarily off 125th to take a look at what remained of the Lenox Lounge. Three years after being forced to close, it still sat empty. When he left the place, owner Alvin Reed stripped the façade, ripping down the Art Deco details and taking the antique neon sign, hoping to erect it on a new space. It was a heartbreaking act of vandalism that yet made sense. Who would want colonists to profit from your history? Still, the result was depressing. Someone had

spray-painted "1939–2012: 80 YEARS FOR THIS" across the plywood that covered the door. Above the ghost letters of LENOX LOUNGE, a realtor's banner advertised: "Entire Building for Net Lease." What happened to Richie Notar's big jazzy plans? Did he change his mind after Reed took the historic details? Notar told the *Daily News*, "the scope of the project (mostly the overall condition of the building) became bigger than anticipated," leading to delays. He moved on to another location. The Lenox Lounge was left to rot.

The honey-paneled walls, the zebra stripes, the air once perfumed by Billie Holiday's white gardenia, the sunlit room that welcomed everyone black, white, with or without teeth, all of it lay in waste. The rent doubled again to $40,000 per month. And then, in 2016, an anonymous LLC filed an application to demolish the building. An architectural firm released a rendering of what's to come— a four-story glass box containing the cosmetics chain Sephora. Total erasure. Across the street, where that empty lot sat years before, a giant glass box has risen, infesting 125th with yet more chains, including one infamous for its power to give hyper-gentrification a shot in the arm. Whole Foods is moving in—and everyone knows what those high-priced groceries signify.

The Whole Foods Effect is powerful. The creators of real estate site Zillow, authors of *Zillow Talk*, revealed how Whole Foods moves in to neighborhoods where home values are rising more slowly than the rest of the city. "But as soon as the Whole Foods opened its doors," they wrote, "these nearby homes' values took off," increasing at twice the speed of other properties. In the *Post* in 2016, one real estate broker reported that Harlem landlords were planning to raise rents as soon as the supermarket opened. Whole Foods is a tool of hyper-gentrification. In cities like Chicago and Detroit, the company has been given millions in taxpayer subsidies to open in poor and working-class neighborhoods that mayors want to "revitalize." I would not be surprised to learn the same is true in Harlem. This should be a scandal, but it's not.

In a 2016 *Times* op-ed titled "The End of Black Harlem," Michael Henry Adams wrote about a gentrification conversation he had with his friend James Fenton, a British writer who bought and restored a Harlem mansion. "You and all the others had better get over your grieving," Fenton said to Adams; "we need Whole Foods." But who is *we*? As always, when talking about so-called neighborhood improvements, we must ask: For whom is it intended? For whom are these newly planted trees, these bike lanes, these cupcake shops and Starbucks? Who will get to enjoy the fresh produce of Whole Foods? "For so many privileged New Yorkers," wrote Adams, "Whole Foods is just the corner store. But among the black and working-class residents of Harlem, who have withstood redlining and neglect, it might as well be Fortnum and Mason. To us, our Harlem is being remade, upgraded and transformed, just for them, for wealthier white people." In response, many of the *Times'* online commenters called Adams a racist. They cried: "Will the whining ever end?"

As Harlem turned into East Harlem, I continued my walk along 125th Street, watching the chain stores dwindle slightly, the FOR RENT signs multiplying on shuttered storefronts. Where buildings had just been demolished, green plywood framed the sites, posted with renderings of developments to come. More of the same glittering glass boxes. More of the Generic City. I crossed under the elevated train tracks at Park Avenue, where homeless people gathered to smoke K2, a cheap but powerful synthetic marijuana. I came upon that Pathmark supermarket that the Abyssinian Church put in back in 1999 for the explicit purpose of spurring development. It did its job. And now? It was being forced to close. Abyssinian had sold the site to mega-developer Extell for nearly $39 million. The Pathmark's presence had likely forced many small grocers to shutter, giving residents no choice but to shop at Pathmark. Now the people depended on it—and they certainly could not afford the Whole Foods going in three blocks west.

In the Pathmark's final hour, I peered inside the windows. The shelves were bare, the checkout conveyor belts empty, no customers stood in line. The cashiers put their arms around each other and wept as they said goodbye. Two hundred employees would now be out of work. A low-income neighborhood would become evermore of a food desert. Another luxury tower would rise. And none of this was the result of "market forces." None of it was natural.

One block east of the shuttered Pathway is the site of the future MEC. In 2009, the Bloomberg administration blighted this entire block of small businesses, using eminent domain to claim it for a $700 million development project, the 1.7-million-square-foot East Harlem Media, Entertainment and Cultural Center. Hence, the regrettable "MEC," which sounds like "meh," which is rather apt. It is designed to be yet another glassy and dull cluster of boxes. Planned to include affordable housing and a community center, spoonfuls of sugar to help the poison go down, MEC will be abundant with office space and market-rate housing, a hotel, and national chain stores. It is celebrated as a gift to the East Harlem community. And it will be green, certified Silver LEED from the U.S. Green Buildings Council.

I am reminded of a passage from Jane Jacobs's *Death and Life*. She wrote about a new housing project in East Harlem "with a conspicuous rectangular lawn which became an object of hatred to the project tenants." No one could figure out why the tenants hated it so much. Grass is good, right? It's green. Then one of the tenants made it clear: "Nobody cared what we wanted when they built this place. They threw our houses down and pushed us here and pushed our friends somewhere else. We don't even have a place around here to get a cup of coffee or a newspaper even, or borrow fifty cents. Nobody cared what we need. But the big men come and look at that grass and say, 'Isn't it wonderful! Now the poor have everything!'" To which Jacobs concluded, "There is a quality even meaner than outright ugliness or disorder, and this meaner quality is the dishonest mask of pre-

tended order, achieved by ignoring or suppressing the real order that is struggling to exist and to be served."

There is a real order to poor and working-class neighborhoods. What might look to an outsider like chaos or decay is actually life—as it is lived, not as it is planned by elite strangers in faraway offices. Just because something is green, doesn't mean it is good, or desired, or that it will serve the people.

Residents and business owners fought against the MEC plan. Justice James Catterson of the state Appellate Division, reported the *Post* in 2011, "accused the city of falsely claiming 'blight' as a ploy to transfer private property to developers." But the courts were powerless to stop it, "thanks to prior rulings from the state Court of Appeals on eminent-domain cases related to Brooklyn's Atlantic Yards development and Columbia University's West Harlem expansion." In other words, eminent domain begets eminent domain—and the city and state are free to abuse it, especially in neighborhoods where poor people live. Said Judge Catterson of the MEC deal, "In my view, the record amply demonstrates that the [East Harlem] neighborhood in question is not blighted . . . and that the justification of underutilization is nothing but a canard to aid in the transfer of private property to a developer."

I finished my traversal of 125th Street with a walk around the MEC block. Sitting at the easternmost end of the street, in an isolated spot that feels like the edge of the world, where 125th breaks from Manhattan and rises into the Triborough Bridge, the block is made of scruffy old, low-rise buildings. They are useful buildings, containing a dry cleaners, a hair braiding salon, a flat-fix shop, an auto body shop, a Baptist church, and one of Manhattan's last remaining gas stations.

Why this block? I wondered as I stood outside Lugo Flat Fixed. Why would the city want to take this little spot? I looked down at the pigeons pecking at rice someone had thrown onto the sidewalk, and up at the stack of tires in front of Lugo's. Affixed to the top of an old

trailer, a taxidermied deer head looked out to Second Avenue, where
the sun was going low and buttery. I followed its gaze. To the north, I
saw the big History Channel sign that heralded the beginning of the
South Bronx. And suddenly I realized that the MEC block was situ-
ated close to the entrance of what realtors like to call SoBro—the next
hot neighborhood just a quick hop over the Harlem River's Third
Avenue Bridge. The History Channel sign was about to come down,
its building undergoing a $25 million renovation for upscale office
spaces. It made sense. Like Robert Moses, Bloomberg was a consum-
mate completist. He and his planners aimed to collect the city into a
unified set of rezoned neighborhoods, all the same, all connected by
bridges and roads and brand-new bicycle lanes that would funnel in
all the right people. When you look at the Bloomberg rezonings, you
can see them tying neighborhoods together, using police action, emi-
nent domain, and other strategies to grab key nodal points between
one place and another. The 125th Street rezoning, ending in the east
with the massive MEC, seemed poised to help spark development in
the South Bronx.

But I could not go over the Third Avenue Bridge just yet. I was
only getting started in East Harlem and, to really see it, I'd have to
visit East 116th Street, the commercial heart of El Barrio.

When I walk on East 116th I feel like I am walking in the city. The
real city. Unplanned and unmolested. While there are a few low-price,
fast-food chains here, most of the businesses are small and local. Mex-
ican restaurants. Bodegas, barbershops, and bakeries. Drugstores and
pawnshops. There's Cuchifritos, lit in exuberant neon where colorful
lightbulbs trace a marquee that announces: BBQ Chicken, Mofongo
Al Pilon, Jugos Tropicales. Inside, women in red-and-white-striped
smocks serve it up with plantains, blood sausage, stewed pigs' ears,
and more—all fried, all golden, all glistening in grease. There's the
Capri Bakery, with its extravagantly decorated cakes covered in plas-
tic toys and candy colors. And Casa El Rodeo, the western-wear shop

where Mexican cowboys get their boots and hats, brilliant shirts em-broidered with roses. (Later, you will see them on the train, playing accordions covered in mother of pearl.) Among the brick-and-mortar shops, a lively sidewalk microeconomy thrives. Men and women sell fruits and vegetables, tamales, hot ears of corn sprinkled with cheese and chili powder, molded *gelatinas* displayed in silvery boxes, and big jugs of *horchata* that the vendors ladle into plastic cups.

East Harlem has been a Puerto Rican neighborhood since the 1950s, when their Great Migration from the island filled New York. With white flight, the working-class Italians of the neighborhood headed for the suburbs. In the 1990s, Mexicans began moving in. Tensions rose. "The Puerto Ricans accuse the Mexicans of stealing jobs and cheating the tax man, and staying in the city as illegal im-migrants," reported the *Times*. "The Mexicans, in turn, accuse the Puerto Ricans of crowding them out of apartments, businesses and parks." Same old story. New groups move into neighborhoods and clash with the old. But this is not gentrification. This is New York always changing. As we see in this example, a kind of equilibrium is maintained in the midst of change, as one low-income group of im-migrants replaces another, each one seeking an affordable place in which to begin a new life. This was the beauty and the function of New York in the twentieth century. For East Harlem, this is chang-ing, too.

The feeling on 116th Street is dramatically different from the feeling on streets where hyper-gentrification has destroyed the so-cial contract. For one, people aren't glued to iPhones like they are downtown. Most walk with eyes up. They see you and you see them. (Remember the research that showed how lower-income people tend to pay more attention to others on the sidewalk?) Everyone dances the dance. No one bumps into anyone here. Bodies shift and shuf-fle, attuned to one another, together and separate, but conscious. I love walking on East 116th just to feel again the "air like of loving,"

that twentieth-century sidewalk ballet, the sense of being a human among other humans, connected if only by a moment of mutual acknowledgment on the city street.

I walk farther east, past the few remaining vestiges of Italian East Harlem. There's a sign for Morrone Bakery, shuttered in 2007 after fifty-one years in business. There's Claudio's barbershop, still here after more than sixty-five years, though Claudio was forced to move from his original location down the street when his rent tripled in 2011. I don't get up to East Harlem much, but when I do, I get a haircut from Claudio. His chairs are pistachio green and 110 years old. He is the last of a vanished breed. But in the summer, like swallows returning to Capistrano, the Italians flock back to East Harlem for the Dance of the Giglio.

There's a wooden platform. Atop the platform is a brass band and a heavyweight Italian folk singer, plus a couple of priests. Rising high above them is the Giglio, "the lily," a tapered wooden tower covered in papier-mâché saints and seraphim. At the top, like an angel on a Christmas tree, stands (at least one year) the Statue of Liberty. At five stories, the Giglio is as tall as a tenement building. Fully loaded, it weighs five tons. During the feast, one hundred men—known as Giglio Boys—take their positions beneath the platform and lift. With their backs and legs, they lift the Giglio, the brass band, the priests, the singer in his mighty girth. But they're not satisfied with just lifting the Giglio. With the singer singing and the cymbals crashing, the men make the Giglio dance, bouncing it on their shoulders, groaning and straining, red-faced and sweating, walking up and down the block while the towering lily wobbles and sways, and everyone runs alongside cheering, filled with the thrill.

This happens annually on Pleasant Avenue, which comes right after First Avenue, and it is here that I take a left and then a right onto 117th Street. All at once, the energy shifts. Some massive structure seems to be sucking all the light and air out of East Harlem. What is that monstrosity?

In 2003, the Bloomberg administration rezoned fifty-seven blocks of East Harlem with the purpose of encouraging growth. Since then, at least fifty new buildings have gone up. Many of them are luxury condos. I went into one of their sales offices once, pretending to be a home hunter, a guise I could easily wear as an apparently educated white man. The salesman, a young guy with slicked blond hair, gave me the hard sell. "This neighborhood is finally becoming residential," he said. But weren't there already residents in East Harlem? In his "exuberant myopia," the salesman ran down a list of the condos going up. They all had human names: Ivy, Leah, Sloane, Conrad. "The neighborhood is completely changing," said the salesman. "Pretty soon, you won't even recognize it."

In 2008, suburbanization came to East Harlem. On the site of the abandoned Washburn Wire factory, manufacturer of piano wire, coat hangers, phonograph needles, and filaments for the cables of the Verrazano-Narrows Bridge, El Barrio would get a shopping mall with Manhattan's first Target store as the anchor tenant. That was the light-sucking monstrosity I encountered on my walk—and it was built with $80 million in tax credits and other subsidies. In some circles, people hoped that its presence would goose the rents and property values in the area, spurring on hyper-gentrification. Jessica Armstead, vice president at Corcoran realty, told the *Sun*, "This mall is going to totally change" East Harlem's real estate profile. The paper reported that Target was "drawing the most excitement among prospective buyers at new residential developments." Armstead said that Target "appeals to everyone. You go in to get toothpaste and come out with three bags. It's amazing." Not everyone was buying the overconsumption extravaganza. Spray-painted on plywood at a nearby construction site, someone wrote: "Take back East Harlem—Revolution Is Coming."

When I approach the East River Plaza shopping center, I feel uneasy. The hulking structure darkens the street, turning it into a claustrophobic pipeline direct to the mall's entrance. I feel funneled, pulled

forward, wedged between the high cement walls of a beige parking garage and a delirious Applebee's. "Eatin' good in the neighborhood!" Flights of pedestrian overpasses crisscross a multistory tower transported from the suburban hinterlands. I walk the ramps, dodging oversize shopping carts caroming out of Costco. People, mostly Latino, stand in a long, snaking line, waiting for car service, their carts loaded with jumbo-size goods. Exhausted from the immersive shopping experience, mothers rest their heads in their arms, braced on cart handlebars. The earsplitting shrieks of unhappy babies echo in the gray cement air.

Shopping here looks like a misery, yet the corporations have won the hearts of the poor and working class with their low-priced goods. How did we ever afford to live without them? In my childhood, my mother clipped coupons, shopped the day-old-bread section, bought dented cans, and made excellent grilled cheese sandwiches from bricks of government cheese. I wore hand-me-downs and off-brands. We managed without Costco and Target. Still, some call the critique of chain stores an example of "bourgeoisie aestheticism." That is an insult. Humans thrive best on small, diverse, local streets. Chains are necessary, some say, because poor people need to shop and work there. But as political theorist Susan Fainstein noted: "Residents are caught in a vicious circle: they cannot afford to patronize independent shopkeepers because their wages are so low, and their wages are so low because large corporations have been able to force down the general wage rate, justifying their stinginess as required by competition." Big-box stores then "create more poorly paid employees who can only manage to patronize businesses that pay exploitative wages." And on the vicious circle goes.

In East Harlem, the East River Plaza is getting bigger, blander, and more estranged. A trio of high-rise towers will be built right on top of the mall, rocketing nearly fifty stories into the sky and filled mostly with luxury tenants. Thousands of new people will be crowd-

ing in. This is density at its worst and it can't be good for the human nervous system.

In my shopping mall daze, I wander into the Target store, that "amazing" miracle of modern consumption. Everything is red, like the inside of a stomach. The people are churning, screaming. The air tastes synthetic, reeking of greasy, freezer-burned cookie dough. I feel disoriented and dizzy. I run away, down the ramps, along the block and into the light again. I return to 116th Street. To the barbershops and bakeries. To the streetside *gelatinas* and jugs of *horchata*. I feel my system come back into regulation. The dizziness disappears. I can breathe again. I stop at a taco stand for supper. The woman turning meat on the grill calls me papi, and we chat, the tacos are good, and I am back in the ballet of city life. But how long can this last?

In the summer of 2016, East Harlem artist and journalist Andrew J. Padilla reported on Twitter that the NYPD was sweeping 116th of its sidewalk vendors. He told me, "Street vendors have seen fines in the thousands of dollars. They've had their products confiscated, even publicly destroyed. There have been cases of police throwing fresh food onto the street. And vendors are commonly arrested on these raids, all for trying to make an honest living." Sweeping away street vendors is a tactic straight out of the book of Giuliani, and it's always done to make room for the shiny new neighborhood—and the shiny new people—to come.

What did the East Harlem resident tell Jane Jacobs in 1961? "The big men come and look at that grass and say, 'Isn't it wonderful! Now the poor have everything.'" Today, it's a shopping mall. The big men and women say, "Now the poor can buy things!" As if there was nothing before. But the big men and women look at neighborhoods like Harlem and East Harlem and see nothing. They see no one. They see deserts and dream of planting grass, never telling the truth about what their strain of weed will bring.

PART THREE

The past, whatever its drawbacks, was wild. By
contrast, the present is farmed. The exigencies
of money and the proclivities of bureaucrats—as
terrified of anomalies as of germs, chaos, dissi-
pation, laughter, unanswerable questions—have
conspired to create the conditions for stasis, to
sanitize the city to the point where there will be no
surprises, no hazards, no spontaneous outbreaks,
no weeds.

—LUC SANTE, *THE OTHER PARIS*

GENTRIFIERS AND THE
NEW MANIFEST DESTINY

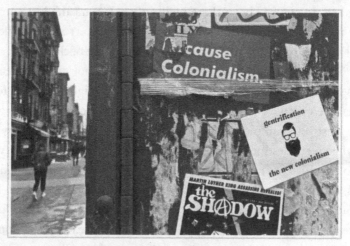

Sticker art. *Jeremiah Moss, 2017*

I N FEBRUARY 2014, WITH THE SLOGAN "DEFEND BROOKLYN" ON THE
sleeve of his sweatshirt, filmmaker Spike Lee gave a Black His-
tory Month talk to an audience of art students at Brooklyn's Pratt
Institute. During the Q&A, one Brooklyn native asked if gentrifica-
tion had its good sides. "I don't believe that," Lee replied, launching
into a defense of his home neighborhood, Fort Greene, where, along
with the surrounding neighborhoods, the white population increased
by 120 percent, while the black population decreased by 30 percent
in the decade between 2000 and 2010. The rents, of course, went up.

Lee recalled his childhood, when the garbage wasn't collected and police weren't out protecting the streets. Addressing the question about gentrification's good sides, he asked, "Why does it take an influx of white New Yorkers in the South Bronx, in Harlem, in Bed-Stuy, in Crown Heights for the facilities to get better?" He railed against what he called "the motherfuckin' Christopher Columbus Syndrome," the urban phenomenon in which newcomers, usually middle-class and affluent whites, believe they've "discovered" a neighborhood, as if nothing and no one had been there before them. "You can't just come in the neighborhood and start bogarting . . . like you're motherfuckin' Columbus and kill off the Native Americans," Lee declared.

Since at least the 1980s, the enduring metaphor of gentrification has been colonialism. The frontier. Ed Koch might have started it when he called for the "new pioneers" to "come east," reversing the "go west" of Manifest Destiny, that nineteenth-century idea in which settlers were destined, preordained by God, to expand ever outward into untamed territories, spreading Anglo-Christian culture and values, while ridding those territories of their people. Journalist John O'Sullivan first defined Manifest Destiny in 1845 as the right to "overspread the continent allotted by Providence for the free development of our yearly multiplying millions." This providentialism remains in America's blood, linked back to Calvinism, to the Puritan colonists whose work ethic, with its belief in the preordination of wealth from God, formed the basis of American capitalism. We can feel it working today behind the revanchist takeback of the city.

Writing on the frontier myth and gentrification, Neil Smith explained how this mythologizing serves to cover up brutal realities. "As a new frontier," he wrote, "the city bursts with optimism. Hostile landscapes are regenerated, cleansed, reinfused with middle-class sensibility" and "real-estate values soar." Those who buy into the frontier myth ignore or deny the human devastation that comes with it. When the poor and working class are repositioned, wrote Smith, "on the wrong side of a heroic dividing line, as savages and commu-

nists, the frontier ideology justifies monstrous incivility in the heart of the city."

It is easy to cast the gentrifier of today as a one-dimensional villain. But what is a gentrifier? Are all gentrifiers monstrously uncivil, revanchist colonists? In the original definition, a gentrifier is a person from an upper-class group who moves to the neighborhood of a lower-class group. From there, it gets more complicated, but one thing is clear: Gentrifiers always have more social power than the people whose spaces they infiltrate. It may be the power of race, typically whiteness. It may be the power of class, which can sometimes be less visible. Seldom mentioned but important to note is the fact that many middle-class and affluent people of color are gentrifiers too, often in lower-income neighborhoods of color. When talking about gentrification, we must keep intersectionality in mind. Sometimes all you need to be a gentrifier is the power of cultural capital. Penniless grad students from working-class backgrounds, actors and dancers working as waiters, black and Puerto Rican hipsters, and stylish queers all have cultural capital. And wherever City Hall and Big Real Estate look to commodify a new frontier, cultural capital is rapidly converted into economic capital. Which brings us to artists and gays.

As I've previously mentioned, artists are often branded as frontline gentrifiers. Sometime in the mid-1990s, people started saying: "Artists are the shock troops of gentrification." The quote has been repeated about a hundred thousand times. Neil Smith seems to have started it in his 1996 book, *The New Frontier: Gentrification and the Revanchist City*. "In the gentrification of the Lower East Side," he wrote, "art galleries, dance clubs, and studios have been the shock troops of neighborhood reinvestment." Not artists exactly. While they certainly play a role in the gentrification process—some more deliberately than others—it is inaccurate to equate artists with a powerful military operation. Worse, it distracts us from the real culprits.

In *Rebel Cities,* David Harvey points out how the people "who create an interesting and stimulating everyday neighborhood life lose it to the predatory practices of the real estate entrepreneurs, the financiers and upper class consumers bereft of any urban social imagination." The more interesting the neighborhood, "the more likely it is to be raided and appropriated." Artists are often unwitting tools of the hyper-gentrification machine. As Rebecca Solnit noted, it's not the artists' fault that yuppies and developers follow: "After all, creeps tend to follow teenage girls around, but teenage girls neither create nor encourage them." Except, of course, when artists do encourage them. There are many examples today of artists putting their work on "art walls" and in other installations co-branded with developers and corporations working to tame and commercialize contested zones. In the East Village, for one, the controversial Icon Realty in 2016 hired street artists to paint murals on the sides of buildings they took over, including the one from which they evicted the beloved Stage Restaurant. It was an obvious attempt to sway negative public opinion. In their press release about the mural by Jerkface, they hit all the key words, describing him as a local, native artist known for his "nostalgia-inducing murals." We might want Jerkface to decline the commission, but how does a working artist turn down a paycheck in a city that has become unaffordable to artists? It's another vicious cycle.

A new movement of artists fighting gentrification is growing. At a 2016 public discussion called "Artists: NYC Is Not for Sale," artists and activists, mostly people of color, gathered to talk about their own role in gentrification—and how to break the cycle. South Bronx native Shellyne Rodriguez asked, "What can we do to shake the developer fleas off our asses?" The answer was simple: just say no. Under the social media tag #nycnot4sale, the group distributed a kind of manifesto, a brochure with an Artists Call to De-Gentrify and pledge to refuse collusion with real estate speculators. It read: "To the developers, we are weapons of mass displacement. By loudly refusing this role, we can become weapons of creative resistance."

G ay men and women have also been scapegoated as urban shock troops. As early as 1983, gay men were linked with gentrification when sociologist Manuel Castells in *The City and the Grassroots* made the connection between gay social clustering in San Francisco's Castro district with neighborhood upscaling. But the situation was not simple. While many middle-class gay men, Castells explained, were renovating buildings, other, less well-off gay men lived in "organized collective households" and "were willing to make enormous economic sacrifices to be able to live autonomously and safely as gays." Less attention has been paid to the ways that lesbians create social space, and they've been less often implicated in gentrification. Due to economic inequalities, women, and queer women in particular, may have less control over the environment than men, but they still cluster. In the 1980s and '90s, Brooklyn's Park Slope was so full of lesbians it was affectionately known as "Dyke Slope." By 2001 they were being pushed out. Said Cynthia Kern, producer of DYKE TV, to *Brooklyn Paper*, "I moved to Dyke Slope when it was strong. Then it became Puppy Slope. Now it's Baby Slope. We can't fit between all the strollers there." Today, queer young people—many of them artists—are living in intentional, often racially mixed, housing collectives across gentrifying Brooklyn. In the past, they might have had a decade or more before hyper-gentrification found them, exploited their cultural capital, and pushed them out—along with their neighbors. Today it happens overnight.

For the development-friendly cachet of artists and gays, some blame—or credit—urban studies theorist Richard Florida for his influential work on the "creative class." In 2002, the same year that Bloomberg became mayor of New York, Florida published *The Rise of the Creative Class* and became an economic development guru. He laid out the "Gay Index" and "Bohemian Index" of cities, explaining how these groups would drive economic growth by attracting high-earning professionals into "talent clustering." The mayors of several cities heeded his advice. (Florida has since written that his ideas were

often "misappropriated and misunderstood" by city leaders.) In the 2012 *Financial Times* op-ed "Cities Must Be Cool, Creative, and in Control," Mike Bloomberg wrote that cities must attract creative talent in order to compete for what he called the "grand prize" of tourists and businesses. A competitive city has to be cool, and that means bike lanes, those green veins that stream gentrifiers into low-income neighborhoods, along with art galleries, free Wi-Fi, and public spaces turned into semiprivatized "creativity" zones where hip professionals interact with global brands.

Florida's creative city idea has its critics. Urbanist Jamie Peck argues that creativity strategies become policy in part because they "work quietly with the grain of extant 'neoliberal' development agendas, framed around interurban competition, gentrification, middleclass consumption and place-marketing." Creativity agendas can deceptively feel lefty, like old Jane Jacobs with her diversity and vibrancy and mixed use. As Peck points out, they "have an apple-pie quality," generating support while disarming opposition. It's hard to critique this stuff. Who doesn't like public art, free Wi-Fi, and other nice things? Bread and circuses are an effective way to control opinion. When I criticized the High Line, I was attacked as a heretic. And don't dare complain about bike lanes. Look, I enjoy riding in the bike lanes, but I'm not going to deny that they're a tool of hypergentrification, attracting a certain class of people (to which I belong) and giving a boost to property values, facts that Bloomberg's transportation commissioner knew well. Let's at least engage critically with these things we enjoy. Sometimes a latte is not just a latte.

When assessing urban improvements, we must always ask: Who is it for? Who is it meant to attract and who will it displace? As Florida himself warned in 2002, the impact of high-earning professionals on existing inner-city residents would be to "raise their rents and perhaps create more low-end service jobs." The classes and, for the most part, the races would not mix. His prediction proved correct. "On close inspection," he wrote a decade later, "talent clustering provides

little in the way of trickle-down benefits." It's good for high-skilled professionals, but not for the poor and working class. Florida has been rethinking his theories, and those city leaders who followed his original advice would do well to listen. In 2016, speaking on the topic of his forthcoming book *The New Urban Crisis,* he said, "I could not have anticipated among all this urban growth and revival that there was a dark side to the urban creative revolution, a very deep dark side." He continued, "The urban pessimists have a point. We neglected their point, which is that cities are gentrifying, people are being priced out, displaced from their homes."

When the real culprits are the city leaders who serve corporate and real estate interests, let's stop pointing the finger at struggling artists and queers. Imagine what would happen to the creative and iconoclastic character of the city—and the nation—without these populations. As Rebecca Solnit wrote, "A city without poets, painters, and photographers is sterile. . . . It's undergone a lobotomy." The system today is such that even the most compassionate young queer poet—imagine her: dedicated to social justice, organizing with Occupy Wall Street and Black Lives Matter, working as a barista in the feminist cooperative bookshop—even she finds herself with little choice but to be a gentrifier, moving to a low-income neighborhood because that's what she can afford and her social network is there. And what about me? I'm a white, educated, middle-class professional. If I leave my rent-stabilized apartment, where will I go? Someplace, no doubt, where I will be a gentrifier.

In her book *A Neighborhood That Never Changes,* urban ethnographer Japonica Brown-Saracino divides gentrifiers into three types: 1) Pioneers, who "celebrate gentrification's benefits and unabashedly welcome the transformation of the wilderness" as they "seek financial gain"; 2) Social Preservationists, who "work to preserve the character of their place of residence" and seek to prevent displacement; and 3) Social Homesteaders, who are neither Pioneers nor Preservationists, but a combination of the two: "They appreciate authenticity . . .

but gentrification's cost for longtime residents and their communities are not their central concern."

All three types benefit from gentrification, and the social preservationist (the category with which I personally identify) also contributes, however unwillingly, to displacement. As Brown-Saracino points out, "preservationists' presence in a gentrifying area—whether because of their race, relative affluence, or cultural capital—signals to others that it is safe and desirable and, thus, invites further investment by homeowners, businesses, and local government." A middle-class white person in a low-income neighborhood, especially a neighborhood of color, is like a drop of blood in a pool surrounded by circling sharks. We have to do something about the sharks before they get in. Unfortunately, many gentrifiers eagerly chum the waters. They are what we might call *gentrificationists,* not just celebrating but actively advocating for neighborhood turnover. When they talk and tweet about the amazing new restaurants, and good riddance to that smelly old (fill in the blank), and Dear Starbucks: Can you please open shop in (fill in the blank) because there is no place *for blocks* to get a good cup of coffee, etc., people are actively working to further the process of displacement. How we talk about the city has an impact.

In Spike Lee's speech, he asked, "Have you seen Fort Greene Park in the morning? It's like the motherfucking Westminster dog show." The *Daily News* went to investigate. Under the headline "Brooklyn Residents Don't Appreciate Spike Lee's Rants on Gentrification," they interviewed newcomers to Fort Greene, all out walking their "fancy pooches." They talked to one twenty-five-year-old with an English springer spaniel she'd named Hudson, presumably after the river. A farm-to-table restaurant owner, she'd just moved to Fort Greene from the Hamptons. She told the paper, "I don't see a negative to cleaning up a neighborhood. . . . I think it's a creative bunch of people doing interesting things. It's all good intentions." Had she never heard about the road to hell and its paving stones? Another young person walking her miniature poodle said, "people have the right to live wherever

they want to live." And a third, a jewelry designer and dog walker from Toronto, agreed that the perks of gentrification far outweigh the drawbacks. "I benefit from it," she said. "I can have a decent cup of coffee."

Like these pioneers, many people didn't like what Spike Lee had to say. He was too angry, said online commenters and journalists. He used the word *fuck* several times. They called him "arrogant" and didn't like that, like television's George Jefferson, he had moved on up to the Upper East Side. He was a wealthy hypocrite who abandoned Brooklyn, they said, and besides, "White people were there first." In an op-ed for the *Daily News*, Errol Louis made some good points about Lee's role in the gentrification of Brooklyn, including flipping several properties and participating in the marketing of "Absolut Brooklyn" vodka. There were definitely conflicts that Lee did not address during that Q&A at Pratt, but that does not fully explain the angry, racially toned backlash he received, and the fierce pro-gentrification cries that swirled around him. Plenty of other financially successful New York artists had railed against gentrification—David Byrne of Talking Heads, whose net worth is $45 million, even used the word *fuck* in a rant against the urban rich—and they didn't get such backlash. But they weren't black people expressing anger about white people moving to Brooklyn, the ultimate urban frontier of the twenty-first century.

BROOKLYN

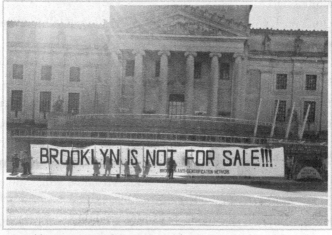

Brooklyn Anti-Gentrification Network protest at Real Estate Summit,
Brooklyn Museum. *Ann McDermott, 2015*

IN THE FALL OF 2015, AN IPHONE VIDEO APPEARED ON THE BLOG
Gothamist showing a scene between a man they called "En-
raged White Guy" and a pair of "Stroller Pushers" (also, appar-
ently, white). The moment plays out on a Downtown Brooklyn street
jumbled with the ever-present scaffolding of building construction.
Day-Glo orange jersey barriers corral the players into a rat's maze.
As the action begins, Enraged White Guy is shouting, "Back the fuck
off me!" He is a jogger. He is shouting at Stroller Husband, who is
dressed in khakis and a polo shirt complete with popped collar, sym-
bol of the preppy ruling class. Stroller Wife shouts back at Enraged

White Guy until Stroller Husband tells her to move their baby out of the fray. Between them all, a black security guard, looking rather bored, tries to break it up. He is ignored. Enraged White Guy, after making a few death threats to the couple, gets to the point.

"You're new in the neighborhood!" he shouts. "I've *been* in this neighborhood. The only reason white people like you are living here is because I *settled* this fucking neighborhood for you."

This gets a laugh from the cameraman, who calls out, "Thank you, white guy!"

"Don't push your stroller into my legs," Enraged White Guy continues. "Don't push your stroller into my legs."

Stroller Wife jumps back in, calling Enraged White Guy "a sick fuck."

Provoked, he points a finger at her and shouts, "White privilege! White fucking privilege! You pushed your stroller right into me. And all I said was, 'Excuse you.' And then you said, 'Fuck you, fuck you!'"

The video cuts out soon after. It is titled "Christopher Columbus of Brooklyn." If we wanted an audiovisual of what Spike Lee called the "motherfuckin' Christopher Columbus Syndrome" that infected Brooklyn in the 2000s, here it is. The whole sordid story is packed into this quick minute and eighteen seconds, intertwined with race, class, heterosexual fertility, and the places where they blur together. There's a first-line gentrifier who casts himself as a brave settler, conjuring images of wagon trains and Manifest Destiny. There are the super-gentrifiers who came after, the yuppie couple with the Sherman tank baby stroller, the status symbol most associated with gentrified Brooklyn in the 2000s. There's the working-class man of color whose low-paid authority is not respected. And there's Downtown Brooklyn, a tangle of new construction, luxury towers on every block. The fight takes place in front of the BellTel Lofts, high-priced condos in the former New York Telephone building, just one among many symbols of Brooklyn's conversion from working to luxury class. At the nearby outdoor Fulton Mall, where poor and working

people shop, local joint Tony's Famous Pizzeria has been pushed out for Shake Shack, while black-owned businesses are gradually giving way to higher-end chains. Goodbye to the purveyors of gold teeth grills and shea butter body oils. Hello prepackaged salads and slim-fit khakis. (In the 2011 documentary *My Brooklyn*, newly arrived gentrificationists called Fulton Mall a "crappy space with B-grade stores.") For the colonists who followed the settlers, it's a glorious triumph—and a long time coming.

I live in Brooklyn. By choice." So Truman Capote began his celebrated essay on the borough in 1959. He calls Brooklyn an "uninviting community" and a "veritable veldt of tawdriness," as he yet defends it to mystified friends who ask, "But what do you *do* over there?" Manhattan types did not go to Brooklyn. It was a place for people of color and working-class ethnics, the people who weren't quite American. Of his youth in blue-collar Brownsville during the 1930s and '40s, Norman Podhoretz wrote, "I came from Brooklyn, and in Brooklyn there were no Americans. There were Jews and Negroes and Italians and Poles and Irishmen. Americans lived in New England, in the South, in the Midwest: alien people in alien places." Twentieth-century Brooklyn was not a white Anglo-Saxon borough. And it was not for aesthetes. If you were a native Brooklynite whose heart yearned for the city, you fled. The interborough migration path traveled in one direction, across the river to Manhattan.

That began to shift in the 1960s and '70s as creative people, hippies, and members of the middle class (mostly, but not all, whites) began buying and rehabbing dilapidated brownstones in neighborhoods across South Brooklyn, such as Park Slope, Cobble Hill, and Boerum Hill. There's a small but potent body of literature on the subject by the writers who were there, including Paula Fox's *Desperate Characters*, L. J. Davis's *A Meaningful Life*, and Jonathan Lethem's *The Fortress of Solitude*. In Davis's novel, Lowell Lake is a failed writer who

leaves Manhattan for the hinterlands across the East River. Speaking for Lowell, the narrator notes with the brio of Manifest Destiny, "Creative young people were buying houses in the Brooklyn slums, integrating all-Negro blocks, and coming firmly to grips with poverty and municipal corruption. It was the stuff of life. It was the stuff he was looking for." Lowell was afflicted with "brownstone fever," as *New York* magazine called it in a 1969 cover story, describing how "[m]ore and more people now are packing up, moving out of their aseptic uptown apartments, making new homes out of old, forlorn but solid and roomy brownstones, restoring them to pristine glory." Said one realtor, "Believe me, there's more courage in going into a brownstone than going west in a covered wagon."

Some of the early brownstoners saw themselves as colonists, in or out of touch with the underlying racism that feeds the dream of settling a "savage" country in which people of color don't count. Others viewed themselves as integrators, community builders, utopianists. Said one to *New York*, "we are preserving here a planner's dream, a natural mix of poor people and hippies and middle class. We don't want to fix things up too much, or else it will get too middle class. . . . This is one of the last natural melting pots." As Suleiman Osman, author of *The Invention of Brownstone Brooklyn*, explains, brownstoning "was a cultural revolt against 'sameness,' conformity and bureaucracy." Liberal-minded people were fleeing the stultifying suburbs of New Rochelle and the sterility of the Upper East Side, in search of "a vestige of an 'authentic community' lost in a modernizing society." This was old-fashioned gentrification, with negative and positive impacts—some displacement of the poor on the downside, the improvement of services on the up. Wherever white middle-class people go, police tag along. Crime goes down. The streets are swept clean, plowed of snow, and stocked with fresh produce. For some time, it might be possible for different classes to all enjoy, more or less, the same benefits. But equilibrium is not sustained. There is a force that presses for inequality.

In the twenty-first century, in a shockingly short amount of time, Brooklyn's character in the collective global consciousness changed. No more the old Dodgers and Nathan's Famous hot dogs, salty crowds of Coney Island, everyday people and ethnic diversity, dockworkers and factory workers. No more *fuggedaboutit*. No more *Do the Right Thing*. Brooklyn no more the low-rise city of high church steeples, industrial riverbank, streets full of stoops full of kids watched by grandmothers leaning on windowsills. In the twenty-first century, Brooklyn became a highly coveted international brand—as it topped the list of the most expensive places to live in America. And this shift wasn't natural. It was by design.

At the end of 2014, *Bloomberg Business* reported that Brooklyn, "where a resident would need to devote 98 percent of the median income to afford the payment on a median-priced home of $615,000, was the least-affordable" place to buy a home in the United States. One real estate broker told the *Times*, "Brooklyn has become unaffordable. For normal, middle-class people with good credit, we used to be able to say, 'We can find you something.'" But no more. Not even in working-class neighborhoods. Not even for the "normal" people.

"Brooklyn is the new Manhattan," journalists repeat. Brooklyn is cool. Manhattan is not. Brooklyn is literary. Manhattan is not. Brooklyn is creative and progressive, the place where new things are happening. Manhattan is dull, conservative, stuck in its ways. All the cool people live in Brooklyn. Young artists and queers, both white and of color, live in collectives where half a dozen housemates split the rent and fight over who ate the last gluten-free vegan cookie while negotiating the complex territories of polyamory. For my own young artist friends, the East Village is now irrelevant. They've never even visited. They make their art and live their lives exclusively in Brooklyn. This looks like good fortune—finally, a real bohemian enclave

in corporatized New York!—but locomotive hyper-gentrification is revving at their door. The kids are barely hanging on, already priced out as they price out those with less money and less cultural capital, attracting speculators and stroller pushers who push everyone deeper into the borough and beyond.

Word spreads fast thanks to the Internet. Social media, nonexistent before the 2000s, speeds up the process. In the past, a cool neighborhood filled with members of the counterculture, along with their bookstores, cafés, and street theater, might maintain its avant-garde status for decades, while bohemians and blue-collars managed to coexist, if sometimes uneasily. Today, when cool moves in, big money follows fast. It's a strategy cooked up in boardrooms and City Hall. The bohemians and lower classes are swept away, pressed to the oceanic edge of the continent. This is the story of Brooklyn in the 2000s. And it all began with Williamsburg.

WILLIAMSBURG

Only occasionally do I go to Brooklyn. I like to visit its sleepy streets and the more industrial parts that still stand, but I don't want to live there. I have nothing against the borough, but to me it has always felt like the country, too far away, too much a reminder of the place I left behind. Lately, I've been looking at its shores from my side of the East River. Directly across from the East Village is Williamsburg. Not long ago, the waterfront was nothing but low buildings, factories, and smokestacks. I used to sit by the river and gaze across at the Domino Sugar factory. It looked like a Rube Goldberg device, with its tangle of contraptions, tubes, and tanks, conveyor bridge connecting the hulking brick refinery to a tower where the Domino sign glowed yellow: SUGAR. An abundance of church steeples once pricked the horizon above the modest skyline. In the light of a fading afternoon, everything along the waterfront would be toasted brown, smutty

and low, punctured by those white steeples. But now the Domino factory is being destroyed for a major development of glittering glass towers soaring fifty-five stories into the air. The low brown buildings are vanishing fast. And the steeples, if they haven't been decapitated in the rush to convert churches into condos, are blocked from view by more glass towers, each one as sleek and dull as the last. More and more, along the waterfront, Williamsburg looks like Miami Beach.

It was the old East Village that spawned the new Williamsburg in the 1990s. A handful of artists had already found cheap rents just one stop across the river on the L train. In *The Last Bohemia*, Robert Anasi describes the depressed industrial neighborhood in 1988 as a ghost town, desolate and dusty, full of rats and shuttered storefronts. It was a blue-collar neighborhood gone to seed, though light industry still flourished. The few artists scattered about mostly went unnoticed. Then someone noticed. In a 1992 *New York* cover story, Brad Gooch published "The New Bohemia: Portrait of an Artist's Colony in Brooklyn." In all its desolation, Williamsburg had been "discovered." A cross-dressing performance artist named Medea de Vyse announced, "In the 1980s, it was the East Village. In the 1990s, it will be Williamsburg."

"By 1999," writes Anasi, the Northside of Williamsburg "was changing so fast that every trip down Bedford made my head swivel. 'When did that get here?' Or, 'When did that place close?'" The new stuff was yoga, art books, record shops. At night, cops arrived to patrol the streets they'd long neglected, harassing loiterers. Big money was on its way. In that same moment, the contemporary hipster first made the scene. And no discussion of today's Brooklyn can avoid the hipster.

Hipster is an old word, but in the book *What Was the Hipster?* Mark Greif places its contemporary rebirth in the year 1999. Unlike *bohemian* or *punk* of the past, *hipster,* according to Greif, identifies a "subculture of people who are already dominant." These are not your underdogs carving out a place to breathe free. The modern-day hip-

ster "aligns himself *both* with rebel subculture *and* with the dominant class." The hipster is thus the "rebel consumer" who rebels against nothing, the so-called artist who creates no art. The hipsters who flooded Brooklyn (and the entire Western world) in the 2000s might look like bohemians, says Greif, but they are not. They are not anti-authoritarian, like other youth subcultures through history. They drink the Kool-Aid of corporate consumer culture as they adopt a fauxhemian style. In a related essay in *New York*, Greif noted how hipsters can be found mixing with "anarchist, free, vegan, environmentalist, punk, and even anti-capitalist communities." The hipster thus infiltrates, appropriates, and commodifies these countercultures, creating elite trends and brands in collaboration with consumer culture.

It was through this process of hipsterization that the New Brooklyn brand was developed and globally disseminated, filling cities with carbon copies of its high-priced coffee bars, rooftop beehives, lumbersexual chic, hyperlocal fetishism, neoprimitive interior design of the rustic and repurposed, curly mustaches and the wax to go with them, all that is twee, all that is "artisanal" and "small batch" and "bespoke." Cafés that serve nothing but breakfast cereal. Artisanally buttered toast for four dollars a slice. Places and products are now branded "Brooklyn" across the world—mostly across Europe—in London, Stockholm, Belgium, Hamburg, Amsterdam. Pity poor Paris, its own bohemian culture destroyed, gone crazy for "Brooklyn Rive Gauche." In 2015 the *Wall Street Journal* reported that, on the once-lefty Left Bank, luxury department store Le Bon Marché was showcasing all things Brooklyn, elevating the borough's hipster trends to high fashion. Paris even has an ersatz diner named after Williamsburg's Bedford Avenue, the fountainhead of hipsterism (and now one of the most expensive retail corridors in America). In stilted English, the diner's website says, "Feel like in Brooklyn!" Which means, "meet friends, feel the cheddar smell, eat with your hands inside or in the streets." Brooklyn has become a global consumer movement born from one neighborhood that was "discovered," became

trendy, and then went supernova when the city government and its developer pals swooped in with big plans.

In 2005 the City Council backed the Bloomberg administration's plan to rezone nearly two hundred blocks of Williamsburg and neighboring Greenpoint, with emphasis on the waterfront. The rezoning, wrote the *Times*, "would transform the long-crumbling waterfront into a residential neighborhood complete with 40-story luxury apartment buildings, shops and manicured recreation areas." While Jane Jacobs excoriated the plan in her letter to Bloomberg, calling it "an ugly and intractable mistake," he handed out a stack of golden tickets—twenty-five-year tax abatements to condominium developers. Like those Grow Monster capsules that explode when you drop them in water, the new Williamsburg instantly swelled.

Su Friedrich's documentary *Gut Renovation* captures this startling change in action. Friedrich moved to Williamsburg in 1989 to live affordably with other artists and queers. In 2005, right after the rezoning, Friedrich started filming. In the span of just five years, we see the neighborhood remade and its population shift. Thriving industrial businesses are evicted—machine shops, garages, bread and egg distribution warehouses—their buildings are demolished, and luxury condos go in like gangbusters. Friedrich tallies the new construction on a map, coloring each parcel with a red Magic Marker. She counts them off: "63, 64, 65 . . ." Designer dogs, baby strollers, and nannies flood the neighborhood. "90, 91, 92 . . ." Developers in dark suits march down the sidewalks. "121, 122, 123 . . ." It's only three years into the rezoning. "166, 167, 168, 169, 170 . . ." Exhausted, Friedrich finally stops at 173 new buildings in 2010. Many more were to come—and are still in the works. That's how fast a Bloomberg upzoning could utterly change a neighborhood.

In 2010, Duane Reade, a ubiquitous regional drugstore chain owned by Walgreens, opened on Bedford Avenue. Said one local to the *Times*, "It's becoming the East Village." (Let us just pause to note, with bowed heads, that young people now associate the old coun-

tercultural neighborhood with chain stores.) Other newcomers to Williamsburg welcomed the chains. One woman pushing a stroller said she was "elated." She told the paper, "Please, can you bring in Dunkin' Donuts too. I also want a Bank of America." She went on to proudly admit that she spent time writing emails to chains, begging them to open in Williamsburg. She got her wish—a Dunkin' Donuts opened on Bedford in 2013. "What the fuck," said a hipster to the *Daily News*.

By 2014, the chains went upscale with the arrival of J.Crew. They used a clever strategy to win over the "rebel consumers" who lust for everything artisanal, neoprimitive, and rustic. The store's executive creative director told *Brooklyn Magazine* how she instructed her team to "pull local artisans from the neighborhood" to help design the store. "I've lived in Brooklyn," she said. "I know people want it to feel local, they want it to feel intimate." Fighting community opposition, Starbucks turned to a similar strategy when they opened their second Williamsburg location in 2014 (their first had arrived just four months earlier). On opening day, greeters welcomed customers, telling them it was "the coolest Starbucks you're ever going to go into." DNAinfo reported that the interior was filled with "curated decor from neighborhood artists," and soon there would be "coffee seminars" and music from local bands. Activist Reverend Billy told Gothamist, "Sbux wants to persuade the hipsters that it is descended from Cabaret Voltaire, but it's only a chain store with bad coffee, with no cultural impact of any kind. Starbucks comes down out of the mountains after the cultural battle has been fought, to steal from the dead." Not all the kids were falling for the mega-chain's faux-local performance. One young resident said, "I'm pissed about it. This is not Manhattan."

But it was looking a lot like it. From 2000 to 2013, the population of the rezoned area grew much faster than the rest of the city—and it shifted dramatically. The white population increased by 44 percent while Latinos declined by 27 percent.

With the condos and the yuppies and the chains, with rents sky-rocketing and working-class people and artists evicted, with cultural institutions vanished, one thing was clear: Williamsburg—the old and the new—was dead. The CHERYL artist collective held a dance party funeral. Costumes like Starbucks Barista and Scrooge McDuck were encouraged. "Of course Williamsburg is dead, it was dead three years ago," a woman in glitter face paint told the *Observer*. "It's all about Bushwick now." As the hipsters and bohemians migrated, journalists scrambled to christen one working-class neighborhood after another "The New Williamsburg." Bushwick, Greenpoint, Bed-Stuy, Crown Heights, East New York, Sunset Park. No place was out of reach.

THE WILLIAMSBURG DIASPORA

The hipsters and artists of Williamsburg, along with the everyday young folks who want to be around hipsters and artists, have pushed outward, straining against and breaking through the boundaries of the neighborhood. In the north, they pressed into the Italian-American enclave along Graham Avenue. During the sacred processions of Catholic saints, hipsters and yuppies stood at the sidelines and looked on with derision, brunch plans inconvenienced by the small parades. "There was one float and a horrible marching band," one onlooker scoffed to the *Times*. "It was very ironic." Unable to grasp the utter lack of irony in a Catholic procession, another bystander dropped his pants, baring his ass to the Italians. "It's something I never saw in my lifetime," said a parade coordinator. "As a man, I wanted to grab him and smash him against a wall."

Meanwhile, in the southern part of Williamsburg, the Hasidic Jewish community panicked as the people they called the *Artisten* invaded their cloistered streets. In 2004, at a Hasidic protest against a new luxury condo, a community member handed out flyers printed

with a prayer begging God to "please remove from upon us the plague of the artists, so that we shall not drown in evil waters, and so that they shall not come to our residence to ruin it. Please place in the hearts of the homeowners that they should not build." War broke out between the two groups in 2009 after the city installed bike lanes, bringing a river of immodestly dressed *Artisten* breezing through.

The neighborhood's borders could not hold the expansion of new pioneers and they burst forth, pressing into Bushwick to the east and Greenpoint to the north. With its vast industrial spaces ideal for studios, Bushwick had sheltered a small artist community since the 1990s. By the mid-2000s this working-class, predominantly Latino neighborhood was "discovered." In 2006, the *Times* released a report titled "Psst . . . Have You Heard About Bushwick?" It was, wrote Robert Sullivan, "the next new neighborhood or, more precisely, a neighborhood that is now in the sights of New York City real-estate agents and developers as the next new neighborhood."

Luxury developers came clamoring—bringing the brutal frontier myth with them. In 2014, the Colony arrived. A residential development marketed toward young professionals, Colony 1209 advertised itself using Manifest Destiny as its unabashed theme. "Let's Homestead, Bushwick-style," read the website, calling the neighborhood "Brooklyn's new frontier." *Colonization* was once a dirty word. No more. The website continued: "Here you'll find a group of like-minded settlers, mixing the customs of their original homeland with those of one of NYC's most historic neighborhoods to create art, community, and a new lifestyle." And don't worry, the website promised, "we already surveyed the territory for you," evoking images of scouting parties sent ahead of wagon trains to hunt for hostile natives. The Colony was publicly subsidized, too, with a fifteen-year abatement expected to save the developers about $8 million in taxes. More than one hundred protesters gathered outside the building to call for an end to the 421a tax abatement program. The Colony's developer responded by changing the building's controversial name to its address, 1209

DeKalb, and scrapping the Manifest Destiny rhetoric. Nothing else changed. Except the rents. They went up.

North of Williamsburg, Greenpoint received its share of wandering pilgrims. An industrial center and home to Polish immigrants as early as the 1800s, by the dawn of the twenty-first century Greenpoint remained a predominantly Polish and Latino blue-collar neighborhood. Hyper-gentrification is changing that.

In 2009 I took a few walks through Greenpoint to observe a neighborhood in flux. On Manhattan Avenue, Polish and Latino culture prevailed. There were greasy spoon diners and an abundance of Polish restaurants, the fragrance of kielbasa wafting to the street. Ninety-nine-cent stores spilled their wares to the sidewalk, racks and racks of floral housecoats for grandmothers to wear while frying pierogi or empanadas in their linoleum-covered kitchens. There was—and thankfully still is—the gorgeous Peter Pan Donut Shop with its curving counter filled not yet with hipsters, but crotchety Poles seated on swivel stools, nursing their coffees and sugar-glazed. Among a handful of low-budget chain businesses, there were several small local stores, including Irving Feller's furrier shop, opened in 1916, its dusty window full of animal pelts and strings of Christmas garland. At the 3 Decker coffee shop, the owners, a Greek couple, bickered back and forth, shouting, *"And* the horse you rode in on!" The feeling on Manhattan Avenue was very different from the streets of gentrified New York. Few people talked or texted on smartphones. No one bumped into me. People said "excuse me" and held the door. When I sneezed, strangers said, "Bless you." Then I walked one block toward the waterfront, to Franklin Street.

Running parallel to Manhattan Avenue, Franklin Street was another world inhabited by a different breed. Though its sidewalks were far less crowded, within minutes of stepping onto Franklin, people bumped into me. They didn't say "excuse me" or acknowledge my

existence. They didn't move to the right like the people on Manhattan Avenue did. The people just one block west didn't know how to walk in New York. Who were they? Why were they here? The street was filled with upscale boutiques, bars, craft beer stores, outdoor cafés, and specialty coffee places where woolly bearded men gazed fixedly into the glow of laptops. Back on Manhattan Avenue I had overheard a woman say to her daughter, "When I was a girl, I wasn't spoiled. My mother disciplined me." On Franklin Street I overheard a woman say to her friend, "Oh my God, *try* the iced tea. It's blood orange and *pear*. Amazing. *Especially* when you've got a *huge* hangover."

In the spring of 2012, Lena Dunham set her hit series *Girls* in Greenpoint. There was talk of tourist buses. Three months later, the *Times* declared Greenpoint the new Williamsburg. Old factories were converted to condos with million-dollar penthouses, young members of the "digerati" flaunted their tattoos, and oh, the smell of patchouli! "Vinyl siding doesn't represent Greenpoint's cachet any longer," the article read, referring to the neighborhood's style of working-class houses; "virtual doormen, rooftop farms, artisanal gin and brick-faced condominiums do." Still, Greenpoint hasn't exploded like Williamsburg. The settlers who could not endure Greenpoint's crummy public transportation, nor its status as a toxic spill zone, with a reeking wastewater treatment plant (affectionately referred to locally as the "Shit Tits" for its digester eggs' resemblance to breasts), hitched their wagons and lit out for other neighborhoods along the Williamsburg border.

In the midst of all this overspreading, the Levi's jeans company plastered the city with an ad campaign starring Brooklyn poet Walt Whitman. "Go Forth," was the slogan, a phrase implicitly followed by "and multiply." Was Levi's capitalizing on the Manifest Destiny takeover of Brooklyn? In one commercial, played on movie screens across town, dozens of denim-clad hipster types cavort while

an artfully scratchy, antiqued recording plays Whitman's "Pioneers, O Pioneers!"

> We must march my darlings, we must bear the brunt
> of danger,
> We the youthful sinewy races, all the rest on us
> depend,
> Pioneers! O pioneers!

It is no coincidence that the artisanal culture of the new Brooklyn so much resembles Olde-Timey America, with its rustic everything, its mason jar picklings, its classes on how to sharpen a felling axe, its heavy-duty denim aprons (for your leisure-time blacksmithing), and its beards. Good Lord, its superabundance of nineteenth-century beards. For the record, I like a good beard, but I'm not going to deny that something's being signified. In their copious facial hair, the new men of Brooklyn look like colonists. They could be homesteading the Great Plains. And for the ladies, there are actual bonnets, that "pioneer accessory" with the "fabulously fresh-off-the-*Mayflower* vibe," according to *Paper* when it announced the hot new trend of 2015. What deep cellular strain of nostalgia is this? Onward, wagons, ho!

The Bedford-Stuyvesant section of Brooklyn, known as Bed-Stuy, has long been synonymous with danger, its slogan: "Bed-Stuy Do or Die." (A trendy restaurant called "Do or Dine" opened in 2011 and became briefly famous for its foie gras doughnuts before closing in 2015.) Abutting the southernmost margin of Williamsburg, Bed-Stuy was known as early as the 1930s as "Little Harlem." A cradle of African-American culture, site of race riots in the 1960s and high crime through the '80s, celebrated in Spike Lee's *Do the Right Thing*, Bed-Stuy has been a solidly black neighborhood with roots going back to the 1830s, when freedman James Weeks established the commu-

nity of Weeksville as a haven for African Americans fleeing slavery and racism. In 2001, Bed-Stuy was 75 percent black, with middle-class African Americans as its first gentrifiers. In 2007, the Bloomberg administration rezoned two hundred blocks of Bed-Stuy. During that decade, the black population dropped to 60 percent as the number of white residents increased dramatically. The *Times* reported: "From 2000 to 2010, the white population soared 633 percent—the biggest percentage increase of any major racial or ethnic group in any New York City neighborhood." In 2012, Bloomberg rezoned another 140 blocks. One year later, Bed-Stuy sold its first million-dollar apartment. Said the *Post*, "There goes the neighborhood."

On a walk through Bed-Stuy today, you'll pass luxury condos wedged between run-down houses, empty lots being prepped for luxury construction, and plywood fences plastered with posters that ask, "Leaving New York?" They offer a number to call to sell your lease to newcomers. Signs for realtors' open houses lead you into renovated brownstones, through pristine rooms, up glossy staircases to roof decks outfitted with banquettes and views of a neighborhood in the throes. New espresso shops sell five-dollar cups of coffee mixed with grass-fed butter and coconut oil, an oleaginous brew that's barely drinkable. New bars offer "Brooklyn kombucha" on tap. And at least one café specializes in baking "small-batch" kolache, a Czech pastry that's highly popular in the midwestern American prairie. Go inside each place and you will find young, upper-class, mostly white people staring into Apple screens, comfortable in their digital pods. That isolationism is a bone of contention.

"Normally you come to a neighborhood, you try to get to know the community," said one African-American Bed-Stuy resident to Neil deMause in *The Brooklyn Wars*. But the white newcomers, said another, "don't want to mix, they don't want to mingle." This is a frequent complaint.

In *The Edge Becomes the Center: An Oral History of Gentrification in the Twenty-First Century*, D. W. Gibson talked with some of the people

and players in today's Bed-Stuy. Shatia Strother, an African-American woman and longtime resident, told how Bed-Stuy always had pockets of wealthy people, "Just not in such large numbers and not in this take-over mentality." Many of the new people, she explained, see Bed-Stuy as a "pit stop" to whatever's next in life. They "come here like we have a little more money, we're driving rents up, we're not going to be involved, we're going to walk down the street with our headphones. We're just here to find the cool bars and restaurants, and we're not really engaged in the larger community." Strother tells them, "Look people in the eye . . . and acknowledge that I'm existing." This isn't true of all the newcomers, of course. Plenty do mix, mingle, and acknowledge, fostering a diverse and integrated experience of the city. Unfortunately, the neighborly folks seem to be outnumbered—and outgunned by more powerful forces.

In his book, Gibson also talked with a young Hasidic real estate developer who brazenly outlined the racial mathematics at work today in changing Brooklyn. Ephraim (a pseudonym) explained how he removes rent-regulated African-American tenants, getting them out of their buildings with lowball buyouts. "The average price for a black person here in Bed-Stuy," he said, "is $30,000." After taxes, that might be just enough to take with you as you leave the city for a more affordable town, maybe down south or upstate, but it will get you nowhere in New York. This is a form of displacement, a one-way ticket out of the city for the poor and working-class African-American population, a tactic for turning neighborhoods over to the upper class and the white. As Ephraim said of blacks in Bed-Stuy, "Everyone wants them to leave, not because we don't like them, it's just they're messing up—they bring everything down." In a low voice, he added, "If there's a black tenant in the house—in every building we have, I put in white tenants. They want to know if black people are going to be living there." If they see one black person in the building, the new white tenants "get all riled up, they call me: 'We're not paying that much money to have black people live in the building.'"

To the south of Bed-Stuy is Crown Heights. Originally one of the most affluent neighborhoods in Brooklyn, by the 1920s it became host to a mix of new immigrants—Jewish, Italian, and Caribbean. After World War II, with redlining, suburbanization, and white flight, it became a predominantly African-American neighborhood, gaining infamy in 1991 for race riots between its black and Hasidic Jewish populations. The 2000s brought an influx of middle-class and affluent whites. "According to census data," reported the *Times* in 2015, "the black population shrank to 70 percent from 79 percent from 2000 to 2010, and the white population almost doubled to 16 percent." Cops showed up to control the streets, hassling black shop owners. New businesses opened, selling organic food and expensive coffee. Landlords harassed longtime tenants, pushing them out. Rents went up by as much as 36 percent. Poor and working-class people of color were forced to move deeper into Brooklyn, or to crowd in with families to help pay the escalating rent. Many had no choice but to leave the city, moving to the South their grandparents had left, or going back to the Caribbean. Commercial rents doubled and then tripled. Longtime small businesses shuttered. In just the two years between 2011 and 2013, dozens of shiny new restaurants arrived in their place.

In 2011, the *Wall Street Journal* announced: "Crown Heights Rediscovered." In 2012, the *Times* called it a "rebirth," with Franklin Avenue as "the epicenter of a renaissance, the next subway stop on Brooklyn's gentrification express." Amanda Burden praised the changes created by the Bloomberg administration's rezonings and other measures. In a 2012 *Times* profile on her work as city planner, Burden said, "We are making so many more areas of the city livable. Now, young people are moving to neighborhoods like Crown Heights that 10 years ago wouldn't have been part of the lexicon." Livable for whom? Which young people? Whose lexicon?

In 2014, Franklin Avenue got a Starbucks. One developer explained it to the *Times:* "People who pay top dollar want to have the new Brooklyn retail experience." Goldman Sachs, dedicating it-

self to "making catalytic investments in neighborhoods across New York," started dumping tens of millions into Crown Heights in an attempt to create the next Williamsburg. So don't say it's natural. Don't call it market forces. Today, walking down Franklin, you'll find the landscape of hyper-gentrification in rapid process. Next to older wig shops and bodegas, new cafés and brunch spots boast crowds of young newcomers clustered outside, waiting by chalkboard signs that advertise CUTE DRINKS and CHOCOLATE, QUICHE, NEW FRIENDS . . . GENTLE, WARM, & COURTEOUS. A sign in a new restaurant window orders passersby to EAT DRINK SMILE. Selling what sounds a lot like the midwestern phenomenon of "Minnesota Nice" (often described as passive-aggressive), the new businesses want the new residents to believe that the new Crown Heights is a nice and gentle place, loaded with smiles and cuteness. Once again, when did New Yorkers need smiles and cuteness? And what if you don't feel like smiling? What if you don't have much to smile about? (In *White Like Me*, people of color tell Tim Wise, "Minnesota Nice is *killing* us.")

In 2015, Common opened in the neighborhood. Occupying the entire building at 1162 Pacific Street, it is located directly across from the Bedford-Atlantic Armory, a homeless shelter for men since 1982. Described as "flexible shared housing," Common is a "curated" living space in which eighteen people pay $1,950 each per month for a single room and the supposed pleasures of living with a crowd. Potluck dinners, coffee deliveries, and free toilet paper are provided in the old-timey glow of Edison bulbs, the ubiquitous design element of twenty-first-century gentrification. With doors programmed to open with a swipe and a tap from your thousand-dollar Apple Watch, Common is not for the common people. It's a designer SRO. When Common's founder first saw 1162 Pacific Street, he thought it had "the potential to incubate a strong, tight-knit community of members" with its exposed brick walls, rear garden, and roof deck. Plus, "it was totally vacant, just emerging from a full renovation." But how did the building become vacant?

On a dark winter morning in 2006, an arsonist poured accelerant over the floor of the stairwell and lit a match. The twenty-six residents all lost their homes. The founders and residents of Common had nothing to do with the fire; they came along years later, after the place was gutted and buffed, and likely had no idea about its tragic history. But this is part of gentrification, too. The domestic tragedies of the near past go unknown by the newcomers who benefit from them. The *Daily News* reported that this "hardscrabble stretch" of Pacific Street was the site of "nine intentionally set fires . . . in the last 15 months." People in the neighborhood blamed the arsons on "greed because the area lies near major redevelopment projects." The *Times* reported that arson investigators discovered the building had been "part of a complicated mortgage fraud scheme." People went to jail. I don't know what happened to the residents of 1162, only that their building showed up empty, renovated, and priced at $4 million. Where did those twenty-six people go? Maybe some of them are now sleeping in the homeless shelter across the street, a site targeted by the Bloomberg-era Economic Development Corporation for a $14 million redevelopment. Proposals included an ice-skating rink and a rock-climbing facility. Those plans have since been put on the back burner, but as the neighborhood changes, as more new people move in, how long will it be before they start complaining about the shelter and clamoring for more amenities?

BEYOND THE DIASPORA

Gowanus is not "Williamsburg adjacent," as the brokers like to put it, but it has still attracted artists—and developers. Farther south and west than the Williamsburg diaspora territories, it is an industrial, working-class neighborhood that sits between Park Slope and Carroll Gardens. An oily oasis of urban wilderness in the middle of bourgeois brownstone Brooklyn, it straddles the Gowanus Canal, which has been

mainlining pollution since the middle of the nineteenth century. One of the most toxic waterways in the United States, the canal is full of shit. Literally. The surface bobs with human feces, brown blobs drifting through rainbowed oil slicks. Gonorrhea, among other unsavory ingredients, has been found in this water. During heavy rains, the canal floods the neighborhood. In 2007, a young minke whale wandered in from the harbor, spent a day cruising the canal, and promptly died. New Yorkers nicknamed the poor creature "Sludgie." In 2015, environmental activist Christopher Swain swam the canal. He prepped for his stunt with hepatitis and tetanus shots, wrapped his body in waterproof suits, and plugged his orifices with wax. He told reporters, "It's just like swimming through a dirty diaper." I stood at the edge of the canal and watched him do a slow breaststroke through the cloudy green water. Each time he rose and fell, the water lapped against his mouth. I yelled out, "What does it taste like?" He yelled back, "Tastes like metal, detergent, and gas!" The woman kayaking beside him for safety added, "Tastes like poop." After his swim, Swain doused himself with bleach. You do not fuck around with the Gowanus.

Working-class and poor people have long lived in this unwanted place. Irish, Italian, Puerto Rican, even a community of Native North Americans, hundreds of Canadian Mohawks who immigrated in the 1920s to work the city's high-steel construction. Artists have been attracted to the area since the 1970s, when they found large, inexpensive studio space and established collectives. The artists have enjoyed a mutually beneficial relationship with the local metalworking shops, lumber yards, glass suppliers, stonecutters, and others from whom they buy materials. In a building known as the Batcave, a nineteenth-century power station abandoned by the Brooklyn Rapid Transit Company, teen runaways, anarchists, punks, and graffiti writers formed a squatter community amid the squalor. In the 2000s they encircled the top of the building with a message for commuters to see from the elevated F train: OPEN YOUR EYES! NO MORE CORPORATE BULLSHIT! FUK WALL ST.

Then the luxury developers descended. They keep putting up glitzy condos, even while the sinks, toilets, and shower drains of Gowanus periodically belch forth a foamy brown goo. Around 2005, the billionaire "King of Diamonds" Lev Leviev and real estate magnate Shaya Boymelgreen bought the Batcave with plans to turn it into "Gowanus Village," a complex of luxury apartments and townhouses. The NYPD raided the place and tossed out the squatters. It will now become Powerhouse Workshop, a gritty-glitzy center for the arts.

In 2009, the Bloomberg administration gave a sweetheart deal to the Toll Brothers, creators of the suburban McMansion. Toll asked the city for a "spot rezoning" to turn a three-acre chunk of Gowanus into a tract for a large luxury residential building. The city obliged. When the U.S. Environmental Protection Agency designated the area as a Superfund hazardous waste cleanup site and Toll backed out, the Lightstone Group took over and built a residential megacomplex with amenities like yoga and wine tasting, plus a waterfront "esplanade park" complete with boat launch and "water access point." In the dreamy renderings of what's to come, the canal is wreathed in green vegetation. Smiling people walk verdant paths and ply blue waters in kayaks. Lightstone calls it "a pioneer among parks."

In 2015, more than 250 artists and small businesses were evicted when a team of developers bought up a portfolio of buildings. Protesters stood in the streets and chalked the sides of the buildings with #KEEPGOWANUSCREATIVE and #STOPARTISTEVICTIONS. Not everyone agreed. In an op-ed, editors at the *Daily News* gave notice to those who might protect the neighborhood and its inhabitants from the luxury onslaught: "We respectfully send this message to the enemies of Gowanus gentrification: You've already lost. Stroll the streets and you will find . . . signs of—gasp!—gentrified life." They're right. Landlords have toppled the Eagle Clothes and Kentile Floors signs, the spectacular neon icons of the neighborhood's industrial heritage. Trendy eateries have moved in. And there's Whole Foods,

that hyper-gentrification machine, 56,000 square feet of price-inflated, self-congratulatory grocery shopping. And it didn't show up by accident—the state's Brownfield Cleanup Program gave Whole Foods $12.9 million in taxpayer-funded credits to build on contaminated land it would also clean up.

The mega-chain tries very hard to *feel* local, catering to the post-Williamsburg set with sections hawking "Brooklyn Flavor," bike repair services, and a shop selling vinyl, both records and objects made from recycled records by "a Brooklyn-based design and lifestyle brand." There's even a nineteenth-centuryish, mustachioed artisanal knife sharpener, dressed in a heavy-duty denim smock to cobble together handmade knives from reclaimed materials. Outside, beyond the extra-large parking lot, Whole Foods has landscaped their bank of the canal with a footpath and gardens. You can sit on a bench and watch the scrapyard across the way, waiting for dead dogs to go floating by. Couples meander, hand in hand, breathing in the stink of raw sewage. On one of the garden walls is a piece of graffiti that must have been commissioned by the supermarket. With its hunter-green color matching the branded shade of the Whole Foods logo banners just above, the rustically rough, spray-painted message admonishes passersby to EAT MORE OF YOUR VEGETABLES. Cartoonist Adrian Tomine lampooned the scene on a *New Yorker* cover, showing a couple seated on a bench, the bearded man sipping red wine, the woman eating a cracker and cheese, both ignoring their baby as it crawls into the canal. Tomine said, "It's strange to see the recent proliferation of health-conscious and environmentally conscious restaurants and grocery stores, right next to the piles of scrap and rubble. I guess it proves that there's no part of the city that can't be revitalized, recontextualized, or ruined—depending on your point of view." Pushing the envelope, in 2017, global retailer Anthropologie debuted a "breezy cotton tunic" they call the Gowanus dress. It sells for $188.

Atlantic Yards is currently the biggest development project in Brooklyn and probably the most controversial. Announced in 2003,

plans for the project originally entailed the takeover of twenty-two
acres near Downtown Brooklyn for sixteen high-rise residential
towers, glossy retail, and the Barclays Center, a sports arena for the
Brooklyn Nets, the basketball team then owned by the development's
mega-developer, Bruce Ratner. The footprint on which it all would
rise included a rail yard, a number of businesses, and several people's
homes. Governor George Pataki and Mayor Bloomberg supported
the use of eminent domain to seize the properties. The Empire State
Development Corporation agreed to designate the area as blight, a
requirement for eminent domain. Ratner would get the land to build
on, along with a bonus of more than $1 billion in public money, sub-
sidies from the city, state, and its taxpayers. Brooklynites fought the
plan for years—and lost.

I went out to the footprint in 2007. It was quiet. Many residents
had already been bought out and silenced with gag orders. The area
had once been full of people. The *Village Voice* reported that commu-
nity activist Patti Hagan took a door-to-door census before the emp-
tying and found "463 residents who either rented or owned, plus 400
people in a homeless shelter, and many small businesses, employing a
total of 225 people." One of those residents was the ninety-four-year-
old artist Louise Bourgeois, whose studio was at 475 Dean Street, a
former garment factory that had housed artists since the 1980s. At the
time of my visit, maybe a few dozen holdouts remained, like Daniel
Goldstein, leader of the opposition; along with people who'd been
there for decades and didn't want to give up their homes, some of
which had been in their families for generations; and those with no-
where to go, like eighty-seven-year-old Victoria Harmon, in a wheel-
chair after a stroke. She told the *Voice*, "What do you think? I want
to go out at this age? Where? I don't know nobody. Here I know
everybody."

As I walked through the desolate footprint I passed buildings
slated for demolition, including the hundred-year-old Ward's Bak-
ery, its lovely architectural details hidden behind plywood. Murals

painted on cinder-block walls and roll-down gates showed a grasping hand and the words: "Ratner—Hands Off Our Homes." At Freddy's Bar & Backroom, once a hangout for Dodgers fans, the walls were plastered in antidevelopment posters and graffiti. One message, addressed to Ratner, Bloomberg, and Brooklyn Borough President Marty Markowitz, read: "Fuck you you fucking fucks," followed by no less than eight exclamation points and a smiley face. Freddy's would soon be forced to move, its building demolished.

By 2010, the state government had grown tired of fighting the holdouts. They gave a thirty-day eviction notice to twenty-two families and businesses. One resident, fifty-seven-year-old Maria Gonzalez, told the *Daily News*, "I don't know what I'm going to do. I can't find an apartment." She'd been living on Pacific Street for thirty-seven years, while the borough around her had become unaffordable. By 2015, the number of holdouts had dwindled considerably. There was Jerry Campbell, hanging on to a house he'd inherited from his grandfather, and Aaron Piller, son of a Holocaust survivor, still running his father's wholesale wool business. When his father died in 2013, Piller told the *Times,* "I don't want to trivialize what happened by comparing this to the Holocaust, but in the end, he felt like here was the government again, coming to take everything from him." As for Campbell, in 2015 the state of New York seized his house, changed the locks, and posted a security guard at the door. The house was then condemned and demolished, along with two flowering trees. "This was my grandfather's home," Campbell told the *Daily News* in 2016. "This was his legacy and now it is gone."

Meanwhile, the Barclays Center opened to great fanfare and Atlantic Yards tried to shed its controversial history by changing its name to Pacific Park. Commercial rents skyrocketed across the neighborhood, forcing local businesses to shutter. WNYC radio noted that many Brooklynites call Barclays an "'ugly rusting spaceship' that's invaded the neighborhood and abducted mom-and-pop shops in its wake." The Pintchik family, local landlords with a large

parcel of properties, contributed to the upscale place-making. Tess Pintchik told WNYC: "We're going for Park Slope meets Meatpacking, a well-cultivated and curated group of tenants, and we really want to help change the neighborhood." Already, many people don't remember what came before. As Bloomberg once said of the mega-project, "Nobody's gonna remember how long it took, they're only gonna look and see that it was done." He was right. Today, few people talk about the land grab and evictions. They talk about basketball games and rock concerts. "The forgetting began before the arena opened," wrote Norman Oder on his blog, Atlantic Yards Report, but "[t]he controversy, the deception, and the obfuscation continue."

What will be the last "last frontier" for Brooklyn's settlers? As of this writing, it is East New York, Sunset Park, and even, at the outermost edge, Bay Ridge. Once again, it won't be natural.

A 2015 editorial in Crain's titled "Gentrify East New York" urged the city government to attract wealthy residents to this "forlorn area at the far end of Brooklyn that has missed out on the borough's renaissance." Mayor de Blasio unveiled plans to rezone the neighborhood as part of a $41 billion city-wide plan to create more "affordable" housing (a fiercely debated concept), along with much more market-rate housing. Just five months after the mayor's announcement, prices on East New York real estate nearly tripled.

At the other end of Brooklyn, Sunset Park is being rejiggered. Developed by Atlanta's Jamestown Properties, Industry City has taken over a sixteen-building collection of industrial warehouses to incubate tech start-ups, "maker spaces," and artisanal-food flea markets. According to the website City Limits, Jamestown is going after "a city rezoning to allow for a hotel and other new uses, plus $115 million in taxpayer money for expanded parking, upgraded roads, and a new water taxi service to serve day-tripping shoppers." The displacement has begun. Nearby landlords are harassing tenants, trying to push them out. Small local businesses are being forced out by hiked rents. And the artists, whose presence was leveraged to attract

higher-income newcomers, are getting priced out of their studios. Meanwhile, in 2017, Industry City's Extraction Lab debuted an $18 cup of coffee, the most expensive in America.

Beyond Sunset Park is Bay Ridge, way out there, where John Travolta once strutted through the streets in *Saturday Night Fever*. I hear they've already got a wine bar and an art gallery. Outside a local dive, a sign's been posted: "Hipsters are what happens when you tell every child that they are special." Sounds like Bay Ridge is bracing itself. And I haven't even mentioned DUMBO or Red Hook or Ditmas (you can't cover it all) or . . . Coney Island. For that one, we're going to need another chapter.

CONEY ISLAND

View of Astrotower and Wonder Wheel from demolition rubble. *Lindsay Wengler, 2010*

T IS 1996 AND I'M IN LOVE WITH CONEY ISLAND. I'M IN LOVE with its decrepit, ancient buildings and amusement park rides, vibrating with color and life. Ice cream, cotton candy, corn dogs, fried clams. I'm in love with the smell of grease and seashore. The feeling of being at the edge of the world. On the margin. And I can't get enough of the freaks. My whole life I've loved the freaks. As a kid, watching and rewatching David Lynch's *Elephant Man*. Later the work of Flannery O'Connor, Carson McCullers, Truman Capote, those southern gothics. Now I'm twenty-five years old and I want to be Joseph Mitchell, the consummate chronicler of Gotham's every-

day oddballs. I go to Coney every chance I get, notebook in hand, and talk to people.

I take the long, slow D train across Brooklyn, reciting the lines of a Paul Blackburn poem in my head as the scenery slides by, each station its own line of poetry, through Sheepshead Bay and Brighton Beach:

> . . . all the way to stillwell
> avenue
> that hotbed of assignation
> clickety-clack

Through the grimy train window, the first glimpse of Parachute Jump quickens my heart. The Cyclone roller coaster's brontosaurus spine shines bleached white in the sun. I emerge from the station under faded billboards—the Coppertone girl losing her shorts to a cocker spaniel, "Don't be a paleface"—and walk through the sugar-perfume cloud of Philip's Candy shop with its red-and-white-striped awning, signs for LIME RICKEY and FROZEN BANANAS. Opened in 1917, it will be evicted in 2001. But we're not there yet. In 1996 we still hear the music of the B&B carousel, wounded but beautiful, old tunes limping in a loop for anyone who rides to grab the brass ring.

Coney Island, they say, is the id to New York City's ego. It has been for as long as anyone alive can remember and then some. Dubbed "Sodom by the Sea" in the 1800s, it was an unregulated, untamed place where the sexes could mingle, and women could behave in ways not otherwise permitted. Coney Island, wrote Italian immigrant Giuseppe Cautela in 1925, "is a place where a man in shackles breaks his bounds. Here he becomes himself." Furthermore, "Nowhere else in the United States will you see so many races mingle in a common purpose for the common good. Democracy meets here and has its first interview skin to skin. The garments of Puritanism are

given a kick that sends them flying before the winds." Tolerance and freedom! Muscles! The beauty of sweating bodies! And no Puritans.

The People's Playground was more tolerant not only of a mix of races and classes, but also sexualities. By the Great Depression, the boardwalk bathhouses were "unabashed" locations for homosexual rendezvous, says George Chauncey in *Gay New York*. Genders crossed even earlier. Jimmy Durante, recalling his days playing ragtime piano in a Coney dive called Diamond Tony's, wrote: "the entertainers were all boys who danced together and lisped. They called themselves Edna May and Leslie Carter and Big Tess and things like that. . . . Some of them were six feet tall and built like Dempsey, so it was never very healthy to make nasty cracks." That was 1910.

Coney Island, they say, is the "great equalizer," where all bodies are free to be expressed on the sand. In the 1930s paintings of Coney by artists like Paul Cadmus and Reginald Marsh, we find orgies of delirious embodiment. Bodies burst from the seams of their skimpy clothing, bodies with hair and veins, bodies built of exuberant rolls of fat. Coney Island is a fleshy atmosphere, everything jiggling and bumping. Everything out of order, out of alignment, set slant. Its own body, from boardwalk to buildings, is an odd body, the freak soul made flesh, unbound by convention, beyond the reaches of polite society. Hotbed of assignation. Clickety-clack. At least it still is in 1996.

From the station I step out to Surf Avenue. To my right is the dormant skeleton of the Thunderbolt roller coaster, a beautiful ruin covered in green vines and white moonflowers, its tracks a jungle for nesting birds. Wedged beneath the wood and steel lattice is the former Kensington Hotel, the house under the roller coaster featured in *Annie Hall*. In 2001, cloaked in the darkness of early morning, Mayor Giuliani will send men and machines to demolish the whole lot. But we're not there yet. In front of me still is Henderson's Music Hall, where the Marx Brothers honed their craft. And the Shore Hotel,

"Paradise by the Sea," built in 1903 and now a hot-sheets joint where you can rent a room for a forty-dollar "short stay" with complimentary porn on the TV. These antique buildings will meet the wrecker in 2010. Spoiler alert: In another decade or so, there won't be much left of this Coney Island. Let's stay in 1996 a little longer.

To my left, in a white-painted hut, sits a pickled punk, a two-headed baby turning in his (their?) formaldehyde jar. A man's voice on a grind tape endlessly loops, "If you've never seen a real two-headed baby, you owe it to yourself to come inside." Ronnie and Donnie have been around. They supposedly appeared at the 1939 New York World's Fair and the famed Hubert's Museum on 42nd Street. I pay fifty cents to gaze upon the two faces, the four closed eyes, the single body curled in a tomb of murky yellow fluid. I've got an appointment to interview the owner, Bobby Reynolds, but he's not here today. Outside the Sideshow Museum, his son, dressed in a red fez with a live iguana by his side, tells me that Bobby's been distracted lately. So I head into Sideshows by the Seashore and end up talking with Rick, who takes tickets, mops the floor, and helps out with whatever needs an extra hand.

"When we used to have the escape artist," Rick explains, "he had to be hoisted up on a cable, so I was the guy who hoisted him." Rick is lean and tall, with thinning black hair and a long ponytail. He tells me that he was a lost soul who found himself at the freak show.

"I was in the red," he says, "financially and spiritually." Then he saw an ad in the back of the *Voice* that said: "Work with freaks on the beach," and he "just knew." He tells me about the sideshow performers, like Baby Dee, who used to pedal a giant tricycle through the East Village. "They were amazing," Rick says, using the gender-inclusive pronoun yet to be popularized. "Half-man half-woman. But they were also a classically trained musician. They played the harp. When they would be onstage playing the harp, the contortionist would come out and go through her contortions. That was a beautiful show. One of the most beautiful things I've ever seen."

An older man named Alfred walks in and lights a cigarette. He's spent his whole life in Coney Island. He points out the door and says, "You are looking at the death knell of one of the most beautiful amusement parks in all the world. I remember when it had class. I remember when the men used to come in suits and ties, and the ladies wore dresses. Come here, I'll show you something." He leads me to the back, where they keep a few items from the Coney Island Museum: an antique bumper car, a wicker rolling chair, a horse from Steeplechase. Alfred sits in the rolling chair, on top of a sign that says "Please Do Not Sit."

"These were pushed by Spanish War veterans when I was a boy," he says, "and, boy, are they comfortable." He runs his hand lovingly along the pink-and-white striped fabric of the cushion. The manager of the Sideshow comes in and asks Alfred to please get off the display. He complies, grumbling in my ear, "I like that guy, I really do, but he can be a real prick."

It's seven o'clock and the show is about to begin. I pay a dollar to watch the Human Blockhead, Enchantra the snake dancer, Indio the fire eater. Then it's Zenobia, a real "born freak." She wears plain clothes, pants and a shirt, no theatrical makeup. Her beard is drama enough, thick and woolly wild.

"I am a woman with a beard," she announces. "If I called myself *the* Bearded Lady, I would be claiming that I, Zenobia, was the one, the only, woman with a beard in the entire world. Could that possibly be true? Of course not. The world is full of women who have beards. Or at least they have the potential, if only they would reach out and fulfill their fabulous potential, as I myself have so obviously done. Historically speaking, hair has been a symbol of power. It goes back to Samson and his great mane. That's why men don't want women having too much in too many places. So people want to know how I deal with walking down the street. 'Cause here I am, a gal with a beard, gallivanting around New York City. You think I'm getting hassled out there? I get more than my fair share. So what do I do?"

She picks up a machete from the stack behind her. "After a long hard day at work, I'm hot, I'm tired, all I want is a nice cold . . ."

"Beer!" the crowd yells.

"Machete!" Zenobia corrects them. She begins juggling three blades. She's good. The crowd roars in applause.

After the show, I walk outside. It's dark. I watch the lights of the Wonder Wheel and the Jumbo Jet and the Cyclone. I am twenty-five years old. I am not Joseph Mitchell. I have no idea that Coney Island, as I know it, will vanish, manhandled by mayors, planners, and real estate developers into chain restaurants and tourist-friendly shops. I'd like to stay here. But time keeps moving.

You might say the story of the battle for New York's soul is encapsulated in Coney Island, that Sodom by the Sea that brought the people of the city together in a space outside the ordinary. For years, the land was grabbed and regrabbed, its extravagant amusement parks burned and rebuilt into new shapes. Coney, like the city, was always changing. And yet it remained, at its soul, the same—a democratic hodgepodge, an unregulated outer zone where the boundaries of convention fell away. And, all the while, the power brokers kept trying to kill it.

With slum clearance muscle, Robert Moses started swinging his meat axe at Coney in the 1950s. He boasted to the *Times* that he'd been grabbing up foreclosed sites and planned to "get rid of about a third" of Surf Avenue. The days of "mechanical gadgets" and "catchpenny devices," he announced, were over. He wanted to rezone the amusement area for residential development. While he did not succeed in killing off honky-tonk Coney, he took a bite.

In 1965, Donald Trump's father, Fred, bought Steeplechase Park with plans to demolish and build "a modern Miami Beach high-rise apartment dwelling." City Hall resisted. Steeplechase had been an amusement park since 1897 and Mayor Lindsay wanted it to remain so, envisioning, said a spokesman for the parks commissioner, "a combination Disney and Tivoli Gardens." In his book *Trump*, Jerome Tuc-

cille describes the city plan for "a monumental park with indoor swimming pools, restaurants, and concert facilities . . . a multilevel seafront park development." Fred Trump did not relent. He changed tactics. How about housing *and* an amusement park? How about Disney? Walt said no. Trump proposed putting Coney in Tupperware, sealing it from the elements under a 160-foot-high "climate-controlled pleasure dome." But what he really wanted was a rezoning, from recreational to residential. The city said no. So Trump destroyed Steeplechase before it could be landmarked and protected. On demolition day, he posed by a bulldozer with an axe in his hand alongside six bathing beauties, all wearing bikinis and hard hats and sipping champagne. It was a party. "Most guests," wrote local historian Charles Denson in his invaluable *Coney Island Lost and Found,* "remember the event as a disgusting display."

In 1976, when casinos were legalized in New York State, Mayor Koch aimed to turn Coney Island into another Atlantic City. Property owners bulldozed in anticipation of casinos that never came. Coney fell from grace. The Shore Theatre started showing porn—*Fairy Tale Adult* and *Let's Play Doctor.* Street gangs and bikers moved in. New Yorkers stayed home in the summer, soothed by their televisions and air conditioners. And yet many locals kept going, lining up to ride the Cyclone, the Wonder Wheel, the Thunderbolt. They still tried their luck, took a *schvitz* at the baths, and ate too many Nathan's Famous hot dogs. The old folks still dragged lounge chairs to the boardwalk to take the winter sun, wrapped in blankets and fur hats, silver reflectors tucked under their chins.

The place was now ripe for anyone looking to create something scrappy among the ruins. "In the early 1980's," reported the *Times* in 1985, "a handful of artists converged on Coney Island, determined to restore to the area the power of fantasy that it once exerted." Philomena Marano and Richard Eagan started the Coney Island Hysterical Society. Dick Zigun launched the Mermaid Parade in 1983, a ragtag artists' celebration of Coney's old Mardi Gras parades, and soon

opened Sideshows by the Seashore, keeping the vaudeville and bur-
lesque spirit alive. By the mid-1990s, Coney was on the upswing—
with its soul intact. That was a sweet spot, when both safety and
creativity increased and coexisted, just like in Times Square, Coney's
cousin in tawdry spectacle. Then signs of the shift to the new global-
ized city came creeping. The Sideshow's lease expired and McDon-
ald's angled to take its space. "It's kind of ironic," said Zigun to the
Times. "In helping to gentrify this boardwalk, which was ridden with
gangs, arson and violence in the 70's, we actually helped make it safe
for places like McDonald's to set up here." But Coney resisted and
Mickey D stayed out. Then, as with everything else, the whole thing
tilted.

Mayor Giuliani brokered the deal that would push Coney Island
toward widespread, state-led redevelopment. For the New York
Mets farm team, the Brooklyn Cyclones, he installed a stadium on
the old Steeplechase site, next to the green ruins of the Thunderbolt
roller coaster. He paid for it with $39 million in taxpayer money and
said, "This ballpark will do for Coney Island what Disney did for
Forty-Second Street." In other words, clean it up, bring in national
chains and condos, and make it friendly to Middle American tour-
ists and global investors. Coney needed "a shot in the arm," insisted
Michael Carey of the Economic Development Corporation, and the
stadium would be the "catalyst . . . to a lot of private development."

Jeff Wilpon, executive vice president of the Mets, mentioned to
the mayor that the Thunderbolt was a dangerous-looking eyesore,
according to the *Times*. "Say no more," wrote Dan Barry. "Whether
by coincidence or design, the Thunderbolt was now squarely in City
Hall's sights." City officials tore it down. Illegally. It belonged to
Horace Bullard, the Harlem-born entrepreneur, millionaire real es-
tate developer, and eccentric king of Kansas Fried Chicken. Bullard
was another man who'd tried in vain to redevelop Coney's amuse-

ments. He had big plans. They went nowhere. He held the lease to the city-owned Steeplechase site, but Giuliani took that from him, too. The mayor, Bullard told Charles Denson, saw it as "his childhood playground" and he wanted it back. Bullard was not informed of the Thunderbolt demolition and did not consent. He eventually got a million-dollar settlement from the city, but "refused to collect the money because it came from taxpayers," wrote the *Times*.

The fall of the Thunderbolt marked a turning point. And it sent a message. Giuliani's revanchist City Hall wasn't going to let a bunch of commie artists, working-class carnies, and one idiosyncratic black businessman cobble together a future for Coney Island built upon the preserved ruins of the old. Coney's honky-tonk days were done. And they collapsed, once and for all, with the vine-tangled tracks of the Thunderbolt.

The roller coaster was built in 1925, constructed atop the already aging Kensington Hotel, a gray clapboard box that became the home of coaster operator Freddy Moran and his longtime partner May Timpano. The steel beams of the Thunderbolt ran through the house's ceiling and down through its foundations. During the summer months, vibrations would shake pictures crooked on the walls and knock knickknacks to the floor. When the cars looped and plunged, "there were rumbles and screams," *The New Yorker* reported in 1982, "and the living room trembled." Lampshades danced and houseplants quivered. "You get used to it," May said. She was living there alone by that time, with Freddy passed away, and carried a gun for protection. But the coaster was a kind of lullaby. It became like thunder, an everyday storm rolling in off the sea.

After the coaster stopped running and nature took over, turning the tracks into a hanging garden, May moved out. The Thunderbolt stood for years, snow-white in winter, deep green in summer, the urban ruin of a lost civilization that many hoped would be restored.

On the November morning when City Hall tore down her old home, May stood by and wept. Fans and preservationists rushed out, hoping to stop the destruction. They were too late. Author and folklorist Steve Zeitlin recalls watching the colossal dinosaur fall: "The steel bent and the old timbers creaked and cracked, and pieces of wood fell like branches of a great tree."

The Thunderbolt was many things. A roller coaster, a relic, a symbol of what was and might be again. It was also a body. Part nature and part machine, organic and constructed, it was one of Coney's freaks. Grafted to the house below it, the coaster became not one, but two, a hybrid like the Half-man/Half-woman, the Alligator Girl, the Lobster Boy. House and not-house, it combined public and private, danger and domesticity. It was, like the bodies rendered in the paintings of old Coney, a body gone out of control, bursting from its seams, unregulated. Those who understand the beauty of a freak body understand the beauty of the Thunderbolt. Its destruction was real, corporeal, but also symbolic, a line drawn in the sand. "Many people saw the building as a symbol of Coney's decline," wrote Denson of the house under the tracks, "but it actually was Coney's monument to survival." What survived in the ruined Thunderbolt, to my mind, was the old freak spirit, the rejection of conventionality. Giuliani must have known that for Coney to be sterilized, the Thunderbolt would have to go.

In the spring of 2001, Giuliani shut down the ragtag flea markets along Surf Avenue. As Charles Denson put it, "the city launched a preemptive attack on Coney's grit. A special team of police officers, directed by the mayor's office, made a sweep" of the markets, issuing summonses and making arrests. The human rabble, like the Thunderbolt, would have to go. After all, the mayor was spending $91 million to give Coney a makeover, including a major renovation of the Stillwell Avenue subway station.

New York City Transit kicked Philip's Candy shop out of the station, where it had been sweetening the air for seventy years. "It's like listening to somebody put nails in your coffin," said the shop's owner, John Dorman, who'd been working the place for fifty-four years. He hoped to return, but when the new subway station opened, Philip's Candy did not. Instead, the city welcomed Bank of America and Dunkin' Donuts.

"Property values are rising," reported the *Times* in 2004, one year after Mayor Bloomberg established the Coney Island Development Corporation (CIDC); "city inspectors are showing up in numbers unseen for decades; something is in the air." It wasn't the scent of candy apples. Ever so quietly, Joe Sitt of Thor Equities, a mega-developer of suburban-style shopping malls, had been buying parcels of land and properties along the boardwalk and Surf Avenue, spending an estimated $100 million on about a dozen acres. In 2005, he revealed his grand plan to *New York* magazine. "Imagine something like the Bellagio hotel right now—just stop and see it," he said. "The lights. The action. The vitality. The people. We wanna evoke the same feeling you get when you're in Vegas. It's exciting. It's illuminated. It's sexy."

Vegas. Disney. Variations on a theme park. But Coney Island was never a theme park. It was a random assemblage of rides and spectacles, unregulated in its chaos, its endless ability to surprise and shock. Theme parks are controlled. And surveilled. As Michael Sorkin explains, "The theme park presents its happy regulated vision of pleasure . . . as a substitute for the democratic public realm, and it does so appealingly by stripping troubled urbanity of its sting, of the presence of the poor, of crime, of dirt, of work."

While Sitt was finalizing his glitzy billion-dollar plan, Mayor Bloomberg announced that the city would invest $100 million to realize his administration's vision for Coney. The plan, said the mayor, "represents one of the largest and most ambitious rezonings that we've proposed for Brooklyn." It would allow for luxury towers, thousands of new apartments, and 460,000 square feet of new retail,

along with tourist hotels and "sit-down restaurants," previously prohibited by Coney's recreational zoning. The city's master plan, as Greg Sargent reported in *New York*, was "meant to encourage private developers—like Sitt—to try to turn Coney into a revitalized, year-round destination."

Not everyone was thrilled by Bloomberg and Sitt's plans. In 2007, the group Save Coney Island marched on City Hall. At the 2008 Mermaid Parade, the Queen Mermaid, dressed in glittering scales and seashells, held a hunger strike to rescue Coney from the "gentrifying apocalypse of retail entertainment hell." Dick Zigun resigned as director of the CIDC. To Bloomberg he wrote that the CIDC plan would mean "a shopping mall full of NikeTowns, Toys R US and 4 thirty story hotels" (along with twenty-six high-rise condo towers). "Only 9 acres out of 61 will be reserved for amusement park rides."

In 2009, Bloomberg rezoned Coney Island, drastically reducing the size of the amusement area and allowing the construction of high-rise hotels and condos. It was the realization of dreams hatched by Moses and Trump. By the end of 2010, Joe Sitt's Thor Equities had demolished the Henderson Building and Shore Hotel, and evicted several businesses, turning Coney into a ghost town. Then the chains started coming. In 2013, Applebee's opened on Surf Avenue.

With a Coney theme, the restaurant unveiled a five-thousand-gallon shark tank filled with amusement park miniatures, including a Wonder Wheel and Cyclone. One of the sharks was named Zane, after owner Zane Tankel, who owned every other Applebee's in the city. He told the *Daily News*, "Coney Island's time has come." But his aquatic namesake wasn't ready for the honey-glazed, Fiesta-Lime-flavored, fast-casual life. The junior Zane had to be removed "after devouring three Lookdown fish in a shocking killing spree," reported the *Daily News* during Applebee's opening week. "That very same day, a Whitetip shark died after colliding with a three-foot Wonder Wheel replica in the tank, leaving employees shaken by the mayhem."

To add insult to injury, Applebee's threw a Mermaid Parade

party, co-opting the countercultural event. For forty-five dollars they granted paradegoers entry into a "comfortable air-conditioned dining room" for drinks and an all-you-can-eat buffet in the "ambiance of the hottest new restaurant" in Coney Island. I asked Reverend Billy, a former King Neptune of the parade, what he thought. He replied: "Applebee's in the Mermaid Parade? Oh, Applebee's must have changed from the soft, safe, middle-class chain diner. They must be naked in there, full of smells and seductions, barkers at the bullhorn and mysterious skinny guys pulling the lever on the Cyclone smoking Chesterfield no-filters while hawking tourist women's legs. Applebee's must have changed. It must have accepted chance, danger, and the End of the World."

The chains kept coming. Classic rides shut down, including the thirty-eight-year-old Zipper, around which the documentary film *Zipper* tells the tragic and convoluted story of Coney's demise at the hands of dueling developers, politicians, and planners. In one scene, the camera cuts back and forth from Joe Sitt, Amanda Burden, and Domenic Recchia, the local city councilman who supported Bloomberg's rezoning. Over the strains of Strauss's "Blue Danube" waltz, they take turns listing the chains they'd like to see. Sitt reads gleefully from his BlackBerry: Ripley's Believe It or Not, Dave & Buster's, Bubba Gump, Hard Rock Live, Rocky Mountain Chocolate Factory, Build-A-Bear Workshop. Burden adds, in a hushed and gushing tone, as if invoking the names of great monuments, "Maybe a Gap! Maybe a Duane Reade!" And Recchia says, without irony, "People keep on saying Thor Equities wants to build a shopping mall. They don't want to build a shopping mall. They want to bring in creative retailers. Let me give you an example: Williams Sonoma."

Eventually, the city bought a chunk of Sitt's properties and leased them to international amusement park company Zamperla to bring in shiny new rides—along with Starbucks coffee. Rents went up. More small businesses were evicted. "We will never make Disney here," Zamperla's president, Valerio Ferrari, told the *Times*. "But it

will be something more . . . refined, cleaner . . . with sit-down restaurants and sports bars." They evicted nine of the eleven boardwalk businesses. "We don't have the same vision," Ferrari said. "They like the way it is, and we don't." Later, he allowed a few to remain, but required them to upgrade their look. What's coming next for Coney is anyone's guess. Round and round she goes. Where she stops, nobody knows.

It is 2016 and I return to the Sideshows by the Seashore. Today it's a revival, Superfreak Weekend, and Zenobia, whose everyday name is Jennifer Miller, will be reprising her original act. I take the F train and get off in the new station. No more sugar cloud of Philip's Candy, no more Coppertone girl. The corridor is lined with Bank of America, Dunkin' Donuts, Baskin-Robbins, Subway. On Surf Avenue, the old hotels of nineteenth-century Coney are gone. I see new buildings, gleaming and clean, housing more chains. The biggest, gaudiest one is IT'SUGAR, a raucous candy store with dozens of locations around the country. When they opened, their CEO bragged to *Brooklyn Paper*, "Our candy stores are not your typical 'old fashioned and stale' stores but more of a hip and cool place." In the same building, there's an Adidas shop hawking Brooklyn Nets apparel, and a Wahlburgers, the Boston-centric fast-food chain opened by Marky Mark and his brothers. A sign on construction plywood reads: "Johnny Rockets Is Coming!"

I cross the street to the sideshow, last remnant of weird old Coney. Admission is now ten dollars. European tourists, who never came to Coney much before, flock the gift shop. I buy a ticket and take my seat on the wooden bleachers to watch Mat "Sealboy" Fraser play the drums with his Thalidomide "flippers," followed by the Velvet Crayon, a man made miniature by *osteogenesis imperfecta*, who plays electric guitar in his wheelchair. Then it's Zenobia's turn. She's glammed it up since 1996, wearing a purple satin gown over jeans

and motorcycle boots, her eyelids painted in purple powder. With gray hairs in her beard, she reflects on the passage of time and wonders if her act still thrills in this age of transgender emergence, when people are more accustomed to gender hybrids. Then she begins her spiel, word for word, the same as it was in 1996.

"If I called myself *the* Bearded Lady, I would be claiming that I, Zenobia, was the one, the only, woman with a beard in the entire world!"

A boy in the audience shouts, "You have a gay name!"

He's maybe eight years old. His mother tells him to stop. Zenobia relishes the moment—as Jennifer Miller she's a professor of performance studies, a lecturer on gender, and director of the left-wing political theater troupe Circus Amok. "Now we can really talk," she says, moving to the front of the stage and kneeling down to address the boy.

"What about the name Zenobia strikes you as gay?"

"It's a gay name!" the boy shouts. His mother tells him to stop. They go around like this, the boy repeating himself. There's a hysteria to his repetition, the needle on his cognitive record skipping. In twenty years, not everyone has become accustomed to gender hybrids. The bearded lady still has the power to unsettle—and raise consciousness.

Zenobia continues to talk it through. She makes a joke. The energy shifts. She asks the boy again what's gay about her name. Quietly now, he says, "Well, it's kinda gay. And it's kinda pretty."

"Ah-ha! That's what we call queer," Zenobia announces, getting to her feet. "The place where gay meets pretty!" And the show goes on. She juggles her machetes. She's still good.

Satisfied, I walk out to the boardwalk, past the many banners for Thor Equities: "Space Available," "Stores for Lease," "Retail Space Available," tied to chain-link fences around bulldozed lots, strapped to shuttered building façades and empty storefronts. Gazing across the brown field where the Thunderbolt once stood, I feel a creep-

ing grief. I reassure myself that everything's okay. This place is still surviving. You can still get a corn dog and a plate of fried clams. The Cyclone still gives people whiplash and the Wonder Wheel turns eternally on its sea-foam green spokes. The crowd is diverse, multicultural, working class. But there is something missing. Coney has lost its edge. Everything feels more controlled. Less alive.

For solace, I walk down to Williams Candy, a sweet little spot that's been here for about eighty years, and buy a small paper bag of malted milk balls. I'm the only customer. Everyone else is going to IT'SUGAR. Next door, the tables at one of the last honky-tonk clam shacks are empty. Ears of corn steam unwanted in hot water while families cram into Applebee's and Wahlburgers.

In his Coney Island history book, *Amusing the Million*, John Kasson writes that the Coney of the late 1800s, the epoch when our New York came to life, "encouraged extravagance, gaiety, abandon, revelry," as well as "the grotesque." The freaks symbolized "the exaggerated and excessive character of Coney Island as a whole," as the unusual bodies "displayed themselves openly as exceptions to the rules of the conventional world." When you get down to it, that's the definition of queer. So we might say that, for a century, New York was a queer city. Exceptional. Unconventional. Where gay meets pretty. Where the strange meets the beautiful.

What surprises are left for us now? What will shake us from our everyday lives, shocking and thrilling us with the unusual, the ambiguous, the fleshy, the loose? In a city so tightly curated and constrained, we are daily deprived of wonders hardly imagined.

QUEENS

5 Pointz. *Jeremiah Moss, 2013*

THE FIRST TIME I SAW 5 POINTZ I WAS RIDING THE 7 TRAIN, THE Flushing local, out to Shea Stadium for a Mets game, somewhere in the early 1990s. You board at Grand Central, down in a dark and dripping tunnel where an old man plays "Besame Mucho" over and over on a Casio keyboard propped on a cardboard box. (Is he still there?) You plunge under the East River and emerge onto the elevated tracks in the sunlight of Long Island City. Queens. Borough of—what exactly? Archie Bunker. Faded ruins of the World's Fair. Airport, airport, racetrack. Far Rockaway with its bungalows and lullaby name.

I didn't see 5 Pointz coming, only that it was suddenly there, a bank of golden light, unfurled and filling the train window with its thrillingly hallucinatory vista of colors and shapes, faces, bodies, and bubbling texts. Was it even real? Known then as the Phun Phactory, the building that later became 5 Pointz was a five-story warehouse, as yellow as an unfrosted cake, splashed with graffiti from foundation to rooftop. It was one of those New York zones where the strange met the beautiful. That first time, it shocked and thrilled me, flashing kaleidoscopically before my eyes for only a moment, before the train hurtled on into the depths of unsentimental Queens.

Queens, borough of today's immigrants, is reportedly one of the most ethnically diverse places on the planet. But it has never been fashionable. Unless I'm missing something, Queens never had a golden age. It was never hot. Then, in 1980, some people tried to make it so. When *New York* magazine published a cover story heralding Long Island City, Queens, as "The Next Hot Neighborhood," the writer described an undiscovered gold mine just across the river from Midtown. A new frontier. "With its underutilized waterfront, postcard view of the Manhattan skyline, low property values, and the best transportation in the city, Long Island City just has to take off." Speculators were descending, buying up properties and mapping out a new neighborhood for the moneyed class. There would be luxury condos, floating restaurants, and glamorous art centers—though most Manhattanites had never heard of the place. Long Island City was still a living part of New York's riverside industrial landscape, a home for Pepsi-Cola, Swingline Staplers, Dentyne, and Chiclets, zoned for heavy industry in 1961 when manufacturers were forced out of lower Manhattan by the government. It was also home to several Latino and white ethnic working-class New Yorkers. Generations of Italians and Greeks lived there. People owned their homes. They hadn't fled to the suburbs. Unlike many redlined neighborhoods, Long Island City in 1980 was still healthy, industrious, far from decline.

"But it's stagnant," wrote *New York*. "And given City Hall's current

bent toward gentrification—the conversion of poor, working-class areas into middle-class refuges—choice neighborhoods convenient to midtown can't be allowed to stagnate."

Among the blue-collar residents, artists lived and worked in Long Island City, priced out of Soho in the 1970s. The P.S. 1 artist's studio space opened in an abandoned elementary school in 1976 and was soon considered a catalyst for gentrification—as one artist told *New York*, "People like me are ruining my neighborhood." Throughout the 1980s, more artists moved in. Galleries opened. New restaurants served quiche. One lifelong resident told the *Times*, "it was the beginning of the end." But the end did not come just yet. Old-fashioned gentrification was not strong enough to dislodge the local community. So while speculators bought properties and sat on them, waiting for the hot new frontier to finally "happen," the working class and artists continued to live in relative harmony, undisturbed by revitalization, "stagnating," for the next two decades. In that stillness, creativity flourished.

In the early 1990s, Pat DiLillo, a disabled plumber from Woodside, Queens, founded the Phun Phactory, an arts organization aimed at getting young graffiti writers to stop tagging up the neighborhood and do work legally on industrial walls. In his search for those walls, DiLillo approached Jerry Wolkoff, a real estate developer who had started buying warehouses and other properties in Long Island City in the early 1970s. One of those properties was a defunct factory built in 1892 for the Neptune Meter Company. When DiLillo asked Wolkoff if his kids could write on the vast, butter-colored exterior, Wolkoff said yes. While the developer hoped to one day build a glass tower to rival the recently risen Citicorp building nearby, those plans were far from imminent, and the Neptune building sat nearly empty. Why not brighten it up? The Phun Phactory, the original 5 Pointz, took off. Thousands of street artists from around the city and the world wrote on it, turning it into a revolving outdoor gallery of urban aerosol art. Established as a nonprofit, the Phun Phactory offered a safe space

for youth at risk, and an alternative to incarceration in a city where Giuliani cracked down on graffiti as part of his zero-tolerance campaign. "DiLillo also tried to rehabilitate lives," wrote *Newsday*, "offering tough love for those sentenced to community service or to work release." While DiLillo managed the exterior, Wolkoff opened the interior to artists, renting out inexpensive studios, sometimes taking art in lieu of rent. It was all good. Then the century turned and the changes long awaited began to arrive.

Across the street from Phun Phactory, scrappy P.S. 1 partnered with the Museum of Modern Art and became MoMA P.S. 1. The partnership put the art center on the map. Tourists and Manhattanites who'd never ventured to Long Island City began trekking out on the 7 train. They discovered that it wasn't such a trek after all. In 2001, the City Council voted to rezone more than thirty blocks to encourage residential high-rises and new retail. The boom was on. That same year, Wolkoff barred DiLillo from the Phun Phactory. Details on their breakup are sketchy. "I have no problem with the graffiti guys staying there," Wolkoff told *Newsday*, "but I don't want Pat running the show anymore. If someone else takes over, that's fine, but Pat is a loose cannon." In the article, DiLillo is described as "hard-boiled" and "abrasive," a tough but guiding father figure to the graffiti artists. Without him to manage the walls, the Phun Phactory devolved into a chaos of scribbled tags and throw-ups. About a year later, local graffiti artist Jonathan Cohen, who goes by Meres One, took over as curator. He renamed the project 5 Pointz, a reference to the five boroughs of New York, and encouraged artists to create more elaborate productions. It started looking less like graffiti and more like art.

When the Bloomberg administration came to power, they set their laser beam on Long Island City. In their vision, it would be all about mixed use, high density, and vibrancy. It would not, however, be for the people living there. Said Amanda Burden to the *Times*, "There is a need for more residential foot traffic to bring stores and restaurants to the area, the kind of amenities the contemporary busi-

nessman is looking for." In the luxury product city, some people are just more valuable than others.

At the distant other end of the 7 subway line, Willets Point remains the last undeveloped piece of the Corona Dumps, the "valley of ashes" made famous in F. Scott Fitzgerald's *The Great Gatsby* and transformed by Robert Moses into Flushing Meadows–Corona Park. Described by Fitzgerald as "a fantastic farm where ashes grow like wheat into ridges and hills and grotesque gardens," that valley, the natural salt marsh of Flushing Meadows, was the dumping ground of the Brooklyn Ash Removal Company in the first decades of the twentieth century. As Robert Caro writes in *The Power Broker*, it was the spot where "all the garbage of Brooklyn" was sent to burn, a hellish place infested by giant rats "so numerous that nearby shanty dwellers eked out livings trapping them and selling them to fur dealers." Most of those giant rats were probably muskrats from the marshland around the dump. As Ted Steinberg describes in *Gotham Unbound*, the Brooklyn Ash property did not cover all of Flushing Meadows—only 300 of the 1,257 acres Moses would claim—and much of it remained natural and wild, in parts cultivated by Depression-era squatters and working-class Italians into vegetable gardens where tomatoes and radishes ripened rapidly in the heat given off by the burning.

In 1936, Moses and the city began the process to condemn the land, evict the people, demolish more than one hundred buildings of homes and businesses, and haul away the mountains of ash so Flushing Meadows Park and its roadways could be built, all with the 1939 World's Fair as an excuse. The Italians moved out in horse-drawn wagons and the "landscape was smashed right down to the bocce courts," says Steinberg. Moses got all but Willets Point, the horn-shaped bit of land that breaks Flushing Bay into Flushing Creek. By the 1940s, auto body shops had moved in, establishing it as the city's center for the repair and junking of cars, along with other industrial businesses. Somewhere along the line, the spot was nicknamed "the Iron Triangle."

In the 1960s, with plans for another World's Fair, Moses tried to take that last bit of land. As the Mets' Shea Stadium was rising, the city parks commissioner, Newbold Morris, got the ball rolling on the land grab, claiming he would build more parkland on the Iron Triangle. The Willets Point Property Owners fought back. They were mostly working-class Italians, holdouts from Moses' last round of evictions. Their lawyers were Italian, too, including a young Mario Cuomo, the future governor of New York. They threatened to sue the city for misapplication of taxpayer money when it became clear that the Flushing Meadow Extension would not be a public park, but a private parking lot for Shea Stadium. If the deal went through, ninety-three businesses would be destroyed and a thousand people would lose their jobs. The fight went on. Moses, Morris, and the extension's supporters described the Iron Triangle as "an eyesore, a disgrace, an affront to thousands of motorists a day and a blemish on the glittering facade of the World's Fair." The fair came and went, Shea Stadium opened, and still the fight continued, until the city finally backed off in 1967. The working class won.

In the 1980s, they were fighting again. This time the enemy was not Robert Moses—it was their former defender, Mario Cuomo. As governor, he supported Mayor Koch's plan to evict the industrial businesses of Willets Point and build a domed football stadium next to Shea to lure the Jets back to New York. The workers weren't happy. "I never thought he would stab us in the back," said the owner of an auto salvage business to the *Times*. He'd been one of Cuomo's original clients. "It's un-American," said another. When asked why he wanted to take the little spot, Cuomo said "he had been guided in the choice by Donald J. Trump," who got the green light to build on the site. But like many big development plans of the past, for reasons too complicated to enumerate, the football stadium fell through.

Throughout the 1990s there was talk of bulldozing the Iron Triangle for hotels, shopping malls, a convention center. There was talk of tearing down Shea Stadium and building a new ballpark, under

Mets owner Fred Wilpon, with an option to muscle out the industrial businesses. In 1997, Giuliani's NYPD, along with federal and state officials, raided the Triangle in an operation called Spring Cleanup. Men were charged with running chop shops. Some were detained by immigration officials. Giuliani, as we know, loved a good raid, a tactic he repeatedly used in neighborhoods targeted for revitalization. By that time, the ethnic mix of the Iron Triangle had diversified into a "kind of gumbo," as the *Times* described it, of "Hispanics, Caribbeans, Asians, East Indians, North Africans, Eastern Europeans and white Americans." A few Italians remained, but they were not the majority, and immigrants—especially the undocumented—are easier to push around. Still, the Triangle survived. Its working-class people continued laboring together in a muddy swamp neglected by the resentful, revengeful city government. For years, City Hall would not give them sidewalks. They would not pave the roads. They would not plow the snow. And they would not install a sewer system. With that, the city created blight, the required condition for eminent domain. It was all part of the long game to grab this long-contested land. Nothing was natural about it.

One summer evening in the 1990s, a friend brought me to the Iron Triangle for dinner. If that seems like a strange place to get a meal, well, it is. We had tickets for a Mets game and didn't want to spend our money on overpriced ballpark food. My friend knew of someplace more interesting, far back of Shea. He led me down the street beneath the elevated train tracks and into the Iron Triangle, through the ravaged roads between auto body shacks decorated with glinting hubcaps and piles of tires. I felt like I'd entered a border town. Dogs roamed unleashed. Salsa music played from open garages where mechanics worked on a steady stream of cars. New bumpers, new headlights, new windshields. Men sat at folding tables playing dominos. Women pushed carts selling shaved ices and empanadas. A scavenger pushed a busted grocery cart loaded with scrap metal. The place felt like another country. My friend and I stepped into a tidy,

scruffy deli and he ordered for both of us in Spanish from the steam table of roasted chicken, empanadas, yellow rice, and beans. Jarritos sodas in neon-liquid bottles. The island taste of tamarindo. We sat and ate, surrounded by mechanics eating out of Styrofoam containers, the grease of work on their hands. This would not last. In 2004, determined to succeed where Moses, Koch, Cuomo, and Giuliani had failed, Mayor Bloomberg set in motion an aggressive plan to take the Iron Triangle from its people.

At two ends of the 7 subway line, 5 Pointz and Willets Point bookend a borough on the cusp of change, where gentrification is happening sporadically. Some of that change has been directly manufactured by City Hall, and some is indirect, spillover from rezoned, redeveloped Brooklyn, the endless push of Manifest Destiny. These days, we hear most often about Ridgewood, Queens. Its borders touch three of Brooklyn's most gentrified neighborhoods—Greenpoint, Williamsburg, and Bushwick—and the L train, that hipster express, skirts its lower regions. Just looking at a map, you can see it was only a matter of time before the Williamsburg diaspora crossed the line.

In 2006, a realtor told the *Times*, "We are getting a lot of people from Williamsburg and Greenpoint, selling there for $1 million, then buying in Ridgewood for $550,000." The president of the Ridgewood Property Owners and Civic Association made a wish for more upscale businesses. "A Starbucks would help," he said. Seven years later, the *Times* reported "Costly Rents Push Brooklynites to Queens." And then, just like that, it was official. Ridgewood had arrived.

One age-conscious young newcomer told the *Times* that Ridgewood was "an old-school place" full of "older people." He likes to wear stylish clothing so he doesn't "feel old." Aptly, he met his girlfriend while working at the chain store Forever 21. Said another young newcomer, "When I first moved there, I never saw people that were my age." She would only need to wait one year for Ridgewood's

demographic shift. "Creative people," she concluded, "love to be the ones that explore new territory." In came the vegan muffins, yoga studios, and "destination pizzerias."

"Queens is the new Brooklyn," real estate brokers began insisting. The *Times* nicknamed the place "Quooklyn."

Excited young entrepreneurs, encouraging more cool young people to move to the dowdy old borough, started selling Queens-branded merchandise, sweatshirts that read "I Heart Astoria" and "QUEENS VS. EVERYONE." The owner of one "premiere life-style store," a former stockbroker who moved to Astoria, told the American Express website, "I was living in this neighborhood that was really underserved. There was nowhere to shop: no gift store, boutique, clothing store." Of course, Astoria was full of businesses—discount shops, low-key restaurants and bars—but they didn't count.

One Upper West Side couple told the *Times* they moved to Jackson Heights for that "being-in-the-melting-pot feel." About midway between Long Island City and Flushing, Jackson Heights is celebrated for its exceptional diversity. Perhaps comparable to what the Lower East Side used to be, it is a neighborhood of recent immigrants and the working class. It's also popular with blue-collar queers. Though no stranger to homophobic and transphobic violence, it hosts several racially diverse gay bars, Queens Pride House, and the annual Queens Pride Parade. Transgender sex workers walk the stroll of Roosevelt Avenue under the girders of the elevated 7 train. But look out. The ex–Upper West Siders, like many others, have begun "recruiting friends" to join them. They hope "the Jax," as they call the neighborhood, will catch on. So do politicians.

In 2012, the *Times* called Jackson Heights' Roosevelt Avenue a "corridor of vice." While violent crime was low, prostitution was high and undocumented immigrants could easily get fake IDs. People were stopped and frisked. Trans women were arrested just for carrying condoms in their handbags. "When you walk up and down Roosevelt Avenue, you'll see the dirt," said Jose Peralta, Demo-

cratic state senator for the district. He hoped Bloomberg's vision for Willets Point would bring national chains to Jackson Heights, and that its transformation would be like Times Square's. The *Times* connected the dots between the two neighborhoods: "If Mayor Michael R. Bloomberg's long-held plan to develop Willets Point, the industrial area near Roosevelt's eastern terminus, into a residential neighborhood comes to fruition, the avenue will become a tributary to that community." And that dirty tributary would have to be sanitized and homogenized.

When Bloomberg put out the call for proposals to redevelop Willets Point, dead plans resurfaced like zombies from the grave: a convention center, a shopping mall, a football stadium, an Olympic village. Then the Mets broke ground on Citi Field, a new ballpark named after Citigroup, the multinational bank fined by the U.S. Securities and Exchange Commission for helping Enron commit fraud. They demolished Shea Stadium, that blue and orange bowl named after William Shea, who brought National League baseball back to New York. Citi Field was situated within spitting distance of the Iron Triangle. That old eyesore, that steadfast survivor, would have to go.

In 2007, Bloomberg revealed his administration's "master plan," announcing, "After a century of blight and neglect, this neighborhood's future is very bright indeed." In the architectural renderings, the new Willets Point is another extension of the Generic City, a grid of glass boxes and shops stamped with global corporate brands, another geography of nowhere with a high-rise hotel and convention center, nearly two million square feet of restaurants and national chain retail, and housing—much of it unaffordable to most New Yorkers. And if the owners of the 250 existing businesses refused to sell their property? The city would use eminent domain to take it from them. Hundreds of workers protested. Sawdust manufacturer Jake Bono told the *Daily News,* "This is the American Dream, to own your own business, your own land. Now, it's turned into an American nightmare."

On a winter's day in 2007 I went to Willets Point to visit the Bono

Sawdust Supply Company. It's located in a long, low brick building, with silver duct pipes zigzagging over the roof, and the company's logo of a smiling cartoon bumblebee on a sign outside. "That's 'cause we're busy bees," Jake Bono explained as he welcomed me into the office, past posters that read "Not For Sale" and "Stop Eminent Domain Abuse." A third-generation sawdust man, Jake was maybe thirty, with a shaved head, meaty hands, and a toothpick stuck between his teeth. On his winter coat was pinned a button with the message "Willets Point Not For Sale."

The small space he ushered me into was cluttered with American flags, maps of Italy, and mementos—black-and-white photographs of the company's founders standing atop mountains of sawdust sacks, along with a calendar girl from 1961 easily disrobed with the lifting of a cellophane sheet.

"It's just for nostalgia," said Jack Bono, Jake's father. A man with a serious face made more so by the presence of a long, white handlebar mustache, he was the son of Sicilian immigrant Jacob Bono, who founded the company with his two brothers in 1933. During the Great Depression, the Bono brothers spent long days delivering bags of sawdust in horse-drawn wagons to saloons, butcher shops, and loading docks all over town. At night, without rest, they laid the bricks for their building, the same structure that stands today.

"How do you put a price on that?" Jack asked, tugging off a dusty pair of work gloves. "I don't want to move. This is my home."

Jake sat chewing his toothpick. The city was pushing him and he didn't like it. "This is street tactics," he said of Bloomberg's maneuvering. "Strong-arming. Extortion. My father's been working here since he's twelve years old. Since I'm a little kid I'm coming here, playing in the sawdust. I learned how to work here, how to interact with people."

The city, insisting that all the Willets Point businesses would be adequately relocated, showed the Bonos a handful of new sites, but none compared to their intricate complex, custom-built by the

hands of their forefathers. In one insulting offer, they were shown a tiny storefront that housed a check-cashing outfit. Jake and his father laughed at the farce. They had to laugh; otherwise it'd be ulcers and sleepless nights, not knowing what was happening next.

The Bonos gave me a tour of the building and explained how the walls, roof, and basement are filled with a Habitrail of metal tubing that whisks the sawdust from one place to another, filtering and sorting as it goes. Each cinder-block room we entered was dusted in gold. It looked like it had just snowed, but the snow was tawny, like sand piled along the windowsills and drifting into corners. It smelled wonderful, fresh and woodsy. I wanted to scoop it into my hands and breathe it in.

"You know what Bloomberg said about us all up here? I heard this on the radio," said Jack. "He said: *'This land is too valuable for you.'* Too valuable for us?"

Jake shook his head and took the toothpick from his mouth. It was half-eaten, ground to splinters. He said, "What's Bloomberg gonna say next? You're wife is too pretty for you, so you can't have her? People have to realize, they could be next. We're not just fighting for us. We feel proud because we're fighting for everyone who owns or wants to own a piece of property. That's what people work for. But with eminent domain, no one really owns their property. It can be taken from you at any time."

With a tone of resignation, his father added, "There's a reason they have that saying, 'You can't fight City Hall.' We have nobody to stick up for us. Nobody." But that wasn't going to stop Jake. "The two of us," he said to his dad, "we're gonna fight to the last breath in our bodies to keep what's ours." They haven't budged yet.

The City Council approved Bloomberg's $3 billion plan, giving the green light to the chosen mega-developers, Sterling Equities, owned by the Wilpons and Katzes of the Mets and Citi Field; and Related Companies, the main developer of Hudson Yards, back in Manhattan. (It's no surprise that Bloomberg also extended the 7 sub-

way line to link Hudson Yards to Willets Point.) The Queens deal was loaded with corporate welfare, starting with a shocking bargain-basement price: the city sold $1 billion worth of public land to the developers for just one dollar.

Through city-led evictions, condemnations, and buyouts, many of the industrial shops vacated the Iron Triangle. Workers held a hunger strike, starving themselves for the right to stay put. The city handed out more eviction notices. The place became a ghost town as street-long stretches of auto body shops sat shuttered. I walked through one afternoon to find all the life drained from the place. No more salsa music. No more women peddling empanadas. No more men play-ing dominoes. I went into the only open deli I could find, unsure if it was the same one I'd visited years before. The three people inside turned their heads and glared. A Latino mechanic stepped forward and thrust his hand out to stop me, saying, "Workers only. This place is not for you." I realized what I looked like—a middle-class white man, the enemy at the gates—and understood that I was no longer welcome in this embattled space. The doors of the Iron Triangle were closed.

On November 19, 2013, I woke to a flurry of emails and tweets about the sudden destruction of 5 Pointz. As commuters rode the 7 train into Manhattan that morning, they looked through the windows as they always had, waiting for that kaleidoscopic view. Some looked forward to the bright orange tiger that leaped from the shoulder of rapper Biggie Smalls, the Notorious B.I.G. Others pre-ferred the cinematic panorama of King Kong holding Faye Wray in one hand while he strangled the 7 train in the other. Some just en-joyed the colorful collage of it all. My favorite piece was a large mural that seemed to sum up what was happening to 5 Pointz and the whole city. *Fressen & Gefressen Werden,* "Eat and Be Eaten," by the team of Onur, Semor, Wes21, and KKade, showed a monster fish clamping its

jaws around a smaller monster fish clamping its jaws around a squid swallowing a crocodile with its teeth around a great white shark opening its mouth to devour a businessman. Suit, tie, briefcase, in he goes, dropping his cup of Starbucks coffee to the sidewalk. You think you're powerful now, the mural implied, but everyone is someone's lunch. It was a beautiful piece, vivid and visceral. On that November morning, along with all the rest, it was gone. Buffed. Vanished.

Under the cover of night, with protection from the NYPD, workers hired by the building's owners erased the walls with coats of white paint. 5 Pointz looked like a body spackled in calamine lotion. All the color gone.

Just one month earlier, at the same meeting that buried Willets Point, the City Council approved plans by Jerry Wolkoff and his son, David, to demolish 5 Pointz and build luxury high-rises much higher than the current zoning allowed. The 5 Pointz community protested. On November 16, hundreds of artists and supporters gathered to play music, make aerosol art, and give speeches. The organizers announced their plan to submit a proposal to the Landmarks Preservation Commission, arguing that 5 Pointz should be protected. Just three days later, it was whitewashed, leaving nothing left to landmark.

When threatened with landmarking, building owners will often "scalp" or "denude" historic structures they want to demolish, destroying everything that makes them eligible for protection. Jerry Wolkoff denied this was his motivation. He told the *Wall Street Journal*, "This is why I did it: it was torture for [the artists] and for me. They couldn't paint anymore and they loved to paint. Let me just get it over with and as I knock it down they're not watching their piece of art going down. The milk spilled. It's over. They don't have to cry." To *New York* he said, "I had tears in my eyes while I was doing it." In the *Village Voice*, 5 Pointz spokesperson Marie Cecile Flageul responded, "The only tears he possibly had this morning were tears of joy." She added, "Jerry Wolkoff just committed the biggest genocide of art in the 21st century."

After the whitewashing, kids were arrested for painting "RIP 5Pointz" on the blank building. Activist artists gilf! and BAMN wrapped it in giant yellow caution tape printed with the words GEN-TRIFICATION IN PROGRESS. Then, in 2014, 5 Pointz was demolished. When you ride the 7 past the site today, there's nothing to see but a muddy hole. Soon it will be filled with generic glass apartment buildings, $400 million monoliths. The Wolkoffs promise there will be a special wall to paint on, but the graffiti artists say they won't lend their soul to towers that toppled their spiritual home. Against protests, the Wolkoffs have gone ahead and registered the name "5 Pointz." They plan to brand it onto the towers to come, no doubt hoping that some of the old vanished cool rubs off.

THE SOUTH BRONX

Anti-gentrification mural by Harry Bubbins, East 140th St.
Ed García Conde, Welcome2TheBronx, 2015

O N AN AUTUMN NIGHT, JUST BEFORE HALLOWEEN IN 2015, A drunken crowd filled a derelict building once part of the sprawling J. L. Mott Iron Works, at the edge of the Harlem River along the postindustrial waterfront of the South Bronx. Ravaged cars peppered with bullet holes lay stacked in a rusty pile. Fires burned in oil drums where desperate men and women stood warming their hands in the crisp October air. It was a post-apocalyptic scene out of the bad old Bronx, but these people weren't desperate for survival—they were desperate for attention. And luxury real estate. This was the "Macabre Suite" art happening, a party to hype

the Bronx as "the next Brooklyn," organized by a group of real es-
tate developers, including the Chetrit Group (who bought the Chel-
sea Hotel) and Keith Rubenstein's Somerset Partners, along with art
dealer Jeanne Greenberg Rohatyn (daughter-in-law of Felix Rohatyn,
the investment banker who suggested in 1976 that the South Bronx
be blacktopped). Stamping their brand into the neighborhood's tough
hide, the developers had just upset the community by erecting a bill-
board nearby renaming the South Bronx as the "Piano District," a
nod to the days when the neighborhood was full of piano factories.
Only now, instead of blue-collar workers, it would feature: "Luxury
waterfront living, world-class dining, fashion, art + architecture.
Coming soon." Rubenstein and Chetrit had announced plans to erect
half a dozen luxury apartment towers on the spot. Tonight they were
celebrating—and generating buzz.

Artist Lucien Smith was the star of the party. His bullet-riddled
cars conjured the "bad old days" of the Boogie Down, but they were
not native to the South Bronx. Smith had salvaged them from the
Knob Creek gun range's Machine Gun Shoot in Kentucky, and
turned them into readymade sculpture. (Coincidentally, J. L. Mott
Iron Works manufactured the first-ever readymade, a urinal bought
by Marcel Duchamp and turned into the infamous *Fountain* in 1917.)
Also in the show were paintings, dance performances, and instal-
lations, including a cluster of televisions that played found footage
from mental institutions, according to *ArtNews*. Onstage, Keith Ru-
benstein took the mike and announced, "We're developing about
two thousand apartments along the waterfront in the South Bronx.
Tonight is an amazing opportunity to introduce a whole new world
to the South Bronx, and celebrate its heritage." One partygoer noted
to *WWD*, "For the Millennials, if you will, this is a pilgrimage. From
Brooklyn to the motherfucking Bronx."

The motherfucking Bronx had never seen anything like this.
"The sprawling event," wrote the *Observer*, "was like witnessing a
presentation of Cirque de Soleil on the set of *Mean Streets*, cast with

a horde of gorgeous and wealthy creatives." In photos from the deca-
dent, Dom Pérignon–soaked bash, celebrities and fashionistas in fur
jackets posed like grinning hobos, rubbing their hands together over
the oil-drum fires. High-profile guests included John Varvatos, Ken-
dall Jenner, and Naomi Campbell. A food truck from the trendsetting
Roberta's Pizza served artisanal slices.

The backlash to the party was immediate and fierce. The me-
dia called it "tin-eared" and "tone deaf." City Council Speaker Me-
lissa Mark-Viverito tweeted, "Lack of empathy & basic awareness are
signs of an ailing society. Who thought 'Bronx is Burning' theme a
good idea?" Social media activists took to Twitter to express their
displeasure, using the hashtag #whatpianodistrict. Up-and-coming
artist Avery K. Singer turned down Rohatyn's request for a studio
visit, writing in a publicized email, "That party you threw was in
such poor, juvenile taste. I am actually shocked. How could you pos-
sibly think staging an urban blight themed party in the south bronx
for rich white people would be a good idea?" For Ed García Conde,
blogger of Welcome2TheBronx, the party brought to mind "a cross
between 'Caligula' and 'The Hunger Games,'" as he told the *Times*.
"Can you imagine the response if we held a party themed with ves-
tiges of the Holocaust? For people in the South Bronx, this was our
Holocaust."

Keith Rubenstein responded to the critics, insisting that his inten-
tions, and those of his co-organizers, were misunderstood. "We're
not displacing anybody," he told the *Times*. "We're bringing people
who might not otherwise come to the Bronx." Of the Piano District
rebrand, he said, "I'm just expressing my thoughts on what I believe
to be an accurate, historical reference to what existed in this area
in the early 1900s." He then called upon his First Amendment right
of free speech. *ArtNet News* followed up with co-organizer Rohatyn,
who said of the exclusive bash, "The entire Piano District community
was included. There was a huge mix of people, and there was good
will all around." On his blog, García Conde posted a photo taken that

night just outside the party. On one side, the party site is ablaze with blushing floodlights as well-dressed revelers stand around chatting. On the other side, tucked beneath the ramp for the Third Avenue Bridge, a homeless man sits by his wheelchair and cardboard box home. I doubt he got the invitation.

The story of the battle for New York's soul is here in the South Bronx: deindustrialization and the loss of working-class jobs, redlining, white flight, the creation of slums, Robert Moses's meat axe cleaving neighborhoods with the Cross Bronx Expressway, white backlash, planned shrinkage, benign neglect, and "the Bronx is burning." In the 1970s, the area became synonymous with urban decay and violence, Fort Apache, the jungle. An "international code word for our epoch's accumulated urban nightmares," in the words of South Bronx native Marshall Berman, it was the no-man's-land to which Ed Koch's brave pioneers would never dare venture. Joe Flood, author of *The Fires*, reported: "Seven different census tracts in The Bronx lost more than 97% of their buildings to fire and abandonment between 1970 and 1980." A building, once burned, might be set ablaze another dozen times. We all know the rubble scenes of tenement skeletons and ragged mattresses, hydrants dribbling like busted faucets, abandoned cars with the guts ripped out. Street gangs with their names stitched on the backs of denim vests: BLACK SPADES, SAVAGE SKULLS, GHETTO BROTHERS. The South Bronx as war zone. Shocked, awed, and blitzed. In the 1980s it's where Tom Wolfe's yuppies took a wrong turn in *Bonfire of the Vanities*. And where the urban wasteland harbored supernatural killer wolves in *Wolfen*— a movie "set during a critical moment in the collapse of radical politics and the emergence of a feral neoliberalism, against a backdrop of urban dereliction and redevelopment," says Jeff Kinkle in his online essay "Neoliberalism as Horror: Wolfen and the Political Unconscious of Real Estate." (Gotta love that title.) The wolfen, revered by

local Native Americans, target a wealthy real estate developer named Van der Veer, a descendant of the Dutch colonizers who first took the city. It's the pioneer mythology come full circle.

Today, the hyper-gentrification gunning for the South Bronx is trying to pass itself off, as it often does, as revitalization. In this supposed wasteland, the gentrificationists insist, there will be fresh vegetables at the corner markets, green spaces, and safe streets. Who could argue with such improvements? No one wants a wolfish wasteland. But by now we know that a rising tide does not lift all boats. We know that early-stage gentrification, in the globalized city, does not sit tight. Its equilibrium tilts quickly. When it does, it brings a mass displacement of lower-income people, and their homes and businesses. It brings the loss of local flavor and character. It dulls the streetscape with generic glass buildings and controlled private-public spaces. It creates a zombie New York. And that is the real horror movie of neoliberalism in the city.

While it's happening slowly in the Bronx, throughout the 2000s Manifest Destiny has been pulling pioneers northward to the latest, if not last, frontier, "discovering" and renaming as they go. "SoBro," short for South Bronx, is the nickname created by the real estate industry to evoke the grit-to-glitz miracle of Manhattan's Soho, or SoHo (short for South of Houston Street). They want so much for us to forget the past. In 2002, the *Times* anointed SoBro's Mott Haven area with a big Neighborhood Report, and the *Voice* asked the inevitable: "Is the South Bronx the New Williamsburg?" Brooklyn developer Carnegie Management had just converted an old piano factory into the Clock Tower Building, with loft apartments renting for $950 to $1,700, high prices for that part of town. Carnegie's Isaac Jacobs told the *Voice*, "This is the new frontier."

In 2005, the City Council approved Bloomberg's plan to rezone the Port Morris section of the Bronx to increase residential and retail development. Activist lawyers and artists fought for half of all new housing to be low-income, but Amanda Burden "objected success-

fully that such set-asides would have discouraged development," according to Joseph Berger in the *Times*. He quoted Neil Pariser, senior vice president of the South Bronx Overall Economic Development Corporation, as saying, "What you don't want to do is relegate an area that has finally achieved a place in the market to only the poor. This should be for everybody." This is a prime example of the skewed logic often heard in the 2000s, in which *diversity* means *not too many poor people* and *inclusion* means *include the rich*. The argument is also used to support national corporate retail. Regarding the possible influx of homogenizing big-box chains to the Bronx, Pariser told the Center for an Urban Future, "bring them on. I'd love to see some of the larger retail chains here in the Hub. . . . [I]t is a diversification of the retail character of our borough."

In 2009 the City Council approved another Bloomberg rezoning and place-making scheme, for an area that stretches across the South Bronx and up along the Harlem River, with the luxurious new Yankee Stadium at its northernmost point. According to the press release, the plan would bring in "about 800,000 square feet of commercial and retail space" and "160,000 square feet of hotel and conference space," along with new residential buildings. The Department of City Planning admitted that the rezoning was intended to "encourage high-profile redevelopment." Community activists fought back, envisioning a future that the *Mott Haven Herald* described: "the Harlem River Waterfront could be transformed within a decade to a Battery Park City of the North, with towering apartment buildings as high as 40 stories overlooking a waterfront promenade laced with open-air cafes and patches of green."

In 2012, when the online grocer FreshDirect threatened to leave New York, abandoning its Queens location for New Jersey, Bloomberg stepped in and offered them a slice of the Bronx, public land, complete with millions of dollars in city and state subsidies. Good Jobs New York online provides a chart of proposed and approved subsidies for the company, including tax credits, grants, and loans. That

list totals over $268 million. Most reports say the final number was around $130 million. Calling this an "outrageous misuse of taxpayer money," South Bronx Unite, a coalition of community groups, filed a lawsuit against the city and FreshDirect—and lost. Bill de Blasio, while running for mayor, vehemently criticized the deal and vowed to stop it and other corporate welfare schemes. Once elected, however, he dropped the issue, breaking his campaign promise. FreshDirect broke ground in the Bronx at the end of 2014. CEO Jason Ackerman told *Crain's*, "This project is going to generate a huge amount of business development in the area. We want to absolutely encourage as many services as possible to follow us into the South Bronx."

To revitalize the Bronx, city leaders gave the borough its own High Line. Of sorts. Built in 1848 and closed around 1970, the elegant steel and stone High Bridge spans the Harlem River, connecting the Bronx to upper Manhattan. In 2015, reclaimed from urban decay and scrubbed clean, it reopened to pedestrians and bicyclists. Immediately, the High Bridge was compared to Chelsea's High Line. At the reopening, Bronx Borough President Ruben Diaz Jr. said, "Downtown may have the High Line, but uptown we have the High Bridge." The *Post* announced, "Finally, Uptown Gets Its Own High Line." And the *Times* declared it a "Scenic and Serene Cousin of the High Line." As we know, the High Line has proven to be a powerful catalyst for hyper-gentrification. It is being copied by competitive cities across the globe, and other neighborhoods in New York. Everyone wants a High Line—for the tourists and property values that follow.

The new High Bridge is lovely. Jane Jacobs probably would have approved. One of its supporters, urban psychiatrist Mindy Thompson Fullilove, explained to the *Times* that it reopened what had been a broken artery, reconnecting one neighborhood to another, and that's a good thing. But there is always a darker strain that flows through such projects of urban rejuvenation. As the real estate blog Curbed noted about the High Bridge, "there are some concerns that, with its sudden, ready access to Manhattan (and the A/C trains just a few

blocks away), developers will now eye the long-ignored Bronx community called Highbridge." *Crain's* reported that gentrification was already reaching Highbridge. Rents had begun to rise, along with evictions and homelessness. The average income of the neighborhood "climbed nearly 15% between 2005 and 2010, buoyed by a tide of people fleeing across the Harlem River from gentrifying areas in upper Manhattan in search of more affordable apartments. . . . That wave was enough to drive rents upward by 10% in the same period." The reopened High Bridge will enable priced-out middle-class Manhattanites to easily access the new Bronx. Who, then, was it intended for?

On the occasion of the High Bridge's reopening, *Newsweek's* Alexander Nazaryan went to check out the South Bronx. He found only a few key signs of change. Artisanal breweries. A tech incubator. A white woman jogging in neon gear along the Harlem River. "Once in a while," he wrote, "you do meet some scruffy artist who lives there, some skinny-jeaned hipster for whom Brooklyn is lame and Manhattan is death. The South Bronx is where it's at, man, haven't you heard? A crowd will inevitably gather around him at a party, as if he'd recently escaped a North Korean prison camp. Everyone wants to know his rent."

Bronx hyper-gentrification might be moving slowly, but it isn't holding back on hype. The *Daily News* called it "South Bronx Sizzle," giving a rundown of the numbers: real estate investors dropped $2.39 billion into the Bronx in 2014, a 39 percent increase from the previous year, and sales of development sites were up by 85 percent. "The frontier is always the best investment," a real estate consultant told *The Real Deal*. The Bronx, she added, is "a seething hotbed of people buying land." Bronxites aren't taking it lying down.

I n 2013, I attended the first annual Bronx Gentrification Conference at the Bronx Documentary Center, located on a quiet street

lined with bodegas and barbershops. From past experiences at similar events, I expected a small crowd, but the place was packed. Turned away at the door, people stood outside in the cold, pressing ears to the glass. From past experiences, I expected a passive group, people who'd been beaten down from years of losing battles. But the Bronxites were not passive. They were angry, passionate, and desperate to be heard. For them, this was new. Apathy had not set in. The people of the Bronx had been watching the gentrification battles raging down in Manhattan and Brooklyn, and had plenty of time to figure out the enemy's strategy. They were also a tough bunch who did not buy the bullshit.

During the first panel, on which all the speakers were white in an audience made up mainly of people of color, an employee of the city's Department of Housing Preservation and Development (HPD) explained how his organization hadn't yet done much to bring in luxury development. But, he said, "we're pushing," because "we believe in economic diversity." He added that the local community boards had been "demanding higher-quality retail . . . national chains that best serve everyone in the community." The audience began to groan. People shook their heads, sucked their teeth, and fidgeted in their seats. The energy in the room was beginning to boil. It exploded when the man from HPD said, "If the definition of gentrification is about displacement, then, so far, gentrification hasn't happened in the South Bronx." An audience member shouted back, "That's the stupidest statement I've ever heard!" The people took over, turning the conference into a community forum. One local woman wondered how to strengthen mom-and-pops "so they can withstand a wave of gentrification." A man from the East Village talked about the invasion of chains and asked why local community boards in the Bronx would want them. Audience members shouted: "Because they don't live here!" and "They don't know any better!" When someone said, "We want a nice café," another man shouted, "You put a nice café in *my* neighborhood, it's getting a brick through the window!"

Since then, several protests have taken place, organized by groups like Take Back the Bronx and South Bronx Unite, to oppose hyper-gentrification. They've protested against FreshDirect and the de Blasio administration's planned transformation of blue-collar Jerome Avenue into a new neighborhood—about which Bronx Documentary Center founder Michael Kamber wrote in the *Times*, "The formula is simple: rezoning; tax incentives for developers; new 11-story buildings that house thousands (some low income, most not). Chain and big box stores are in—immigrants fixing cars are out. Speculators are already staking claims." They also protested a pop-up art show at the abandoned old Bronx Borough Courthouse, a landmark Beaux-Arts building shuttered since the 1970s, bought by a developer in the 1990s, and opened briefly in 2015 for No Longer Empty, a non-profit that curates art exhibits in vacant spaces around the city.

The show, titled *When You Cut into the Present the Future Leaks Out*, featured many local artists and community events, but one event did not sit well. Called "Future Tenant: A Broker Party," it was produced in partnership with the South Bronx Overall Economic Development Corporation and advertised as "a tenant attraction event to convene entrepreneurs, real estate brokers, and business owners interested in the area." According to an exposé on the arts blog Hyperallergic, the artist participants didn't know about the broker party. They were disturbed by their unwitting role in attracting investors. Local artist and activist Shellyne Rodriguez told journalist Jillian Steinhauer, "Artists are not the root cause [of gentrification]. But artists are well aware at this point that we are the bees to the honey." She asked, "are you using yourself as bait to developers in order to gain access to interesting spaces without really fully thinking about the repercussions?" A group of protesters attended the show's opening. They shouted, "Don't use art to pimp us out!" A few weeks later, after discussions with angry community groups, No Longer Empty canceled the brokers' party, but the tensions continued, as they often do when art is exploited to usher in gentrification.

A couple of weeks after the "Macabre Suite" art happening, I took a walk through Port Morris/Mott Haven, expecting to find a neighborhood fully in the throes of socioeconomic transition, like Bed-Stuy or Crown Heights, dotted with cute cafés and boutiques, peopled by shiny, happy newcomers. Instead, I found a neighborhood still lagging behind the curve. Walking down Alexander Avenue and Bruckner Boulevard on that sunny Saturday afternoon, I passed mostly shuttered storefronts. One lonely sushi restaurant, a frequent sign of gentrification, wouldn't open until dinner. Scaffolding shadowed the sidewalks. A storefront gospel church offered all-day prayer. On the side of an old piano factory, a FOR LEASE banner flapped in the wind, heralding development, but on close inspection the building was wrapped in razor wire and marked "Parole Office." By the on-ramp to the Third Avenue Bridge, a powder blue Winnebago spray-painted with the words "Who's Your Daddy?" offered DNA paternity testing on the spot. Nearby, Calientito, a Dominican and Puerto Rican restaurant, had its shutters down and a SEIZED BY THE MARSHAL sticker affixed to the window. They'd just been evicted. Later that evening, community members would gather for a Day of Solidarity in front of the restaurant, which they called "the first victim of gentrification in Port Morris." Other signs of protest were evident, if you looked closely for them. On a busted-out fire alarm call box, perhaps neglected since the burning 1970s, someone had slapped stickers for #whatpianodistrict and "Boycott FreshDirect."

I kept searching for signs of the "South Bronx Sizzle," that gold rush of gentrification that everyone was buzzing about. In the pioneering Clock Tower Building, I wandered into Charlie's Bar & Kitchen. I found groups of young people eating brunch, sipping mimosas, and glittering in the bright November sunlight that streamed through the spotless windows. In the back room, a group of middle-class African-American millennials partied, gentrifiers less visibly so. In the front room, everyone was white with fresh-scrubbed Middle American looks. Where had they all come from? I hadn't seen any-

one like them on the streets or getting off the subway. Had they tele-
ported here directly from the Meatpacking District? Maybe they all
took an Uber. Through the window, I watched while small groups of
others like them trooped under the bridge, one bunch after another,
like ants following a trail to something sweet. I hurried after and
found myself in the shadowy cul-de-sac where the "Macabre Suite"
party had been held. The people weren't going down there to repair
a motorcycle or order an industrial ice machine, as one could do. In-
stead, every last one of them headed into the Mott Haven Bar & Grill,
a corner spot designed in old-timey hipster style, but with football on
the flat-screen televisions. I didn't go in.

I walked under the bridge, past the homeless man's encampment,
toward the site of "Macabre Suite." Out in front stands the Beethoven
Pianos building, its antique gold signage painted on grimy chicken-
wire windows: Tuning, Moving, Repairs, Storage, Grand, and Up-
right. Founded in 1918, in the glorified time before the Bronx was
ripped apart and left to burn, it surely inspired the Piano District re-
naming scheme. I looked around for other signs of change. Facing the
building, on one of the wide concrete slabs holding up the bridge's
overpass, beamed a bright, freshly painted mural by the legendary
TATS Cru. In vivid colors it showed a busty, dreamy-eyed woman lis-
tening to 45s on a record player by the words "Welcome to the South
Bronx. Act like you know."

Locally based TATS Cru started out illegally tagging subways
in the early 1980s. Today they're professional muralists who've done
commissions for corporations like Coca-Cola, Nike, and Bloomberg.
Responding to accusations of having sold out, Cru member Bio told
ABC News, "Everybody works for someone at some point." He's
right. Everybody's got to pay the rent. And yet, as we've seen, graffiti
and street art, once the outlaw symbols of urban unrest and rebel-
lion, are now co-opted by corporations, developers, and city govern-
ments to help bring gentrification to "edgy" neighborhoods.

The strategy is also known as "artwashing," what writer Feargus

O'Sullivan defined in *The Atlantic*'s *CityLab* as the process whereby "the artist community's short-term occupancy is being used for a classic profit-driven regeneration maneuver. . . . When a commercial project is subjected to artwashing, the work and presence of artists and creative workers is used to add a cursory sheen to a place's transformation." Just like No Longer Empty's pop-up show and Lucien Smith's "Macabre Suite." But maybe also like the TATS Cru mural, though it's not so clear. O'Sullivan adds, and I would agree, "This doesn't mean that artists are themselves predatory. Many artists live on working-class money, their movements within cities dictated not by a desire to transform a neighborhood but to secure affordable space to work and live in." While the TATS Cru mural welcomes newcomers to this hotly contested corner of the South Bronx, it also slyly warns them to "act like you know." In other words: be respectful. As one of my blog readers, Miz Overstood, explained: "act like you KNOW you are the gentrifiers making people lose their homes, act like you KNOW you in the south bronx, yes be polite just not TOO polite. and also boldly jogging in your lululemon bullshit will not generate good vibes neither."

Standing outside Beethoven Pianos, I looked up to the slice of blue sky between the factory bricks and the bridge, beyond the black silhouette of chain-link fence and razor-wire loops. Other painters had offered a different message to the newcomers. High above, with its face turned to commuters driving into Manhattan, stood Rubenstein and Chetrit's controversial Piano District billboard. Since the art party and its aftermath, the sign had been attacked by a fusillade of paint grenades. Angry Bronxites had splattered the words *luxury, fashion, dining,* and *architecture* with explosions of beige and white. Wait a minute. Beige and white? The preferred neutrals of modern condo decor? They couldn't find any red, the blazing hue of blood and rage? Considering these tame and tasteful color choices, I could not help but wonder if the developers were behind this. Maybe they hired a team of paint bombers to give their billboard a certain edge.

In today's hyper-gentrified city, it's often impossible to tell the real from the simulation, the authentic from the appropriation.

I walked away feeling unsure—about the paint splatters and the mural, but also about the possibility of hyper-gentrification in the South Bronx. Two trendy restaurants do not make a Meatpacking District. This is still a tough corner of town full of people ready for the fight. But we've seen other tough corners get whitewashed away, slaughterhouses turned into condos, dark alleys transformed into glamorous pedestrian thoroughfares. And we've seen fighters fall. The new people are coming. Manifest Destiny demands it. In 2016, the city approved plans for Rubenstein and Chetrit's luxury apartment towers. In renderings, they look like all the other monstrous glass hulks cluttering the city's waterfronts. Utterly unlovable, they will yet fill with people. They will cast their long shadows upon the oily green Harlem River where new pioneers will paddle in candy-colored kayaks, modern versions of Lewis and Clark's expedition canoes. Looking inland from that water today you'll find another sign, painted in bubbly graffiti along a row of concrete jersey barriers facing out from the crumbling shore of the South Bronx. In big letters, the message reads: NO LONGER BURNING.

ON MEMORY AND FORGETTING

Banksy mural, downtown Manhattan, checking on the health
of the city's heart. *Aaron Bawol, 2010*

H OW WE TALK ABOUT THE CITY MATTERS. WHEN MAYOR BILL
de Blasio took over from Bloomberg in January 2014 with
promises to heal the economic gap in New York's "tale of
two cities," his rhetoric helped to shift the collective conversation.
Previously ignored or left largely undebated in the mainstream press,
gentrification became a trending topic.

In the February 2, 2014, issue of *New York* magazine, Justin Da-
vidson published a controversial and much-discussed piece titled "Is
Gentrification All Bad?" His answer was no. "Gentrification can be
either a toxin or a balm," he said, distinguishing between changes

that occur, naturally and gradually, from inside a neighborhood and those that invade with rapid force. "A nice neighborhood," he concluded, "should be not a luxury but an urban right." A few weeks later, partly in response, Spike Lee gave his anti-gentrification jeremiad in Brooklyn. The floodgates opened.

Josh Greenman at the *Daily News* published an op-ed called "Gentrifiers, Hold Your Heads High." He described himself as a Brooklyn gentrifier and cited the history of changing neighborhoods, how one ethnic group replaces another, characterizing the current shift as just another phase in the normal, ongoing rhythm of the city. "Everyone replaces someone," he wrote, calling gentrification "mostly innocuous, inevitable and, in a diverse and economically dynamic city, healthy." Later in 2014, the *Guardian* called gentrification "not just 'natural,' but also healthy for cities." The sentiment continued into 2015, with a *Slate* article titled "The Myth of Gentrification: It's extremely rare and not as bad for the poor as you think," followed by another in *The Economist* that cried, "Bring on the hipsters. Gentrification is good for the poor."

In early 2015, after losing the fight to save Times Square's Café Edison, I started a grassroots project called #SaveNYC, with a mission to raise awareness and pressure so-called progressive politicians into protecting the city's small businesses and cultural institutions, the stuff that gives New York its New Yorkness. For the first time, journalists criticized me. I had been blogging loudly on the issue of hyper-gentrification for eight years, but now I was getting organized, calling for reform, and in de Blasio's New York—at least at the beginning—this was perceived as a threat. I was derided as a nostalgic complainer, out of touch with reality and unaware of history.

In the *Observer,* Anthony Fisher wrote an op-ed titled, "The Tyranny of Nostalgia Is Making Cities Unaffordable," naming me as nostalgia tyrant number one, an elitist who spends too much time "kvetching that 'New York is dying.'" In a *Daily News* op-ed, architectural historian Francis Morrone told me and other "nostalgic

complainers" to "get a grip." He called us the "vanishing New York mindset," a whiny bunch with no historical perspective. Also in the *Daily News*, Glynnis MacNicol argued that while the "vanishing of New York is a miserable business," to advocate for reform is an act of nostalgia for one's youth. New York is always changing and we need to accept that, "instead of weeping over what it used to be." In *New York*, Justin Davidson returned to the topic, hosting a gentrification grudge match between me and Nikolai Fedak, the pro-development blogger of New York YIMBY (Yes In My Backyard). "The only unchanging constant in New York is change," Fedak told us. "I think the city needs to evolve, and Jeremiah's nostalgic for the city of the past." And in her book *St. Mark's Is Dead*, Ada Calhoun listed me under the category of "Nostalgics." From Calhoun's perspective, the city never dies, it only keeps changing, and complaints about its vanishing are perennial, mere expressions of longing for one's youth, when the complainers were "at their hottest."

First of all, in terms of hotness, I peaked at forty. But let me address this nostalgia business.

One: There is nothing nostalgic about fighting to preserve the economic and cultural diversity of a city. It has more to do with the present and future than it does with the past. *Right now* people are being evicted from their homes and businesses. *Right now* the city is choking on chain stores. Do we really want a future New York with nothing but Starbucks, banks, and luxury towers, where no one but the most affluent can afford to live? It's not regressive nostalgia to worry about that. It's forward-thinking anxiety.

Two: I am absolutely nostalgic about the lost city—and why not? Pete Hamill called nostalgia "far and away the most powerful of all New York feelings." But those feelings don't invalidate the facts about hyper-gentrification and its part in the long history of Elites trying to strangle the wild and progressive city. Those feelings don't change the fact that New York is being systematically reconstructed to embrace a small segment of humanity and exclude the rest.

Three: Nostalgia is not a bad thing. It's an important part of mental health. In a mortality salience study from the United Kingdom, researchers found nostalgia to be a "meaning-providing resource" and a form of "terror management." When instructed to think about death, subjects prone to nostalgia were less disturbed by their own mortality. In another study from China, nostalgia was found to decrease feelings of loneliness. "Nostalgia," wrote the authors, "is a psychological resource that protects and fosters mental health." A third study showed that "[n]ostalgia increases empathy toward those in need, which, in turn, increases charitable intentions and giving." In short, nostalgia can be a positive emotion that bolsters our sense that life is meaningful, decreases our fear of death, increases self-esteem, strengthens social bonds, and boosts empathy, which then leads to helping others. If only New York had more nostalgics.

I'd like to understand the people who keep repeating, "You're just nostalgic." The statement is likely meant to invalidate and minimize the complaints of those who point out that the city is being destroyed by hyper-gentrification. The preservationist's argument is framed as emotional, not rational, and therefore not to be taken seriously. In our Enron Society, emotions, associated with femininity and weakness, are devalued in a sexist and sociopathic system juiced on competition and dominance. Empathy is met with derision. "You're just nostalgic" feels like gaslighting, a tactic used to convince people that what they perceive is not true. *You're just imagining it. There's nothing happening here. You're being emotional.* We're all just a bunch of hysterical Cassandras, screaming about the fall of Troy and something about, you know, Greeks hiding inside horses.

Why are some people so invested in getting us to forget the past? Many probably profit from the new New York. Or they like it and don't want to feel bad about liking it. They want to enjoy guilt-free lattes, bike lanes, and nice restaurants without having to think about the impact. Or else they just can't bear the pain of loss. Some are nostalgics of a different sort. At the end of *Times Square Roulette,* Lynne

Sagalyn names five types of nostalgics or "voices of lament." While she's talking about 42nd Street, her categories could apply to different emotional approaches people take when facing the losses of the radically changed city as a whole.

The Wistfuls, Sagalyn explains, "reflect fondly on the experiences they had" in the past, but "are not bitter about the changes." Their motto: "You win some, you lose some." Skeptics are "suspicious of the changes taking place," preferring the old to the new, but seem resigned to it. Mild-mannered Reminders share stories of loss, but "without histrionics." And Resilients are a sunny group whose "optimism comes from faith in the city's unpredictable ways." Sad about the losses, Resilients yet believe that New York's indomitable spirit will overcome. Then there are the Retrogrades. The most impassioned, they "voice intense personalized outrage at the intentional destruction," and celebrate the memory of a tawdry city while directing anger at developers and the government. They specifically lament the loss of authenticity, "resenting its replacement with a 'State of Fun.'"

If it's not yet abundantly clear, I'm an outraged Retrograde. I get impatient with the Wistfuls, Skeptics, Reminders, and Resilients, with their "Oh, well, everything changes" shrug of futility and forgetting. New Yorkers need to remember and get angry. I know it's hard. We're all stumbling through a smoke screen of propaganda and doublespeak. Around the world, people feel helpless watching their cities get squeezed by the same money-drunk global monoculture and winner-take-all drive to compete. With a force so ubiquitous, it's difficult to recall that urban life was ever different. Writing in 2015 on the death of bohemian Paris, Luc Sante nailed it when he said, "We have forgotten what a city was." We must remember.

From its beginnings, the city was a place of emancipation. "City air makes you free," an expression from the Middle Ages, refers to the feudal law that liberated serfs once they'd lived in a city for

a year and a day. For centuries, marginalized people have escaped the countryside and found freedom in cities—from enslavement and oppression, the restrictions of rural and suburban life, patriarchy, heteronormativity, and conformity. London urbanist Loretta Lees, writing on the emancipatory city, says the urban idea "lies at the heart of many utopian conceptions of democracy, tolerance, and self-realization."

The city was open—especially to people and ideas unwelcome elsewhere. Rebecca Solnit, writing on the neoliberalized gentrification of San Francisco, put it well when she said, "Cities had a kind of porousness—like an old apartment impossible to seal against mice, cities were impossible to seal against artists, activists, dissidents, and the poor."

The city was oppositional. Trafficking in transgression and subversion, it resisted the psychological safety and familiarity of mass culture. Marxist urbanist Henri Lefebvre called the city a "place of desire, permanent disequilibrium, seat of the dissolution of normalities and constraints, the moment of play and of the unpredictable." People did not go to the city to find the normal and the known.

The city was public. Resisting privatization, it provided an accessible arena in which people could meet and mix to create and share ideas, often with the larger crowd. These ideas might be threatening elsewhere, but the city could hold them. "Cities," wrote sociologist Saskia Sassen, "are the spaces where those without power get to make a history and a culture," but this cannot happen in what's become a privately controlled office park.

The city was diverse. Even in its most central arteries, it provided space to live and make a living for countless types of people, various classes, colors, and characters. It was supportive of the small and local, where diversity flourishes. The abundance of mom-and-pop operations gave the cityscape its unique character and provided space for many odd ways to make a buck.

The city was affordable. When people are not working for just

the rent, they can take risks, creatively, sexually, professionally, and politically. They can speak up. They can choose meaningful, often lower-paid work that helps others, like social work, teaching, nursing, and firefighting. Affordability allows people to continue small family businesses. In the affordable city, small was sustaining—to the individual and the wider culture.

The city was democratic. Its people were not primarily consumers; they were citizens, active participants in shaping their environments. As Jane Jacobs wrote, "Cities have the capability of providing something for everybody, only because, and only when, they are created by everybody."

This may sound like I'm describing an idealized utopian city that never existed, but the way I see it, this city did exist—not completely, not consistently, but enough to make itself profoundly felt and known. Maybe this was the city that the rambunctious people of the twentieth century were working toward, until they were thwarted by a different idea of what the city should be—unequal, controlled, branded, and sold. That city, rigged for the fortunate few, is not just. And the ideal city, if we're ever to reach it, must be just.

For Susan Fainstein, author of *The Just City,* justice in the urban context encompasses equity, democracy, and diversity. She prefers the word *equity* to *equality,* defining it as the "distribution of both material and nonmaterial benefits derived from public policy that does not favor those who are already better off at the beginning." Let me highlight that: *The just city does not favor those who are already better off.*

Since Koch, New York has been shaped by a pro-growth regime that strongly favors the already better-off. I've given many examples, but if you need another, consider one prominent New York real estate developer: Donald Trump. In 2016, the *Times* reported that, over the course of his career, starting in the 1970s, Trump "reaped at least $885 million in tax breaks, grants, and other subsidies for luxury apartments, hotels, and office buildings in New York." That infusion of public financial support enabled him to turn his powerful father's

seed money into a real estate empire—and a shocking political move-ment that put Trump in the White House. Alicia Glen, de Blasio's deputy mayor of housing and economic development, said, "Trump is probably worse than any other developer in his relentless pursuit of every single dime of taxpayer subsidies he can get his paws on." Or maybe he's a typical player in a game rigged in his favor. What does Glen say about the rigging? When will City Hall change the rules of the game? Only when we demand it.

To create a just city, we all must participate in its restructuring. Conceived by Henri Lefebvre in 1968 and expanded upon by David Harvey in 2008, the Right to the City idea describes the collective right of inhabitants to produce and occupy urban space—"the freedom to make and remake our cities and ourselves," as Harvey puts it. It calls for more democracy with a focus on class politics. But urbanization is not only a class phenomenon. Class lines intersect with race and eth-nicity, gender and sexuality, immigration status, and other categories less easily categorized, like struggling artist, dissident, eccentric.

As I think about the right to the city, I'm also thinking about who *needs* the city, because there are many people who don't function well outside of cities. Do some people need the city more than oth-ers? And does greater need bestow a greater right? One could argue that queers need the city, because straight life can be lived anywhere, while queer life requires an ecosystem most often found in urban centers. Artists, writers, and intellectuals need the city to stimulate ideas and creativity. Immigrants need the city as entry point. People of color need it to escape the racism that, while not absent from the urban, is more rampant in smaller places. The elderly need the city's accessible abundance of services. Lower-income people need urban community more than higher-income people do, if only because money brings independence. Oddballs need the anonymity of city life in which to go unnoticed and unbothered. And city people, those whose temperament is unsuited for life outside, need the city. You know who you are.

Let's go back to that idealized New York. I don't like leaving it hanging there, mislabeled as a utopian dream. Emancipatory, open, diverse, public—is this not what a city is in its bones? Is this not the true character—dare I say nature—of the city? Cities are seldom characterized as constricting, closed, homogeneous, private, though those words are becoming ever more applicable. The True City, not the utopian, is what I'm trying to get to.

In psychoanalysis, there is the idea of the True Self and the False Self. D. W. Winnicott described the True Self as the one we're born with. It is our essential nature, alive and spontaneous. "Only the True Self can be creative," he wrote, "and only the True Self can feel real." But if our early caretakers interfere with us, if they manipulate and abuse us, we may develop a False Self, a thick protective shell around the hidden True Self. At its worst, the False Self presents as authentic, but it is lacking. Incapable of creativity and spontaneity, it is not fully alive. It's what analyst Helene Deutsch called the "as-if" personality, a plastic type that "lacks the necessary spark" of true life. It might also be described as the narcissistic personality. I believe we're living in a time of the city's False Self. Presented as revitalized and creative, it lacks a spark. Its governing caretakers have interfered with it and abused it. The neoliberalized city is the "as-if" city, a narcissistic city that presents a cold shell and calls it real. But what if we could open that shell? To liberate the True City, we do what we do to liberate the True Self. We reconnect the broken links. We remember what was.

In this age of what cultural critic Henry Giroux calls "the violence of organized forgetting," in today's amnesic New York, to remember is a radical act. To remind is to resist.

Once we stop our collective forgetting, there's a good chance we'll be angry. This is a sign of increasing health. No mayor, even a professed progressive, is going to buck the system until New Yorkers make demands heated with righteous indignation, that catalytic emotion that has also been vanishing from the city. After Ed Koch brought neoliberal governance to City Hall, Irving Howe, editor of

Dissent, wrote in 1987 about the changing emotional atmosphere of the city. The new tone, he said, was nasty, disdainful of the lower classes, and pumped up with the "aggression of winners." Sound familiar? Observing how the city's diversities and unconventionalities were getting swept away by money, greed, developers, and corporations, Howe wrote:

> [W]hat seems to have all but vanished from the discourse of the city, perhaps even its consciousness, is the stress liberals and radicals used to place on the outrage, the violation of moral norms and democratic values that the extremes of wealth and poverty represent. One rarely hears any longer expressions of social dismay or anger or even guilt. If the developers tighten their grip on Manhattan, driving out small storekeepers and booksellers and offbeat movie houses, and the city, dispensing tax breaks and helpful indifference, acquiesces with at best a weary version of the "drip-down" argument—why that's the way things are, the way they've always been.

When people today shrug and say, "New York is always changing," they are deciding not to remember the past or to influence the future. They are saying, *This is the way things have always been and will always be. Nothing can be done.* But today's urban change is neither eternal nor natural. Something can be done. To do it, we'll not only have to remember and remind, we'll also have to feel our guilt, anger, and grief. We'll have to risk being disagreeable.

Cranky is a word the press has used to describe me. I embrace it. If New York is to survive with its soul intact, it needs all the cranky people it can get. Those in power want us to shut up and leave town. We are flies in their imagined ointment. Back in 1995, writing in the free-marketeering *City Journal,* David Brooks said, "It would be a

shame if New York dragged on through the next decades as a wayward home for cranky, marginalized dissenters." But that was the city! Remember? New York of agitators and nonconformists, of creation and disruption, of people who were awake and worked to wake the rest of America with writing, art, politics, and social justice. That is the city for which I am nostalgic, and outraged, and cranky as hell. Aren't you?

New York, with all its influence and might, often sets the global trend. What if, instead of competing for tourists and corporations, our urban leaders competed for the title of Most Equitable City? What ripples would be set in motion? We are living in a time when much of America and the world could benefit from a healthy dose of good, old New York values.

CONCLUSION

FOR GENERATIONS, NEW YORKERS HAVE BOTH CELEBRATED and grieved the city's changeability. *Harper's* claimed in 1856 that New York is "never the same city for a dozen years together. A man born in New York forty years ago finds nothing, absolutely nothing, of the New York he knew." More recently, Colson Whitehead declared: "You are a New Yorker when what was there before is more real and solid than what is there now." Fair enough. But as I hope this book has illustrated, the nature of urban change has changed. As Adam Gopnik put it, "Cities change. It is their nature. Those which stop changing stop being cities. Cities that change entirely, though, cease to be themselves." For years now, New York hasn't been itself. It is being de-urbanized.

Mayor de Blasio, the city's progressive hope, has so far failed to save New York from real estate developers, either because he's in their pocket, as many news sources and New Yorkers believe, or because he's no match for the power they've long taken from a City Hall that's been happy to give. In 2016 he announced that the only way to create affordable housing, for an inclusive city, is through develop-

ment. This is a free-market myth. As journalist Henry Grabar said, "Entrusting affordable housing to real estate developers is a bit like going to McDonald's to lose weight." Luxury development creates an exclusive city. It also prevents resistance. In the book *In Defense of Housing*, David Madden and Peter Marcuse write, "A city where the dangerous classes have been removed does not rebel." This is not only bad for the city; it's bad for the nation—and the world.

We need rebel cities, those open spaces of agitation and art. We especially need them now, as an extreme right-wing nationalist movement rises across the globe. In the immediate wake of the 2016 presidential election that catapulted billionaire real estate developer Donald Trump into the White House, New York was awash in swastikas. Hate crimes spiked as nativism again reared its head in the city. New Yorkers attacked New Yorkers on the subways and streets, targeting Jews, Muslims, queers, and people of color. At the Tenement Museum on the Lower East Side, where our New York story began, visitors confronted guides with hostile remarks about immigrants. In the city's enduring battle between tolerance and trade, tolerance appeared to be losing. But since Trump's inauguration, New Yorkers have risen up, gathering every day to protest in our public spaces, fighting for racial and economic justice. Hours after Trump signed an executive order to strip federal funds from "sanctuary cities" that protect immigrants, thousands of New Yorkers flooded Washington Square Park, that old rebel space. They chanted, "This is what democracy looks like!" and waved signs that read "I ♥ Immigrant NY." Once again, the insurgent heart of the city has a beat.

And so, as I write this in unstable and uncertain January 2017, I dare to hope. Today's violent convulsions may be signs that the New Gilded Age is thrashing in its death throes. Over the past few years, the Occupy movement, Black Lives Matter, and Bernie Sanders have energized a new generation of activists. The mainstream media finally started talking about economic inequality. Even the Interna-

tional Monetary Fund, a major champion of neoliberalism, admitted that free-market policies hinder growth, concluding, "The evidence of the economic damage from inequality suggests that policymakers should be more open to redistribution."

Neoliberal policy is a toxic plague on New York's soul. It is neither natural nor inevitable. This is good news. The disease can be treated. To do so, the tension between trade and tolerance must be rebalanced. Countless activist groups and progressive policy organizations are hard at work to make this happen. A better future is possible if we take the right steps. Here's my wish list:

1. Empower community boards to make real decisions by giving voting rights to the people. In small towns, residents vote on chain stores and developments. New Yorkers should have the same democratic right.

2. Rezone the city to control the spread of chain businesses. San Francisco is leading the charge to limit "formula retail" through regulation, and a number of smaller cities are doing the same.

3. Pass legislation like the long-debated Small Business Jobs Survival Act to protect small businesses from unreasonable rent hikes. Even better, bring back commercial rent regulation.

4. Expand landmarking to protect legacy businesses that contribute to the culture and history of the city. In 2015, San Francisco voters passed the Legacy Business Historic Preservation Fund to provide grants to local, long-term businesses. That's a start.

5. Impose a vacancy tax on landlords who create high-rent blight. Or follow London's example. After three to six months of vacancy, commercial landlords can no longer claim the loss on their taxes.

6. Lower fines for small businesses. Starbucks can pay the Board of Health a fortune for every fly buzzing around, but Mom and Pop can't.

7. End tax abatements and other incentives for developers, corporations, and chains. Reroute those deals to developers of affordable housing and to small, local businesspeople.

8. Strengthen and expand residential rent regulation. Create real affordable housing not tethered to luxury development.

9. Enforce a moratorium on new luxury construction. New York's housing crisis is an affordability crisis. Politicians in San Francisco, Los Angeles, and other cities are fighting for this measure.

10. Reduce speculative real estate investment with a tax on luxury pieds-à-terre, as recommended by New York state senator Brad Hoylman. This is similar to London's "ghost town" tax. Also consider Switzerland's rules to control foreign investment.

11. On the federal level, tighten eminent domain. Private property should only be taken for public use, not private profit.

12. Try creative ways to restrain mass tourism. Launch a city-sponsored campaign telling tourists to behave like guests. Start an insider benefits program that lets New Yorkers skip tourist lines at museums. Stop building hotels. Amsterdam, Venice, and Barcelona are all working on several measures to cope with the tourism crisis.

Just because New York has historically been a city of growth doesn't mean it must swell forever. Our global growth-obsessed culture is a catastrophe. Constantly pushed to consume, we are addicted to everything—food, shopping, iPhones, money—enslaved to a system that tells us to expand until nothing's left. We have spoiled the world, poisoning the water and puncturing the sky. We fill the bellies

of birds with plastic trash. We feed the fish antidepressants, cocaine, and painkillers, a cocktail of our own suffering pissed out and flushed to the sea. We demoralize the poor and working classes of all races, triggering spasms of violence. This is not sustainable. And today's New York is not sustainable. The city is being destroyed by its own so-called success. Jane Jacobs named the problem decades ago when she wrote about "the tendency for outstanding success in cities to destroy itself—purely as a result of being successful."

Limiting growth wasn't always blasphemy. "Once," wrote *Times* architectural critic Paul Goldberger in 1987, "there was a time when the city of New York saw its responsibility for physical planning as a simple mandate: to limit growth." This protected the public. But it changed when City Hall went from tending to its citizens to competing for outside investors, upscale professionals, and tourists. "The city is no longer our protector," Goldberger continued, "but a full-fledged participant in the orgy of Manhattan real-estate development." It's only gotten worse.

As I write this, my new landlord (an LLC behind an LLC) tries to get me out of my rent-stabilized apartment with a lowball buyout. At the same time, I'm on the verge of having to vacate the office I rent for my private practice. I love my office. It's in an old, affordable building that caters to psychotherapists, acupuncturists, Reiki healers, antiques dealers, the Abraham Lincoln Brigade Archives, a purveyor of books about chess, and one wandering alley cat. My office is quiet. I hear the bells of Grace Church tolling the hours. I feel calm there. My patients feel calm there. Thousands of New Yorkers visit the building every day in pursuit of inward growth and health. But a real estate investment firm has bought the place for $100 million. We hear they want bigger tenants, one or two large companies to replace more than three hundred small businesspeople, mostly in the helping professions. The firm's website explains: "we turn under-achieving real estate into exceptional high-yielding investments." I don't know where I'll go next.

It's a terrible feeling to be unwelcome in your own town. Sometimes, I want to give up. Then I catch a glimpse. The True New York is still here, hidden in the gaps. If you slip outside the static, you can feel it. You might have to get up early in the morning. You might have to find a certain street, some overlooked block where old buildings contain multitudes—lamp repairman, zipper shop, fortune cookie factory, and that woman who sells nothing but scissors. The atmosphere relaxes and hums. You feel like a human being among other human beings. This is how it used to feel all the time. Remember? Someone mutters. Someone sings. Someone gives you an inviting look. And you think: Here is New York.

This is why I stay.

I stay to hear the jazz musicians playing in the parks, and to browse the tables of books for sale on the street. I stay for a drink in a quiet bar lit by golden autumn light, and for Film Forum double features in black and white. I stay for egg creams. For the amateur opera singers practicing with their windows open so we all can listen. For the Chinese grandmothers dancing by the East River, snapping red fans in their hands. For the music of shopkeepers throwing open their gates. I stay for the unexpected spectacle and the chance encounter. And for those tough seagulls gliding inland on rainy days to remind us that Manhattan is an island, a potential space both separate and connected. Most of all, I stay because I need New York. I can't live anywhere else. So I hold on to what remains. We've lost a lot, but there's so much left worth fighting for. And while I stay, I fight.

ACKNOWLEDGMENTS

I'm forever grateful to my agent, Anthony Mattero at Foundry, a true mensch and a tireless advocate who believed passionately in this book—and all its crankiness—from the start.

At HarperCollins, thank you to Denise Oswald, who really got my vision, for championing and acquiring the book, and to Jessica Sindler, a crack editor who did a first-rate job seeing it through to full realization. Thanks also to her assistants, Amber Oliver and Alivia Lopez, for taking care of all the thankless tasks.

I owe a debt of gratitude to the manuscript readers who were beyond generous with their time and thoughtfulness: The indispensable Romy Ashby helped whip the book into shape from its beginnings; city scholar Julian Brash gave his expertise and guidance on all things urbanism; and Michael Henry Adams, E. V. Grieve, Andrew J. Padilla, Sebene Selassie, and Sherill Tippins offered valuable edits and additions to select chapters. Thanks also to Ira Silverberg and Kenneth Goldsmith for their early support, and to David Kamp, another true mensch, for his bighearted encouragement and editorial advice.

Thanks to the #SaveNYC Planning Committee for keeping things going while I was sequestered to write this book: Jonathan Boorstein, Jackie Broner, Lee Michael, and Beatriz Rodriguez. To Janice Isaac, deputy of the Vanishing New York Facebook page, for her unwavering support. And to all the many dedicated readers of the blog who kept me going with their virtual encouragement—and

constructive criticism—over the years, and whose knowledge of the city helped to shape this book. I wish I could name you all. (Special shout-out to Laura Goggin for the fruit flies in Mars Bar's watermelon vodka, and to Amy Nicholson for the Coney timeline.)

I am also grateful to the people who allowed me to interview them for my blog, portions of which have enhanced this book with their unique voices and ideas: Jonny Aspen, Regina Bartkoff, Cornelius Byrne, Jake and Jack Bono, Arleen Bowman, Ivy Brown, Alan Brownfeld, Annie and John De Robertis, Jay Goudgeon, Carl Hultberg, Mike Joyce, Melva Max, Warren Allen Smith, Peter and Mark Rubin, and Richard Wilkinson.

Thanks to my mother and father, who have supported my writing habit since kindergarten, and to all the good friends who kept my confidence.

Finally, endless thanks to Rebecca Levi, my intrepid companion who spent innumerable hours walking New York with me in search of things to blog about, who read multiple drafts of this book, and who listened with (almost) indefatigable patience to all my grievances and gripes about the state of her native city.

NOTES

In my research, I relied on the work of other blogs and fellow bloggers, some heavily, others lightly, but all important in cobbling together the story of today's living city. In alphabetical order, these include: Amusing the Zillion, Atlantic Yards Report, Barry Popik's Big Apple, Bowery Boogie, Curbed, DNAinfo, Eater, E. V. Grieve, Flaming Pablum, Gothamist, Living with Legends: Hotel Chelsea Blog, Lost City, Neither More Nor Less, New York Shitty, Washington Square Park Blog. In most cases, throughout the book, I cite sources within the text. I also offer the following notes.

INTRODUCTION

3 Bryan Waterman, *The Cambridge Companion to the Literature of New York* (Cambridge and New York: Cambridge University Press, 2010).

3–4 Caleb Carr quoted in "Talking Bloomberg," *New York Times* online, August 16, 2013; Patti Smith in conversation with Jonathan Lethem at the PEN America World Voices Festival, Cooper Union, May 1, 2010; David Byrne, from "Will Work for Inspiration," CreativeTimeReports.org; David Rakoff, from "Isn't It Romantic," in *Half Empty* (New York: Anchor, 2011); Adam Gopnik, from "Gothamitis," *The New Yorker*, January 8, 2007.

6 Joseph Mitchell, excerpt from unfinished memoir, *The New Yorker*, February 11 and 18, 2013.

1 THE EAST VILLAGE

15 "The East Village was not always the East Village." See Jesse McKinley, "F.Y.I.," *New York Times,* January 1, 1995; also Earl Wilson, *Earl Wilson's New York* (New York: Simon & Schuster, 1964).

17 Rosalyn Deutsche and Cara Gendel Ryan, "The Fine Art of Gentrification," *October,* no. 31 (Winter 1984). See also Deutsche, *Evictions: Art and Spatial Politics* (Cambridge, MA: MIT Press, 1996). For a counterargument, see James Cornwell, "Villains or Victims: Are East Village Artists Willing Agents for Gentrification and the Displacement of the Poor?" in Clayton Patterson, ed., *Resistance: A Radical Social and Political History of the Lower East Side* (New York: Seven Stories Press, 2011).

21 Eileen Myles, "Buildings and Cigarettes," in Mark Crispin Miller, ed., *While We Were Sleeping: NYU and the Destruction of New York* (New York: McNally Jackson Books, 2012).

23 Paul Goldberger, "Green Monster," *The New Yorker,* May 2, 2005.

24 On Cooper Union, see Denny Lee, "Planners Wary of College's Expansion, But Cooper Union Calls It Essential," *New York Times,* July 28, 2002; Lydia Polgreen, "City Planners Approve Cooper Union High-Rises, Citing College's Public Benefits," *New York Times,* September 4, 2002.

2 HYPER-GENTRIFICATION IN THE REVANCHIST CITY

36 "Neighborhood Changes in New York City During the 1970s: Are the Gentry Returning?" *Federal Reserve Bank of New York Quarterly Bulletin,* Winter 1983–1984.

3 LUDLOW STREET AND THE LOWER EAST SIDE

44 "Communist theme apartment building" from "Briefly Noted" review of *Tibor Kalman: Perverse Optimist,* in *The New Yorker,* December 7, 1998.

44–45 Frederique Krupa, "Red Square, New York," 1992, downloaded from simple-is-beautiful.org.

45–46 M&Co on Red Square, from Michael Bierut, ed., *Tibor Kalman: Perverse Optimist* (New York: Princeton Architectural Press, 1998).

4 THE BATTLE FOR NEW YORK'S SOUL

57 John Dollard, *Caste and Class in a Southern Town* (New Haven, CT: Yale University Press, 1937). Full sentence, "The immigrants are, in one manner of speaking, our 'Negroes,' but they are temporary Negroes."

57 "'The floodgates are open,'" quoted in Eliot Lord, John J. D. Trenor, and Samuel June Barrows, *The Italian in America* (New York: B. F. Buck, 1905).

58 Jennie-Ralph had many names, including Earl Lind, Ralph Werther, and Jennie June. S/he published *Autobiography of an Androgyne* in 1918, followed by *The Female Impersonators* in 1922.

58–59 Ford Madox Ford, *New York Is Not America* (New York: Albert & Charles Boni, 1927).

60 Ellwood Cubberley, *Changing Conceptions of Education* (Boston and New York: Houghton Mifflin, 1909).

61 Edmund Morgan, *American Slavery, American Freedom* (New York: Norton, 2003). On the racial bribe and special privileges, see Lani Guinier and Gerald Torres, *The Miner's Canary: Enlisting Race, Resisting Power, Transforming Democracy* (Cambridge, MA: Harvard University Press, 2009); and Michelle Alexander, *The New Jim Crow* (New York: New Press, 2012).

61 On working-class immigrants embracing whiteness, see Jennifer Guglielmo, *Are Italians White? How Race Is Made in America* (New York: Routledge, 2003); and Noel Ignatiev, *How the Irish Became White* (New York: Routledge, 2008).

62 Lewis Mumford, "The Plan of New York," *New Republic*, June 15, 1932.

63 W. E. B. Du Bois, opinion piece in *The Crisis* 24, no. 4 (August 1922).

65 On ethnics buying into whiteness through suburban homeownership, see David R. Roediger, *Working Toward Whiteness: How America's Immigrants Became White* (New York: Basic Books, 2005).

65 James Baldwin, *The Price of the Ticket: Collected Nonfiction 1948–1985* (New York: St. Martin's Press, 1985).

65 Seward Mott, "The Case for Fringe Locations," *Journal of the American Institute of Planners* 5, no. 2 (1939).

65 Ta-Nehisi Coates, "The Case for Reparations," *The Atlantic*, June 2014.

68 On blockbusting: Mothers forced to work, fathers took two jobs, etc., from Norris Vitcheck, "Confessions of a Blockbuster," *The Saturday Evening Post*, July 14–21, 1962.

71 "Between June and September of 1966," from a poll taken by Louis Harris for *Newsweek*, found in CBS News special report, "Black Power/White Backlash," 1966.

71 Johnson quote as recalled by Bill Moyers in "What a Real President Was Like; To Lyndon Johnson, the Great Society Meant Hope and Dignity," *Washington Post*, November 13, 1988.

72–73 Pete Hamill, "The Revolt of the White Middle Class," *New York*, April 14, 1969.

74 Nixon tapes from David E. Rosenbaum, "Nixon Tapes At Key Time Now Drawing Scant Interest," *New York Times*, December 14, 2003.

74 Ehrlichman on the War on Drugs, from Dan Baum, "Legalize It All," *Harper's*, April 2016.

75 On RAND and rational choice, see Alex Abella, *Soldiers of Reason: The RAND Corporation and the Rise of the American Empire* (New York: Houghton Mifflin Harcourt, 2008).

75–76 "Irredeemable rookeries" speech by Robert Moses, found in Max Page, *Creative Destruction of Manhattan* (Chicago: University of Chicago Press, 2001), noted as typescript of speech by Robert Moses at the Commodore Hotel, November 14, 1956, Municipal Reference Library, vertical files, "NYC Slums."

78 Roger Starr, "Making New York Smaller," *New York Times Magazine*, November 14, 1976.

78 Rita Koenig, "Mr. Podsnap Goes to Town," *New York*, May 13, 1985; Roger Starr, *The Rise and Fall of New York City* (New York: Basic Books, 1985).

5 THE BOWERY

82 On CBGB's fight with landlord, see Cathy Jedruczek, "CBGB Feeling Punk'd, as Nonprofit Stops Lease Talks," *Villager*, June 15–21, 2005.

83 Varvatos talking to camera: For *Burning Down the House: The Story of CBGB*, film directed by Mandy Stein, 2009.

85 Bobby Steele explained the loogie incident to the blog Can't Stop

the Bleeding: "'They were telling me what 'PUNK' is. 'It's not punk.' So, I finally had enough, and said 'This is PUNK!' and spit on them."

89–90 Kate Millett. *Mother Millett* (London and New York: Verso Books, 2002).

95 On Bowery House, see Dan Barry, "On Bowery, Cultures Clash as the Shabby Meet the Shabby Chic," *New York Times*, October 12, 2011.

99 On Blue & Cream planting a flag, see Alexandria Symonds, "Ceci N'est Pas CBGB," This Recording (blog), October 3, 2011.

101 M. Christine Boyer, "Cities for Sale," in Michael Sorkin, ed., *Variations on a Theme Park: The New American City and the End of Public Space* (New York: Hill & Wang, 1992).

6 THE NEOLIBERAL TURN

104 George Monbiot, "Neoliberalism: The Ideology at the Root of All Our Problems," *Guardian*, April 15, 2016.

105 Ken Auletta, "The New Power Game," *New York*, January 12, 1976.

108 "We're not catering to the poor anymore" from Arthur Browne, Michael Goodwin, and Dan Collins, *I, Koch: A Decidedly Unauthorized Biography of the Mayor of New York City* (New York: Dodd, Mead, 1985).

109 Patricia Morrisroe, "The Yupper West Side," *New York*, May 13, 1985.

109 Steve Fraser, "A Wall Street State of Mind," *The Nation*, special issue on "Bloomberg's New York: The Gilded City," May 6, 2013.

110 "J-51 and 421a tax losses together cost the city $1.4 billion," from Roger Sanjek, *The Future of Us All: Race and Neighborhood Politics in New York City* (Ithaca, NY: Cornell University Press, 2000).

110–111 Spread of AIDS, from Rodrick Wallace, "A Synergism of Plagues: 'Planned Shrinkage,' Contagious Housing Destruction, and AIDS in the Bronx," *Environmental Research* 47 (1988).

112 Broken Windows Theory debunked, see Bernard Harcourt and Jens Ludwig, "Broken Windows: New Evidence from New York City and a Five-City Social Experiment," *University of Chicago Law Review* 73 (2006); and David Greenberg, "Studying New York City's Crime Decline: Methodological Issues," *Justice Quarterly* 31 (2014).

113 "There's a chill in the air . . ." from Vivian S. Toy, "Council Approves Package of Curbs on Sex Businesses," *New York Times*, October 26, 1995.

7 LITTLE ITALY

119 For two views on contemporary gentrification in Chinatown, see Samuel Stein, "Unprotected and Undone," in Tom Angotti and Sylvia Morse, eds., *Zoned Out! Race, Displacement, and City Planning in New York City* (New York: Terreform, 2016); and Nick Tabor, "How Has Chinatown Stayed Chinatown?," *New York*, September 21, 2015.

127 Adele Sarno, interview by Sandi Bachom, "#SaveNYC 85 yr old ADELE SARNO: Faces 'IRONIC' Eviction by Italian American Museum 3/28/15," YouTube.

8 SEPTEMBER 11

130 Djuna Barnes, "Greenwich Village As It Is," *Pearson's Magazine*, October 1916.

130 KKK and John Roach Straton on Al Smith, see Robert A. Slayton, *Empire Statesman: The Rise and Redemption of Al Smith* (New York: Free Press, 2001), and "When a Catholic Terrified the Heartland," *New York Times*, December 10, 2011.

132 Tad Friend, "Why America Hates New York," *New York*, January 23, 1995. See also Jane O'Reilly, "Why Heartland America Hates New York," *New York*, August 16, 1971.

132 David Brooks, "Out-of-Step New York," *City Journal*, Spring 1995.

133 "A powerful giant is one thing," Milton Glaser, in Miriam Greenberg, *Branding New York: How a City in Crisis Was Sold to the World* (New York: Routledge, 2008).

136 For research on terrorism and consumerism, see N. Mandel and D. Smeesters, "The Sweet Escape: Effects of Mortality Salience on Consumption Quantities for High- and Low-Self-Esteem Consumers," *Journal of Consumer Research* 35, no. 2 (2008): 309–23; Marieke Fransen, Dirk Smeesters, and Bob Fennis, "Mortality Salience and Brand Attitudes: The Moderating Role of Social Presence," in Margaret C. Campbell, Jeff Inman, and Rik Pieters, eds., *Advances in Consumer Research* 37 (2010), 534–35; J. C. Choi, K. Kwon, and M.

Lee, "Understanding Materialistic Consumption: A Terror Management Perspective," *Journal of Research for Consumers* 13 (2007); U. Dholakia, "How Terrorist Attacks Influence Consumer Behaviors," *Psychology Today*, December 1, 2015.

137 "Our city suffered two tragedies a decade ago . . ." Gary Taustine, from Letters to the Editor, *Daily News*, September 8, 2011.

9 GREENWICH VILLAGE

149 Hopper's eviction by NYU, from Gail Levin, *Edward Hopper: An Intimate Biography* (New York: Knopf, 1995).

152 Christopher Hitchens, "Last Call, Bohemia," *Vanity Fair*, June 12, 2008.

10 BLOOMBERG

155–156 On sexual harassment lawsuits, see Larry Cohler-Esses, "Mike Settled 'Abuse' Case," *Daily News*, March 27, 2001. On the joke book, see Michael Wolff, "Full Bloom," *New York*, November 5, 2001, and Elizabeth Kolbert, "The Mogul Mayor," *The New Yorker*, April 22, 2002; Michael Saul, "Bloomy Defends Bid to Gag Aide," *Daily News*, September 10, 2001; "Campaigning for Mayor: Confronting the Economy's Future and Media Rumors," excerpts from mayoral debate, *New York Times*, September 10, 2001.

155 "He seems not quite able to articulate . . . " from Nick Paumgarten, "Bloomberg Courts Makor," *The New Yorker*, August 6, 2001.

156 "No turn of events," from Michael Wolff, "Bloomberg News," *New York*, August 27, 2001.

162–163 On newsstands, see Glenn Collins, "Newsstands of Tomorrow Get Mixed Reviews Today," *New York Times*, August, 29, 2008, and Winnie Hu, "Newsstands to Give Way to New Kiosks with Ads," *New York Times*, October 10, 2003.

13 HIGH LINE 1: THE MEATPACKING DISTRICT

185 Matt Pincus, "The Wild West," *New York*, March 3, 1997.

193–193 Diane von Furstenberg perfume rumor from *New York Post*, Page Six, "Designer Scent 'Em Running," July 2, 2009.

14 THE NEW GILDED AGE AND THE ENRON SOCIETY

200 On the potential cooling benefit of supertall luxury towers, see "The Science of Supertalls," presented by Jesse M. Keenan, research director, Center for Urban Real Estate, and Luc Wilson, Kohn Pedersen Fox Associates, at the 2015 Municipal Art Society Summit for New York City, October 22, 2015.

201 "Plutocratic cloud," from Rowland Atkinson, "Limited Exposure: Social Concealment, Mobility, and Engagement with Public Space by the Super-rich in London," *Environment and Planning A* (2015).

203 A 2015 city-sponsored study . . . NYC Center for Economic Opportunity and Abt Associates, "The Effects of Neighborhood Change on New York City Housing Authority Residents," May 21, 2015.

203–204 "We won't have any sun," from Greg Smith, "High and Mighty NYCHA: Luxury Towers on Leased Land Would 'Look Down' on Projects," *Daily News*, June 11, 2013.

204 Ian Frazier, "Hidden City," *The New Yorker*, October 28, 2013.

208 Paul Piff et al., "Higher Social Class Predicts Increased Unethical Behavior," *Proceedings of the National Academy of Sciences USA*, March 13, 2012; Paul Piff, "Wealth and the Inflated Self: Class, Entitlement, and Narcissism," *Personality and Social Psychology Bulletin*, August 20, 2013.

209 E. M. Caruso, K. D. Vohs, B. Baxter, and A. Waytz, "Mere Exposure to Money Increases Endorsement of Free-Market Systems and Social Inequality," *Journal of Experimental Psychology: General* 142, no. 2 (2013): 301; Adam Grant, "Does Studying Economics Breed Greed?," *Psychology Today* online, October 22, 2013.

16 ON THE SIDEWALK

226 Edwin Denby, "First Warm Days," in *The Complete Poems* (New York: Random House, 1986).

228–229 E. M. Lamberg, "Cell Phones Change the Way We Walk," *Gait and Posture* 35, no. 4 (2012).

229 On class and pedestrian behavior, see Pia Dietze and Eric Knowles, "Social Class and the Motivational Relevance of Other Human Beings," *Psychological Science*, October 3, 2016.

229 On the Keith Haring sculpture, see Daniel Maurer, "When Art Attacks! Keith Haring's Self-Portrait Kicked Someone in the Head," Bedford & Bowery, January 16, 2015.

231 Rem Koolhaas, "The Generic City," in S, M, L, XL (New York: Monacelli Press, 1995).

231 Jan Gehl et al., "Close Encounters with Buildings," Urban Design International 11 (2006).

17 HIGH LINE 2: WEST CHELSEA TO HUDSON YARDS

239 Philip Lopate, "Walking the High Line," in Portrait Inside My Head: Essays (New York: Simon & Schuster, 2014).

246 For Jonny Aspen on zombie urbanism, see interview with Aspen on Vanishing New York, http://vanishingnewyork.blogspot .com/2016/08/zombie-urbanism.html. Also Jonny Aspen, "Oslo— The Triumph of Zombie Urbanism," in Rodolphe El-Khoury, ed., Shaping the City: Studies in History, Theory, and Urban Design (New York: Routledge, 2013).

18 THE TROUBLE WITH TOURISTS

253 James Wolcott, "Splendor in the Grit," Vanity Fair, May 11, 2009.

254 Penny Arcade, from "Mediocrity Is the New Black: Penny Arcade On Making It in 'The Big Cupcake,'" Bedford & Bowery, October 30, 2014.

257 Jeremy Boissevain, Coping with Tourists: European Reactions to Mass Tourism (Providence, RI: Berghahn Books, 1996).

257 On anti-tourist graffiti in Berlin, see Claire Colomb and Johannes Novy, eds., Protest and Resistance in the Tourist City (London and New York: Routledge, 2017).

20 SUBURBANIZING THE CITY

279–280 Rem Koolhaas and the Harvard Project on the City, Mutations (Barcelona: Actar, 2000).

280 Richey Piiparinen, "The Persistence of Failed History: White Infill as the New White Flight?," New Geography, July 10, 2013.

283 One Starbucks every 5.5 blocks in Manhattan—calculated by

math student Aleksey Bilogur on his blog at http://www.resident mar.io/2016/02/09/average-chain-distance.html.

283 Steven Barrison, forum on "The Death (& Rebirth?) of NYC's Mom-and-Pops," New York City, October 20, 2016.

283 On the history of commercial rent control in New York, see John J. Powers, "New York Debates Commercial Rent Control: Designer Ice Cream Stores versus The Corner Grocer," *Fordham Urban Law Journal* 15, no. 3 (1986).

284 Tim Wu, "Why Are There So Many Shuttered Storefronts in the West Village?," *The New Yorker* online, May 24, 2015.

286 Sarah Schulman quote from *While We Were Sleeping: NYU and the Destruction of New York* (New York: McNally Jackson Books, 2012).

289 "Books smell like old people," from David Denby, "Do Teens Read Seriously Anymore?," *The New Yorker* online, February 23, 2016.

21 HARLEM AND EAST HARLEM

293 D'Amato singing, from David Bird and Sara Rimer, "Disharmony and Housing," *New York Times*, October 22, 1985.

293–294 Neil Smith and Richard Schaffer, "The Gentrification of Harlem?," *Annals of the Association of American Geographers* 76, no. 3 (1986).

295 Reverend Butts, "slave catcher," from Peter Noel, "The Sins of Reverend Calvin Butts," *Village Voice*, October 27, 1998.

297 Frederick Douglass Boulevard rezoning and its effect on population, from Sylvia Morse, "Harlem: Displacement, Not Integration," in Angotti and Morse, eds., *Zoned Out!*, citing Leo Goldberg, "Game of Zones: Neighborhood Rezonings and Uneven Urban Growth in Bloomberg's New York City" (M.C.P. thesis, Massachusetts Institute of Technology, 2015).

301 Cynthia Cornell, quoted in Brendan Bartholomew, "Gentrification Evictions Could Amount to Elder Abuse," *San Francisco Examiner*, March 10, 2016.

302 Robin Middleton, quoted by Harlem historian and activist Michael Henry Adams on his Facebook page.

314 On chains and "bourgeoisie aestheticism," see Daniel Akst, "On the Contrary; Why Chain Stores Aren't the Big Bad Wolf," *New York Times*, June 3, 2001.

22 GENTRIFIERS AND THE NEW MANIFEST DESTINY

322 "Artists: NYC Is Not for Sale," discussion, part of the Decolonize This Place project, October 29, 2016.

323 Manuel Castells, *The City and the Grassroots: A Cross-Cultural Theory of Urban Social Movements* (Berkeley: University of California Press, 1984).

324 Jamie Peck, "Struggling with the Creative Class," *International Journal of Urban and Regional Research* 29, no. 4 (2005).

324 Bloomberg's transportation commissioner knew well: Samuel Stein, "Bike Lanes and Gentrification: New York City's Shades of Green," *Progressive Planning*, no. 188 (Summer 2011).

323–325 Richard Florida, "The Creative Class and Economic Development," *Economic Development Quarterly* 28, no. 3 (2014); Richard Florida, "More Losers Than Winners in America's New Economic Geography," *CityLab*, January 30, 2013. On the dark side: Lydia DePillis, "The Re-education of Richard Florida," *Houston Chronicle*, October 24, 2016.

23 BROOKLYN

331 Truman Capote, "Brooklyn Heights: A Personal Memoir," *Holiday*, February 1959.

335–336 Mark Greif, *What Was the Hipster? A Sociological Investigation* (New York: n+1 Foundation, 2010), and "What Was the Hipster," *New York*, October 24, 2010.

338 On Williamsburg racial shift of population, see Philip DePaolo and Sylvia Morse, "Williamsburg: Zoning Out Latinos," in Angotti and Morse, eds., *Zoned Out!*

339–340 On the war between Hasidim and hipsters, see Michael Idov, "Clash of the Bearded Ones," *New York*, April 11, 2010.

353 On the seizure of Jerry Campbell's house, see Michael O'Keeffe, "No Place Like Home: Atlantic Yards Project Has Jerry Campbell Fighting for His Place in Brooklyn," *Daily News*, April 13, 2016.

24 CONEY ISLAND

358 Paul Blackburn, "Clickety-Clack," in *The Selected Poems* (New York: Persea Books, 1989).

358–359 Giuseppe Cautela, "Coney," *American Mercury*, November 1925.

360 For a detailed description of a night at the Shore Hotel, see Dan Glass, "Loving by the Hour," *The L Magazine*, November 9, 2005.

363 Jerome Tuccille, *Trump: The Saga of America's Most Powerful Real Estate Baron* (Washington, DC: Beard Books, 1985).

366 Steve Zeitlin, "The House Under the Roller Coaster," *Journal of New York Folklore* 27 (2001).

369 *Zipper: Coney Island's Last Wild Ride*, directed by Amy Nicholson, 2012.

25 QUEENS

377 Ted Steinberg, *Gotham Unbound: The Ecological History of Greater New York* (New York: Simon & Schuster, 2015).

378 "an eyesore, a disgrace, an affront," from Thomas Buckley, "Junkmen Battle the Fair to Stay in Business," *New York Times*, April 12, 1964.

26 THE SOUTH BRONX

390 Party quotes from Leigh Nordstrom, "Gigi Hadid and Naomi Campbell Party in Lucien Smith's 'Macabre Suite,'" *WWD*, October 30, 2015.

392–393 Jeff Kinkle, "Neoliberalism as Horror: Wolfen and the Political Unconscious of Real Estate," posted online at Cartographies of the Absolute, May 14, 2010.

400–401 Feargus O'Sullivan, "The Pernicious Realities of Artwashing," *CityLab*, June 24, 2014.

27 ON MEMORY AND FORGETTING

405 "at their hottest," from Ada Calhoun, "My City Was Gone. (Or Was It?)," *New York Times*, October 31, 2015.

406 For papers on nostalgia, see C. Routledge et al., "The Past Makes

the Present Meaningful: Nostalgia as an Existential Resource," *Journal of Personality and Social Psychology* 101, no. 3 (2011); X. Zhou et al., "Counteracting Loneliness: On the Restorative Function of Nostalgia," *Psychological Science* 19, no. 10 (2008); X. Zhou et al., "Nostalgia: The Gift That Keeps On Giving," *Journal of Consumer Research* 39, no. 1 (2012).

408 Saskia Sassen, "Who Owns Our Cities—And Why This Urban Takeover Should Concern Us All," *Guardian*, November 24, 2015.

411 D. W. Winnicott, "Ego Distortion in Terms of True and False Self" (1960) in *The Maturational Process and the Facilitating Environment: Studies in the Theory of Emotional Development* (London: Hogarth Press, 1965); and Helene Deutsch, "Some Forms of Emotional Disturbance and their Relationship to Schizophrenia," *Psychoanalytic Quarterly* (1942).

411–412 Irving Howe, "Social Retreat and the Tumler," *Dissent*, Fall 1987.

Conclusion

415 On Bill de Blasio's relationship with developers, see Mark Crispin Miller, "What's the Biggest Scandal in de Blasio's Administration? That He Belongs to the Developers Destroying New York City," *Huffington Post*, April 18, 2016; Josh Dawsey, "De Blasio's Ties to Real-Estate Industry Are Scrutinized," *Wall Street Journal*, April 22, 2016; Derek Kravitz, "Bill de Blasio, Friend of Real-Estate Developers?," *The New Yorker* online, September 11, 2013; Jennifer Fermino, "Most New Yorkers See de Blasio's Cozy Real-Estate Developer Relationships as Unethical, Poll Shows," *Daily News*, May 25, 2016.

415 De Blasio statement on the inclusive city, from Rosa Goldensohn, "De Blasio Says More Streetcars and Ferries Could Be on the Way," *Crain's*, Insider (blog), November 1, 2016.

416 Henry Grabar quote from "Inside the Gamble That Could Make or Break Bill de Blasio," *Next City*, January 5, 2015.

416 On the Tenement Museum, see Sebastian Malo, "At New York Immigration Museum, Guides Cope with Hostile Remarks," Thomas Reuters Foundation News, November 21, 2016.

417 International Monetary Fund report, see Jonathan D. Ostry, Prakash Loungani, and Davide Furceri, "Neoliberalism: Oversold?," *Finance and Development*, June 2016.

SELECTED BIBLIOGRAPHY

Alexiou, Joseph. *Gowanus: Brooklyn's Curious Canal*. New York: New York University Press, 2015.

Anasi, Robert. *The Last Bohemia: Scenes from the Life of Williamsburg, Brooklyn*. New York: FSG Originals, 2012.

Angotti, Tom. *New York for Sale: Community Planning Confronts Global Real Estate*. Cambridge, MA: MIT Press, 2011.

Angotti, Tom, and Sylvia Morse, eds. *Zoned Out! Race, Displacement, and City Planning in New York City*. New York: Terreform, 2016.

Berman, Marshall. *All That Is Solid Melts into Air*. New York: Penguin, 1988.

Berman, Marshall, and Brian Berger. *New York Calling: From Blackout to Bloomberg*. London: Reaktion Books, 2007.

Brash, Julian. *Bloomberg's New York: Class and Governance in the Luxury City*. Athens: University of Georgia Press, 2011.

Brown-Saracino, Japonica. *A Neighborhood That Never Changes: Gentrification, Social Preservation, and the Search for Authenticity*. Chicago: University of Chicago Press, 2010.

Caro, Robert. *The Power Broker: Robert Moses and the Fall of New York*. New York: Vintage, 1975.

Chang, Jeff. "Vanilla Cities and Their Chocolate Suburbs: On Resegregation." In *We Gon' Be Alright*. New York: Picador, 2016.

Chauncey, George. *Gay New York: Gender, Urban Culture, and the Making of the Gay Male World, 1890–1940*. New York: Basic Books, 1995.

Conn, Steven. *Americans Against the City: Anti-Urbanism in the Twentieth Century*. New York: Oxford University Press, 2014.

David, Joshua, and Robert Hammond. *High Line: The Inside Story of New York City's Park in the Sky*. New York: FSG Originals, 2011.

Davis, Mike. *Evil Paradises: Dreamworlds of Neoliberalism.* New York: New Press, 2008.

Delany, Samuel. *Times Square Red, Times Square Blue.* New York: New York University Press, 2001.

Denson, Charles. *Coney Island: Lost and Found.* Berkeley, CA: Ten Speed Press, 2004.

Edsall, Thomas, and Mary Edsall. *Chain Reaction: The Impact of Race, Rights, and Taxes on American Politics.* New York: Norton, 1992.

Ehrenhalt, Alan. *The Great Inversion and the Future of the American City.* New York: Vintage, 2013.

Ellard, Colin. *Places of the Heart: The Psychogeography of Everyday Life.* New York: Bellevue Literary Press, 2015.

Fainstein, Susan. *The Just City.* Ithaca, NY: Cornell University Press, 2011.

———. "Planning and the Just City." In Peter Marcuse et al., *Searching for the Just City: Debates in Urban Theory and Practice.* London and New York: Routledge, 2009.

Fensterstock, Ann. *Art on the Block: Tracking the New York Art World from SoHo to the Bowery, Bushwick and Beyond.* New York: Palgrave Macmillan, 2013.

Fitch, Robert. *The Assassination of New York.* London and New York: Verso Books, 1996.

Flood, Joe. *The Fires: How a Computer Formula, Big Ideas, and the Best of Intentions Burned Down New York City—and Determined the Future of Cities.* New York: Riverhead Books, 2011.

Freeman, John, ed. *Tales of Two Cities: The Best and Worst of Times in Today's New York.* New York and London: OR Books, 2014.

Freeman, Joshua B. *Working-Class New York: Life and Labor Since World War II.* New York: New Press, 2001.

Fullilove, Mindy Thompson. *Root Shock: How Tearing Up City Neighborhoods Hurts America, and What We Can Do About It.* New York: One World/ Ballantine, 2005.

Gibson, D. W. *The Edge Becomes the Center: An Oral History of Gentrification in the 21st Century.* New York: Overlook Press, 2015.

Glass, Ruth. "Introduction: Aspects of Change." In Centre for Urban Studies, ed., *London: Aspects of Change.* London: MacKibbon & Kee, 1964.

Greenberg, Miriam. *Branding New York: How a City in Crisis Was Sold to the World.* New York: Routledge, 2008.

Hackworth, Jason. *The Neoliberal City: Governance, Ideology, and Development in American Urbanism*. Ithaca, NY: Cornell University Press, 2006.

Hammett, Jerrilou, and Kingsley Hammett. *The Suburbanization of New York*. New York: Princeton Architectural Press, 2007.

Harvey, David. *A Brief History of Neoliberalism*. New York: Oxford University Press, 2007.

———. "From Managerialism to Entrepreneurialism: The Transformation in Urban Governance in Late Capitalism." *Geografiska Annaler*. Series B, *Human Geography* 71, no. 1 (1989).

———. *Rebel Cities: From the Right to the City to the Urban Revolution*. New York: Verso Books, 2013.

Jackson, Kenneth. *Crabgrass Frontier: The Suburbanization of the United States*. New York: Oxford University Press, 1987.

Jacobs, Jane. *The Death and Life of Great American Cities*. New York: Vintage, 1992.

Jones, Jacqueline. *A Dreadful Deceit: The Myth of Race from the Colonial Era to Obama's America*. New York: Basic Books, 2013.

Kasson, John. *Amusing the Million: Coney Island at the Turn of the Century*. New York: Hill & Wang, 1978.

Klein, Naomi. *The Shock Doctrine: The Rise of Disaster Capitalism*. New York: Picador, 2008.

Kunstler, J. Howard. *The Geography of Nowhere: The Rise and Decline of America's Man-Made Landscape*. New York: Simon & Schuster, 1993.

Larson, Scott. *Building Like Moses with Jane Jacobs in Mind: Contemporary Planning in New York City*. Philadelphia: Temple University Press, 2013.

Lefebvre, Henri. *Writings on Cities*. Cambridge, MA: Wiley-Blackwell, 1996.

Lees, Loretta, et al. *Gentrification*. New York: Routledge, 2007.

Lees, Loretta, et al. *Planetary Gentrification*. Cambridge, England, and Malden, MA: Polity, 2016.

Ley, David. *The New Middle Class and the Remaking of the Central City*. New York: Oxford University Press, 1997.

Madden, David, and Peter Marcuse. *In Defense of Housing*. London and New York: Verso Books, 2016.

Marcuse, Peter. "Gentrification, Abandonment, and Displacement: Connections, Causes, and Policy Responses in New York City." *Washington University Journal of Urban and Contemporary Law* 28 (1985).

Martinez, Miranda. *Power at the Roots: Gentrification, Community Gardens,*

and the Puerto Ricans of the Lower East Side. Lanham, MD: Lexington Books, 2010.

Montgomery, Charles. *Happy City: Transforming Our Lives Through Urban Design*. New York: Farrar, Straus & Giroux, 2014.

Ocejo, Richard. *Upscaling Downtown: From Bowery Saloons to Cocktail Bars in New York City*. Princeton, NJ: Princeton University Press, 2014.

Osman, Suleiman. *The Invention of Brownstone Brooklyn: Gentrification and the Search for Authenticity in Postwar New York*. New York: Oxford University Press, 2012.

Page, Max. *The City's End: Two Centuries of Fantasies, Fears, and Premonitions of New York's Destruction*. New Haven, CT: Yale University Press, 2010.

———. *The Creative Destruction of Manhattan*. Chicago: University of Chicago Press, 2001.

Patterson, Clayton, ed. *Resistance: A Radical Social and Political History of the Lower East Side*. New York: Seven Stories Press, 2011.

Rhodes-Pitts, Sharifa. *Harlem Is Nowhere*. New York: Back Bay Books, 2013.

Rieder, Jonathan. *Canarsie: The Jews and Italians of Brooklyn Against Liberalism*. Cambridge, MA: Harvard University Press, 1987.

Roediger, David. *The Wages of Whiteness: Race and the Making of the American Working Class*. Rev. ed. London: Verso, 2007.

———. *Working Toward Whiteness: How America's Immigrants Became White*. New York: Basic Books, 2005.

Sagalyn, Lynne. *Times Square Roulette: Remaking the City Icon*. Cambridge, MA: MIT Press, 2001.

Sante, Luc. *Low Life: Lures and Snares of Old New York*. New York: Farrar, Straus & Giroux, 2003.

———. "My Lost City." In *Kill All Your Darlings*. Portland, OR: Yeti, 2007.

———. *The Other Paris*. New York: Farrar, Straus & Giroux, 2015.

Schulman, Sarah. *The Gentrification of the Mind: Witness to a Lost Imagination*. Berkeley: University of California Press, 2013.

Sennett, Richard. *The Conscience of the Eye: The Design and Social Life of Cities*. New York: Norton, 1992.

Sherman, Scott. *Patience and Fortitude: Power, Real Estate, and the Fight to Save a Public Library*. Brooklyn: Melville House, 2015.

Shorto, Russell. *The Island at the Center of the World: The Epic Story of Dutch Manhattan and the Forgotten Colony That Shaped America*. New York: Vintage, 2005.

Smith, Neil. "Gentrification Generalized: From Local Anomaly to Urban 'Regeneration' as Global Urban Strategy." In Melissa S. Fisher et al., *Frontiers of Capital: Ethnographic Reflections on the New Economy*. Durham, NC: Duke University Press, 2006.

———. "New Globalism, New Urbanism: Gentrification as Global Urban Strategy." *Antipode* 34, no. 3 (2002).

———. *The New Urban Frontier: Gentrification and the Revanchist City*. London and New York: Routledge, 1996.

Soffer, Jonathan. *Ed Koch and the Rebuilding of New York*. New York: Columbia University Press, 2012.

Solnit, Rebecca. *Hollow City: The Siege of San Francisco and the Crisis of American Urbanism*. London and New York: Verso, 2002.

Sorkin, Michael. *Variations on a Theme Park: The New American City and the End of Public Space*. New York: Hill & Wang, 1992.

Steinberg, Stephen. *The Ethnic Myth: Race, Ethnicity, and Class in America*. Boston: Beacon Press, 2001.

Strausbaugh, John. *The Village: 400 Years of Beats and Bohemians, Radicals and Rogues, a History of Greenwich Village*. New York: Ecco, 2014.

Sussman, Ann, and Justin Hollander. *Cognitive Architecture: Designing for How We Respond to the Built Environment*. New York: Routledge, 2014.

Tippins, Sherill. *Inside the Dream Palace: The Life and Times of New York's Legendary Chelsea Hotel*. Boston: Houghton Mifflin Harcourt, 2013.

Tissot, Sylvie. *Good Neighbors: Gentrifying Diversity in Boston's South End*. London and Brooklyn: Verso, 2015.

Traub, James. *The Devil's Playground: A Century of Pleasure and Profit in Times Square*. New York: Random House, 2004.

Verhaeghe, Paul. "Capitalism and Psychology—Identity and Angst: On Civilisation's New Discontent." In Wim Vermeersch, ed., *Belgian Society and Politics*. Ghent: Gerrit Kreveld Foundation, 2012.

———. *What About Me? The Struggle for Identity in a Market-Based Society*. Brunswick, Australia: Scribe, 2015.

Vitale, Alex. *City of Disorder: How the Quality of Life Campaign Transformed New York Politics*. New York: New York University Press, 2009.

Wakefield, Dan. *New York in the '50s*. Boston: Houghton Mifflin, 1992.

Wallace, Deborah, and Rodrick Wallace. *A Plague on Your Houses: How New York Was Burned Down and National Public Health Crumbled*. London and New York: Verso, 2001.

White, E. B. *Here Is New York*. New York: Curtis, 1949.

Whyte, William H. *City: Rediscovering the Center*. Philadelphia: University of Pennsylvania Press, 2009.

———. *The Exploding Metropolis*. Berkeley: University of California Press, 1993.

Wilkerson, Isabel. *The Warmth of Other Suns: The Epic Story of America's Great Migration*. New York: Vintage, 2011.

Wilkinson, Richard, and Kate Pickett. *The Spirit Level: Why More Equal Societies Almost Always Do Better*. New York: Bloomsbury Press, 2011.

Zukin, Sharon. *Loft Living: Culture and Capital in Urban Change*. New Brunswick, NJ: Rutgers University Press, 1989

———. *Naked City: The Death and Life of Authentic Urban Places*. New York: Oxford University Press, 2011.

Zukin, Sharon, et al. *Global Cities, Local Streets: Everyday Diversity from New York to Shanghai*. Routledge, 2015.

Zukin, Sharon, et al. "The Omnivore's Neighborhood? Online Restaurant Reviews, Race, and Gentrification." *Journal of Consumer Culture*, October 14, 2015.

Resources

Many local activist and preservation groups are working to fight displacement, achieve urban justice, and maintain the character of our neighborhoods. These are just a few. Please Google them and get involved.

ASAP: Artist Studio Affordability Project
Bowery Alliance of Neighbors
Brooklyn Anti-Gentrification Network (BAN)
Coalition to Protect Chinatown and LES
Crown Heights Tenant Union
El Barrio Unite
Equality for Flatbush
FIERCE (Fabulous, Independent, Educated Radicals for Community Empowerment)
Greenwich Village Society for History Preservation (GVSHP)
Historic Districts Council
L.E.S. Dwellers
New York Communities for Change
New Yorkers for a Human-Scale City
Queens Neighborhoods United
Right to the City Alliance
#SaveNYC
South Bronx Unite
Take Back NYC
UPROSE

INDEX

JEREMIAH MOSS, creator of the award-winning blog Vanishing New York, is the pen name of Griffin Hansbury. His writing on the city has appeared in the *New York Times*, the *New York Daily News,* and online for *The New Yorker* and *The Paris Review.* As Hansbury, he is the author of *The Nostalgist,* a novel, and works as a psychoanalyst in private practice in New York City.